Spirituality and Reform

Spirituality and Reform

Christianity in the West, ca. 1000–1800

Calvin Lane

LEXINGTON BOOKS/FORTRESS ACADEMIC
Lanham • Boulder • New York • London

Published by Lexington Books/Fortress Academic
An imprint of The Rowman & Littlefield Publishing Group, Inc.
4501 Forbes Boulevard, Suite 200, Lanham, Maryland 20706
www.rowman.com

Unit A, Whitacre Mews, 26-34 Stannary Street, London SE11 4AB

Copyright © 2018 by The Rowman & Littlefield Publishing Group, Inc.

All rights reserved. No part of this book may be reproduced in any form or by any electronic or mechanical means, including information storage and retrieval systems, without written permission from the publisher, except by a reviewer who may quote passages in a review.

British Library Cataloguing in Publication Information Available

Library of Congress Cataloging-in-Publication Data

Names: Lane, Calvin, author.
Title: Spirituality and reform : Christianity in the West, ca. 1000-1800 / Calvin Lane.
Description: Lanham, MD: Lexington Books-Fortress Academic, 2018. | Includes bibliographical references and index.
Identifiers: LCCN 2018027531 (print) | LCCN 2018031575 (ebook) | ISBN 9781978703940 (electronic) | ISBN 9781978703933 (cloth : alk. paper) | ISBN 9781978703957 (pbk. : alk. paper)
Subjects: LCSH: Church renewal--History. | Church history.
Classification: LCC BV600.3 (ebook) | LCC BV600.3.L355 2018 (print) | DDC 270--dc23
LC record available at https://lccn.loc.gov/2018027531

∞™ The paper used in this publication meets the minimum requirements of American National Standard for Information Sciences Permanence of Paper for Printed Library Materials, ANSI/NISO Z39.48-1992.

Printed in the United States of America

For Daniel and Elizabeth

*Deus meus misit angelum suum,
et conclusit ora leonum,
et non nocuerunt mihi*
Daniel 6:22

*et exclamavit voce magna, et dixit:
Benedicta tu inter mulieres,
et benedictus fructus ventris tui
Jesus*
Luke 1:42

Contents

Images	ix
Acknowledgments	xi
Introduction: Spirituality and Reform	1
1 The Spiritual Landscape: The Mass in the Middle Ages	9
2 The Spiritual Landscape: Mediating the Holy in the Middle Ages	31
3 The Spirituality of High Medieval Reform Movements: Popes and Monks	49
4 Medieval Mysticism and Reform	77
5 The Spirituality of Late Medieval Reform Movements: Pushing the Boundaries	93
6 Sixteenth-Century Reformations: The Sacraments	117
7 Sixteenth-Century Reformations: Preaching, Sacred Space, and Music	139
8 Sixteenth-Century Reformations: Pastoral Care and the Life Cycle	159
9 Sixteenth-Century Reformations: Early Modern Catholicism	175
10 Spirituality and the Encounter: Opportunities for a Primitive Church	195
11 Spirituality and the Bloody Theater: Martyrdom in the Middle Ages and Early Modernity	213
12 Religions of the Heart: New Movements of the Seventeenth and Eighteenth Centuries	225
Epilogue: Post Tenebras Lux?	247
Appendix 1: Timeline	253
Appendix 2: Shortlist of Primary Sources in English Suitable for Teaching	257
Bibliography	259
Index of Persons	281

Index of Subjects	285
About the Author	289

Images

Cover, Altar Frontal in Torslunde Church (1561), Zealand, Denmark. CC-BY-SA Lennart Larsen, National Museum of Denmark.

Figure 1.1 Monstrance, c.1450 Cologne, Germany. The Friedsam Collection, Bequest of Michael Friedsam, 1931, Metropolitan Museum of Art, New York, NY. Accession Number: 32.100.226. https://www.metmuseum.org/art/collection/search/467485.

Figure 2.1 Reliquary Casket with Scenes from the Martyrdom of St. Thomas Becket c.1173–1180. Gift of J. Pierpont Morgan, 1917, Metropolitan Museum of Art, New York, NY. Accession Number: 17.190.520. http://www.metmuseum.org/art/collection/search/464490.

Figure 3.1 Master of Sir John Fastolf, Saint Francis, c. 1430–1440. The J. Paul Getty Museum, Los Angeles, CA Digital image courtesy of the Getty's Open Content Program. http://www.getty.edu/art/collection/objects/2733/master-of-sir-john-fastolf-saint-francis-french-or-english-about-1430-1440/.

Figure 5.1 Albrecht Dürer, *Knight, Death, and the Devil*, 1513. Harris Brisbane Dick Fund, 1943, Metropolitan Museum of Art, New York, NY. Accession Number: 43.106.2. https://www.metmuseum.org/art/collection/search/336223.

Figure 6.1 Valerius Sutton, Communion cup and paten, 1630–1635. Bequest of Irwin Untermyer, 1973, Metropolitan Museum of Art, New York, NY. Accession Number: 1974.28.152a, b. https://www.metmuseum.org/art/collection/search/205655.

Figure 11.1 Jan Lukyn, Dirk Willems saving his pursuer, Thieleman van Braght, *The Martyr's Mirror* Courtesy of the Mennonite Library and Archives, Bethel College, Newtown, KS.

Figure 12.1 Allegorical image of the side wound of Christ, ink and watercolor on paper, Moravian Archives Herrnhut, Germany. TS.Mp.375.4.

Acknowledgments

This book is for a wide variety of readers. My teaching for a public university and a seminary while also serving parishes as an Episcopal priest has helped me stay in touch with such a diverse audience. Many thanks, then, to students at Nashotah House Theological Seminary and Wright State University, and likewise the people of St. Mary's Church in Franklin, Louisiana, and St. George's Church in Dayton, Ohio. I am certainly grateful for capable administrators like Carol Herringer, Jonathan Winkler, Garwood Anderson, Andrew Grosso, Jack Gabig, and Steven Peay. I must also thank the rector of St. George's, Benjamin Phillips (himself very much a determined disciple of the sixteenth-century reformations) for having me on his staff and for not merely accepting but supporting my twin vocation as a scholar. He has often kept Martin Luther and Thomas Cranmer in my field of vision.

Librarians at several institutions, most notably Nashotah, Wright State, and the University of Dayton have rendered invaluable help. I am also grateful for the many colleagues who gave advice and read draft chapters, especially Peter Yoder, Ezra Plank, Zachary Guiliano, and Rabia Gregory. I am particularly indebted to Dr. Gregory for her use of certain draft chapters in her courses at the University of Missouri-Columbia, for the feedback her students provided, and for her redirecting me on several important points. I also am grateful to the capable staff at Lexington Books/Fortress Academic, especially Michael Gibson. Among these colleagues, however, my near omni-competent wife Denise Kettering-Lane, professor of Brethren Studies at Bethany Theological Seminary has kept me from making too much of a fool of myself—or so we both hope. I cannot thank her enough for the many conversations about this project, for her grace and patience with my beginning such conversations "in the middle" having had the first part in my head, and for living out some of the traditions described in this study.

This book is dedicated to our children. My son bears the name of that captive prophet whose refusal to break his rule of prayer led him to a den of lions, but God closed their mouths. And through this experience, a pagan king declared that the God of Daniel is to be praised. My daughter bears the name of another priest's daughter, a woman who sang out to her cousin Mary, "blessed are you among women and blessed is the fruit of your womb," words prayed by billions of women and men every day. Among my hopes for Daniel and Elizabeth, whom I love so much, whose

bright eyes and smiles inherited from their mother bring infectious joy, and whose laughter causes me to stop ruminating on long-dead bishops, is that they might be enriched by the practices, born of reform and renewal, described in this book, ways of living the Christian life that have shaped generations. Or at the very least, I hope they will understand what often captivates the attention of both their parents.

<div align="right">
LCL III

Easter Day, 2018
</div>

Introduction

Spirituality and Reform

In 1526, the churches of Zurich, Strasbourg, and Nuremberg were experimenting with vernacular liturgies. Leading a program for reform in Wittenberg, Martin Luther had been reticent to issue a German rite for a variety of reasons, principally because he did not want other regional evangelical churches to perceive his liturgy as a staple for orthodoxy. However, when he saw these new rites emerging in cities to the south, Luther felt the need to offer a German mass as a stabilizing force. In the preface of the *Deutsche Messe*, Luther wrote that there should be three forms of service: (1) the continuance of his earlier revisions of the Latin mass known as the *Formula Missae*, (2) a German rite which would be the principal worship pattern for most people, and then (3) worship in the homes of seriously committed individuals.[1] Luther's program for reform, one initially focused on questions of justification, had now expanded quite naturally to patterns of prayer, devotion, and every day practice.

This book is about the dynamic intersection between reform movements and Christian spirituality. Adopting an expansive view of both "reform" and "spirituality," we will trace the spiritual commitments of Christians at critical moments of change, exposing a continuous dialogue between practice and belief. The historiographical borders between "the Middle Ages," "the Reformation," and "the Enlightenment" are lowered to see a series of reform programs, each of which developed new sensibilities about what it meant to live the Christian life. The subject matter begins around the year 1000 in monastic communities which hoped to revive earlier, arguably classical patterns of primitive Benedictine practice. From there, moments of reform, retrieval, or renewal are examined from the high middle ages through the sixteenth-century reformations and then the text closes with the pietistic movements of the eighteenth century. At the outset of this expansive study of close to a thousand years, it should be clear that this book insists that Christianity comprises both ideas and practices. Consequently, the attempt here is to weave an account that fully incorporates theology and cultural history. What we find by examining these different moments of reform is that religious change both *shaped* and *was shaped by* patterns of liturgy and devotion, attitudes toward art and the material context of devotion, mysticism,

monasticism, pilgrimage, and certainly the character of public worship and private prayer.

SPIRITUALITY

Spirituality and reform, as concepts, both deserve some unpacking at the outset. In contemporary settings, both words are used rather vaguely, and this presents a number of problems for students of both history and theology. Further complicating the situation, scholars too have had difficulty reaching a consensus about the meaning of these words. For the sake not only of methodological precession but basic clarity, we need some working definitions. Spirituality will here be used in an inclusive, capacious sense, referring to the subjective practice and experience of religion as well as the spiritual exercises—devotions, activities, patterns of discipline, etc.—which individuals or groups have used to build up, as they perceive it, their relationship with God. That definition, though, has a term within it that needs even further unpacking: religion. The word religion (*religio*) itself has an inherent Christian meaning: it means to bind, and it assumes that one is not naturally bound but rather loose and in need of binding. The root of the word is the same as rule (*regula*), that which holds one's life together or, more specifically, that which holds one together with God. Therefore, the very word "religion" itself presumes that without this element—whatever it may be, whatever it may look like, whatever it entails doing or not doing—the individual or perhaps society or perhaps creation itself will become disconnected from God, spinning off into the outer darkness.

Spirituality, then, which focuses on the practice and experience of religion (that binding of humanity and God), is an extraordinarily broad term. This study, consequently, is going to be wide-ranging: the goal will be to consider personal and corporate prayer, meditation and contemplation, mysticism, liturgy, pastoral care, and preaching. Of course, one cannot escape discussions of confessional identity or, perhaps put better, religious identity, that is, how one perceives herself as a Christian vis-à-vis other Christians and other people in general. Likewise, apologetics (writings to persuade), polemics (writings to condemn), and hermeneutics (how one interprets scripture) will feature in every century and every movement under examination. Traditional branches of theology will also be important, for example soteriology (how God saves), ecclesiology (the nature of the church), sacramental theology (how certain rituals may or may not convey grace), and eschatology (God's final intention for creation). All these elements give shape to how Christians live and practice Christianity, day by day, generation by generation. In the simplest of terms, this study approaches spirituality as practice.[2]

While the word *spiritualis* appeared twenty-two times in Jerome's fourth-century Latin translation of the Bible, *spiritualitas* (spirituality) was a neologism appearing in an anonymous fifth-century letter. The word referred to the nature of a life lived in accords with God's purposes or, put differently, the quality of life—again practice—which should arise from the presence of the Holy Spirit. Moreover, the context was a call to the reader for progress or development: the author of the letter wrote "act in order to grow in spirituality."[3] By the high middle ages, the notion of a "spiritual life" often referred to ways of life that were focused on the interior; when people spoke or wrote about spirituality they were concerned with devotions or disciplines which could cultivate an inner life. As a result, "spirituality" was usually construed as the arena of contemplatives, that is, people who had withdrawn from the world in some way to focus the whole of their lives on prayer. The distinction between the active life and the contemplative life is important to grasp, as this is emphatically not a divide between clergy and lay-people. The active life is any state of life which is engaged in the world. Surely, we think of marriage, raising children, commerce, politics, warfare, etc. But parish priests and bishops too are just as *secular* as they are engaged in work in the world. A contemplative, on the other hand, has receded from the world, its cares and concerns, to live a life absorbed in forms of prayer. At the same time, though, one should also not assume that all *religious* clergy, that is, monastic clergy living according to a rule, are contemplatives. While many orders do have a contemplative orientation, that is not an irreducible element of monastic life. Obviously, the mendicant friars wandering through the world preaching and teaching were engaged in the world, and in some ways the ethos of balance prevented even the Benedictines from total withdrawal. Put differently, not all monks were engaged solely in prayer. So, we have the divide between the active life and the contemplative life to keep in mind, but we also have a similar (though not synonymous) divide between secular and religious clergy. And, to repeat, for most of the middle ages, spirituality was understood to be the turf of the contemplative.[4]

Many medieval writers insisted that real spiritual progress is impossible for those in the active life. The dominant thinking was that to develop one's relationship with God, one naturally had to withdraw into contemplation. People in the active life needed to simply stick to the basics of moral theology: make good confessions, attend mass and receive the sacrament at Easter, do good works, avoid evil, prepare for a holy death. No matter how pious one might appear, she or he was never going to grow closer to God without bowing out of the active life. Recall, though, that our working definition of spirituality is quite different from that of late medieval ascetical and systematic theologians: the rubric here is practice, and frankly the division which seemed so stark may have existed only on paper. In fact, the late medieval German mystics make allowance for a

sort of democratic spirituality, to borrow from Bernard McGinn. Some in the fourteenth and fifteenth centuries began to think that spiritual growth can and does happen in the active life—and they were followed in that conviction by still others, Francis de Sales for example in the seventeenth century. For the historian using a broad lens, whether we are discussing the practices of a laywoman raising ten children or the practices of a hermit who has not spoken in ten years, it is all spirituality and it is all worth analysis. That is not to say that this study will be unconcerned with those authors who *did* teach that withdrawal was necessary; that would omit a major part of the tradition. So, while treated and analyzed, those voices will not be privileged.[5]

With a working definition of spirituality established it should be clear that attempts to systematize are profoundly difficult. Christian spirituality has grown, developed, and evolved in lots of different directions and caution is necessary. Those caveats being made, there are nevertheless some common patterns, and in fact we can say some things about the forms and language of Christian spirituality in a generalized way. But again, there are always exceptions—what follows are not airtight categories. Perhaps the best example is the pattern of spiritual progress envisioned as moving up a series of stages or up a ladder or even up a mountain. While there are variants, the general pattern is three-fold: a purgative stage, an illuminative stage, and finally the unitive stage.[6] And what we find through the course of centuries is a steady evolution of this pattern; sometimes it gets subdivided, sometimes the contents change, sometimes what one does changes. The progressive pattern of steps, an ascent to God, remains. Another example is asceticism, a word that some readers may associate with flagellation and heroic displays of fasting. Asceticism in fact is better understood as the active engagement of devotions and disciplines. Flagellation is ascetical, but so is something as simple as maintaining daily prayer or time for scripture study. Either way, the Christian is actively engaged in dying to self to have a deeper experience of Christ. Mysticism, which is often (but not always) a more passive experience, usually means an unmediated, direct experience of God. Mystical experiences sometimes come with visions and ecstasies. These may be subtle or quite wild, for example levitations, hysterical sobbing, even the stigmata (the wounds of Christ miraculously appearing on one's body).[7]

Two rather tricky terms are meditation and contemplation. While in contemporary English parlance these two are used interchangeably, it was not so in the medieval and early modern context. Meditation is at the level of discursive, word-based prayer. It is perhaps the most basic kind of prayer.[8] Contemplation, however, is the fixing of one's heart and mind on an object, image, or concept. It usually assumes a posture of reception. The visual, including sometimes darkness (the definitive absence of the visual), is key. In contemplation, one gazes upon something, or to borrow

from Julian of Norwich, *beholds* something. One drinks it in for a long period and, in this act of contemplation, that which is contemplated pervades the individual, soaking and permeating. The critical difference between meditation and contemplation is that contemplation is beyond words. As a result, medieval and early modern church authorities were intermittently fearful of contemplatives veering beyond established doctrine.[9]

Yet another common characteristic of the highly varied tradition of Christian spirituality are three descriptive terms: affective, speculative, and practical. Affective or affectionate prayer taps into emotion (affections), dealing more with the desires than the mind. The word "love" is regularly used by the figures examined here and we might even think of the "heart," but it may be helpful to know that the Greek word in scripture for heart, *kardia* was translated in some early English Bibles as "bowels." We might think of "gut desires" to properly understand "affections."[10] Franciscans, for example, are often understood to have an affectionate spirituality. A deeply sensitive identification with the crucified Jesus is the signature of Francis himself and it was imprinted on his order much the same way the stigmata was, according to tradition, imprinted on his body. Speculative spirituality refers to seeking God with the mind, time spent studying scripture, for example. To be clear, this kind of study is not rumination, that is, chewing on scripture for an affective response, but rather to know more about God. The Dominicans, historically, have a speculative spirituality: this order counts theological reflection, teaching, and preaching as spiritual activities. In the middle ages if a Dominican friar had the choice between joining others in the choir offices and studying to prepare for a sermon, he was to choose sermon preparation. Speculation assumes that one grows closer to God by understanding him more and more through the mind, a point argued forcefully by the great Dominican theologian Thomas Aquinas. Practical spiritual traditions insist that God is best known in the disciplined patterns of Christian living, by obeying a rule, by getting up every day and spending time in prayer, spending time in service, and spending time working. For those with a practical spirituality, God is found in the everyday, and a good example would be the late medieval movement known as the *Devotio Moderna*. Among figures like Thomas Kempis, there is no push for working oneself up with emotion, and the idea that one should spend all day in intellectual study would be abhorrent. The "practical divinity" of the puritans of the seventeenth century with their commitment to hours of prayer, hours of work, hours of study, and even hours of rest and recreation likewise stressed bringing daily life under a Godly discipline. According to proponents of practical spiritual traditions, God is found not in ecstasies and visions, nor is he found in intellectual propositions, but rather in a humility that comes by way of a rhythmic, ordered life.[11]

REFORM

The forgoing discussion has tried to provide a sketch of what we mean by the word "spirituality." This book, however, is not yet another text on Christian spirituality, but rather a broad study of the intersection of spirituality and reform. So, what do we mean by "reform" and "reformation?" During the sixteenth century, the canton of Geneva adopted the motto *post tenebras lux*, after darkness comes light. The implication, at the most basic level, is that change had come, a change so stark that it could be compared to the distinction between night and day. There was a deep sensitivity about and awareness of major change. Indeed, the reformations of the sixteenth century were incredible moments of social, political, and religious transformation, even revolution. Reform, however, was not limited to those programs for change, and it is a poorly trained historian who sees some vast, dark, unchanging middle ages, untouched by reform until the light of Luther and Calvin. Indeed, the very term "middle ages" was coined by historically savvy writers of the fifteenth and sixteenth centuries who reflexively understood themselves to be part of an age and movement which they called the "renaissance," a rebirth of some classical, golden age which was itself conceived in different ways. One cannot miss though that those easy historiographical borders are polemical and even fabricated. The narrative runs that the darkness of a clericalist, Pelagian, and Biblically-illiterate middle ages was scattered with severity by the light of the "The Reformation," a monolithic program for liberation totally different from everything that came before it. A more accurate presentation is to see those centuries we casually call "medieval" as marked by wave after wave of reform movements, and likewise those centuries succeeding the sixteenth as also marked by further programs for reform.[12]

Adopting a broad approach, reform will be understood as conscious change involving groups or church bodies. In this sense, it is not simply evolution or gradual adjustment but change that is felt with acuity. This was change that required advocacy, explication, and endorsement, change that could be characterized by those who experienced it, for good or ill, as beginning or ending an epoch. The question, then, naturally arises, why are the bookends for this study c. 1000 and c. 1800? In one sense, the whole history of Christianity is a story of continuous change and growth. Given the rubrics just outlined, one could include the spirituality of the fourth century or the twentieth, periods of major change in the life of the church. The brackets set for this study, though, are more than organizational. A common feature of reform movements from the high middle ages to the beginning of modernity in the eighteenth century is the search for a primitive Christianity, one perceived as more authentic and genuine than that being experienced. In a general way, then, religious change from c. 1000 to c. 1800 was often pitched as retrieval. Even if

Introduction 7

they involved gross historical inaccuracies, these reform movements, all of which involved practice, perceived their goal as a return to a true faith and Christian life, one delivered and disencumbered from error. Sixteenth-century reform movements (which have so often been crammed together as "The Reformation") are here understood as part of a longer sweep of religious change which manifested as a perceived return to a golden age, a time of apostolic purity not only in belief but also in practice.

The purpose of this text is to examine a dialogue between spirituality and moments of intense religious change. As noted, the range of material is vast, but there are some classical patterns: religious change, no matter how intellectual, no matter how theological, no matter how conceptual and abstract involved changes in practice, recurring themes like stages in Christian progress, and a host of methods for what is often called spiritual direction. This introduction began with a brief description of one element of Luther's reform program, the German Mass of 1525: sacrificial language was eliminated, change was made gradually by retaining a Latin rite, and even devotion in the domestic sphere was considered as a future possibility. This book is the story of other such moments, the way religious change informs and is informed by practice.

NOTES

1. Martin Luther, "The German Mass and Order of Service, 1526," in *Luther's Works*, ed. Ulrich Leupold (Philadelphia: Muhlenberg Press, 1965), vol. 53, 51–90.

2. Philip Sheldrake, *Spirituality and History: Questions of Interpretation and Method* (Maryknoll, NY: Orbis, 1998), 40–64; Sandra Schneiders, "The Study of Christian Spirituality: Contours and Dynamics of a Discipline," *Christian Spirituality Bulletin* (Spring, 1998), 1–12; Peter Tyler and Richard Woods, "Introduction: What is Christian Spirituality" in *The Bloomsbury Guide to Christian Spirituality*, ed. Tyler and Woods (London: Bloomsbury, 2012), 1–6; Alister McGrath, *Christian Spirituality: An Introduction* (Oxford: Blackwell, 1999) 1–12, 27–34. The historian Carlos Eire once challenged a definition of spirituality advanced by Bernard McGinn by questioning how McGinn's definition of spirituality was distinct from moral theology. Without offering comment, I confess that the definition here may likewise be open to that criticism. Should it disappoint, I have nevertheless described what exact phenomena will be studied in this book. Bernard McGinn, "The Letter and the Spirit: Spirituality as an Academic Discipline," *Christian Spirituality Bulletin* (Fall, 1993), 1–10. See also Brent Nongbri, *Before Religion: A History of a Modern Concept* (New Haven: Yale University Press, 2015).

3. *Patrologia Latina* 30:115A. The letter has been attributed to Jerome, Pelagius, and Faustus of Riez.

4. Janet Burton and Julie Kerr, *The Cistercians in the Middle Ages* (Woodbridge: Boydell, 2011), 103–24; Ulrike Wiethaus, "Christian Spirituality in the Medieval West," in *The Blackwell Companion to Christian Spirituality*, ed. Arthur Holder (Oxford: Wiley-Blackwell, 2011), 122–38.

5. Amy Hollywood, "Introduction" in *Cambridge Companion to Christian Mysticism*, ed. Amy Hollywood and Patricia Beckman (Cambridge: Cambridge University Press, 2012), 1–36.

6. *Pseudo-Dionysius: The Complete Works*, trans. Colm Luibheid and Paul Rorem (New York: Paulist Press, 1987); Bernard McGinn, "*Unio Mystica* / Mystical Union" in

Hollywood and Beckman, eds., *Cambridge Companion to Christian Mysticism*, 200–10; Sarah Coakley and Charles Stang, eds., *Rethinking Dionysius the Areopagite* (Oxford: Wiley-Blackwell, 2009); Stang, "Negative Theology from Gregory of Nyssa to Dionysius the Areopagite," in *The Wiley-Blackwell Companion to Christian Mysticism*, ed. Julia Lamm (Oxford: Wiley-Blackwell, 2013), 161–76.

7. Barbara Newman, "What did it mean to say 'I saw'? The Clash between Theory and Practice in Medieval Visionary Culture," *Speculum* 80 (2005), 6–41; Veerle Fraeters, "*Visio* / Vision" and Dyan Elliot, "Raptus / Rapture" in Hollywood and Beckman, eds., *Cambridge Companion to Christian Mysticism*, 178–88, 189–99.

8. Jean LeClerq, *The Love of Learning and the Desire of God: A Study of Monastic Culture* trans. Catherine Misrahi (New York: Fordham University Press, 1982), 15–17; Thomas Bestul, "*Meditatio* / Meditation" in Hollywood and Beckman, eds., *Cambridge Companion to Christian Mysticism*, 157–66.

9. Denise Baker, *Julian of Norwich's Showings: From Vision to Book* (Princeton: Princeton University Press, 2014), 15–62; Christiania Whitehead "The Late Fourteenth-Century English Mystics" in Lamm, eds., *Wiley-Blackwell Companion to Christian Mystisicm*, 367–70; Charlotte Radler, "*Actio et Contemplatio* / Action and Contemplation," in Hollywood and Beckman, eds., *Cambridge Companion to Christian Mysticism*, 211–22.

10. Sarah McNamer, *Affective Meditation and the Invention of Medieval Compassion* (Philadelphia: University of Pennsylvania Press, 2009); Martin Thornton, *English Spirituality: An Outline of Ascetical Theology according to the English Pastoral Tradition* (Cambridge, MA: Cowley, 1986), 16–20. On *kardia* as gut, see works by the Reformed theologian James Smith.

11. Jill Raitt, ed., *Christian Spirituality: High Middle Ages and Reformation* (New York: Crossroads, 1987), 15–74; "The Medieval West" in Cheslyn Jones, Geoffrey Wainwright, and Edward Yarnold, eds., *The Study of Spirituality* (Oxford: Oxford University Press), 277–341; "Schools of Spirituality" in Tyler and Woods, 57–183.

12. Constantine Fasolt, "Hegel's Ghost: Europe, the Reformation, and the Middle Ages" *Viator* 39 (2008), 345–86; Lawrence Besserman, "The Challenge of Periodization: Old Paradigms and New Perspectives," in *The Challenge of Periodization: Old Paradigms and New Perspectives*, ed. Idem (London: Routledge, 1996); Steven Ozment, *The Age of Reform, 1250–1550: An Intellectual and Religious History of Late Medieval and Reformation Europe* (New Haven: Yale University Press, 1980); Bruce Gordon, ed., *Protestant History and Identity in Sixteenth-Century Europe* (Aldershot: Ashgate, 1996); Anthony Grafton, *What was History?: The Art of History in Early Modern Europe* (Cambridge: Cambridge University Press, 2007).

ONE

The Spiritual Landscape

The Mass in the Middle Ages

The mass was the center of the medieval world, not only spiritually but conceptually. As a ritual, the mass was ubiquitous. As an idea, it ordered the universe. As an element of culture, it shaped politics and art. The mass stood at the conjunction of Christian practice and belief as it was, day by day at every altar, the intersection of heaven and earth. According to the liturgy itself, the mass harmonizes angelic and human voices, as the whole of creation lifts praise to the creator. As Miri Rubin put it, "the lives of men and women, of cities and nations, could be encompassed, redeemed, transformed, or forsaken through it." The mass was the crossroads of scholastic theology in its sacramental definitions, its ethical reflections, and its understanding of the human condition, the Incarnation, soteriology, and justification. The mass was at the conjunction of popular culture where mysticism, art, and literature shared abiding concerns. It was the place where all strata of society engaged in deep prayer and devotion even if many did not understand the language spoken on the other side of the rood screen, that divider between sacred and profane. It would also become the crossroads for most reformers both in their understanding of the Eucharist and in their practice of celebrating the rite as discussed in a later chapter. This chapter, however, focuses on the undoubted centerpiece of medieval Christian spirituality, the mass, examining the theology, practice, material context, and experience of the mass in medieval culture.[1]

THEOLOGY: THREE VIGNETTES

It should be stressed that thought and practice always have a dynamic relationship. Sometimes practice and prayer will help clarify theology, rather than the liturgy directly articulating belief. In other words, this study does not assume that devotion and liturgy merely instantiate intellectual concepts. That caveat made, three vignettes concerning Eucharistic theology in the high and later middle ages will be a helpful place to start. They are the Berengarian controversy of the eleventh century, the appearance of the highly influential *Four Books of Sentences* by Peter Lombard in the twelfth century, and then the Fourth Lateran Council of 1215.

In mid-eleventh century France, word circulated that the charismatic scholar Berengar of Tours (999–1088), then teaching in Angers, was spreading errors about the presence of Christ in the Eucharist, possibly questioning Christ's presence in the elements of bread and wine. Some thought that Berengar was teaching that the bread and wine are merely shadows of Christ and not the true body and blood of Jesus. Berengar was summoned for a series of examinations involving multiple popes and their legates, the most startling of these being a council held by Pope Nicholas II during Eastertide 1059. There Berengar encountered Cardinal Humbert of Silva-Candida, one of the most strident members of the reform party, then riding high in Rome. Just five years earlier, Humbert laid a writ of excommunication on the altar of Hagia Sophia in Constantinople, an event which marked the start of the Great Schism of 1054 which formally divided the Eastern Christians from the Latin West. Now Humbert forced Berengar to swear to a fully physical understanding of Christ's presence in the Eucharist. The oath, which Berengar later repudiated, made its way into a sizeable number of contemporary canon law collections. *Ego Berengarius*, as the oath is known, can be found in no less than Gratian's Decretum, a major source of medieval canon law, as well as in a codex issued to the monks of Canterbury in the late eleventh century by Lanfranc, William the Conqueror's archbishop of Canterbury. Lanfranc, a staunch ally of the Roman reform party, would later write a treatise on the Eucharist specifically targeting what he believed were Berengar's errors. *Ego Berengarius* dramatically reads that the body of Jesus is "physically handled and broken by the priest and torn by the teeth of the faithful. Not just in a sacrament, but in truth." As thorough as this oath seemed, the great reformist pope Gregory VII called on Berengar again to be very clear about his understanding of the Eucharistic presence of Christ in 1078 and again in 1079. Gregory had himself examined Berengar previously as a papal legate, but in 1078 he made Berengar affirm: "I believe that the bread on the altar is after consecration the very Body of Christ, born of the Virgin . . . and the wine his very Blood that flowed from his side on the Cross."[2]

A decade later Berengar was dead, but controversy about the nature of the Eucharist remained alive. It was not really a new thing when Berengar was first examined either. In the 850s, two other theologians, Paschasius Radbertus (785–865) and Ratramnus of Corbie (d.c. 870) had struggled with one another over how to rightly describe Christ's presence; Radbertus won out in the long run, teaching that when one ingests the body and blood of Christ, one becomes successively more like Christ. While Eucharistic controversy was not a new phenomenon, the controversy circling around Berengar of Tours set the stage for what historians often call the long twelfth century, a period of great theological and ascetical development much of which focused on the altar.

Our second vignette is the appearance of a monumentally important text, the *Libri Quattuor Sententiarum*, the *Four Books of Sentences* by the Paris Master, Peter Lombard (1100–1160). In the emerging universities, the *Sentences* displaced the practice of scriptural exegesis coupled with reading "florilegia" of the early church Fathers (collections of patristic quotes). With the *Sentences*, one had a more systematic textbook, an organized tour through the basics of theology. Written in the 1150s when Lombard taught at the cathedral school in Paris, the four books successively discuss the doctrines of the Trinity, creation, the Incarnation, and the church's sacraments. And almost all major theologians after Lombard, from Alexander of Hales (c. 1185–1245) to William of Ockham (1288–1347) and even Martin Luther, prepared a commentary on this ubiquitous text. Writing a commentary on the *Sentences* was how one made his bones, so to speak, as a theologian. Another testimony of its widespread importance is the sheer number of copies. Over 600 medieval manuscript copies exist today, an astounding number for any medieval text.[3]

Lombard's genius was not in originality; any reading of the *Sentences* shows that his strength was as a compiler, distilling the ideas of others. In the fourth book, Lombard treats the sacraments and he argues that these were instituted by God as remedies for original and actual sin. As a visible form of an invisible grace, a sacrament presses on human senses while signifying and sanctifying. Lombard writes that Christ's death empowered the sacraments of which there are seven. Some of these offer grace and a remedy against sin (e.g., baptism), some only a remedy against sin (e.g., marriage), and still others strengthen through grace (e.g., Eucharist, holy orders). Bishops alone offer confirmation which consists of laying on of hands and signing the forehead with the cross with oil. Through it, Lombard explains, the Holy Spirit is imparted to strengthen those who have been baptized. It is, he writes, greater than baptism because it is given by a higher minister. Like baptism and holy orders, confirmation cannot be repeated. Penance is, as St. Jerome wrote back in the fifth century, "a second plank after a shipwreck": when baptized Christians lose the innocence given at baptism, but they may take it up

again through penance. Regarding holy orders, there are seven: doorkeeper, lector, exorcist, acolyte, subdeacon, deacon, and priest. According to the *Sentences*, the episcopate is a dignity, not an order. Of the seven, only deacons and priests are truly sacred—this is largely because the church developed the other five orders after the apostles and are not mentioned in scripture.[4]

While Peter Lombard produced what would become the seminal theological textbook for first-year theology students in the middle ages, the Fourth Lateran Council provided the seminal body of practical decrees regarding the Eucharist. This is our third vignette. Pope Innocent III (r. 1198–1216) convened the Fourth Lateran Council in 1215 and, for some context, that is only about sixty years after Peter Lombard produced his *Sentences* and just over a century after the death of Berengar. Lateran IV was one of the largest councils of the church; it was attended by over 71 patriarchs, 412 bishops, 900 abbots, and representatives from several monarchs. Three articles from Lateran IV should draw our attention. According to Article 1, the bread and wine of the Eucharist, by the power of God, are changed in substance and, further, only a properly ordained priest can consecrate the elements. Article 20 states that chrism (holy oil) and the Eucharist are to be kept under lock and key in churches. As we will see below, several arrangements emerged to satisfy this article's requirement, including boxes in anterooms. Article 21 insists that all Christians should confess their sins to a priest at least once a year and receive the Eucharist at minimum once a year at Easter. Confessions are held inviolate by the confessor-priest. So, in sum, Lateran IV decreed that a physical change occurs in the elements making them the Body and Blood of Christ; that the Eucharist is to be reserved and stored properly; and that all Christians are to confess and receive the Eucharist at least once a year.[5] Having considered some theology, we should turn our attention to practice.

PRACTICE

Increasingly, historians of the middle ages have been captivated by the tension between the individual and the corporate. Some have discerned an individualistic tone to Christian spirituality from the high middle ages extending through the sixteenth-century reformations and into the modern era. In other words, a medieval focus on individual devotion and individual salvation has held firm. The evidence is often the devotional practices connected to the Eucharist. For instance, instead of one high mass which gathered the community together, most churches had multiple masses even at the same time, and the main purpose of these was for the individual to catch a glimpse of the host. On the other hand, there are historians who have countered that analysis by arguing that everything

about the medieval mass is communal in orientation. In the 1980s, John Bossy offered an image of the medieval mass as a "social miracle," one that established peace within a community. More recently Eamon Duffy has argued that the medieval sources repeatedly stress the corporate and unitive nature of the Eucharist. Indeed, Duffy writes, the mass "could only be used to endorse existing community power structures because the language of Eucharistic belief and devotion was saturated with communitarian and corporate imagery." And Duffy continues by striking at one of the key arguments about individualism: that people at mass simply prayed their own prayers. He stresses, instead, what these prayers actually prayed about: the primers (books of prayer) which lay-folks used during mass direct people to reflect on the host as the source of both individual and corporate renewal.[6] Ultimately it is difficult to make a firm conclusion either way, and perhaps it is better to let the ambiguity stand: there was a tension in the later middle ages between individual devotion and corporate expressions of liturgy in the mass.

Fleshing out an experience of the mass will be helpful. First, it was unusual to receive more than once a year. As required by Lateran IV, Christians usually confessed annually, during Holy Week, and received at Easter. This necessity, in fact, became a major struggle for parish clergy who needed help hearing everyone's confession and distributing communion. The mendicants who might not have had parish assignments and other poor priests were dragooned into service by parish rectors to get the job done. What, then, was reception like? Most masses were noncommunicating and mainly a visual experience for everyone beyond the altar party. Receiving communion often happened outside of the mass itself, either before or after the liturgy, and one received from the elements kept safely in a pyx or tabernacle. It must be understood that the medieval mass was not principally about receiving the elements; it can be argued that reception was a completely separate experience.[7] This helps us understand another aspect about reception, that is, that usually only the celebrating priest received within the liturgy. Claims about medieval clericalization usually cite this fact, but often miss the point. At most masses, the line was not between clergy and lay-people, but rather between the celebrating priest and everyone else. In other words, while laypeople did not receive at most masses, neither did any other clerics who were present—including the pope himself. Only the priest at the altar and maybe also the altar party (the deacon and the subdeacon) received the elements. This makes sense if we understand the mass, as medieval Christians did, as having little to do with the gathered church receiving communion. The celebration of the mass was understood as a propitiating sacrifice for the sins of the living and the dead. The administration of communion (which, to repeat, could happen before, during, or after mass) was the reception of the consecrated elements themselves. The words "mass" and "communion" were not interchangeable.

While most Christians received once annually, some received more often. There are accounts of Lady Margaret Beaufort, the pious mother of Henry VII, receiving monthly, for example. And, to be clear, receiving was very serious business. William of Auxerre (d. 1232) thought that one could see the host without preparing through penance, but receiving communion was a different matter. If one skipped penance and received, it could, as Paul wrote in 1 Corinthians 11:29, bring condemnation from God himself.[8] Communion involved kneeling at the opening of the rood screen where the priest met the communicants in this liminal space between sacred and profane. A long cloth, known as a houseling cloth, was stretched out under the chins of the communicants to prevent even a crumb from falling to the floor. Reception was sometimes called receiving one's rights, pointing again to the mass as an instrument for community formation: being a member of the community entailed a right to communion. But again, it must be emphasized that receiving was not the usual experience, and more importantly, it was not really the point of the mass. The goal, instead, was making Christ present, seeing his flesh lifted up, and ensuring all the benefits that flowed from that action for the whole church, both living and dead.[9]

A parish church was a mass machine and a priest's primary function was to celebrate the sacraments. Thomas Aquinas wrote in his *Summa Theologica*: "A priest has two acts, one is principal, namely to consecrate the body of Christ; the other is secondary, namely to prepare God's people for the reception of this sacrament."[10] Thus a priest was, above all else, one who said mass and only secondarily a pastor. And even then pastoral care was about the sacraments, the means of grace through which God works. Preaching, to be clear, was not a normative function for a priest. He may not have known how. On specials occasions he may have read aloud a sermon from one of the available prepackaged sermon collections, but this was surely not part of the usual experience of the mass.[11] By the late middle ages, a priest could say mass but once a day. However, with multiple altars and multiple assisting vicars, masses could often be heard many times a day. Around the year 1450, in one church alone in Antwerp around 200 masses were said or sung every week. When one considers that there were many other churches in the same city, even the same neighborhood, it becomes clear that masses were constant.

While any given parish church had multiple altars, the Sunday parish mass itself was celebrated at the high altar, a stone monument distanced from the nave where the people gathered. A rood screen of stone or wood, also known as a pulpitum, divided this sacred space—a place where God regularly became bodily present—from the profane space of the nave. The fourteenth-century pulpitum at Exeter Cathedral has niches built into it for even more altars. So on the one hand altars were everywhere, but boundaries were still needed, reflecting the medieval

understanding of order. To borrow from a book title, church architecture was theology written in stone, and the Gothic was a showcase for how the medieval mind understood the metaphysical universe, the center of which was the mass, God bridging heaven and earth.[12] Consider here the concept of Gothic luminosity. This is mediated light rather than direct light, the kind that changes and transforms what is normally seen in the world outside. Earlier Romanesque churches were heavy and windows were thin. Peterborough Cathedral, finished in 1200, has monstrously thick pillars. Soon enough, though, the Gothic style would offer walls of fine stone tracery allowing light to filter through. The walls grow porous and the stone itself is transfigured. Sainte Chapelle in Paris, a space finished in 1248, is a jewel box flooded with colored light. Peterborough may be understood as the last gasp of the Romanesque while Sainte Chapelle represents a new style with walls seemingly of glass.[13] Now, if that contrasts with the darkness of the Romanesque, we ought also to consider (fast-forward) what came in the eighteenth century: the clear glass which is simply translucent. This is the neo-classical, rational architecture of the Enlightenment. The Gothic is not so bright and clear, but rather luminous.

What does the Gothic say about the mass? This style is preeminently concerned with order and hierarchy. The art historian Erwin Panofsky argued that the Gothic space was deeply informed by medieval scholastic theology. This was the age of the great theological compendia called summas, Thomas Aquinas' being one example. The Capuchin liturgical historian Edward Foley puts it best: "As gifted minds were attempting a vast synthesis of the divine order on paper, architects were undertaking a parallel synthesis in stone."[14] The Gothic church was a model of the divinely ordered universe, and of course everyone had a proper place. At mass, the priest, in place of Christ himself, stood on the praedella, the step just before the altar, the deacon on the next step down, and the subdeacon on the step below that, all within the most scared precincts of the sanctuary. Other clerics remained within the quire or presbytery, possibly each within a stall denoting his place in the community. This was a buffer zone between the sanctuary of the high altar and the outermost space, the nave, the largest portion of the physical space where the people milled about. In total, this represented the throne room of God with its gradations of courtiers as well as the cosmos correctly structured. The barrier between the quire was the rood screen, however it was a permeable boundary: one could see through it and indeed people could pass through it. In a staggering sense, God himself passed through this boundary at Easter where his people met him on their knees waiting to receive the sacrament.[15] Out in the nave, pews were a slow development, coming into vogue only after the sixteenth century when worship took on a distinctly didactic character, reflecting the Protestant sensibility that the core of worship is a sermon or teaching message directed to the people as

opposed to a work directed to God. In other words, pews would later convert the nave into a classroom where a learned cleric provided a lecture.[16] This will be discussed in more detail below, but it is helpful to contrast that didactic image with medieval sensibilities about the purpose of a priest, as taught by Thomas Aquinas, and what the Gothic style says about the universe and the nature of Christian worship.

Returning to the parochial experience of the medieval mass, during the liturgy it was not uncommon for people to mill about in the nave. Some may have brought a stool. The patron of the parish, often a wealthy member of the community, had the right of naming his candidate for rector to the bishop (this right was called an advowson) and he may have built his own private seating for his family. The Sunday mass, however, was certainly not the only show, even at the same time slot. In chantry chapels a priest with one server may have been in the middle of celebrating a mass while the high mass was starting. These liturgies in side chapels involved only the priest and a server and, from altar to altar, they could operate independently of each other. When the server rang the sacring bell, the people would clamor to see the host during the elevation.[17]

What was the high mass on Sunday like? First, there was no single mass liturgy in the middle ages, but rather a wide diversity of forms. There were five basic families of liturgies known as "rites." That is a technical term. Each "rite" had its own distinct way of observing and celebrating the prayer offices, the mass, pastoral liturgies, and other ceremonies. The five "rites" were the Roman rite, the Gallican rite, the Mozarbic rite, the Celtic rite, and the Ambrosian rite. Within each rite there were subdivisions called "uses" and then, to make matters even more complicated, one finds diversity even within a single diocese. What follows is a general description of the most common expression of the Sunday parish mass in England around the year 1250—the Sarum use (or Salisbury use) of the Roman rite. The high mass on Sunday began with a procession winding around the church. As they walked, the priest would sling holy water as a blessing (known as asperges) using a wand called an aspergillum. The three sacred ministers—subdeacon, deacon, and priest—would approach the altar and at the bottom step they would put on their respective vestments of tunicle, dalmatic, and chasuble. They would recite the Confiteor (a confession of sin) and then ascend to the altar singing the Introit psalm appointed for that day They then sang the *Kyrie Eleison* (a hymn of penance), and the *Gloria in Excelsis* (a hymn of praise). This was followed by the appointed collect for that day, the appointed epistle lesson, the appointed Gospel lesson, and the Nicene creed.[18]

The Sunday high mass had a unique language shift at this point. After the creed, the parish priest would leave the sanctuary for the nave, the place of the people. Ascending a pulpit, he would lead the people in a

vernacular office called prone which was inserted into the otherwise Latin liturgy. Prone had three parts: the bidding of the bedes, a vernacular hymn, and then community announcements. The bidding of the bedes, a form of vernacular prayer, was the most important element of prone. The people were to pray for the pope, the bishops and clergy, and especially for their parish priest. They were bid to pray for secular rulers, the king and the mayor of their town for example. They were also to pray for those in need, pilgrims and travelers, the sick, those in prison, and expectant mothers. These petitions form the first half of the bidding of the bedes. In the second half, the priest instructed the congregation to pray for the dead and especially the dead of that particular parish. The names of the recently deceased, great benefactors, and those whose death anniversary was that week were read aloud. To keep track, names were recorded in the parish's bede-roll. After this litany of concerns, a vernacular hymn was sung and the priest made community announcements, particularly noting any feast days or fast days in the coming week. Feast days would mean a day off work and enjoying a party, the parish ale. On many Sundays, after prone was finished the people made an offering of pennies and beeswax. Sometimes the people brought forward objects to be blessed like candles on Candlemas, butter, cheese, and eggs at Easter, and apples on St James' Day. Moreover, people would line up in order of social rank to make these offerings and receive the blessings, once again highlighting hierarchy and order.[19]

Following this vernacular interaction came the canon of the mass with its elevation of the consecrated elements. The elevation of the host became normative by the twelfth century, while the elevation of the chalice was a bit more sporadic and was not uniform until much later. There was a debate in the high middle ages about the elevation; some theologians, Peter the Chanter for instance, held that both elements were not consecrated until after the wine was consecrated. By the twelfth century, however, it became accepted that the dominical words effected the consecration. This meant that the host was indeed the body of Christ after the words *hoc est enim corpus meum* while the wine, for a very short interval, remained merely wine. Then the chalice too had the dominical words *hoc est sanguinem meum* breathed over it and the wine became the blood of Christ. At the moment of the elevation, it was not uncommon to draw a dark curtain across the reredos (the ornate panel immediately above the altar) so that people far away from the altar could more clearly see the white host in contrast. In some places mechanical devices also lowered puppet angels down around the host for even more dramatic effect.[20]

Sacring bells were rung at the moment of elevation both to honor and signal the presence of Christ, the canon itself being inaudible. Not only was the consecration at a distance from the nave and in Latin, the priest reverently whispered it in low tones. According to the vernacular fourteenth-century *Lay folks Mass Book*, the bell was a practical way of alerting

the people who had no other way of knowing where the priest was in the canon to now look up and see God. Falling to their knees, the people peeked through little drilled holes in the rood screen called rood squints or elevation squints. Again, we have to remember that masses could occur simultaneously and the attraction was the elevation.[21] There are stories of people engaged in one liturgical activity, for instance hearing a sermon or the fore-mass in one part of the church and on hearing the bell, they dropped what they were doing and rushed over to see the host elevated at another altar. In the early fifteenth century, William Thorpe reported that while he was preaching, a bell rang and all his listeners ran over to an altar to see the host. At the collegiate church of St. Mary Ottery in the diocese of Exeter, the bishop attempted to bring some order in 1339: he forbade the ringing of sacring bells while the choir offices were sung. The daily round of offices was being interrupted by the temptation to run away and see an elevation.[22] The sixteenth-century reformer and archbishop of Canterbury Thomas Cranmer grumbled:

> What made the people to run from their seats to the altar, and from altar to altar, and from sacring (as they called it) to sacring, peeping, tooting, and gazing at that thing which the priest held up in his hands, if they thought not to honor the thing which they saw. What moved the priests to lift up the sacrament so high over their heads? Or the people to say to the priest "Hold up, Hold up" or one man to say to another "stoop down" or to say "this day I have seen my maker" and "I cannot be quite except I see my maker once a day"? What was the cause of all these, and that as well the priest and people so devoutly did knock and kneel at every sight of the sacrament, but that they worshipped that visible thing which they saw with their eyes and took it for very God.[23]

After the canon and the Our Father (the Lord's Prayer), the priest would kiss a carved wooden disk called a pax-board. Pax-boards often had the image of the *Agnus Dei*, the Lamb of God. At high mass, this object was then taken to the congregation where everyone kissed it. This ritual became a place-holder, even a substitute, for receiving the elements—remember the people usually received communion only at Easter. The pax was also a means of securing peace in the community.[24] The primers, those books written for the laity to use during mass, even had prayers to be said while kissing the board, usually focusing on peace. But the pax-board ritual upheld more than peace. It also reinforced social hierarchy. People could get quite upset if the pax-board was given out of order. In one instance, a layman felt so slighted that he smashed the board over the clerk's head, even drawing blood, all because the pax-board was given to another man first, a man he believed was beneath him in the social order.[25]

After the peace, the priest would make his own communion and then bless and dismiss the people. On his way out, he recited the so-called Last

Gospel, the prologue to John's Gospel, beginning *in principio verbum erat*, "in the beginning was the Word." Those words, focused on the Incarnation, took on a talismanic character in the middle ages, as the phrase was carved on all manner of objects, sacred and profane, to ensure protection and blessing. On most Sundays the priest would reappear to bless a loaf of bread, called the holy loaf, which was cut up and given to the people, likely another substitute for receiving communion.[26]

THE MATERIAL CONTEXT

The vessels used at mass, especially their shape, evolved according to need. The point is that vessels, for all their glory, achieved their shape, size, and character from necessity. Following this logic, it makes sense that, as the wine was only consumed by the priest, vessels for wine are really not as numerous or grand as vessels for bread. Indeed, the elevation of the bread during the canon became expected by the late eleventh century while the elevation of the chalice came later still, not becoming universal until well after the sixteenth century.[27] We should remember that the signature feast of the late middle ages, Corpus Christi, is a celebration of Christ's body. It was not until 1849 that the Roman Catholic Church instituted the Feast of the Most Precious Blood. For medieval spirituality, the body was front and center and the blood was, although quite important, secondary.

In the western church, it was common by the ninth century to use unleavened bread at mass. By the eleventh century the practice had become the western norm. It was also common to bake two sizes: a larger priest's host which could be seen at the elevation and smaller hosts for communion.[28] The kind of bread and its size influenced what vessels were used. Prior to the high and later middle ages, there was not much of a distinction between vessels for reserving the Eucharist in the church and vessels for carrying the Eucharist to the sick. Around the year 1100, there was only the pyx, a box container; it occupied a space on the altar, serving a number of purposes. During mass, the priest would have his larger host on the paten (a round plate) and then other hosts in the pyx would be consecrated for communing the lay—that is, if there was to be communion either during or after mass or for visiting the sick.[29] By the later middle ages the paten had gotten fairly small as it was intended to hold only one piece of bread, the priest's host. In the sixteenth century, Protestant reformers would often use larger plates to carry larger amounts of bread in order to serve more than the officiating minister. Curiously, many Protestant churches today, especially Anglicans who were influenced by the Gothic revival of the nineteenth century, have reverted to those small patens but force them to bear large numbers of hosts to commune an entire congregation—but these plates were not de-

signed for that purpose. During the high middle ages, at communion, the priest would take the pyx (not the paten) with him to the rood screen opening to commune the people. Consequently, the shape of the pyx evolved so that it could be held with greater ease. It was often a box with a stem base and a conical lid, sometimes surmounted with a cross. Thus the pyx evolved from being a simple box into the vessel known as a ciborium (the Greek name implies a cup-like vessel for seeds). For visiting the sick and dying, hosts would be put into smaller pyxes to be taken out of the church.

Another unique vessel for the bread was the Easter sepulcher, a receptacle born in England but which gained popularity on the continent. The *Regularis Concordia* (Monastic Agreement), written in England around 970 for monks and nuns, gives directions for a dramatic liturgical practice during Holy Week. Sometime after the liturgies of Good Friday, a crucifix and later a consecrated host would be "buried" in a wooden box near the high altar, possibly draped with a curtain. Early on Easter morning, the host would be "resurrected" with great celebration. By the later middle ages, Easter sepulchers often became stone constructions and some were built by wealthy patrons on top of their tombs to be close even in death to the Eucharistic presence.[30]

The vessel most redolent of Eucharistic practice in the later middle ages was the monstrance. Its precursor was a vessel known as the ostensorium, a container for viewing smaller relics. In various shapes and sizes, an ostensorium could be carried in procession, held ceremonially to bless a congregation, or be set up for veneration outside of the liturgy. Though not a "garden variety" ostensorium, the St. Bernward Ostensorium from Hildesheim, crafted between 1350 and 1400, displayed not one but ten relics.[31] By the later middle ages, there was considerable overlap surrounding the Eucharist and relics. Approaches to the host and to relics were virtually indistinguishable: these were things to see and adore.[32] The natural consequence was to put a consecrated host in an ostensorium whose glass container was refashioned for the round host. This accounts for the evolution of the monstrance, a vessel to hold the host for liturgical blessings and to show (*demonstrare*) the host to the people so they could adore Christ's body.[33] See figure 1.1.

By the later middle ages, devotion to the exposed sacrament was a source of spiritual nourishment and mystical experiences, but it was also occasioned by a talismanic approach to the Eucharist. From the later middle ages to the sixteenth century, the practice of adoration received both support and suspicion. On the one hand, Pope Leo X (r. 1513–1521), the same pope who excommunicated Luther, gave permission for the reserved sacrament to be exposed while mass was being celebrated—a theologically, liturgically, and devotionally confusing arrangement which the Council of Trent later overturned. On the other hand, there were medieval voices of authority who had qualms about such practices.

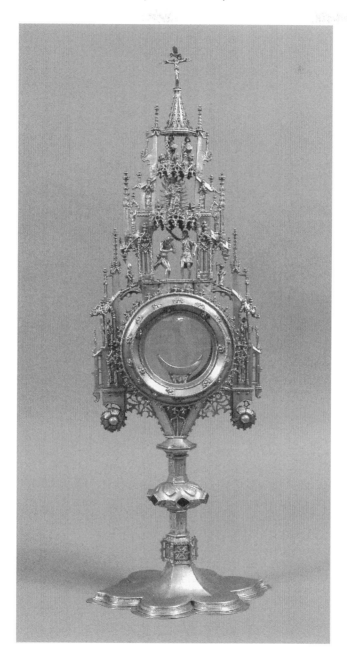

Figure 1.1. Monstrance, c. 1450 Cologne, Germany. The Friedsam Collection, Bequest of Michael Friedsam, 1931, Metropolitan Museum of Art, New York, NY. Accession Number: 32.100.226. https://www.metmuseum.org/art/collection/search/467485.

In the fifteenth century, Cardinal Nicholas of Cusa (1401–1464) was extremely worried that people understood the Eucharist as a magical talisman, something that could bring temporal blessing. After all, many believed that on the day one saw the host, one could be assured of safety, stave off sudden death, and if pregnant, enjoy a safe delivery. While Cusa did not object to adoring Christ's presence in the elements, his concern was how the elements were increasingly understood as primarily for adoration and for their near-magical side-effects instead of the sacrament which brings peace between God and humanity. This imbalance, he believed, was leading to superstition.[34]

What, then, of reserving the sacrament? During the high and later middle ages, the Eucharist was often reserved in a pyx, a small box set on the altar and covered by a veil or suspended by a chain over the altar. Sometimes the sacrament was kept in a box built into the wall of the sanctuary or even in the sacristy. By the twelfth century, the common practice in Italy was to use wall tabernacles while in northern Europe, particularly in Germany, towering spires called sacrament houses were built within the sanctuary. In the sixteenth century, many of these were preserved in Lutheran portions of Germany even though they were no longer used. In England and the Rhineland such phenomena were simply removed instead of becoming heirloom furniture.[35] In addition to these spire sacrament houses, some creative medieval architects designed tabernacles with built-in monstrances often behind a grill so that the host could be exposed. During the sixteenth century, tabernacles in Roman Catholic churches migrated to the center of the superaltar, the shelf immediately above the altar. Again, this was for practical purposes. After the Council of Trent's call for more regular reception, the priest needed the reserved sacrament within arm's reach. In the later middle ages, however, one generally finds three possibilities: (1) the pyx on the altar or suspended above it; (2) the sacrament house to the side of the altar; or (3) the wall tabernacle to the side of the altar.[36]

Discussion thus far has focused on vessels for the bread: patens, ciboria, pyxes, tabernacles, sacrament houses, and monstrances. What about vessels for the wine? The chalice was not something people saw very often. While the host was universally elevated by the twelfth century, this was not the case with the chalice. It was elevated much more sporadically. In fact, the printed Roman missals of the early sixteenth century (those of 1500, 1507, and 1526), do not mention the elevation of the chalice at all. Most chalices were cone-shaped, attached to a stem leading to a hexagonal or octagonal base. A node bulging in the middle of the stem made holding it easier. Gold and silver were the preferred materials, although tin was a concession to poorer churches. Wood, glass, and copper were routinely forbidden by synods or individual bishops. Sometimes enameled, there are instances of small bells being attached to the chalice. As the priest alone received the consecrated wine, the chalice only needed to

hold a small amount and was therefore shallow—another example of practice informing shape. Cruets follow the same pattern: because only the celebrant received, only a small amount of wine and water were consecrated. The offertory procession in which people brought the bread and wine to the priest in the early church had mostly died out by the high middle ages. Why would there need to be such a procession for only small amounts of bread and wine, particularly when communion itself was not a normative part of mass? By 1300 it was gone from the Roman rite as used by the papal curia. Cruets grew smaller and were often glass so that the priests could discern quickly which had wine and which had water before pouring. Sometimes they were marked A for Aqua and V for Vino. The material context of the mass points to the primacy of sight, of seeing the consecrated host, of seeing God in the form of bread, and thus practical need formed the physical shape and character of the vessels.[37]

TO DRAW NEAR AND ADORE

By the later middle ages, all levels of society wanted access to daily masses. Gentry often sought licenses for altars in domestic chapels, employing family chaplains to say mass in their homes. Likewise, servants could go to the early morning "Morrow Mass," around 5 a.m., to *see* God before work. This desire to be close to the Eucharist and offer adoration gave rise to guilds and confraternities dedicated to Corpus Christi. Their officers often had the privilege of holding the canopy over the monstrance during the Corpus Christi day procession, and the guilds gave money to charitable institutions to honor Corpus Christi—hospitals for the urban poor and colleges at both Oxford and Cambridge, for example. The Corpus Christi guild also ensured that beeswax candles surrounded the altar to properly honor to the true Body of Christ. Those same candles were often then carried before the priest traveling to bring the dying their viaticum, their final communion. Wills indicate that even the middling sort would leave money for candles if not a certain number of masses to be said for their souls in purgatory.[38]

Since late antiquity Christians had believed that the celebration of the Eucharist not only offers honor and glory to God, but also benefits the living and the dead. By the later middle ages, though, this dimension of the mass had become central and formal lists of the "fruits of the mass" or "benefits of the mass" were drawn up.[39] Lists of specific benefits first appeared in the thirteenth century, growing from four or five to ten and then finally twelve in their quasi-official form, although there are variants. One early theological treatise on the fruits of the mass was written by the Franciscan Duns Scotus (c. 1266–1308) and he listed a three-fold blessing from the mass: it was a blessing for (1) the celebrating priest; (2)

the whole church; and (3) those for whom the mass was offered. This last fruit surely affirmed intercessory prayer, but it was also a theological rationale for the widespread practice of mass stipends, the practice of paying a priest to say a certain number of masses for specific intercessions (votive masses). Indeed, a large portion of the clergy lived entirely on mass stipends and one of the by-products of the reformations of the sixteenth century would be the sheer reduction of clergy. Many priests served no other purpose but saying votive masses. That reduction was foreseen by none other than Jean Gerson (1363–1429), the early fifteenth-century chancellor of the University of Paris who called for a smaller and better educated clergy rather than so many priests living off votive mass stipends.[40]

To return to the "fruits of the mass," over time these began to reflect what one might call magical sensibilities, the idea that if one did something formulaic he or she could control elements of life, instrumentally causing certain outcomes. Fruits of the mass often included not aging on the day one heard mass, a safe delivery for pregnant women if they gave birth that same day, safe-guarding for one's house or barn from lightning and fire that day, and even a day of good digestion. What makes this "magical" is the promise of controlled, unfailing results.[41] If one does A, then B will happen. Votive masses, mentioned above, are those masses celebrated for specific purposes or to honor a specific doctrine. In addition to masses for the dead, there were masses of the Holy Trinity, of Our Lady, of the Holy Angels, and of the Holy Spirit among others. In the later middle ages there were lists of what order these masses should be said to achieve specific purposes. If one wanted safety in travel or a safe delivery, one should pay for a certain series of masses: one specific mass on the first day or for the first several days, the mass of the Holy Angels for example, which was followed by another specific mass on the next day or series of days, perhaps the mass of the Holy Trinity, and then perhaps yet another specific mass on the third day, perhaps the mass of Our Lady. These series, following various formulae, could go for a few days or even a full year. Quite frequently, though, they ran for thirty days and were known as trentals, one of the most popular being the Trental of St. Gregory or the Pope Trental. According to legend, Pope Gregory the Great (r. 590–604) had a horrifying vision of his mother in purgatory requesting thirty masses to be celebrated. She appeared again, once they were completed, to confirm her entrance into heaven. The Pope Trental therefore called for thirty masses said at various points on the calendar over the course of a year, along with other devotions, and it promised the safe delivery of a soul from the pains of purgatory.[42] First we should notice how this was a formulaic *quid pro quo* transaction. One paid for X to happen, and if everything was done properly, X was indeed supposed to happen. Secondly, these votive masses were near constant and they were almost independent of the liturgical year. Save for certain feasts and

fasts, the church's calendar could be ignored; the stipends had been paid and the votive masses in their various series trucked on. Both Catholic and Protestant reformers targeted this industry for change in the sixteenth century.

These medieval sensibilities were strengthened by the miracle stories connected to the Eucharist, stories and legends which abounded. Certainly, there was a transactional dimension to the mass and contemporary cynics were not unknown. But we would be wrong to underestimate the sincere convictions most people had and that they really believed miraculous tales which served to reinforce the power of the mass. Yet another story connected to Pope Gregory the Great became one of the most common Eucharistic miracle tales of the middle ages, and one that became ubiquitous in medieval Christian art. Though it has many variants, the story is that Pope Gregory was celebrating mass and during the liturgy Christ himself appeared on the altar surrounded by the instruments of his passion thus confirming his bodily presence in the elements. Images of the Mass of St. Gregory appeared in manuscript art, sculpture, and stained glass.[43] In popular medieval sermon collections we find similar stories, perhaps even knock-off versions. A poignant example of a mass miracle story is found in John Mirk's *Festial*, a fourteenth-century English sermon collection. A monk who had doubts about Christ's presence in the Eucharist was at mass, and there he had a vision of an angel stabbing a child and the blood filling the chalice. The monk cried out for mercy, acknowledging his error in doubting, and the sacrament returned to its unbloody appearance. That story too has many variants. Sometimes it was a corrective, but sometimes it was a gift as was the case with St. Bridget of Sweden (1303–1373) who also saw the host turn into a child. The moral for those hearing the story was that Christ is bodily present and one should not dare doubt this.[44]

Having considered Eucharistic devotion, we turn our attention to the early summer feast of Corpus Christi. At the age of sixteen, the Belgian Norbertine nun Juliana of Cornillon (1192–1258) started having visions of the full moon, but the moon always had a dark spot which eventually grew into a black stripe. This was interpreted to be the host, as well as the whole church. The black stripe, however, indicated that something was missing, namely a feast specifically to honor the body of Christ. In 1246, then, the feast of Corpus Christi was instituted in Juliana's own diocese of Liege. Later, the archdeacon of that same diocese became Pope Urban IV, and he proclaimed Corpus Christi as a feast for the whole western church in his bull *Transiturus* (1264).[45] The institution of Corpus Christi intersects with the story of a much-celebrated Eucharistic miracle. According to tradition, in the year before Urban issued *Transiturus*, central Italy was wracked by political division and the pope took refuge to the north in the town of Orvieto. Just before he arrived, however, he stopped at the suburb of Bolsena. A priest of that village who had suffered doubts

about Christ's presence was celebrating mass and was shocked to see the host miraculously bleeding. Drops of blood fell onto the corporal, the white cloth at the center of the altar. This was hailed as a Eucharistic miracle and the blood-stained corporal was set up in a shrine in the cathedral in Orvieto, which can be visited even today.[46] For Pope Urban, then, this Eucharistic miracle combined with his experience of the devotion he knew back in Leige, devotion inspired by Julianna's visions. Thus *Transiturus* appeared the next year. Moreover, this was the first papal move to institute a church-wide feast. Corpus Christi is held on the Thursday following Trinity Sunday and, in the middle ages, it usually included a great procession of Christ's Eucharistic presence. In the next century, thanks largely to the Dominicans, the feast became extraordinarily popular, not merely a requirement of the calendar. Existing liturgical books throughout Europe had Corpus Christi liturgies added to the blank pages available while Thomas Aquinas, a contemporary of Julianna and Pope Urban IV, is traditionally credited with the Corpus Christi hymns *Pange Lingua* and *Tantum Ergo*.[47] The Bolsena miracle which had, according to tradition, factored in Pope Urban's support for Corpus Christi, was captured much later by the Renaissance artist Raphael in a famous fresco displayed in the Apostolic palace in the Vatican.

The shrine at Orvieto is one of several medieval holy blood shrines.[48] In 1270, the Cistercian monks of Hailes Abbey in Gloucestershire acquired a phial that supposedly held the blood of Christ. As one might imagine, the shrine they constructed became a major pilgrimage destination until it was destroyed during the dissolution of the monasteries under Henry VIII in the 1530s. In a last-ditch effort to preserve the monastery itself, the abbot declared that the phial was a fraud; his gesture failed and both abbey and shrine were leveled.[49] A similar Holy Blood shrine remains today in Bruges. Their phial, supposedly brought to Bruges by a crusader, was said to contain Christ's blood caught by Joseph of Arimathea at the crucifixion. Around 1300, the city held an annual procession to showcase the phial and Pope Clement V (r. 1305–1314) attached indulgences to the event. There is also the Holy Blood of Dijon. The story goes that, in 1430, a wealthy woman bought a monstrance from a second-hand dealer, but she was surprised to find that a host was still in the lunette (the container). When she tried to remove the host with a knife, it started to bleed. The woman took it to her priest and eventually the bleeding host was enshrined at Dijon.[50]

The story of the Holy Blood at Wilsnack in Germany draws together all of these themes and highlights the concerns raised by contemporary theologians. In 1383, Wilsnack was burned to the ground in a military raid. When the people went through the smoldering wreckage of St. Nicholas' Church, they found three hosts from the sacrament house that had survived. Miraculously, these hosts appeared to be bleeding. To verify the miracle, the bishop attempted to consecrate them in a mass, but

before he got to the dominical words, one of them poured forth blood. St. Nicholas' Church was rebuilt with a shrine to the holy blood and pilgrims, including the English laywoman Margery Kempe, came from great distances to venerate. Despite their popularity, shrines dedicated to Eucharistic miracles posed a problem: according to the church's teaching, every mass at every altar presented the true body and blood of Christ. Why would one travel to Wilsnack to see the body of Christ when it was at one's local parish church? This was recognized acutely by Nicholas of Cusa who, as Cardinal Legate to Germany, led a major inspection of that country from 1450 to 1452. He was deeply troubled by the Wilsnack shrine and tried unsuccessfully to shut it down. Nicholas believed that the real blood of Jesus could be found at every Christian altar. If people rush off to shrines, he feared that they would come to believe that only miraculous hosts are the real body of Christ and doubt their priest's ability to consecrate.[51]

JOINING HEAVEN AND EARTH

To properly understand the spiritual landscape for Christians in the middle ages, this chapter has focused on the centerpiece of medieval Christian devotion: the mass, a spectacle to behold, a liturgy which united Christians both living and dead, a ritual with tones both individualistic and corporate. Perceptions of the mass were guided by teachings from both the *summas* and the pulpits, but the Eucharist also had a life of its own in popular practice and imagination, resisting control. The mass was spiritual and material; it was about a God who is both transcendent and imminent, wholly other yet incarnate and familiar. Our attention now shifts in the next chapter to a teeming variety of other spiritual disciplines, themes, and practices. There should be no doubt, however, that the mass—a rite which built cathedrals and chantry chapels, which made women and men fall to their knees, which organized the daily life of individuals and whole communities, which inspired songs and visions, which elicited simple prayers and dense prose—was at the center of medieval Christian spirituality.

NOTES

1. Miri Rubin, *Corpus Christi: The Eucharist in Late Medieval Culture* (Cambridge: Cambridge University Press, 1991), 1; Bryan Spinks, *Do This in Remembrance of Me: The Eucharist from the Early Church to the Present Day* (Norwich, UK: SCM, 2013).
2. Margaret Gibson, "The Case of Berengar," in *Council and Assemblies* ed. G. J. Cuming and Derek Baker (Cambridge: Cambridge University Press, 1971), 61–68; James McCue, "The Doctrine of Transubstantiation from Berengar through Trent: The Point at Issue," *Harvard Theological Review* 61 (1968), 385–430; Charles Radding and

Francis Newton, *Theology, Rhetoric, and Politics in the Eucharistic Controversy, 1078–1079* (New York: Columbia University Press, 2003).

3. G. R. Evans, ed., *Medieval Commentaries on the Sentences of Peter Lombard* (Leiden: Brill, 2002), vol. I, 84–85; Marcia Collish, *Peter Lombard* (Leiden: Brill, 1994), 33–90.

4. Philipp Rosemann, *Peter Lombard* (Oxford: Oxford University Press, 2004), 59; Jacques-Guy Bougerol, "The Church Fathers and the Sentences of Peter Lombard," in *The Reception of the Church Fathers in the West: From the Carolingians to the Maurists* ed. Irena Backus (Leiden: Brill, 1997), 113–64.

5. Norman Tanner, ed., *The Decrees of the Ecumenical Councils* 2 vols. (London: Sheed and Ward, 1990); John Moore, Brenda Bolton, James Powell, and Constance Rousseau, eds., *Pope Innocent III and His World* (Aldershot, UK: Ashgate, 1999).

6. John Bossy, "The Mass as a Social Institution, 1200–1700," *Past & Present* 100 (1983), 29–61; Eamon Duffy, *Marking the Hours: English People and their Prayers, 1250–1550* (New Haven: Yale University Press, 1996), 96, 168; Idem, *The Stripping of the Altars: Traditional Religion in England, 1400–1580* (New Haven: Yale University Press, 1992), 121–23, 131–54.

7. Joseph Jungmann, *The Mass of the Roman Rite: Its Origins and Development* (Notre Dame, IN: Ave Maria, 1951), Vol. II, 359–91; Bob Scribner, "Popular Piety and Modes of Visual Perception in Late Medieval and Reformation Germany," *Journal of Religious History* 15 (1989), 448–69.

8. Rubin, 63–64.

9. Duffy, *Stripping of the Altars*, 91–130; Robert Whiting, *The Blind Devotion of the People: Popular Religion and the English Reformation* (Cambridge: Cambridge University Press, 1989), 17–47; Rubin, 35–63.

10. Thomas Aquinas, *Summa Theologica*, Supplement, quest. 40, article 4, response.

11. Carolyn Muessig, ed., *Preacher, Sermon, and Audience in the Middle Ages* (Leiden: Brill 2002); R. N. Swanson, *Religion and Devotion in Europe, c. 1215–1515* (Cambridge: Cambridge University Press, 1995), 52–71.

12. Richard Kieckhefer, *Theology in Stone: Church Architecture from Byzantium to Berkeley* (Oxford: Oxford University Press, 2004); Aymer Vallance, *English Church Screens* (London: Batsford, 1947); Andrew Spicer and Sarah Hamilton, "Defining the Holy: The Delineation of Sacred Space," in *Sacred Space in Medieval and Early Modern Europe* ed. Spicer and Hamilton (Aldershot, U.K.: Ashgate, 2006), 1–26.

13. Erwin Panofsky, *Gothic Architecture and Scholasticism* (New York: NAL Penguin, 1951); Charles Radding and William Clark, *Medieval Architecture, Medieval Learning: Builders and Masters in the Age of Romanesque and Gothic* (New Haven: Yale University Press, 1992).

14. Edward Foley, *From Age to Age: How Christians Have Celebrated the Eucharist* (Collegeville, MN: Liturgical Press, 2008), 193.

15. Duffy, *Stripping of the Altars*, 111–12.

16. Christopher Marsh, "Sacred Space in England, 1560–1640: The View from the Pew," *Journal of Ecclesiastical History* 53 (2002), 286–311.

17. Swanson, 140–41, 173–74; Duffy, *Stripping of the Altars*, 114–39.

18. John Harper, *The Forms and Orders of Western Liturgy from the Tenth to Eighteenth Century* (Oxford: Oxford University Press, 1991), 109–26; Andrew Hughes, *Medieval Manuscripts for Mass and Office: A Guide to their Organization and Terminology* (Toronto: University of Toronto Press, 1982), 81–86. See also Eric Palazzo, *A History of Liturgical books from the Beginning to the Thirteenth Century* (Collegeville, MN: Liturgical Press, 1998); Richard Pfaff, *The Liturgy in Medieval England: A History* (Cambridge: Cambridge University Press, 2009).

19. Foley, 208; Duffy, *Stripping of the Altars*, 334–37; Swanson, 212–15.

20. Rubin, 62; Caroline Walker Bynum, *Holy Feast, Holy Fast: The Religious Significance of Food to Medieval Women* (Berkeley, CA: University of California Press, 1987), 51–54; Lothar of Segni (Innocent III), "De sacro altaris mysterio," *Patrologia Latina* ed. J-P Migne (1854), vol. 217: 868.

21. Anne Hudson, "A New Look at the *Lay folks' catechism*," Viator 16 (1985), 243–58; Idem, "The *Lay folks' catechism*: a postscript," Viator 19 (1988), 307–9; G. B. Lane, "The Development of Medieval Devotional Gestures," PhD Dissertation, University of Pennsylvania (1970).
22. Rubin, 59–60.
23. Thomas Cranmer, *Writings and Disputations of Thomas Cranmer* ed. John Cox (Cambridge: Cambridge University Press, 1844), 229.
24. Kiril Petkov, *The Kiss of Peace: Ritual, Self, and Society in the High and Late Medieval West* (Leiden: Brill, 2003); Jungmann, vol. II, 321–32.
25. Bossy, 29–61; Hughes, 87–92.
26. Jungmann, vol. II, 427–55; Hughes, 92; Rubin, 72–74; Duffy, *Stripping of the Altars*, 124–26.
27. Foley, 224–26.
28. Jungmann, vol. II, 381–82.
29. Foley, 219–21; Rubin, 77–82; G. J. C. Snoek, *Medieval Piety from Relics to the Eucharist: A Process of Mutual Interaction* (Leiden: Brill, 1995), 115–31. There was no great distinction in the middle ages between visiting a sick person and visiting a dying person.
30. Foley, 222; Rubin, 294–97; Duffy, *Stripping of the Altars*, 29–37; Alfred Heales, "Easter Sepulchers, Their Object, Nature, and History" Archaeologia 42 (1869), 263–308.
31. Images may be viewed at http://www.learn.columbia.edu/treasuresofheaven/relics/Ostensorium-with-Paten-of-St-Bernward.php.
32. Snoek, 241–308; Scribner, 448–69.
33. Foley, 223; Snoek, 283–91, 300–8.
34. Charles Zika, "Hosts, Processions, and Pilgrimage in Fifteenth Century Germany," Past and Present 118 (1998), 25–64.
35. Bridget Heal, "Sacred Image and Sacred Space in Lutheran Germany," in Wil Coster and Andrew Spicer, eds., *Sacred Space in Early Modern Europe* (Cambridge: Cambridge University Press, 2005), 39–59.
36. Foley, 224; Rubin, 44–48.
37. Foley, 224–27; Alan Clark, "The Functions of the Offertory Rite in the Mass," Ephemerides Liturgicae 64 (1980), 309–44.
38. Swanson, 116–22, 232–34; Whiting, 276–28; Duffy, *Stripping of the Altars*, 370–74.
39. Jungmann, vol. I, 175–95; Jacques Le Goff, *The Birth of Purgatory* trans. Arthur Goldhammer (Chicago: University of Chicago Press, 1984), 213–20, 289–95.
40. Foley, 234–35; Swanson, 141–42; Duffy, *Stripping of the Altars*, 139.
41. Foley, 234; Jungmann, vol. I, 175–95.
42. Duffy, *The Stripping of the Altars*, 114–16, 243, 370–74.
43. Rubin, 108–29; Caroline Walker Bynum, *Wonderful Blood: Theology and Practice in Late Medieval Germany and Beyond* (Philadelphia: University of Pennsylvania Press, 2007), 86–90; Idem, "Seeing and Seeing Beyond: The Mass of St. Gregory in the Fifteenth Century," in *The Mind's Eye: Art and Theology in the Middle Ages*, ed. Anne-Marie Bouché and Jeffrey Hamburger (Princeton, NJ: Department of Art History, Princeton University, 2005), 208–40; Duffy, *Stripping of the Altars*, 238–40.
44. Duffy, *Stripping of the Altars*, 102–7; Bridget Morris, *St Birgitta of Sweden* (Woodbridge, Suffolk: Boydell, 1999); Bynum, *Holy Feast, Holy Fast*, 23, 27, 213–14.
45. Rubin, 164–212; Bynum, *Holy Feast, Holy Fast*, 55–56, 164–65, 175–80.
46. Bynum, *Wonderful Blood*, 119, 135, 149.
47. Rubin, 196–204; Richard Pfaff, *New Liturgical Feasts in Late Medieval England* (Oxford: Oxford University Press, 1970).
48. Swanson, 329–40; Nicholas Vincent, *The Holy Blood: King Henry III and the Westminster Blood Relic* (Cambridge: Cambridge University Press, 2001).
49. J.C.T. Oates, "Richard Pynson and the Holy Blood of Hayles" The Library 5.13 (1958), 250–77; Duffy, *Stripping of the Altars*, 104; Bynum, *Wonderful Blood*, 143–44.
50. Mark Holtz, "Cults of the Precious Blood in the Medieval Latin West" PhD Dissertation, University of Notre Dame (1997); Bynum, *Wonderful Blood*, 168–69.

51. Zika, 25–64; Bynum, *Wonderful Blood*, 25–45; Snoek, 321–22.

TWO

The Spiritual Landscape

Mediating the Holy in the Middle Ages

In the waning years of the twelfth century Bishop Hugh of Lincoln visited the Benedictine monks of Fecamp in Normandy. An inveterate collector of relics, Hugh was very glad when the brothers showed him some bones of Mary Magdalen. They balked though when he tried to snap off a bit to take for his own collection back home. Instead they allowed the bishop to kiss the bones in veneration. To the monks' horror, however, Hugh used the opportunity to bite off a fragment.[1] There should be little question that medieval spirituality was intensely material and that there was an all-encompassing desire to be physically close to the holy, to touch, taste, and feel the presence of holiness. The medieval Christian, moreover, had countless opportunities to do just that; even though there were boundaries between the sacred and the profane, heaven and earth often overlapped. This chapter examines the most important of these opportunities: the cult of Mary and the saints, relics, pilgrimage, and the seven sacraments.

MEDIATING THE HOLY: OUR LADY

Anything that could be said or sung about Jesus' mother found a place in a "mélange" of ideas about the Blessed Virgin.[2] While she represented humility and lowliness, she was also the exalted queen of heaven, "our lady." No one equaled Mary and no one was greater than Mary save for the Holy Trinity. And yet she was the very embodiment of meekness and passivity; her words "Let it be unto me according to your word" (Luke 1:38) echoed in the ears of those praying the Angelus, a short daily

prayer. Mary was also a unique combination of ideal types for women, both a holy virgin and a mother. She was likewise the focus of a growing number of feasts, days to recall her Purification, the Annunciation, her Assumption, her Nativity, and for her own presentation in the Temple. Certainly, a Marian feast was observed in every month and by 1500 most parish churches offered a Lady Mass on Saturdays. Due to the extra-biblical tradition that she was bodily assumed into heaven, she was a universal patron. Her body, therefore, was not buried in any one place. While this did not prevent second order relics as well as shrines dedicated to Marian apparitions, there could be no wrangling over Jesus' mother: she could be a patron for all.

The later middle ages have been hailed as the age of the Virgin. In a sense, western Europe was in love with Mary and her titles reveal how she was perceived.[3] Biblically, she had called herself *Ancilla Domini*, handmaid of the Lord, an appellation common in the middle ages too. The Council of Ephesus in 431 had declared her *Theotokos*, the God-bearer, or more commonly, Mother of God. That pivotal declaration affirmed the full divinity and full humanity of Christ and rejected the Nestorian heresy that Mary gave birth only to a man who was inhabited by Christ, a separation of Christ's two natures. Starting with Irenaeus of Lyon (130–202), some extended Paul's description of Christ as the new Adam (1 Corinthians 15:45) to Mary, calling her the second Eve. As mother of a new humanity, Mary participated in the reversal of the destruction caused by the first Eve.[4]

The title Queen of Heaven emphasized Mary's intercessory role that she would always plead for sinners with her son. Consider the image in the space above many Gothic church doors: Christ the terrible judge (*pantocrator*) sits enthroned on the day of doom watching as some rise to bliss and others descend to hell while Mary, the loving mother, intercedes with her son. The variation Queen of Angels highlighted the idea that the number of redeemed humans was going to make up for the number of fallen angels. Similarly, there was also the title Queen of the Saints, a designation which reaches back to the Second Council of Nicaea (787): the council declared that while the Triune God receives *latria* (worship), saints may receive *dulia* (veneration). The council made a special distinction for Mary who alone could receive *hyper-dulia*, the highest form of veneration.[5] While the title Our Lady reflected western courtly sensibilities, there was also *Stella Maris*, Star of the Sea, a title which emerged from an error in an ancient Hebrew Dictionary. In the fifth century, Jerome translated the Hebrew name *Miryam* (Mary) as meaning in Latin, *Stilla Maris*, drop of the sea. However, this was transcribed incorrectly as *Stella Maris*, star of the sea, and that error became widespread: Mary became the star by which poor souls sailing through life are guided into the safe harbor of Christ.

These are all quite positive, but there is also the title *Mater Dolorosa*, the sorrowful mother. This comes from the anonymous thirteenth-century poem, *Stabat Mater*.[6] Its root is the notion that Mary shared in the sufferings of her son, a participation foreseen during Christ's infancy when aged Simeon in the Temple took Christ in his arms and said to Mary, "a sword will pierce your heart also" (Luke 2:34–35). This image of the sorrowful mother parallels the intense focus on the sufferings of Christ in the later middle ages. Prayers, poems, meditations, charms, and even guilds were focused on the Five Wounds of Christ while Jesus often appeared not only as the dread judge, but as the Man of Sorrows, bloody, crowned with thorns, and surrounded by the instruments of his passion. Mary's suffering was woven into this motif.[7] Finally, the title Mediatrix points simultaneously to her two-fold function in the medieval mind. First, she cooperated with God so that the Incarnation could be achieved (Mary's assent "Let it be"). In this sense, Mary is the mediating vehicle by which God joins with his creation. The movement is God coming to humanity with Mary as the channel. This seems obvious, possibly innocuous even to later Protestants. Secondly, however, Mary is the avenue by which humans ascend to God. Bernard of Clairvaux wrote "through her, he who through her was given to us, might take us up to himself."[8]

Three visions of Mary—apparitions of the virgin—stand out for discussion. First, in 1061, Mary appeared to the Lady Richeldis in the English village of Walsingham and instructed her to build a shrine modeled on the house in which the Annunciation took place. Completed around 1200 and known as "England's Nazareth," the shrine focused the pilgrims' attention on God breaking into the everyday life of Mary, just as God interrupted his creation to reclaim it.[9] Secondly, in 1208 in Prouille in southern France, St. Dominic was laboring to convert the Albigensian heretics and Mary appeared to him and gave him a rosary, a chain of beads for prayer. This resulted in a connection between the rosary and moments of victory. For example, the pope ordered the praying of the rosary during the naval battle of Lepanto against the Turks in 1571.[10] Thirdly, around 1251 Mary appeared to Simon Stock, the English prior general of the Carmelites, and gave him the brown scapular, part of the habit of the Carmelites, instructing Stock that the one who dies wearing the scapular will be saved. Martin Luther would later react to this specific train of thought, recounting his youthful belief that a monk's cowl would save him. The Carmelites had a characteristic devotion to Mary and, as Simon Stock was English, the feast of Our Lady of Mount Carmel was first observed in England.[11]

Marian piety shot through medieval liturgies, perhaps the most obvious example being the Marian antiphons, short hymns attached to other rites.[12] Likely the most famous of these is the *Salve Regina* (Hail Queen). Although often attributed to Bernard of Clairvaux, most scholars think its origins are earlier. The banished children of Eve, the lyrics read, weep in

a valley of tears, crying out for Mary's intercessions. With an origin as early as the sixth century in the east, the Hail Mary may be the most popular of all Marian prayers. It became mainstream in the West as part of the Little Office of Our Lady, a short liturgy with psalms and Marian hymns. The Little Office began as a private devotion in the tenth century, but many abbeys began closing their community offices with it. In 1095, Pope Urban II (r. 1088–1099) decreed that it should be prayed on Saturdays by all clergy so that Mary would assist in the first crusade. In addition to the Little Office, a series of meditations emerged in the thirteenth century focusing on the sorrows of Mary, the Dolours, Hours, Swords, and Sorrows of Mary. These meditations began with the prayer *Sub tuum praesidium*, a prayer which is actually the oldest known prayer to Mary and one in which Mary is characterized as a refuge. To return to the Hail Mary, by the early twelfth century in the west, it had left the couching of the Little Office of Our Lady; by then we find people praying the Hail Mary in repetitive sets. One hundred and fifty Hail Marys were often interspersed with glorias and sometimes Our Fathers, and then the one hundred and fifty were divided into sets of fifty. By roughly 1150, Christians were saying these prayers on beads. A set of fifty came to be known as rosarium, after yet another of Mary's titles, *Rosa Mystica*, the Mystic Rose. Medieval rosary beads came in all configurations and could include charm pendants, holy medals, and even feathers.

What about the Angelus, that prayer which, by its connection to tower bells, had such a civic valance? The Angelus was born at the general chapter of the Franciscans in 1269, which decided that their friars would teach people to pray the Hail Mary in the morning and in the evening at the three-fold ringing of a bell. In 1317, the Dominicans followed suit, encouraging people in towns to do likewise. A decade later, in 1327, Pope John XXII ordered bells to be rung across Rome to interrupt the flow of the day just as Gabriel's annunciation interrupted the downward flow of history. The Angelus, a set of three Hail Marys with interspersed scripture quotes about the Incarnation, organized the day: morning, noon, and evening. From Rome, the Angelus spread throughout Europe.[13]

Among the medieval voices tied to Marian piety, Bernard of Clairvaux (1090–1153) ranks first.[14] In his famous Sermon on the Aqueduct, he described Mary as the aqueduct which leads divine waters to earth. In his Sermon on the Twelve Stars, he connected Mary with the woman described in Revelation clothed with the sun and surrounded by twelve stars, an interpretation that birthed one of the most common artistic portrayals of Mary. There is no doubt that Bernard loved Jesus' mother and taught people to ask for her intercessions. However, like many high and late medieval theologians, he was suspicious of the Immaculate Conception. This idea, born in the high middle ages but not formally dogmatized by the Roman Catholic Church until 1854, is that Mary was preserved from original sin in that her parents did not conceive her through normal

sexual intercourse. Rather, her father's seed reached her mother's womb miraculously. Bernard was not alone in his dislike for this concept. Peter Lombard, Anselm of Canterbury, Bonaventure, and Thomas Aquinas himself all opposed it, often citing Mary's need for a savior herself. If she was somehow preserved from the "stain" (*macula*) of original sin, was her humanity different from the rest of the descendants of Adam and Eve? In Lyon, the Feast of the Conception of Mary was introduced sometime in the eleventh century and prayers and liturgies followed. It was Duns Scotus (1265–1308) and a steady march of Franciscans who pushed the Immaculate Conception forward. Although the Dominicans steadily opposed it, Scotus and others after him argued that Christ preserved Mary from original sin and, in this sense, Christ is Mary's savior.[15]

Debates on the Immaculate Conception were complicated, and we should recognize the diversity of thought among Christians who were all passionately devoted to the virgin. It is hard to demote Bernard's famous commitment to Mary because he opposed a teaching which so many other notable theologians also found problematic. So well known was Bernard's love for Mary that in the fourteenth century Dante Alighieri had the great Cistercian abbot appear at the close of the Divine Comedy praising Mary. In the closing canto, Dante has Bernard instruct the main character, "Look now upon the face that is most like the face of Christ, for only through its brightness can you prepare your vision to see him."[16] Mary, in the medieval mind, was the entry way for seeing the face of Jesus.

MEDIATING THE HOLY: SAINTS AND THEIR RELICS

Mary was ultimately one of many heavenly courtiers who could, to borrow from the Marian hymn *Salve Regina*, intercede for the "poor banished children of eve" struggling through the "valley of tears." The phenomena of saints, relics, and pilgrimage highlight the tangible sensibilities of medieval Christians. Identifying some Christians as having achieved a particular degree of holiness, the urge to touch their remains, and the belief that one can locate a specific place or object and invest it with spiritual meaning and power, all point to a distinctly material spirituality. A shrine was a locus of power and its existence presumed a delineation between the sacred and the profane. The medieval imagination had sharp lines between the holy and the mundane, even complex gradations of the sacred. Gothic churches, as discussed previously, were designed to divide holy from common while pilgrimage reflected the journey one makes to God, a winding path of increasing holiness leading to the fullness of God's presence. The impulse to visit a sacred site goes back beyond the middle ages, arguably to scripture.

The church was understood as encompassing both the living and the dead in three states of existence: the church militant on earth, the church expectant in the fires of purgatory, and the church triumphant comprised of the saints in heaven. Fortunately for earth-bound Christians, the church militant could request the intercessions of the church triumphant and venerate what they left behind: bits of bone, fragments of cloth, their personal effects. These relics were a vital conduit to the heavenly Jerusalem. This sensibility about the holiness and power of the bones of saints can be seen coursing through Christian history. There is even scriptural warrant. 2 Kings 2:14 recounts miracles attributed to the mantle of Elijah and the bones of Elisha while Acts 19:12 describes the healing power of handkerchiefs that had been in touch with Paul's body. In *The Martydom of Polycarp* (c. 156), Polycarp's bones are described as "more valuable than precious stones and finer than refined gold."[17] Likewise Helena (c. 250–c. 330), the mother of Constantine, made her famous trip to the Holy Land in 326 specifically to find the places and physical objects that came in touch with Jesus Christ. She went around finding the location of Christ's birth, his sepulcher, and other sites from scripture, and the ultimate relic, the true cross. Power surrounded these places and objects and, like water, could splash onto those visiting them. In the fifth century, Jerome reported demoniacs writhing before the graves of martyrs while unseen saints punished unseen demons.[18]

The topic of shrines among early Christians has led to accusations of syncretism, the notion that the saints merely picked up where divinized pagan heroes left off, pagan beliefs being sublimated within Christian practice. Despite the persistence of this depiction, it was challenged in Peter Brown's highly influential *Cult of the Saints* (1982). Brown highlights what it meant to be a saint and what it would mean to visit their bones. The very thing that made a pagan hero a hero was that he did not taste death. A martyr, on the other hand, became a martyr *precisely* because she or he tasted death. This is no small detail. And this touches on Christian thinking about death itself, how the dead are treated, and material bodies. Christians in late antiquity had breached the boundaries that were established in the classical world, redrawing them and in fact creating a new system of boundaries. In the ancient pagan world, the dead were physically outside the city bounds. It was unsuitable to have cemeteries within city limits; in other words, there was the city of the living and the city of the dead with a bright line between the two. Christians violated that sensibility because they wanted to live in close proximity—ideologically and physically—to the holy dead. No better altar for the Eucharist could be found than the tomb of one who died for the faith.[19] And pagans were horrified by the practices tied to relics, practices integral to the veneration of the saints. Devotion at *martyria*, shrines on the graves of the martyrs, eventually gave way to the bones themselves being "translated" (moved) to the great churches of Europe.[20]

Another common misimpression is that relics were a folksy detail of Christian practice tolerated by the theologically educated for the sake of simple lay-people. Was the veneration of teeth, hair, and breast milk a pastoral accommodation? It is wise to refrain from projecting contemporary sensibilities onto the past and allow the strangeness to stand unresolved. The culture of relics was central to Christian spirituality in the early and medieval church. The religion of the "vulgar" was also the religion of the elite: learned theologians visited shrines and venerated bones as the tangible remains of people brushed with holiness. There was, however, some calculation. The translation of relics into the great basilicas was a shrewd, although certainly not impious, move on the part of bishops. They drew close to the power of the saints, appropriating their authority for the church's mission. Such saints could be strategic patrons in the church's effort to evangelize. They also served as patrons for individuals at moments of spiritual anxiety and relics were seen as a comforting gift from God himself. Accordingly, there developed a certain enterprise about relics. If a city was to grow in importance, it needed good relics, and when imported relics showed up at the city gates, often in grand procession, they were welcomed in royal fashion. The church militant on earth was meeting the church triumphant in heaven and thereby giving succor to the church expectant in purgatory.[21]

What about distinctions among the saints? Martyrdom was a critical element in the life of the early church, even a marker of Christian identity.[22] However, when persecution ceased in the fourth century, the church had to renegotiate the paths to holiness. Monasticism, then, became a form of spiritual athleticism and the vocation of the desert naturally replaced the vocation of martyrdom. In fact, Benedict of Nursia in the sixth century described the monastic life as a living martyrdom. So, when one could no longer reject the world, embrace the counter-culture of Christianity, and strive after holiness by being a red martyr, covered in blood, he or she could become a white martyr instead. Consonant with medieval sensibilities about order and hierarchy, relics themselves became classified and ranked in the middle ages. First-order relics included bones or body parts, second-order relics were physical objects that had a connection to the saint, and then third-order relics were strips of cloth, known as brandea, that had been wrapped around first-order relics. A record from around the 580s describes pilgrims in Rome lowering strips of cloth down into the tomb of St. Peter. When pulled back up, the strips were supposedly heavier, as if the cloth physically absorbed some of Peter's sanctity.[23]

First and second order relics were treated with great care, being housed in reliquaries by the early middle ages. Such containers were of various shapes and sizes but were often moveable, so they could be used in processions. The reliquary in figure 2.1 was for relics of St. Thomas Becket and images on its side show the archbishop's martyrdom in 1170.

By the later middle ages, they could also be used in fundraising. For example, after an uprising in Laon left the cathedral badly damaged, the cathedral's relics were taken on tour in 1112, even crossing the English Channel, to raise money to rebuild.[24] People wanted to be near these objects and they were willing to pay. The instance of the touring Laon relics, while not rare, was a clear inversion of the normal pattern, however. In this case, the relics came to the pilgrims rather than the pilgrims making a journey to places and objects of holiness. That is an important model to notice because it reflects a good deal of medieval spiritual sensibilities and it was a model that sixteenth-century reformers would contest: for the medieval Christian, one journeys to God through twists and turns along a route marked by increasing holiness. For many sixteenth-century reformers, God journeys to helpless sinners who (to complete the metaphor) are not strong enough even to stand, much less walk.[25] The example of the Laon relics, while breaking the normal pattern in the

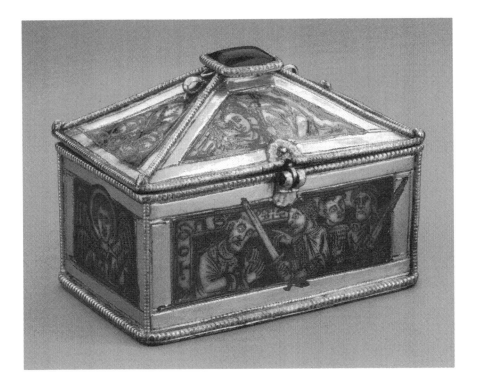

Figure 2.1. Reliquary Casket with Scenes from the Martyrdom of St. Thomas Becket c. 1173–1180. Gift of J. Pierpont Morgan, 1917, Metropolitan Museum of Art, New York, NY. Accession No. 17.190.520. http://www.metmuseum.org/art/collection/search/464490.

middle ages, nevertheless demonstrates the intense appeal and attraction that relics had.

Pilgrimage was also about journeying and entering the narrative of scripture or of saints' lives. A fourth-century woman, Egeria the Pilgrim, left an account of her journey from Spain to Jerusalem sometime in the 380s, recording her experiences at sacred spots specifically so that her fellow nuns back home could share in her pilgrimage. Moments in scripture, Jesus' birth or his passion, for example, had been captured at these places and the sacred story in any given place was recounted and relived perpetually by pilgrims seeking to climb into the narrative.[26] With the rise of Islam in the seventh century, Christian pilgrimage routes to the Holy Land were cut off, and consequently Rome took on preeminent status. This was in addition to a swath of changes in Christian pilgrimage practices around this time. Martyria and the sites of the Holy Land were joined by shrines for saints in northern Europe, and the relics themselves had experienced movement, translation, as was the case with the bones of St. Cuthbert from the Holy Isle of Lindisfarne in northeast England to Durham. Cuthbert had died in 687, and two centuries later, in 995, the monks of his community fled a Viking incursion. They took with them Cuthbert's reliquary and one day during their journey it became immovable, as if by divine mandate. The monks understood this to mean Cuthbert wanted this to be the community's new home, and Durham Cathedral was built on the spot. This story captures something of medieval sensibilities about relics and pilgrimage. Holiness was not limited to the biblical figures or the early martyrs, and now communities in northern Europe were being shaped by new saints and new relics.[27]

With the closing of routes to the Holy Land, Rome became, de facto, the ultimate destination for pilgrims. What goes up can also come down. When the crusaders took Jerusalem in the year 1099, pilgrims started pouring back into the Holy Land, and consequently pilgrimage to Rome declined a bit. In fact, in the thirteenth century the pope himself was doing some economic development for Rome and tried to pitch the eternal city as a pilgrimage destination because it had slacked at that point. He still wanted people to come to Rome, to stay and spend money. And when the crusaders' states fell in 1244, Rome's popularity shot back up.[28]

MEDIATING THE HOLY: PILGRIMAGE

Why did people want to go on pilgrimage? To be clear, travel in the later middle ages was far from easy. It could be a major undertaking, not infrequently dangerous, and possibly lasting a full year. The motivations, though, were as powerful as the risks. The power of relics and the desire to enter holy moments—to climb into the biblical story or that of the saints—were significant. A pilgrim often had a pre-existing attachment to

the saint whose relics she or he visited. Perhaps the pilgrim had even promised the saint a pilgrimage to pay homage for all the intercession the saint had provided or perhaps will provide. According to a chronicle, King Cnut of England (r. 1016–1035) went to Rome because "wise men have told me that the Apostle Peter has received from God the power of binding and loosing and carries the keys of paradise. I therefore deemed it useful in no ordinary way to seek his patronage before God." Cnut's words in the chronicle highlight the sense that saints not only had intercessory power, but that they preferred requests for intercession made before their relics.[29] Many of these shrines also had the reputation for healing. In his *City of God* Augustine describes miracles occurring at the shrine of Stephen the Protomartyr. These sensibilities about saints' power particularly manifest at their remains carried through to the middle ages. Strips of cloth that had touched Thomas Becket's wounded head after he was murdered at Canterbury in the twelfth century were said to have healing properties, and thus one reason why people would visit the shrine at Canterbury Cathedral was to experience a miraculous healing.[30]

By the later middle ages there was also the hope of receiving an indulgence, as some shrines had indulgences attached to them. If one prayed before the relics, he or she received an indulgence, knocking time off purgatory. Visiting the Church of St. Cosmas and St. Damian in Rome merited a thousand years while visiting St. Cecilia in Trastevere, just over the Tiber river, netted one hundred. Yet another reason to go on pilgrimage was punishment. Starting in the twelfth century, church courts often commanded pilgrimage as penance. Bishop Jacques de Vitry (1180–1240) was both a major recruiter for the crusades and an eminent preacher on the subject of pilgrimage. He explained that when one sins with every limb of the body, one must make reparation with every limb of the body. In other words, penance was not simply a mental act. Odo of Rigaud, archbishop of Rouen in the early thirteenth century was known for imposing pilgrimage for a variety of crimes: forgery, breaking sanctuary, irrevences during liturgies, and sexual indiscretions. For his botched kidnapping of Pope Boniface VIII in 1303, Guillaume de Nogaret, chancellor of King Philip IV of France, was ordered to make pilgrimage to several shrines in France, Spain, and finally the Holy Land where he was to exile himself. In 1319, Roger da Bonito was ordered to make pilgrimage to Rome, Santiago, and Jerusalem not for kidnapping a pope, but for killing a bishop![31] Sometimes penitent pilgrims were ordered to wear chains or heavy iron coats on their journey, and there are many stories of these physical burdens miraculously falling off at the shrines, a sign that the penance had been accepted by God and his saints. Pope Gregory VII (r. 1073–1085) ordered a man named Conrad to wander from shrine to shrine wearing chains and carrying a parchment which listed his sins. The pope stipulated that he was do so until the burdens miraculously fell and the parchment appeared to be wiped clean. After wandering as far as

Jerusalem, at last his chains miraculously fell and the parchment became blank while at a shrine in Hungary.[32]

While some went on pilgrimage for punishment, others went for tourism. In medieval Europe, most people lived their entire lives within a thirty mile radius of their birthplace; many people never left that small corner of the world. That motivation is certainly displayed in Geoffrey Chaucer's great vernacular work, *The Canterbury Tales*, a piece discussed below. To summarize, then: a list of motivations ought to include the intercession of the saints regarding earthly trials, the possibility of miracles and healings, indulgences to shorten one's future sentence in purgatory or that of a deceased relative, making penance, and the understandable desire to see the world as a tourist. Marxist historians of the mid-twentieth century often reduced motivations to the financial or simply the social. However, historians today are leery of projecting contemporary sensibilities onto medieval pilgrims by ignoring sincerely held spiritual motivations. There is, however, a more immediate problem with the Marxist-reductionist approach: this was not a world where one can hypostasize "religion" as we often conceive it in the modern west. In other words, this was not a world in which one had a life with all its essential spheres of existence in place and then tacked onto that (and thus detachable) is one's personal, subjective, and private religion. In medieval Europe, we cannot extract and isolate "religion." Motivations were naturally mixed. In plain terms, within the same person we will find the yearning to be close to the holy jostling alongside the yearning to see the sights. Pilgrims knew the risks and the hardships involved in crossing Europe and an ascetical motivation cannot be denied. This illustrates a method for religious history preferred in this study: people are spiritual amphibians with multiple, even conflicting, motivations. Power and authority, for example, were mediated through a variety of sources, the king or government, the church itself, the Bible, and sites of intrinsic holiness, shrines for instance. These jostled together in the minds and hearts of medieval women and men.[33] We ought to be leery, therefore, of single source explanations for why someone did something, a pilgrim risking his life to journey to Jerusalem for example.[34]

Considering the dangers of pilgrimage, the First Lateran Council decreed protection for pilgrims in 1123; those who robbed pilgrims could suffer excommunication. Highwaymen were not the only source of danger, though. The Alps which formed a natural barrier in northern Italy dictated the best time to set out for Rome. August was the best month to journey from northern Europe as late summer was the safest time to cross the mountains. One would then winter in Rome but move north again in the spring before the hot Italian summer. Most of the great shrines as well as the established routes to them had hospices to provide rest for pilgrims. There was a specifically English hospice established in Rome, a house dedicated to the Holy Trinity and St. Thomas Becket (a nod to

England's preeminent shrine), and the earliest account we have of an English pilgrim being at this hospice is from that eccentric fifteenth-century laywoman Margery Kempe. Having crossed in the late summer, Margery was in Rome by August 1414. She spent the winter there, leaving after the following Easter. Margery, known for her wild sobbing and wailing, got herself kicked out of the English hospice. Of course, there were several well-known hospices along the different routes to other shrines, Compostella in Spain and Canterbury in England for example.[35]

In addition to travelogues like Margery Kempe's book, the sources available for medieval pilgrimage include pilgrim guides and itineraries. A whole genre of literature emerged to guide people on how to make a pilgrimage. Laced with miracle stories, the *libri indulgentiarum* are books which ranked shrines by listing the indulgences a pilgrim could receive at each one. Perhaps the most well-known of these was the *Staycons of Rome*, a text which first appeared around 1370 and went through six editions. Its purpose was to pitch Rome as a pilgrim destination over Jerusalem, Santiago, and other shrines. There is also non-literary evidence of pilgrimage. Badges, like the cockle shell of St. James of Compostella, indicated where a pilgrim had been. Graffiti in Rome and elsewhere help to bring some of the grittiness of pilgrim activity into view while revealing the origins of the foreign visitors.[36]

Historians regularly use information about major pilgrimage sites—Rome, Santiago de Compostela, or Canterbury—to fill in the gaps about smaller sites, shrines whose details are missing in the historical record. Among the greater sites, there was the Holy Land whose cities and countryside were graced by Christ himself and so many other biblical figures. There was also Rome with shrines to Peter, Paul, and other martyrs. England had Canterbury's shrine to Thomas Becket, the archbishop who defied King Henry II over the rights of the church, and Cuthbert's shrine at Durham. There were also shrines for apparations of Mary, Walsingham and Norwich for example.[37] And of course there were Holy Blood shrines like Wilsnack in Germany and Orvieto in Italy. These are the major shrines, but there were hundreds more where local saints and miracles were venerated. People loved to visit the Cistercian monastery in Boxley to see the Holy Rood (cross); a mechanical Jesus on the cross moved his head and blinked his eyes. Even Henry VIII made a pilgrimage there in his youth. In 1538, the bishop of Rochester, John Hilsey publicly displayed all the wires and mechanisms before it was burned in London.[38]

In the later middle ages, there was a gradual shift from veneration to aquiring indulgences reducing one's time in purgatory. Surely the other motivations described above, including pious veneration, remained. However, as time wore on, the teaching, preaching, and practices connected to indulgences grew more systematic. These remissions could be obtained for a variety of acts, not simply prayers at a shrine. However,

shrines came first historically and indulgences were attached to them later. In 1300, Pope Boniface VIII did something quite different: he made the whole of Rome a shrine for the purpose of indulgences, rather than attaching indulgences to a specific shrine. In his papal bull *Antiquorum habet fida relatio*, Boniface declared a plenary indulgence (a complete remission of all time in purgatory) for anyone making pilgrimage to Rome in 1300, a year he termed a jubilee. This was motivated, in part, because Boniface had a major falling out with Philip IV of France and money was not coming in from that wealthy country. Certainly, this was an economic boon, but again, per our discussion of multiple motivations, Boniface's fiscal impetus was not necessarily on the minds of pilgrims, people who had lots of reasons to come to Rome. One of these motivations, we must acknowledge, was the spiritual experience. A jubilee in which sins are wiped clean is rooted in Leviticus 25, which specified every fiftieth year as a jubilee. Boniface envisioned the jubilee to happen once a century, but after his pontificate jubilees happened more often and more sporadically. Pope Alexander VI (r. 1492–1503) declared 1500 to be a Jubilee and, according to tradition, this was the first jubilee to include the liturgical opening of the "Golden Doors." Specific doors at major churches in Rome would be opened only during jubilee years, symbolizing welcome into God's mercy. So successful was the jubilee of 1500 that the piles of money left at the altars of St. Peter's basilica had to be collected with rakes. Martin Luther was not alone when he reviled the Golden Doors as literally golden because they brought the pope so much gold.[39]

To conclude this discussion of pilgrimage, we turn to the great vernacular English text, *The Canterbury Tales*. Geoffrey Chaucer (1343–1400) wrote a collection of stories each told by a pilgrim staying at a hospice along the route to Canterbury around 1390. Written in middle English, there are around eighty manuscript copies from the fifteenth century. What the *The Canterbury Tales* highlights, though, for a discussion of pilgrimage may be summarized as (1) it evinces the desire among all socioeconomic levels of society to visit Canterbury, as there are representatives from all classes telling the tales; (2) it illustrates the phenomenon of hospices at well-defined locations along established routes; and (3) it highlights that pilgrimage, while a deeply spiritual experience, could also be a very earthy experience. These are bawdy people with rough humor, and they each made the journey for lots of reasons while rubbing shoulders with people who also had lots of reasons for visiting the shrine.[40] But that does not lessen their desire to touch the holy.

MEDIATING THE HOLY: THE SEVEN SACRAMENTS

In the later middle ages, the presence of the holy was mediated not only in the mass and the cult of the saints. Through the priesthood, the church

offered seven sacraments, each of which addressed a different context of life. Most definitions, beginning with Augustine in the fifth century, describe a sacrament as a visible sign of an invisible grace. Scholastic theological treatises as well as manuals for clergy list sacraments of initiation (baptism and confirmation), sacraments for various callings (marriage and ordination), sacraments to remit post-baptismal sin (penance and unction, i.e., last rites), and of course the mass.[41] In his *De Sacramentis*, Thomas Aquinas linked the sacraments to the four cardinal virtues and the three theological virtues: baptism related to faith, unction to hope, the Eucharist to love, confirmation to fortitude, confession to justice, marriage to temperance, and ordination to prudence. As discussed, the mass was the centerpiece of medieval spirituality, and in many respects the mass—the "most blessed sacrament"—eclipsed the other six. In some treatments, both theological and practical, the other six sacraments flow out from the mass. This pattern appeared in a variety of media including stained glass, murals, and manuscript illuminations. In St. Michael's Church in Doddiscombsleigh, near Exeter, stands one of the most fulsome seven sacraments window in an English church. Completed around 1480, the window has Christ in the center, his wounds pouring out streams of blood leading to each sacrament.[42]

Baptismal fonts stood near the west door in churches (emphasizing baptism as the entryway for the Christian life). However, given the high rate of infant mortality and the fear of children dying unbaptized, midwives commonly administered the sacrament to newborns immediately after delivery. If the infant was healthy and brought to the church, the full rite included exorcizing wicked spirits, applying blessed salt to purify the candidate, the priest dabbing his thumb on his tongue and putting saliva on the candidate's ears and nostrils (as Christ applied saliva when he healed the deaf mute in Mark 7), questions posed to non-parental sponsors of the candidate (Godparents) about the Christian faith, the pouring of water on the candidate in the name of the Trinity, and then giving the newly baptized a white garment and a candle. Whether baptized at home or in the church, one received confirmation much later. A bishop, as a successor of the apostles, would recognize the validity of one's baptism by laying on hands, praying for God's defense, and anointing one's forehead with oil. Confirmation records from the middle ages are extremely spotty and ages varied considerably. It was not rare for one not to receive confirmation at all. However, the average age seems to have been between five and seven.[43]

To receive communion, usually at Easter, one had to go to another sacrament first, penance. A priest would sit in a chair, possibly near an altar, and listen while a kneeling penitent disclosed his or her sins. Semi-private booths were developed in the late sixteenth century. The confessor would then assign penance, something as simple as saying a prayer or as complicated as going on pilgrimage, and then pronounce absolu-

tion, a remission of sins which was contingent on the completion of the penance. As discussed, the Fourth Lateran Council (1215) decreed that all Christians had to confess before receiving communion. Quoting the fourth-century church father Jerome, Peter Lombard described penance in his twelfth-century *Sentences* as "a second plank after a shipwreck."[44] When baptized Christians lose the vesture of innocence given at baptism, he explained, they may take it up again through the sacrament of penance. Similarly, extreme unction, an anointing at the time of death, prepared one to exit the mortal life by returning to God's grace. Along with final confession and viaticum (final communion), unction became part of several deathbed rituals. Achieving a holy death became such a concern that a genre of literature, the *ars moriendi*, emerged and would continue beyond the reformations of the sixteenth century. As sensibilities about dying well evolved, the literature only grew.[45]

Baptism, confirmation, confession, mass, and unction were sacraments that all Christians could experience. The remaining two, however, mediated God's grace for particular states of life, vocations either to marriage or holy orders. Marriage itself was understood as a state of life instituted by God in creation, and therefore not unique to Christians. However, for Christians, this state of life symbolized Christ's mystical marriage to the church. Stemming from Christ's words in the gospels, marriage was indissoluble save for abandonment and adultery. The church, however, found ways of annulling certain marriages, that is, identifying some defect from the start thereby invalidating the marriage altogether. While the vows between husband and wife effected the sacrament, the church facilitated weddings by having them on the porch steps, not the high altar. The priest heard the vows and pronounced a blessing on the marriage.[46] The language of marriage was also used to describe Holy Orders, a marriage between the cleric and the church. Ordination gave a cleric a new spiritual character so that he would be effective in ministry. After all, priests were entrusted with celebrating the sacraments, the vehicles for God's grace.

Beyond the specific list of seven sacraments, neatly delineated by scholastic theologians, there were other phenomena and practices that came to be known as sacramentals. These can be divided into three categories. First there were objects blessed by priests and distributed during regular liturgies—candles at Candlemas, palms on Palm Sunday, or holy water through the year. These could be taken home and serve as devotional aids or protective talismans. The second category is blessings said by priests out in the community for the benefit of the world's order—using salt and holy water to bless a home, blessing fields for a good harvest, or invoking God's blessing on a community while "beating the bounds" during rogation-tide, a practice of processing around village borders with prayers and psalms. The third category, however, escaped clerical control. These are the prayers, charms, and incantations that lay-

people would use for protection or even to manipulate the natural world, leading some scholars to liken these practices to magic.[47]

WATER IN THE DESERT

The medieval Christian was like a traveler in a parched desert, but one with several well-known oases. Along with the intercession of Mary and the saints, made especially manifest at shrines which housed their relics, the seven sacraments mediated the holy to a culture which yearned for rich, tangible, and sensible moments of divine encounter. Even though there were boundaries between the sacred and the profane, heaven and earth overlapped at recognizable places and spaces.

NOTES

1. John Shinners, ed., *Medieval Popular Religion, 1000–1500: A Reader* (Toronto: University of Toronto Press, 1997), 182–83.
2. Miri Rubin, *Mother of God: A History of The Virgin Mary* (New Haven: Yale University Press, 2009), 191–284; Daniel O'Sullivan, *Marian Devotion in Thirteenth Century French Lyric* (Toronto: University of Toronto Press, 2005), 3–32; Elizabeth Johnson, "Marian Devotion in the Western Church," in *Christian Spirituality: High Middle Ages and Reformation* ed. Jill Rait (New York: Crossroads, 1987), 392–414.
3. Michael Carroll, *The Cult of the Virgin Mary: Psychological Origins* (Princeton: Princeton University Press, 1986), 3–21; Donna Ellington, *From Sacred Body to Angelic Soul: Understanding Mary in Late Medieval and Early Modern Europe* (Washington: Catholic University of America Press, 2001), 1–46.
4. Jaroslav Pelikan, *Mary through the Centuries: Her Place in the History of Culture* (New Haven: Yale University Press, 1996), 39–66; Luigi Gambero, *Mary and the Fathers of the Church: The Blessed Virgin Mary in Patristic Thought* (San Francisco: Ignatius, 1999), 43–58.
5. Pelikan, 113–34; Johnson, 392–414; Susan Keefe, *Water and the Word: Baptism and the Instruction of the Clergy in the Carolingian Empire*, 2 Vols (South Bend: University of Notre Dame Press, 2002).
6. David Rothenberg, *The Flower of Paradise: Marian Devotion and Secular Song in Medieval and Renaissance Music* (Oxford: Oxford University Press, 2011), 193–240.
7. Pelikan, 125–38; Ellington, 77–101; Rubin, 346.
8. Pelikan, 125–38; Ellington, 102–41.
9. Carroll, 90–147; Gary Waller, *The Virgin Mary in Late Medieval and Early Modern English Literature and Popular Culture* (Cambridge: Cambridge University Press, 2011), 80–106.
10. Carroll, 177–81.
11. Andrew Jotischky, *The Carmelites and Antiquity: Mendicants and their Pasts in the Middle Ages* (Oxford: Oxford University Press, 2002), 45–89; Carroll, 116–28.
12. Rothenberg, 3–23.
13. O'Sullivan, 63–68; Johnson, 392–414; Rubin, 252–54; Rothenberg, 141–49.
14. Rubin, 149–57.
15. Rubin, 173–76; Pelikan, 189–200; Carroll, 156–57; Luigi Gambero, *Mary in the Middle Ages: The Blessed Virgin Mary in the Thought of Medieval Latin Theologians* (San Francisco: Ignatius, 2005).
16. *The Divine Comedy of Dante Alighieri*, trans. Courtney Langdon (Cambridge: Harvard University Press, 1921), vol. III, Paradiso, Canto 31–33.

17. Paul Foster and Sara Parvis, eds., *Writings of the Apostolic Fathers* (London: Continuum, 2007).

18. Robert Bartlett, *Why Can the Dead Do Such Great Things? Saints and Worshippers from the Martyrs to the Reformation* (Princeton: Princeton University Press, 2013); Carolyn Walker Bynum, *The Resurrection of the Body in Western Christianity, 200–1336* (New York: Columbia University Press, 1995), 59–114; Martina Bagnoli, Holger Klein, Griffith Mann, and James Robinson, eds., *Treasures of Heaven: Saints, Relics, and Devotion in Medieval Europe* (New Haven: Yale University Press, 2010).

19. Peter Brown, *The Cult of the Saints: Its Rise and Function in Latin Christianity* (Chicago: University of Chicago Press, 1981).

20. Debra Birch, *Pilgrimage to Rome in the Middle Ages* (Woodbridge, Suffolk: Boydell, 1998), 24, 31–32; Cynthia Hahn, *Strange Beauty: Issues in the Making and Meaning of Reliquaries, 400–c. 1204* (University Park, PA: Pennsylvania State University Press, 2012).

21. Brown, 17, 30, 65–99.

22. Rowan Williams, *Why Study the Past?: The Quest for The Historical Church* (Grand Rapids: Eerdmans, 2005), 32–59.

23. Birch, 30–31; Bartlett, 239–325.

24. Shinners, ed., *Medieval Popular Religion,*

25. Simon Coleman, "Pilgrimage as Trope for an Anthropology of Christianity" *Current Anthropology* 55 (2014), 281–91

26. Maribel Deitz, *Wandering Monks, Virgins, and Pilgrims: Asectic Travel in the Mediterranean World, A.D. 300–800* (University Park, PA: Penn State University Press, 2005), 43–105; Glenn Bowman, "Christian Ideology and the Image of the Holy Land: The Place of Jerusalem Pilgrimage in the Various Christianities," in *Contesting the Sacred: The Anthropology of Christian Pilgrimage* ed. John Eade and Michael Sallnow (London: Routledge, 1991), 98–121.

27. B. J. Nilson, *Cathedral Shrines of Medieval England* (Woodbridge, Suffolk: Boydell, 1998); Diana Webb, *Pilgrimage in Medieval England* (London: Hambledon, 2000).

28. Alan Morinis, ed., *Sacred Journeys: The Anthropology of Pilgrimage* (Westport, CT: Greenwood, 1992); Bryan Le Beau and Menachem Mor, eds., *Pilgrims and Travelers to the Holy Land* (Omaha: Creighton University Press, 1996).

29. Birch, 39–40; Diana Webb, *Medieval European Pilgrimage, c. 700–c. 1500* (London: Houndsmill, 2002).

30. Benedicta Ward, *Miracles and the Medieval Mind: Theory, Record, and Event, 1000–1215* (Philadelphia: University of Pennsylvania Press, 1987), 117–20.

31. Birch, 59.

32. Bartlett, 429, 398.

33. Ethan Shagan, *Popular Politics and the English Reformation* (Cambridge: Cambridge University Press, 2003), 1–27; Brent Nongbri, *Before Religion: A History of a Modern Concept* (New Haven: Yale University Press, 2015).

34. Victor Turner and Edith Turner, *Image and Pilgrimage in Christian Culture* (New York: Columbia University Press, 1978); Simon Coleman, "Pilgrimage as Trope for an Anthropology of Christianity" *Current Anthropology* 55 (2014), 281–91.

35. Terence Bowers, "Margery Kemp as Traveler" *Studies in Philology* 97 (Winter, 2000), 1–28; Birch, 123–49.

36. Donald Howard, *Writers and Pilgrims: Medieval Pilgrimage Narratives and their Posterity*, 17, 29; Webb, 174–78; Birch, 1–22; Rob Lutton, "Richard Guldeford's Pilgrimage: Piety and Cultural Change in Late Fifteenth- and Early Sixteenth-Century England" *History* 98 (2013), 41–78.

37. Whiting, 54–62; Duffy, *The Stripping of the Altars: Traditional Religion in England, 1400–1580* (New Haven: Yale University Press, 1992), 190–200; John Shinners, "The Veneration of the Saints at Norwich Cathedral in the fourteenth century" *Norfolk Archaeology* 40 (1988), 133–44; Carroll, 115–47.

38. Leanne Groeneveld, "A Theatrical Miracle: The Boxley Rood of Grace as Puppet," *Early Theatre* 10.2 (2007), 11–50.

39. Birch, 197–202; Bartlett, 504–86.
40. Ronald Ecker and Eugene Crook, eds., *The Canterbury Tales: A Complete Translation into Modern English* (Palatka, FL: Hodge & Braddock, 1993).
41. Miri Rubin, "The Sacramental Life," in Miri Rubin and Walter Simons, eds., *The Cambridge History of Christianity: Volume 4 Christianity in the West, 1100–1500* (Cambridge: Cambridge University Press, 2009), 219–237.
42. Whiting, 17–19.
43. Susan Karant-Nunn, *The Reformation of Ritual: An Interpretation of Early Modern Germany* (New York: Routledge, 1997).
44. Jacques-Guy Bougerol, "The Church Fathers and the Sentences of Peter Lombard," in *The Reception of the Church Fathers in the West: From the Carolingians to the Maurists* ed. Irena Backus (Leiden: Brill, 1997), 113–64; Elizabeth Rogers, "Peter Lombard and the Sacramental System" PhD Dissertation, Columbia University (1917), 62–69.
45. Paul Binski, *Medieval Death: Ritual and Representation* (Ithaca, NY: Cornell University Press, 1996); Caroline Walker Bynum, "Death and Resurrection in the Middle Ages: Some Modern Implications" *Proceedings of the American Philosophical Society* 142 (1998), 589–96.
46. David D'Avray, *Medieval Marriage: Symbolism and Society* (Oxford: Oxford University Press, 2005); Idem, "Authentication of Marital Status: A Thirteenth-Century English Royal Annulment Process and Late Medieval Cases from the Papal Penitentiary" *English Historical Review* 120 (2005), 987–1013.
47. Swanson, 31–35, 182–84.

THREE

The Spirituality of High Medieval Reform Movements

Popes and Monks

At the turn of the millennium two phenomena aligned to critically impact Christian life and thought: a reform-oriented papacy with an increasingly international influence and a revival of Benedictine monasticism. This combination led to a push for more uniformity in liturgy, the mainstreaming and indeed canonizing of clerical celibacy, and a revived emphasis on the hours of prayer. The high middle ages also witnessed the continual evolution of monasticism and this chapter will trace the spiritual sensibilities and commitments of a succession of monastic movements. To best understand these reform movements, I offer the model of waves, each lapping over the last, sharing some elements yet diverging in other ways. After treating the so-called Gregorian Reform and the papacy, we will examine the family of houses connected to the abbey of Cluny beginning in the tenth century. This Cluniac wave will be followed by yet another wave composed of a variety of congregations, notably the Cistercians, the Canons Regular, and the Carthusians, each of which hoped for a more austere form of life in the eleventh and twelfth centuries. Then a third wave will emerge in our study: the mendicant orders of the thirteenth century, primarily the Dominicans, Franciscans, Carmelites, and Augustinian Friars. Each of these waves, all of which gave rise to new patterns of Christian life and practice, fostered an urgency to retrieve the primitive meaning of monastic rules, a recommitment to apostolic poverty, a sense that the Christian vocation implied being withdrawn from the world or, on the contrary, living ever-deeper in the world.

Chapter 3

PAPAL REFORM AND SPIRITUALITY

The reform movement which would change the western church, often known as the "Gregorian Reform," had a double origin. On the one hand, by the tenth century, the papacy was entangled in local Roman politics. As the de facto property of a few competing aristocratic Italian families, the office of pope was ripe for renewal. On the other hand, certain new monastic communities hungered for a return to the Rule of St. Benedict. Perhaps the most famous was the Abbey of St. Peter and St. Paul at Cluny, a community founded by Duke William of Aquitaine in the duchy of Burgundy in 910. These and other houses became centers for reform. One of their goals was an end to simony, the practice of paying for ecclesiastical appointments, so named for Simon Magus who tried to buy the power of the Holy Spirit from St. Peter in Acts 8. Likewise, clerical marriage and concubinage (the practice of keeping a woman in one's home without marriage) were in their sights, as were banning clergy from participation in war, the improvement of both clergy and lay morality, and wresting the appointment of church offices from lay control. Obviously, this was a bundle of disparate concerns rather than a neat package. At roughly the same time, a succession of popes, beginning in 1046 with Clement II (r. 1046–1047), was deeply influenced by the same concerns emanating from these monastic houses. By the end of the century, Pope Gregory VII would echo the primitivism of the Benedictine reformers in a letter to the emperor detailing his desire for the church to return to the teachings of the Holy Fathers and to walk in well-trodden paths. These reformist communities entered a symbiotic relationship with reformist popes to advance an agenda which evolved through the eleventh century. And organically each issue listed above gave rise to the next.[1]

It is common to date the start of a long-term transformation of the papacy with Leo IX (r. 1049–1054). When Leo arrived in Rome from north of the Alps, he brought with him both an entourage of reform-minded clerics and an abiding sense that the papacy should be a moral force in the universal church. There has been a tendency to describe the papal reforms as beginning with "moderates" but leading to "radical reformers." Under the heading of "moderates," most include Leo himself and Peter Damian (1007–1072), a monastic reformer most noted for his earlier ascetical life as a hermit and then later, as a cardinal, his contributions to canon law. These moderates focused on improving the Christian moral and spiritual life, particularly among the clergy. Likewise, the moderates were ready to work with royal powers to achieve their goals. Damian was one of the earliest theologians to distinguish the parallel authorities of the emperor and the pope with the metaphor of two swords. On the other hand, "radicals" have been labeled as such because of their agenda to divide the life of the clergy from the polluted world of the laity and their drawing a bright line under the power of the pope as existing, by

divine providence, over and above the authority of kings. Under the heading of "radicals," many historians have listed Humbert (1015–1061), bishop of Silva-Candida. In addition to laying the writ of excommunication on the altar of Hagia Sophia in Constantinople thus dividing the western church from the Greek east over the issue of papal authority, Humbert also wrote a tract against simony. That list of radicals usually also includes Gregory VII (r. 1073–1085), the pope most associated with reform in the high middle ages. Thus the potentially misleading though quite common short-hand for the whole movement is "the Gregorian Reform."

While the eleventh century reforms are often pushed together and equated with this single pope, they were hardly that well-organized. Moreover, the seeds for reform were planted long before Gregory's pontificate and bore their full fruit, arguably, much later at the Fourth Lateran Council (1215). It is important to see the broad nature of this extraordinary period of cultural, intellectual, and theological transformation and, likewise, to recognize that religious change is messy and happens in fits and starts. In concrete terms, the dynamic nature of the relationship between the reformist popes and reformist monastic houses needs to be recognized as does the *longue durée* of religious change. In short, reform took a considerable amount of time beginning in the late tenth century and coalescing at the start of the thirteenth.

Thanks to Pope Gregory I (r. 590–604), in the early middle ages, the bishop of Rome was seen as responsible for building up the church while also serving as an ultimate appellate judge. While many popes had been effective in holding synods and sending missionaries, the papacy's power and effectiveness largely depended on the leadership skills of the sitting pontiff. Most often the pope was not terribly different from other bishops, save for his role in imperial coronations, in forming new dioceses, and in serving as a court of final appeal in Christian life and thought. Those were the very rights, however, which the popes of the eleventh century used as a spring board. One of the most important elements in the rise of the powerful high medieval papacy was the popes' extension of privileges, immunities, and papal protections to monasteries beyond the Alps. When a pope declared that a religious house answered directly to him and not to local diocesan or royal authorities, he was creating real over-lordship beyond the traditional bounds of his power. Cluny is the classic example: when Duke William of Aquitaine founded the house in 910 he put it under the direct protection of the papacy. Around the same time, the monastery of Fleury was granted a charter that even allowed them exemption in the case of an interdict. This meant that if the pope utilized his most potent disciplinary power of suspending the sacraments in that diocese, the monastery could continue its sacramental life unabated. These ties of loyalty, built over the course of a number of pontificates, elevated the power and prestige of the papacy, and this paralleled the

emergence of new sensibilities about the reform of clerical life and apostolic purity in those very monastic houses.[2]

Those ties of patronage which helped to change the nature of the papacy and strengthened reform efforts were being forged long before Leo IX's election as pope in 1049. Even so, Leo did make important contributions to this transformational period. The details of his election are a case in point. How a bishop was selected, even the bishop of Rome, was often a consensual process involving royal authorities. Canon laws on the subject varied considerably and, even if available, they were not necessarily followed closely. Ideally, the candidate was to be at least thirty years old, drawn from the local clergy, and approved by the metropolitan archbishop of the province. The reality, however, was that bishops were drawn from noble families to solidify power bases and candidates were usually nominated by a secular ruler. Leo's election was no different. The emperor and most of Rome's power players chose Bruno, bishop of Toul in France in early 1049. Bruno, however, insisted that the people and clergy of Rome should vote by acclamation, an endorsement he received when he reached the city. However, before traveling to the eternal city where he was so warmly welcomed, the future Pope Leo thought it best first to hold a meeting with Hugh, the abbot of Cluny, and one of his monks, Hildebrand. The latter would become the famous reformer pope Gregory VII. It is clear that Leo, before he reached Rome itself, was already committed to improved clergy morals and an end to clerical marriage and simony. Over the 1050s, Leo and his immediate successors would address those issues as well as the state of papal elections and the administration of the papal court all while strengthening the international authority of the Roman see. When Leo was elected, no pope had traveled north of the Alps in 250 years, but this pope changed that, and he did so in the cause of reform. He held councils in France and Germany summoning clergy and issuing decrees far from Rome itself. At one council at Reims, Leo had the body of St. Remigius removed from his tomb and placed on the high altar. Every bishop and abbot at the council was to swear before the holy relics that he had not committed simony.

Leo was particularly concerned with personnel. Rome itself had a staggering rotation of liturgies and for centuries the popes had farmed out liturgical responsibilities to seven nearby bishops. Known as cardinal-bishops, these were the bishops of Ostia, Palestrina, Porto, Albano, Silva-Candida, Velletri, and Labiacum. Over time, these bishops along with other major clergy in Rome, the cardinal-priests and cardinal-deacons, became a bureaucracy in the pope's service. By 1100, this college of cardinals led the curia, administrative offices headquartered near the basilica of St. John Lateran. Critically, Leo IX drew foreigners from the north, reformers like himself, into the curia. He also started a practice which his successors, particularly Gregory VII, would utilize to extend Roman authority and reform, the use of legates. Much like the cardinals,

legates were not a new phenomenon but also like the cardinals their role was changing. The pope used bureaucrats to speak on his behalf in different corners of Europe and frequently to convene synods under his authority, thereby extending papal power in real practice. Hildebrand, the future Gregory VII, actually deposed bishops as a papal legate in France in 1056. While Leo increased the use of legates, it was still on an as-needed basis. Gregory VII, however, appointed standing legates to offer consistent papal representation far from Rome, often undermining local diocesan bishops. In short, the pope's voice was becoming universal in the west.[3]

By 1059, Pope Nicholas II (r. 1059–1061) had formally declared that the cardinals were to elect the pope, eliminating secular nomination. Tensions grew in the 1070s between Emperor Henry IV and Nicholas' successor, Gregory VII, leading to Henry's attempt to depose the pope and Gregory's response of excommunication in 1076. No pope had ever excommunicated an emperor, and this move, unimaginable a century earlier, severely weakened Henry's authority. In a dramatic move in 1077, a barefoot Henry begged for reconciliation by kneeling in the snow on three successive days before Gregory's castle at Canossa in Tuscany. The pope's advisors reminded him that, as a priest, he was obligated to forgive penitent sinners and so, despite misgivings, Gregory absolved the emperor and lifted the excommunication. Peace did not last; both struggled to the end of their lives to raise the authority of their respective offices over the other, a conflict known as the investiture controversy. In 1122 their successors, Pope Calixtus II and Emperor Henry V achieved the Concordat of Worms which allowed for secular rulers only to invest bishops and abbots with property and secular office. Although secular rulers would continue to be involved, the vision was that churchmen would elect churchmen.[4]

What were the effects of this shift in papal authority on the practice of Christianity? Three broad elements can be listed: (1) the pope as an effective (not merely symbolic) and final authority in the western church; (2) the morals and place of clergy in relation to other Christians; and (3) the rise of an international character to the church ("Christendom") that worked slowly to flatten regionalism. Regarding that first element, as should be clear, the presence and power of the pope by the year 1100 was vastly more manifest than it had been just a century before. By aligning with the new reformist monasteries, by traveling in person beyond the Alps, by convening synods either in person or through representatives outside Rome, and by creating standing legates, the eleventh-century popes were making their office more than a symbolic center for the western church but rather an activist ruling presence.[5]

Regarding the second element, the reform of the clergy, there was a host of specific issues targeted. While the end of simony was the early goal, clerical celibacy was also an item of concern, and this would include

both concubinage and clerical marriage. Denouncing a priest for visiting a prostitute or keeping a concubine in his home was unspectacular, but married priests were not universally rejected in the eleventh-century west. When one legate tried to press for clerical celibacy in Reims, he was stoned and barely escaped with his life. Nevertheless, the steady process of reform was unabated: clergy were to live a distinctly different lifestyle than lay-people. Coupled with the exclusion of secular lay authorities in the election of important clergy, a fervent push for clerical celibacy had the consequence of creating a seemingly higher estate, one perceived as truly set apart from the everyday life and concerns of this world. This contributed to the sense that one relied on the holy priest to make intercessions and, more than that, the sense that only those in the contemplative life could make spiritual progress. We can even see the investiture controversy in a liturgical and sacramental framework: in the eyes of the reformers, sacred persons, much like sacred space, needed to be set apart from the rest of the world.[6]

Regarding the third summary element, the rise of Christendom and the flattening of regionalism, two examples will be helpful. First, across the high and late middle ages there was a slow but discernable push toward a uniform liturgical expression; the final triumph, we might argue, was the Council of Trent's decision in the sixteenth century to call for one missal for the entire Catholic world. The early seeds of that push for uniformity can be found in the eleventh century. When Lanfranc became archbishop of Canterbury after the Norman Conquest of 1066, he worked to weed out local Anglo-Saxon saints' days in England and replace them with more universally recognized saints. Although this "purge" has been overemphasized in some treatments, it remains that Lanfranc did make strides toward a uniform devotional life. The Gregorian dream was of one church that prayed, celebrated, fasted, and feasted together. Similarly, when Pope Urban II called for the first crusade in 1095, he was galvanizing the whole of the western church in a common mission.[7] However brutal, the first crusade was construed as a pilgrimage for the whole of Christendom. The church at the dawn of the twelfth century was in the midst of renewal and reform and at the center was an energetic, activist papacy.

FIRST WAVE: CLUNY AND THE BENEDICTINE REVIVAL

As mentioned above, Duke William of Aquitaine founded a monastic community in 910 at Cluny, near the modern border between France and Switzerland. In the next century, this house was deeply associated with the revival of the Rule of St. Benedict. The place and function of the Benedictine Rule within monastic communities, however, was itself changing. In the early middle ages, a period which knew several monas-

tic rules, the Benedictine Rule was not conceived as a legal code, but rather as the source of a particular ethos. It functioned as a touchstone or starting place to be revered but not as law. In the sixth century, St. Benedict himself envisioned small communities living as a family and balancing their days between farming just enough to eat, private reading, and corporate prayer. In the following centuries, Benedict's Rule was adapted several times. During Charlemagne's reign, Benedict of Aniane (c. 747–821) took the Rule as a reference point even while he reduced the monks' manual labor and increased their public prayer. Cluny, though founded in part as an ardent reaction to decline in monastic fervor, did not diverge from this rather flexible understanding of the Rule. It was only with the Cistercians, discussed below, that the Rule came to be seen as the great law of monasticism to be observed to the last jot. So while the genesis of Cluny was in many respects a search for primitive purity and strict observation, the Rule of St. Benedict was still a source to be adapted rather than a codifed law to be enforced.[8]

Taking their cue from ninth-century theorists like Benedict of Aniane, the monks of Cluny construed the purpose of monastic life as a service of prayer, and not merely for one's self but for the whole world. Odo, second abbot of Cluny (c. 878–942) wrote in his revisions of the Rule that monks did service on behalf of others through their intercessions. For example, the Feast of All Souls, a day specifically to pray for those in purgatory, was born at Cluny in the eleventh century. In succeeding generations Cluny formed daughter houses throughout western Europe and the trademark of their life was the liturgy, particularly an elaborate observation of the choir offices. The monks rose around 2 a.m. or 3 a.m. for the office of Matins, after which they could sleep a bit more. Prime and Lauds were sung at 6 a.m., Terce at 9 a.m., Sext at noon, and Nones at 3 p.m. Vespers was held at dusk and compline concluded the day soon thereafter. To these were added several other devotions, such as Matins for the Dead, and psalms could be multiplied for countless reasons. Community masses were celebrated twice daily, the Morrow Mass after Terce and the High Mass around midday, to say nothing of the private masses being celebrated by the ordained monks in small chapels. In eleventh-century Cluniac houses eight to twelve hours of the day were spent in corporate liturgy. This left little time for reading or contemplation while manual labor became ritualized; the monks proceeded to the garden, for example, and did a few minutes of weeding together.

Regarding organization, Cluny was a curious phenomenon. All the affiliated houses were effectively outgrowths of the great monastery at Cluny; monks from Spain to England professed obedience to the abbot of Cluny and consequently they each had rights at the mother house. In the words of C. H. Lawrence, it was something of a "ramshackle spiritual empire." Notwithstanding, Cluny represents a new landscape. Scores of Cluniac monks became bishops and prelates, most notably Pope Urban II

in 1088, and they brought their formation to bear on the whole church. The outcome was that monastic life under an organized rule was increasingly understood as the premier way of living as a Christian.[9]

SECOND WAVE: NEW MONKS

As the Cluniacs and the Gregorian Reform washed across eleventh-century Europe, another wave crested just behind it, sharing some of the initial wave's aims but diverging in other ways. We should be clear (and throughout this book) that as new reform movements appeared, not infrequently in the form of new religious orders, preceding religious orders did not vanish. It was not as if new monks appeared and old monks closed shop. At a much larger level that must be emphasized when we reach the reformations of the sixteenth century. To return, however, to the new and indeed overlapping wave of reform in the twelfth century, we should recognize again that the Cluniacs expended much of their energy on managing their houses and their extravagant liturgies. Even as a source of ethos (as opposed to law), the Rule taught balance and this most elementary of Benedictine values had been set aside. During the twelfth century, the image of the desert fathers striving in the wilderness grew increasingly attractive as an alternative to Cluny and other Benedictine houses. Clusters of hermits appeared in lonely mountain settings like the Tuscan hills at Camaldoli. In addition to dissatisfaction with the easiness of Cluny, this moment witnessed the nagging question of the *vita apostolica*, the apostolic life.[10] This will be a running thread in our study largely because of the concept's flexibility: the hallowed primitive life of the earliest Christians was an idea utilized for a variety of agendas. Acts 2 describes a community which shared property, but beyond this picture ascetical theologians and reformers could deploy the motif of apostolic purity for a host of new models of Christian life. In this fertile context, new forms of monasticism emerged in the twelfth century.

Cistercians

The formation of the Cistercians has traditionally been framed as a response to corruption. Scholars have recently questioned this narrative, recognizing the aura of hagiography. What seems beyond contest is that the early Cistercians deployed the rhetoric of renewal in the face of decay. In 1098, an abbey was founded at Citeaux, just north of Cluny, and these so-called white monks, much like the Cluniacs two hundred years before, started as a reformation, an attempt to recapture an original observance of the Benedictine Rule.[11] What was different, as argued by Rowan Williams, was the conception of the Rule itself as law. The founder of the Cistercians, Robert of Molseme (1028–1111) wrote about

the righteousness of the Rule, how the integrity of the Rule should be defended without failure. As a result of the "Gregorian Reform," the twelfth century was a time of increasing legal consciousness. In multiple arenas of life—canonical, monastic, liturgical, political—the church struggled to form itself as a quasi-state. A litigious mindset was the natural by-product.[12] The Cistercians looked to the Rule of St. Benedict as the legal norm for their life. It is for this reason that the Cistercians, more so than the Carthusians who were founded at the same time, could speak so powerfully to the culture of the twelfth century, an age hungry for clear definitions. The third abbot of Citeaux, Stephen Harding gave organizational shape to what had been just one more struggling group of hermits. Harding composed the order's constitution, the Charter of Charity, sometime before 1118. While the Rule of St. Benedict presumed autonomous communities and Cluny developed a seemingly feudal network marked by subjugation, the Cistercians made the near-revolutionary move of instituting a general chapter in which all Cistercian abbots gathered annually. By the middle of the twelfth century, close to eight hundred abbots would be present at general chapter. Instead of subjugation, houses had responsibilities for each other on an unprecedented international scale. Before this model of cooperation was adopted by the mendicants in the thirteenth century, the only phenomenon close to the scope of the Cistercian general chapter was an ecumenical council.[13]

It should not surprise us that the most important figure in Cistercian history, Bernard of Clairvaux (1090–1153), advocated both the careful observance of the Rule and the supreme authority of the papacy. At the age of twenty-two, in 1112, Bernard had become a monk of Citeaux and within three years he was given the task of founding a new house at Clairvaux in Champagne. This was the first of sixty-eight houses Bernard would found over the course of thirty-five years. By the time of his death in 1153, there were around 350 Cistercian communities and 164 of those looked to him for direction. Bernard's work and writings are characterized by the theme of conversion, the continual, lifelong turning to God. In 1145, within living memory of the founding of the order, the first Cistercian pope was elected, Eugene III. Naturally, he solicited Bernard to assist him in advocating for a new crusade. Though he agreed, Bernard took a new approach. Previous crusades were pitched as opportunities for indulgences (as well as worldly gains); going on crusade was a way to earn something, in this case, merit in heaven. Bernard reversed the equation: going on crusade was the grateful response of a Christian who knew his debt to God and wished to do something for God in return.

In Bernard's writing on the subject, the crusader is depicted as one engaged in a conversion to the God who first loved him in Christ. If we can bracket the bloody violence of crusade, we can see how Bernard wanted Christians to move toward God in love, to strive toward the restoration of the image of God marred but not destroyed by the primor-

dial fall. So central was the emphasis on conversion, a change of heart, that the Cistercians veered from previous monastic practice and only accepted adults as novices. Boys would not be taught letters in their houses and no one was accepted under the age of sixteen; in 1157, the age would be raised to nineteen.[14] Far from the scholastics of their own century and the next, the Cistercian project was oriented toward achieving a deeper experience of God who is love. And that requires conversion.[15]

This driving sensibility was clear in a sermon Bernard preached in Paris in 1140, "On Conversion." In the middle ages, "conversion" usually meant joining a religious order, surely a priority in this sermon, one that resulted in twenty men making their profession at Clairvaux. But it is equally clear that Bernard was not interested solely in recruits. He was seeking a genuine conversion of their hearts. Around the same time, Bernard wrote a piece, "On Loving God," for the pope's chancellor. His message was that the reason why one ought to love God is for God himself, not for any other gain, and that a true Christian life was lived in response to the love which God had first shown humanity in the sacrifice of Christ. Later that decade, in 1148, Pope Eugene III reached out to Bernard again for a new text on papal spirituality. Bernard used the opportunity to revise that classic patristic work on pastoral care and spirituality, Gregory the Great's *Book of the Pastoral Rule* (c. 590). His work, "On Consideration" does not simply discuss practical issues, but rather his focus is on the heart, the challenge of being involved in day-to-day tasks while being centered in God. One ought to know himself and the world around him, but ultimately, he should know God, the ultimate truth and ultimate love. In fact, a right understanding of self (as created in the image of God and in need of God) will lead one to a knowledge of God, a claim Bernard makes in many places. Bernard's hope was that the pope and his curia would keep their lives oriented to a contemplation of God even in the midst of worldly affairs.

Bernard's collection of sermons on Song of Songs was years in the making. In the middle ages, writing a commentary on this book was nearly a requirement to be a theologian, and Bernard followed a common pattern, assuming that Solomon wrote three books, each more complex than the last, outlining how the soul can grow in practical goodness and ultimately to a contemplation of God. Bernard's reading, expressed in sermons he preached from 1135 until his death in 1153, employs an allegorical understanding of Christ and the Church: the longing between bride and bridegroom. He describes contemplation as a kiss because the contemplative is allowed to participate in the Trinity whose chief characteristic is love. His desire for rigor and order did not lead Bernard to a dry intellectualism, but rather he joined affections with the intellect and, like his contemporaries William of St. Thierry and Richard of St. Victor, love is the dominant theme. The intimacy of bride and bridegroom, then, best captures the dynamic between the soul and Christ. A slave is moved

toward his master by fear, a worker is moved toward his employer for money, a student is moved toward his teacher for knowledge, and a son will move toward his father for respect. A lover, though, seeks a kiss. Bernard writes that when he reflects on the patriarchs and prophets longing for the Incarnation, he is ashamed of the lukewarm lethargy of his own day. Song of Songs, on this reading, is about the heart yearning for intimacy with God.[16]

Much of the writings of the English Cistercian Aelred of Rievaulx (1110–1167) was concerned with the kind of conversion Bernard described. Aelred, a contemporary of Bernard, was the son, grandson, and great-grandson of married priests, but the push for clerical celibacy reached England in his youth. To drive the point home, Pope Urban II banned the ordination of the sons of priests unless they entered religious life. Consequently, Aelred joined the new Cistercian order. Aelred's best-known work, "On Spiritual Friendship," should be placed in his pastoral context: he was abbot of the Cistercian monastery at Rievaulx and he wanted his novices to have a burning heart for God. Prior to writing "Spiritual Friendship," he wrote a text which is précis to it, "The Mirror of Charity." Here Aelred stresses the attitudes and inner motivations of monks, how they ought to navigate temptations, how their life is to reflect the unity of God (hence the title), and how a monk ought to be at one with God who is love. This conception of the monk's life, as a perpetual Sabbath, even while engaged in labor, highlights the Cistercian's apophatic sensibilities.[17] The terms cataphatic and apophatic are rather basic distinctions that divide two approaches to God: cataphatic spirituality employs images we know from this life as aids to know God whereas apophatic spirituality regards images as unhelpful, even as obstacles. Apophatic voices stress that God is beyond any image we can conjure in our minds or with stone, paint, or glass. Scripture has much to say here: the alienation that comes after the fall, the inability for humanity to rightly perceive the creator, Christ as the image of the invisible God. Apophatic sensibilities are most obvious in the churches built by Cistercians: proportional and harmonious floorplans, smooth, natural-colored stone perforated by clear glass, and walls barren of paint or sculpture. Decrying the architectural trends of his day, Bernard chastised Gothic ornamentation as superfluous, ridiculous, and even monstrous. Eyes should be fixed instead on a singular crucifix rather than wander about gorging on delights. Again, we find the conversion of the heart to one fixed point. As a result, Cistercian abbeys in places like Fontenay in France and Fountains in England were constructed with characteristic simplicity. According to tradition, the white monks even preferred to build their abbeys in rural locations, "lonely wooded places" in the words of Bernard himself, to be free of distraction.[18]

Canons Regular

If the Cistercians represent a very organized form of renewal, then on the other end of the spectrum was a more diffuse movement, the canons regular. Their story brings us back to the convictions of the Gregorian Reform, linking papal and monastic programs for reform and spirituality. The reigning assumption was that the earliest apostles lived a communal life, relinquishing private property, and forgoing marriage. In other words, the star spiritual athletes of the early church—monks—were also the paradigmatic clerical leaders of the early church. Eleventh-century reformers reasoned that priests ought to be celibate and live in community according to a rule. The western church thus experienced a major push to separate clergy—pastors of secular, non-monastic communities— from the entanglements of the world. The effect was to make secular priests live like monks and across Europe we find houses of clergy forming, sometimes voluntarily but sometimes after pressure. Urban II (r. 1088–1099), for example, praised a group of Bavarian canons who lived together like monks for their "life so deserving of the approval of the holy fathers and practices of apostolic rule."[19]

The newly discovered Rule of St. Augustine often provided these canons an outline for life together. After his conversion in 385, the early church Father Augustine lived in a monastic community, and after he became bishop, he continued to live according to a monastic rhythm, even forming his household into a community. When his sister entered religious life, the bishop wrote a letter of counsel to her; it was more or less a treatise on monasticism. His comments on the importance of liturgical prayer, reading, silence, and poverty were discovered at the close of the eleventh century, reworked and adapted for a male audience, and instituted as a monastic rule for communities of priests. For Christians of Western Europe, hungry for apostolic primitivism and monastic life, the appearance of this rule connected with one of the greatest Fathers must have seemed like a gift from heaven itself. In addition to this primitive glow, its strength was in its flexibility. Each house which adopted it had the liberty to draw up their own schedule for offices and daily life. Most of them were similar to Benedictine abbeys, although many used the shortened offices of secular priests. The very term "canons regular" in fact is somewhat generic: these are priests living in community (canons), and they were living according to a rule (regular). They were far from an order, but their adaptability proved a strength. Houses of canons regular emerged quickly in England and by the end of the twelfth century rivaled the Benedictines at least in the number of communities. One clear factor was ease of patronage: these houses were typically smaller and had less financial need and as such the lower nobility could become patrons comparatively cheaply.[20]

In 1110, the Paris scholar William of Champeaux retreated from academic life and formed a house of canons regular just outside the city. The Abbey of St. Victor would draw largely from students from the nearby university, resulting in a community of men with high scholarly ability who were contemplatives nonetheless, figures like Hugh of St. Victor (c. 1096–1141) and Richard of St. Victor (d. 1173). Because of their asceticism, more rigorous than most houses of canons regular, the Victorines developed a good relationship with the Cistercians; Bernard himself used this abbey for retreat. Hugh had shaped the distinctive Victorine fusion of biblical study, theological investigation, and contemplation, but it was Richard in the next generation who offered a truly disciplined, systematic approach to contemplation, becoming something of a master for later medieval mystics. He stands out in the reading of most of the mystics discussed in our next chapter. Richard's work, for example, *The Twelve Patriarchs* and *The Mystical Ark*, stressed an intellectual approach to contemplation, distinguishing himself from the affective approach of the Carthusians (described below). This distinction, in rather simplified terms, will likewise separate Dominicans and Franciscans.[21]

While the canons regular were a diffuse movement of individual houses like the Abbey of St. Victor, the Premonstratensians (also known as Norbertines) emerged from the canons regular as a recognizable order and well represent the transformation of secular clergy into monks. Their founder, Norbert of Xanten (c. 1080–1134) relinquished a cathedral canonry to wander as an iterant preacher in search of the apostolic life. Finding clergy living with concubines and neglecting holiness of life, the solution in his mind was community life under a rule. In 1119, at the Council of Rheims, Pope Calixtus II (r. 119–1124) asked Norbert to found a community and he chose a forest site near Laon, near a chapel called Prémontré. With his new community which curiously included clergy, laymen, and women, he vowed a life "according to the Gospels and sayings of the Apostles and the plan of St. Augustine." The "white canons," so called for their habit of bleached wool, linked together scripture, apostolic primitivism, and the Rule of St. Augustine. Norbert did not remain in the community but became archbishop of Magdeburg in 1126 and founded other houses along the model at Prémontré. At first, the Norbertines were separate houses, all similar in being canons regular and acknowledging Norbert as their founder. After Norbert's death, the abbot of the original community gathered all the superiors to form a general chapter, compose institutes, and seek papal approval.

What makes the Premonstratensians a triumph for monasticism over the usual life of secular clergy is not simply forgoing marriage and private homes. Rather it was their spirituality. The primary objective of the Premonstratensians was the sanctification of their own members rather than an outward focus on evangelism. This is the staggering difference between the movements of this second wave in the twelfth century and

the third wave, the friars who appeared in the thirteenth century. In the twelfth century, the dominant thinking (classically expressed by Bernard) was that the most authentic path of Christian holiness was the cloister. And with the emergence of the Premonstratensians, we see, at least at a symbolic level, monastic life absorbing even the secular priesthood, refashioning its daily life and spiritual orientation.[22]

Carthusians

While the Cistercians claimed a litigious commitment to the Benedictine Rule, and the canons regular pushed monastic life into the secular sphere, another movement in this twelfth-century wave addressed the appeal of the desert. In 1080, the master of the cathedral school of Rheims, Bruno of Cologne abandoned academic life to join a community of hermits. They later relocated to a secluded site in the Alps near Grenoble in 1084, coming to be known as the Grand Charterhouse (Grande Chartreuse). The Carthusians brought the paradigm of the desert into monastic communities, and by the 1120s other communities of hermits began to look to the Carthusians as a model for imitation. By the middle of the century many of these clusters banded together to form a general chapter under the leadership of the prior of the Grand Charterhouse. Each community then came to be known as a charterhouse.

The Carthusian way of life would differ greatly not only from Cluny and traditional Benedictine practice, but from the other new orders as well. They certainly were a community, but the focus of life was solitude: the genius of the Carthusians was finding a way to live as a solitary, silent hermit within a community with the all-encompassing goal of private meditation. Unlike other communities, the Carthusians adopted the unusual pattern of private cells. Most monasteries, Cluniac, Cistercian, or otherwise, had large dormitory rooms. Not only did each Carthusian have his own room, he also had his own garden plot and lavatory off his cell. On weekdays, the monks only gathered together for vespers in the evening and compline before sleep; the other offices prayed alone in their cells. Meals were eaten in solitude, each cell having a hatch through which food could be delivered. On Sundays, the community gathered for Mass, chapter, a common meal, and a period of conversation. The great bulk of life, inspired by the desert fathers, was spent in private, silent prayer.[23] This isolation is not so much a flight from the world as a deepening clarity of what is truly lovely. From a Carthusian perspective, it is only when one fixes his eyes on God, the only real source of joy, that he is able to have a true sense of God, relationships, and the world. The way one does that according to the Carthusians is by staying fixed in a stable place and developing a longing for heaven whose life is the opposite of worldly living. This is far from the balance found in the Benedictine Rule.

Instead, the whole Carthusian enterprise is a reformation of the affections, developing a heart for God alone.

A good example of the affective character of Carthusian spirituality is found in *The Road to Zion*, a text by Hugh of Balma (d. 1439), the prior of a Charterhouse near Geneva. In the 1450s, this piece was invoked in a controversy involving Nicholas of Cusa (a reformist cardinal and himself the author of mystical texts) to determine if one could reach God through sheer love. Hugh had stressed that the intellect cannot penetrate the highest understanding, an unmediated encounter with God. While Hugh certainly did not isolate love from knowledge, the focus is on the daily aspirations of the heart for the presence of God.[24] This Carthusian yearning for God is likewise found in an earlier work, *The Life of Christ* by Ludolf of Saxony (c. 1295–1378). The text is a series of meditations on various scenes in the life of Jesus from his birth to the Ascension, and in each one the reader is to visualize the details, pray, reflect on the moment, and even insert himself imaginatively.[25] *The Life of Christ* captivated Ignatius of Loyola later in the sixteenth century and he adapted its method of imagining visual scenes for his own *Spiritual Exercises*.

THIRD WAVE: MENDICANT SPIRITUALITY

The Fourth Lateran Council (1215) was in many respects the long-term triumph of the reform movements which began at the turn of the millennium. The initial wave of Cluniacs c. 1000 was followed by yet another wave composed of the Cistercians, the Canons Regular, and the Carthusians. However, at the opening of the thirteenth century, a third wave was emerging on the horizon and this new reform movement rode the energy of Lateran IV. What made this next wave different from the monastic reform phenomena we have traced to this point was a rethinking of the place and focus of the monastic vocation. The obvious mark of monastic reforms in the eleventh and twelfth centuries had been a primitivism aimed at fostering the apostolic life and holiness within the cloister. However, members of this third wave will turn out into the world rather than retreat from it. While the mendicants (a word which means beggar) shared with the Cistercians, Canons Regular, and Carthusians a commitment to apostolic primitivism, their movement into the world was a major course change, one for which they received criticism. It is important to keep in mind that the twelfth-century orders felt that the only way to draw closer to God was to retreat from the world. The mendicants of the thirteenth century challenged that baseline presupposition.

The mendicants' common focus on poverty was only a starting place, and even that did not remain consistent; what exactly constituted poverty was defined and redefined in different ways. In the years on either side of Lateran IV, different voices began to reassess the element of poverty in

the New Testament and how Christ and the original apostles were essentially wandering homeless preachers, living by the benevolence of others. The mendicants insisted that their calling, consistent with that pattern, was to own nothing, to be free of material possessions, and to be committed singularly to their ministry of apostolic witness.[26] From there, however, each of the mendicant orders branched out to have their own charism and peculiar strength.

Two important caveats need to be made before looking at different mendicant groups. First, again consistent with the wave model, other monastic orders persisted alongside the mendicants. At Lateran IV, Pope Innocent III praised the Cistercians as the paradigm for monastic orders while approving the new mendicants. But even with the formation of these mendicant groups at the start of the thirteenth century, there was a wariness about them. Canon 13 of Lateran IV clamped down on the formation of new religious orders. There is an ongoing debate about how new religious movements in the thirteenth century addressed that obstacle, whether they successfully became formal orders, were marginalized by church authorities, or engaged with existing orders possibly folding into them. This is especially the case when we think of women's religious movements in the twelfth and thirteenth centuries. In the early 1220s, for example, a group of women were forming themselves into a new Cistercian nunnery just outside Reims and one moderately wealthy widow provided an endowment for the convent on her daughter's entry to the community. However, the widow hedged her bets: she stipulated that if the convent closed, her daughter and the endowment should go to another religious community. This fear about the viability of a new convent highlights the uneven and potentially risky process of protean and unregulated groups integrating into an existing religious order.[27] All of that was happening alongside the rise of the mendicants.

The second caveat is that there were many different mendicant orders, some persisting to this day, some fading away, some splintering into multiple orders. Geoffrey Chaucer, in his fourteenth-century *Canterbury Tales*, mentions "the Orders Four" referring to the Dominicans, the Franciscans, the Carmelites, and the Augustinians. Although initially founded for men, each of these also developed parallel opportunities for women, known as "second orders." Likewise, there were ways for lay-people to associate with each mendicant order as "third order" members. While there were many kinds of mendicants, these four were the best known of them, and our discussion will take Chaucer's list as a helpful focus.

Dominicans

By the close of the twelfth century, the hunger for apostolic primitivism had led not only to the rise of the Cistercians, but also more suspicious movements. The best example is the so-called Poor Men of Lyon,

also known as Waldensians after their leader, Peter Waldo (c. 1140–c. 1205). Luke 10 describes Jesus sending out his followers without provision but trusting in the providential care of God, and the Waldensians hoped to do just that. The Cathars (also known as the Albigensians) who emerged in the south of France shared that commitment to simplicity, but unlike the Waldensians, the Cathars taught a heretical dualism reminiscent of early Gnosticism; this raised serious concerns. The bishop of Osma in Spain, Diego (1170–1207) recognized the need for clear preaching to help those who heard the Cathar message, but Diego also understood the strength that these heretics drew from their primitivism. The bishop therefore set out preaching in the same manner as his opponents, as a beggar. And when Bishop Diego died during the venture, his assistant, Dominic Guzman (1170–1221) took up the cause. Dominic attended the Fourth Lateran Council in 1215, a gathering which among so much else made the call for more and better-trained preachers, and the following year Pope Honorius III approved Dominic's new Order of Preachers, and they adopted the Rule of St. Augustine.

Preaching as a service for others was the overarching concern for this order, later more commonly known as Dominicans. In fact, the fifth master of the order, Humbert of Romans, wrote in the thirteenth century that preaching takes precedence over every spiritual activity, decrying other monks who made themselves "silly through excess of devotion." This does not reflect an aversion to ascetical theology but rather the Dominican understanding of preaching as a form of devotion as well as their imitation of Christ the preacher. The Dominicans believed that preaching sprang from love, and that even when a Dominican was at rest, he should be preparing his next preaching expedition.[28] There is no way to separate out a particular Dominican spirituality apart from preaching. Of course, even the early Dominicans had rich prayer lives, but their prayers were mainly simple petitions. Their own spiritual progress was never an end in itself, but rather a means to become better preachers, that apostolic calling to be of service to others. Likewise, Dominican houses were different from the abbeys of previous orders. When taking vows, they essentially promised obedience to the superior and a life of poverty. Little more was formally constitutive of Dominican life. Nothing was to get in the way of preaching and sermon preparation and, as a result, study became tremendously important. As the Dominican Hugh of St. Cher said, "First the bow is bent in study, then the arrow is released in preaching." There are moments in their history, however, in which even Dominican leadership felt this willingness to forgo all for the sake of preaching had gone too far. In some houses, eating together became rare, and we find priors requiring their friars to gather for a meal at least on major feast days, roughly fifteen times a year. The same was true of the daily offices. The Dominicans were encouraged to say the office together, but not if they had to be on their way to preach or needed to prepare.[29]

The Cistercians were shocked by this apparent betrayal of the core of monasticism, a life of stability in a cloister with an unswerving devotion to a rule. As noted, the Dominicans were not interested primarily in their own spiritual growth, a key issue for the Cistercians. Interestingly enough, however, we can draw a connection between the white monks and the new preachers: both were concerned with sincere conversion. For the Cistercians, the way to conversion was a recognition of God's love and then to respond with a life reflecting God's love (hence Aelred's *Mirror of Charity*). And, for Cistercians, the premier way to engage that reflection was the punctilious observance of a rule in a fixed community. The Dominicans, however, began to see monastic rules as potential obstacles, as strictures which could divert one from the real goal of conversion. A comparison with yet another order will be helpful. The Franciscans shared the Dominicans' commitment to apostolic poverty, but for the Friars Minor everything turned on *imitating* the apostolic life as a program for one's own spirituality: preaching is one element within the act of imitation. For the Dominicans, it was the other way around: they began preaching because preaching was needed; it just happened to be part of the apostolic life. Both orders grounded themselves in the vision captured in Luke 10 but in critically different ways: the Franciscans emphasized the life and the Dominicans emphasized the job itself. Later in the middle ages, we find Franciscans anxiously debating whether their friars may wear shoes. Such a deliberation was foreign to the Dominican approach.[30]

Within a generation of their founding, Dominicans were being commissioned as papal inquisitors; their mission was to save souls and correct those who wandered from the faith. And this apostolic and corrective service was done at the command of the pope. Certainly, we can find members of other orders as well as secular clergy engaged in inquisition, but the work of the inquisitor was the natural outworking of Dominic's vision; this was their vocation. The famous fourteenth-century Dominican inquisitor Bernardo Gui was effectively honoring Dominic's legacy. The Dominicans' place within high medieval reform movements which consistently intertwined the papacy and monasticism thus becomes clear: the Gregorian Reform drew a line between clergy and lay, "monasticizing" the Christian world and privileging the celibate and the uniform; and then following Lateran IV, the papacy deployed Dominican inquisitors to discipline all Christians of the border-less universal church (so imagined) as obedient members of a universal abbey.[31]

The Dominican account of the Christian life is deeply intellectual; for the Order of Preachers, one unites with God through the intellect. Any contemplative ascent to God is basically an act of the mind, although love and the affections are certainly involved and should not, from a Dominican perspective, be understood as being in conflict with the mind.[32] When one considers the medieval Dominicans, or medieval theology in

general, the name Thomas Aquinas immediately emerges. Arguably the greatest systematic theologian of the period, Aquinas also had distinct ascetical sensibilities. Standing behind Thomas, however, was his teacher at Paris, Albert the Great (c. 1200–1280), a Dominican deeply influenced by the writing of the late patristic author, Pseudo-Dionysius. This shadowy figure from the fifth century described celestial hierarchies and taught that God is incomprehensible, shrouded in mystery. Consequently, Albert wrote that God is seen precisely in our ignorance of him. This "negative theology" exposes the false idols of human imagination, shabby and insufficient images of God. The true God nevertheless makes his characteristics known in various ways, as truth for example. Thomas Aquinas (1225–1274), also a master at Paris, agreed with Albert that God makes his attributes known to us, but he veered from his teacher on what it will be like to see God in heaven. For Albert, the vision of God is like a limitless ocean. Thomas argued that the climax of the Christian life will be something much more intelligible, though known only in part during the earthly pilgrimage.

The medieval Dominicans, for the most part, had a speculative approach to Christian spirituality, a posture that privileges intellectual questions and answers. This ought to be set in the context of the revival of the empirical thought of Aristotle among both Christians and Muslims in the thirteenth century. In his *Summa Theologica* (1265–1274), Thomas argued that Christians ought not to privilege supposedly higher forms of prayer, but that simple petitions are best. When one makes even short petitions, she is relying on God. Prayer, Thomas writes, should be brief and frequent. If the mind wanders, one should stop rather than kneeling for long periods. Aquinas also writes that while God can lift people into supernatural states, there are really only two instances of true rapture: Moses and Paul. This brings us to a medieval debate: what is the purpose of prayer if God is all-sovereign? Thomas argued that human initiatives, including prayer, do bring about real effects. This is not an interference with God's plan. Rather, God has granted free will to humanity so that we might be, in Thomas' language, "secondary causes" for God's work. In prayer, we do not change God's mind or exploit him, but rather participate in work that God himself caused in the first place. And petitions are themselves an act of worship: petitionary prayer acknowledges God's dominion. The Christian should aim for love, not visions or ecstasies. Aquinas claimed that love, worked out in everyday situations, marks the presence of God in one's life. In discussing contemplation, we see Aquinas in a characteristically Dominican vein: contemplation, he writes, is an intellectual pursuit which obligates one to share the results with others through preaching and teaching.[33]

Franciscans

Like the Dominicans, the Order of Friars Minor (Little Brothers) or Franciscans emerged at the beginning of the thirteenth century riding the energy of Lateran IV as well as speaking to that persistent hunger for apostolic primitivism. As discussed above, both Dominicans and Franciscans were inspired by Christ sending out his followers to share the good news, trusting in divine providence to supply their needs. Although Francis of Assisi (1181–1226) was a contemporary of Dominic, there is a clear difference between the way these two founders related to their orders. It cannot be overemphasized how paradigmatic Francis became for the Franciscans. This was not necessarily true of the Dominicans and Dominic. For the Franciscans, though, they imitated and tried to capture something of the spiritual experience of Francis himself. The fourteenth-century collection of stories about St. Francis and his followers called *The Little Flowers of St. Francis* directly compares Francis and his followers with Christ and the Apostles.[34]

The story of a well-born Italian, Francesco di Bernardone, hearing a sermon on Matthew 10, the parallel to Luke 10, is well known. He sensed that God was leading him to spend time among lepers and to tend to their needs. Francis wrote that among these poorest and most outcast of human beings, he felt his heart open to God. He believed that the Holy Spirit had brought him to see the despised and mortified flesh of Jesus Christ in these people, the *minores* of society. As a result, works of mercy, living among the poor, and finding God in the middle of such experiences became characteristic of Franciscan spirituality. Moreover, Francis understood all of creation as sharing in brotherhood, thus his famous "Canticle of Creation" and the Franciscan orientation toward the world, not away from it. At the close of the thirteenth century, the lay Franciscan penitent Angela of Foligno (1248–1309) recounted her mystical experiences of being at peace with the Trinity and all of creation. In a similar vein and around the same time, an anonymous Franciscan author composed a dialogue between Francis and "Lady Poverty." When the Lady asks Francis and his brothers to see their enclosure, they take her to a hill and show her the whole created world.[35]

In 1209, Francis presented himself and a small group of loyal followers to Pope Innocent III. According to tradition, Innocent verbally approved both Francis's "proposal for life" and their request to become a new order. Years later, Francis recounted how this way of life had been revealed to him by God and how it was patterned on the Gospel texts, not a *vita apostolica*, but a *vita evangelica*. Six years after this endorsement, Lateran IV banned new religious orders and required the Franciscans either to complete a new rule or accept an existing rule. In 1221 this task was still unfinished, and an enormous gathering of Franciscans was held to settle the matter. A new pope, Honorius III (r. 1216–1227) appointed a

cardinal as their protector, Hugolino, and along with other brothers he tried to persuade Francis to accept an existing rule (e.g. Benedict's Rule, Augustine's Rule, or the Cistercian's Charter of Charity). Francis refused, declaring that God "wanted me to be a new fool in the world." Within the year a rule was finally composed and, after some shortening, it was approved by Honorius through a papal bull in 1223. Consonant with Francis's "proposal of life," the Franciscan Rule is focused on living in evangelical poverty in the world; leaders within the order are known by the title minister, meaning servant. Hugolino, later Pope Gregory IX (r. 1227–1241), was instrumental in developing a similar rule for the sisters of the Second Order Franciscans, the Poor Clares. In addition to canonizing Francis not long after his death in 1226, Gregory settled a question left awkwardly open, though his decision was later disputed. The pope interpreted the OFM Rule to mean that while the Franciscans could not own anything themselves, buildings, for example, they could use them if given by donors. Franciscans would venture out on missions to serve and then return to such bases constructed by benefactors.[36]

The year 1224 marked the most dramatic moment in Francis' life. He felt called to leave the leadership of the order to another and retreat into seclusion on Mount La Verna in Tuscany. There, deep in prayer, he had a vision of a six-winded seraph, the highest of the nine orders of angels, and according to tradition he received the stigmata, the five wounds of Christ, imprinted on his very body. See figure 3.1. In death, he lived up to his other nickname, *il poverello* (the poor one): as he was dying, Francis gave away everything, even his bedclothes, and then asked to be laid naked on the bare earth.[37] Unlike the Dominicans, Francis and the medieval Friars Minor were deeply committed to an affective form of piety. A classic example is Francis' development of the first Christmas nativity scene in 1223 in a cave north of Rome. He did this specifically so that people could see the weak and vulnerable humanity of Jesus, the Word made flesh. To borrow from his close associate and disciple Clare of Assisi (1193–1253), "this was the Lord who was poor in the crib . . . poor as he lived in the world . . . and who was naked on the cross."[38]

Among later Franciscans, Bonaventure (1221–1274), a contemporary of Thomas Aquinas, stands out. In his *Journey of the Mind into God* (1259) and his *Major Life of St. Francis* (1260) this Minister General of the Franciscans and later cardinal described the goal of the Christian life as a contemplative intimacy with the crucified Christ. In a similar way, his *Tree of Life* (mid-1260s) offers a program for growth through prayerful participation in Christ's suffering. This text inspired a monumental painting of the tree itself in a Franciscan house in Florence in the fourteenth century and its symbolism reinforces the Franciscan call to serve the urban poor.[39] Franciscans like Ubertino of Casale (1259–1329) would argue that every Christian must live in poverty. Part of a movement within the Franciscans known as the Spirituals, Ubertino rejected the moderating interpre-

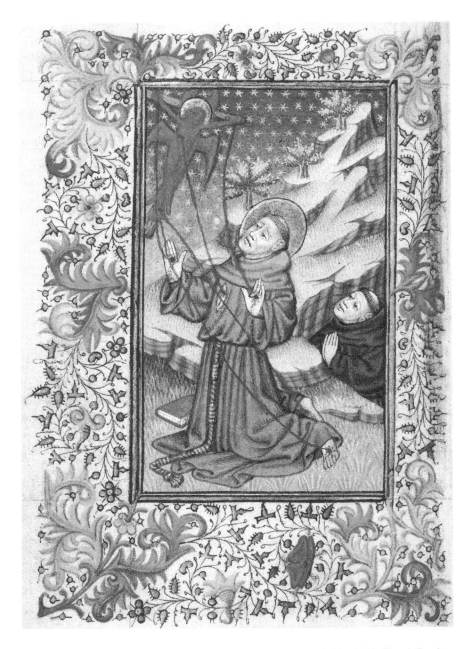

Figure 3.1. Master of Sir John Fastolf, Saint Francis, c. 1430–1440. The J. Paul Getty Museum, Los Angeles, CA. Digital image courtesy of the Getty's Open Content Program. http://www.getty.edu/art/collection/objects/2733/master-of-sir-john-fastolf-saint-francis-french-or-english-about-1430-1440/.

tations of Francis' legacy, for example, Pope Gregory IX's clarifications back in the 1230s about using donated property. Poverty, the Spirituals insisted, ought to be absolute. Ubertino's *The Tree of the Crucified Life of Jesus* (1305) even describes such moderation as a sign of the apocalypse. While this teaching about absolute poverty was condemned by the papacy, the combination of seeing poverty as the summit of the Christian life and the casting of Francis himself as a kind of second Christ led to a fifteenth-century division of the Franciscans into the Conventuals and the Observants, the latter being the heirs of the rigorous Spirituals. The division was officially recognized in 1517 by Leo X. Then, in 1525, from among the Observants emerged a third form, the Capuchins who wanted to live as poor hermits. By the sixteenth century, Francis' Little Brothers had splintered into three different groups.[40]

Carmelites

At the start of the twelfth century, the Carmelites were simply hermits in Palestine. We have neither a founding date nor a founder for this order and this hole in their narrative filled them with some angst. Later Carmelites felt compelled to create stores about Elijah himself founding them on Mount Carmel, for example, the fabricated "Institution of the First Monks." These hermits, however, won some organization when Albert, patriarch of Jerusalem provided them with a rule in 1214. The Carmelites spent their life almost completely in prayer, often in silence, and early on they had no public ministry, no wandering to preach like the Dominicans or service among the poor like the Franciscans. Within a generation, however, the Holy Land was falling back to Muslim control, and the Carmelites migrated to Europe. On arrival, they began to adopt the patterns of the mendicants, engaging in teaching, caring for the poor, and living in community. In 1247, Pope Innocent IV approved a revision of the Rule of St. Albert which made this metamorphosis official.[41]

The signature characteristic of their spirituality is their deep devotion to Mary. In fact, their commitment to the Virgin exceeds even late medieval standards. The English Carmelite Simon Stock (possibly himself a legend) had a vision of Mary in the mid-thirteenth century, and she gave him their distinctive brown scapular (a tunic), telling him that the one who dies in this habit will be saved. The scapular was combined with a white cloak for which they became known as White Friars. The present treatment of the medieval Carmelites is brief primarily because the ascetical stars of this order, Teresa of Avila and John of the Cross, appeared in the sixteenth century; they will receive much attention later. What is notable about the medieval Carmelites after 1247 is the unresolved tension between being a hermit in solitude and being a mendicant in the world. In 1270, their prior general Nicholas the Frenchman wrote a circular letter "The Flaming Arrow" in which he plead for a return to the

hermetic life, claiming that the advocates for the new mendicant way among the Carmelites were illegitimate sons. But even a burst of reform in the fifteenth century could not draw them back to solitude. Medieval Carmelite spirituality is thus a strained combination of the priorities of Lateran IV and the call of the desert.[42]

Augustinian Friars

Care must be taken to distinguish the thirteenth-century Augustinian Friars, also known as Augustinian Hermits or Austin Friars, from the earlier Canons Regular who are sometimes known as Augustinian Canons or Austin Canons. While they both used the Rule of St. Augustine, these are two distinct groups. As noted, in the wake of Lateran IV monastic groups were under pressure to choose an existing rule. In Italy clusters of hermits were using Augustine's Rule and at a general meeting in Rome in 1256 these communities banded together into the Great Union which formed the Order of Augustinian Hermits. They spread quickly to Germany, England, France, and Spain. Within forty years, the Augustinian Friars had eighty houses in Germany alone. While these Friars certainly lived a common life and were committed to the ideal of poverty, two elements distinguish them: their teaching ministry and the influence of Augustine himself.

The Augustinian Friars rivaled the Dominicans in theological reflection; they formed educational centers for their members known as *studia generalia*. However, the Augustinian Friars were far less speculative than the Black Friars. The will, for example, drives a person, not the intellect. And the will is naturally corrupted by original sin. Here is where Augustine's own theology is important. The Augustinian Friars looked to St. Augustine himself for more than his rule; they were shaped by his theological vision of human beings deeply wounded by original sin and healed by God's grace. When a person is good, God is effectively at work on that person. Love does not emerge from us but is rather the fruit born of God's pouring his grace into us. The human person, wounded by the fall, is not even able to recognize the good without this grace; this mental handicap is known as the noetic effect of sin. Moreover, even with God's grace in this life, there is a struggle with sin. In the sixteenth century, the Augustinian Friar Thomas of Villanova argued that humanity's hope is in God alone "who gives life to our dead works . . . our righteousness is to be despised and the righteousness of God to be magnified." Readers familiar with Luther's theology will find this familiar as Luther himself was an Augustinian Friar. From an ascetical perspective, the Augustinian Friars taught a deep dependence on God. Once one receives God's love (a passive posture), one directs that love back to God and to neighbor. From there one can grow in the virtues. The Augustinian Friars had a practical spirituality, a way of life which finds the transforming presence of God

breaking into the most everyday of routines. This grace begins with God and extends to humanity, rather than humanity building a ladder up to God, a futile attempt that would actually end back with humanity and false idols.[43]

WAVES

The eleventh-century Gregorian Reform, aided by the rise of the Cluniacs, was marked by a sense of return, a retrieval of apostolic faith and practice. Succeeding generations shared these sensibilities and wave after wave of monastic movements built toward Lateran IV in which the dream of those monk-reformers was triumphant. That vision, whose twelfth-century standard-bearers were the Cistercians, Carthusians, and the Canons Regular, addressed the nagging question of the shape of the *vita apostolica*. But a third wave, the mendicants, followed Lateran IV and offered still different answers to roughly the same questions. Each of these waves, from the Cluniacs to the mendicants, had to translate their primitivism into practice; their reformations were in continuous conversation with patterns of spirituality. Finally, a cautionary word bears repeating as a coda to this chapter: the religious orders and their reform movements—their ways of living, their commitments, their vision—did not disappear when new reform movements emerged later, not even during the reform movements of the sixteenth century. As we will see in chapter 10, for example, the Franciscans were just as important in Roman Catholic missionary work in the sixteenth and seventeenth centuries as were the Jesuits, a religious society formed in the 1530s.

NOTES

1. Ephraim Emerton, *The Correspondence of Pope Gregory VII* (New York: Norton, 1969), 88; Colin Morris, *The Papal Monarchy: The Western Church from 1050–1250* (Oxford: Oxford University Press, 1991); I. S. Robinson, *The Papal Reforms of the Eleventh Century* (Manchester: Manchester University Press, 2004); I. S. Robinson, *The Papacy 1073–1198* (Cambridge: Cambridge University Press, 1990); H. E. J. Cowdrey, *Gregory VII, 1073–1085* (Oxford: Oxford University Press, 1998); Idem, *The Cluniacs and the Gregorian Reform* (Oxford: Clarendon, 1970).

2. Joseph Lynch, *The Medieval Church* (New York: Longman, 1992), 136–50; Geoffrey Barraclough, *The Medieval Papacy* (New York: Harcourt, Brace, and World, 1968), 63–117.

3. Kathleen Cushing, *Papacy and Law in the Gregorian Revolution* (Oxford: Oxford University Press, 1998); Kriston Rennie, *Law and Practice in the Age of Reform* (Turnhout: Brepols, 2010); James Brundage, *Medieval Canon Law* (New York: Longman, 1995).

4. Uta-Renate Blumenthal, *The Investiture Controversy: Church and Monarchy from the Ninth to the Eleventh Century* (Philadelphia: University of Pennsylvania Press, 1988); Maureen Miller, *Power and the Holy in the Age of the Investiture Conflict* (New York: Palgrave Macmillan, 2005).

5. Kathleen Cushing, *Reform and the Papacy in the Eleventh Century: Spirituality and Social Change* (Manchester: Manchester University Press, 2005), 55–90; Mary Stroll, *Popes and Antipopes: The Politics of Eleventh Century Church Reform* (Leiden: Brill, 2009).

6. Ann Barstow, *Married Priests and the Reforming Papacy: The Eleventh Century Debates* (New York: Edwin Mellen, 1982); Megan McLaughlin, *Sex, Gender, and Episcopal Authority in an Age of Reform, 1000–1122* (Cambridge: Cambridge University Press, 2010); Henrietta Leyser, "Clerical Purity and the re-ordered world," in Miri Rubin and Walter Simons, eds., *The Cambridge History of Christianity: Volume 4 Christianity in the West, 1100–1500* (Cambridge: Cambridge University Press, 2009), 11–21; Louis Hamilton, *A Sacred City: Consecrating Churches and Reforming Society in Eleventh Century Italy* (Manchester: Manchester University Press, 2010).

7. H. E. J. Cowdrey, *Lanfranc: Scholar, Monk, Archbishop* (Oxford: Oxford University Press, 2003), 38–45; Robert Somerville, *Pope Urban II's Council of Piacenza* (Oxford: Oxford University Press, 2011). For a more nuanced interpretation, see Richard Pfaff, "Lanfranc's supposed purge of the Anglo-Saxon Calendar," in *Warriors and Churchmen in the High Middle Ages*, ed. Timothy Reuter (London: Hambledon, 1992), 95–108.

8. David Knowles, *The Monastic Order in England: A History of its Development from the Times of St. Dunstan to the Fourth Lateran Council, 940–1216* (Cambridge: Cambridge University Press, 2004); Cowdrey, *Cluniacs and the Gregorian Reform*, xiii–xxvii; Noreen Hunt, *Cluniac Monasticism in the Central Middle Ages* (London: Macmillan, 1971).

9. C. H. Lawrence, *Medieval Monasticism: Forms of religious life in Western Europe in the Middle Ages* 4th edition (London: Routledge, 2015), 76–132. See also Steven Vanderputten, *Monastic Reform as Process: Realities and Representations in Medieval Flanders, 900–1100* (Ithaca: Cornell University Press, 2013).

10. Henrietta Leyser, *Hermits and the New Monasticism: A Study of Religious Communities in Western Europe, 1000–1150* (New York, 1984), 1–37; John Van Engen, "The 'Crisis of Cenobitism' Reconsidered: Benedictine Monasticism in the Years 1050–1150" *Speculum* 61 (1986), 269–304.

11. Emilia Jamroziak, *The Cistercan Order in Medieval Europe* (New York: Routledge, 2013), 13–36; Janet Burton and Julie Kerr, *The Cistercians in the Middle Ages* (Woodbridge, Suffolk, UK: Boydell, 2011), 1–20; Constance Berman, *The Cistercian Evolution: The Invention of a Religious Order in Twelfth-Century Europe* (Philadelphia: University of Pennsylvania Press, 2000), Louis Lekai, *The Cistercians: Ideals and Reality* (Kent, OH: Kent State University Press, 1977), 1–32; Pauline Matarasso, *The Cistercian World: Monastic Writings of the Twelfth Century* (London: Penguin, 1993).

12. Rowan Williams, "Three Styles of Monastic Reform," in *The Influence of St. Bernard*, ed. Benedicta Ward (Oxford: Sisters of the Love of God, 1976), 24–40.

13. Lawrence, *Medieval Monasticism*, 169–75.

14. Martha Newman, *The Boundaries of Charity: Cistercian Culture and Ecclesiastical Reform, 1098–1180* (Stanford: Stanford University Press, 1996), 21–29.

15. Jean Leclerq, *The Love of Learning and the Desire for God* (New York: Fordham University Press, 1961); Bernard McGinn, "The Spiritual Teachings of the Early Cistericians" in Brunn, ed., *The Cambridge Companion to the Cistercian Order*, 218–32; Bernard McGinn, *The Growth of Mysticism* (New York: Crossroad, 1996), 149–224.

16. G. R. Evans, ed., *Bernard of Clairvaux: Selected Works* (Mahwah, NJ: Paulist, 1987), 63–99, 145–206.

17. Marsha Dutton, ed., *Aelred of Rievaulx, Spiritual Friendship* (Collegeville, MN: Cistercian Publications, 2010); Elizabeth Freeman, *Narratives of a New Order: Cistercian Historical Writing in England, 1150–1220* (Turnhout, Belgium: Brepols, 2002), 31–53.

18. Thomas Coomans, "Cistercian architecture or architecture of the Cistercians?" in *The Cambridge Companion to the Cistercian Order*, ed. Mette Bruun (Cambridge: Cambridge University Press, 2013), 151–69; Diane Reilly, "Art" in ibid., 125–39; Burton and Kerr, 56–81; Jamroziak, 56–178; Maximilian Sternberg, *Cistercian Architecture and Medieval Society* (Leiden: Brill, 2013); Geoffrey Harpham, *On the Grotesque: Strategies of Contradiction in Art and Literature* (Princeton: Princeton University Press, 2006), 39.

19. Patrologia Latina 151:338B, Urban II, Epistle 58.

20. Lawrence, *Medieval Monasticism*, 148–53; J. C. Dickinson, *The Origins of the Austin Canons and their Introduction into England* (London: SPCK, 1950).

21. Grover Zinn, ed., *Richard of St. Victor: The Twelve Patriarchs, The Mystical Ark, Book Three of the Trinity* (New York: Paulist, 1979); Caroline Walker Bynum, "The Spirituality of the Regular Canons in the Twelfth Century: A New Approach," *Medievalia et Humanistica* 4 (1973), 3–24; Ritva Palmén, *Richard of St. Victor's Theory of the Imagination* (Leiden: Brill, 2014).

22. Lawrence, *Medieval Monasticism*, 153–56; Theordore Antry and Carol Neel, eds., *Norbert and Early Norbertine Spirituality* (Mahwah, NJ: Paulist, 2007), 1–14; Francois Petit, *Spirituality of the Premonstratensians: The Twelfth and Thirteenth Centuries* (Collegeville, MN: Liturgical Press, 2011), 1–43; H. M. Colvin, *The White Canons in England* (Oxford: Clarendon, 1951).

23. Julian Luxford, ed., *Studies in Carthusian Monasticism in the Late Middle Ages* (Tournhout, Belgium: Brepols, 2008); Lawrence, *Medieval Monasticism*, 145–48.

24. Dennis Martin, ed., *Carthusian Spirituality: The Writings of Hugh of Balma and Guigo de Ponte* (New York: Paulist, 1997).

25. Charles Conway, *The Vita Christi of Ludolph of Saxony* (Salzburg: University of Salzburg, 1976).

26. C. H. Lawrence, *The Friars: The Impact of the Early Mendicant Movement on Western Society* (New York: Longman, 1994).

27. Anne Lester, *Creating Cistercian Nuns* (Ithaca: Cornell University Press, 2011), 1–14; Constance Berman, "Were there Twelfth Century Cistercian Nuns?" *Church History* 68 (1999), 824–64; Herbert Grundmann, *Religious Movements in the Middle Ages* trans. Steven Rowan (Notre Dame: Notre Dame University Press, 1995).

28. Eric Borgman, *Dominican Spirituality* (London: Continuum, 2001); Daniel Lesnick, *Preaching in Medieval Florence* (Athens, GA: University of Georgia Press, 1989).

29. Simon Tugwell, ed., *Early Dominicans: Selected Writings* (Mahwah, NJ: Paulist, 1982), 1–16; Michèle Mulchahey, *First the Bow is bent in study: Dominican Education before 1350* (Toronto: Pontifical Institute of Medieval Studies, 1998).

30. Tugwell, ed., *Early Dominicans*, 16–24.

31. Christine Ames, *Righteous Persecution: Inquisition, Dominicans, and Christianity in the Middle Ages* (Philadelphia: University of Pennsylvania Press, 2009), 5–10.

32. Simon Tugwell, ed., *Albert and Thomas* (New York: Paulist, 1988); Lawrence, *The Friars*, 65–88.

33. Tugwell, ed., *Albert and Thomas*; Idem, "The Spirituality of the Dominicans" in *Christian Spirituality: High Middle Ages and Reformation*, ed. Jill Raitt (New York: Crossroad, 1987), 15–31; Lawrence, *The Friars*, 271–90; Jean-Pierre Torell, *Christ and Spirituality in St. Thomas Aquinas* (Washington: Catholic University of America Press, 2011).

34. Michael Cusato and Guy Geltner, eds., *Defenders and Critics of Franciscan Life* (Leiden: Brill, 2009).

35. Diane Tomkinson, "Angela of Foligno's Spiral Pattern of Prayer" in *Franciscans at Prayer*, ed. Timothy Johnson (Leiden: Brill, 2007), 195–219; Regis Armstrong, Wayne Hellman, and William Short, (eds.), *Francis of Assisi: Early Documents* (New York: New City, 1999–2002), vol. 1, 529–54.

36. William Short, "The Rule and Life of the Friars Minor" in *Cambridge Companion to Francis of Assisi*, ed. Michael Robson (Cambridge: Cambridge University Press, 2012), 55–67

37. Michael Cusato, "Francis and the Franciscan Movement (1181/2–1226)," in Robson, ed., *Cambridge Companion to Francis*, 17–33; Lawrence, *The Friars*, 26–42.

38. Wayne Hellmann, "The Spirituality of the Franciscans" in Raitt, ed., *Christian Spirituality*, 31–50; Lezlie Knox, *Creating Claire of Assisi: Female Franciscan Identities in Later Medieval Italy* (Leiden: Brill, 2008).

39. Ewert Cousins, ed., *Bonaventure: The Soul's Journey into God, the Tree of Life, the Life of St. Francis* (New York: Paulist, 1978); Amanda Quantz, "At Prayer in the Shadow of the Tree of Life" in Johnson, ed., *Franciscans at Prayer*, 333–55.

40. David Burr, *The Spiritual Franciscans* (University Park, PA: Pennsylvania State University Press, 2001); Duncan Nimmo, *Reform and Division in the Franciscan Order (1226–1538)* (Rome: Capuchin Historical Institute, 1987); Daria Mitchell, ed., *Poverty and Prosperity: Franciscans and the Use of Money, Spirit, and Life* (New York: St. Bonaventure, 2009).

41. Andrew Jotischky, *The Carmelites and Antiquity* (Oxford: Oxford University Press, 2002); John Welch, *The Carmelite Way* (New York: Paulist, 1996).

42. Steven Payne, ed., *The Carmelite Tradition* (Collegeville: Liturgical Press, 2011); Valerie Edden, "The Mantle of Elijah: Carmelite Spirituality in England in the Fourteenth Century," in *The Medieval Mystical Tradition*, ed. Marion Glasscoe (Cambridge: Brewer, 1999), 67–83; Keith Egan, "An Essay toward the Historiography of the Origin of the Carmelite Province in England" *Carmelus* 19 (1972), 67–100.

43. Adolar Zumkeller, "Spirituality of the Augustinians" in Raitt, ed., *Christian Spirituality*, 63–72; Benedict Hackett, "The Spiritual Life of the English Austin Friars of the Fourteenth Century," in *Sanctus Augustinus* (Rome, 1956), 421–92.

FOUR
Medieval Mysticism and Reform

DEFINING TERMS

To understand "mysticism" and "mystics," we should begin with some definitions. Those words are modern terms used by historians of religion starting in the nineteenth century looking back over many centuries to describe and, perhaps more importantly, categorize specific figures. This label identifies an individual who espoused, advocated for, or personally underwent a direct, immediate experience of the presence of an otherwise hidden God. One of the problems, however, with categorizing figures in this way is that these "mystics" were very often fully engaged in community, the regular round of more everyday Christian practices, and sometimes even the wider world. Their visions were not the sum of their experience of Christian faith and practice. In fact, their writings were often spring-boards for critiquing the status quo of the church, thus the opportunity to view their "mysticism" along the lines of reform and reformation. Unfortunately, the women and men we know as "mystics" are often filtered into this category without acknowledging that broader activity: in the twelfth century, Bernard of Clairvaux's mystical approach to the biblical book Song of Songs manifested in sermons to his Cistercian community; in the thirteenth century, Bonaventure wrote his mystical *Journey into the Mind of God* while also doing high-profile legal, political, and ecclesiastical work; the sixteenth-century Carmelite Teresa of Avila (discussed in a later chapter) wrote about her visions while founding new convents. To some extent, then, the label "mystic" hides the reality that these unmediated experiences of God came to people engaged in lots of projects, often reformist, and these projects were connected to and informed by their mystical experiences.

It is also important to remember that "mysticism" is not a uniquely Christian phenomenon. The mystery cults of the late ancient Mediterranean are so called because their rites and devotions were only available to the initiated, that is, those who had the hidden mysteries revealed to them by the inner circle. One can argue that there is something irreducibly mystical within Christianity in general too: Jesus Christ, God incarnate, offers the visible face of the invisible Father; Jesus reveals that which cannot be seen naturally. As a category which allows for historical interpretation, though, Christian mysticism occupies a peculiar space within Christian spirituality, and the later middle ages has been dubbed by Bernard McGinn as the golden age of Christian mysticism. The challenge, however, is to put these mystical voices in their proper context and to recognize that they were implicitly calling for a reform of Christian practice, or at the very least they raised questions about what constituted an authentic experience of God and how that could be achieved. One ought to see them thus: in the later middle ages, while the cult of the Eucharist and that of the saints captured the attention of most lay-folks and the Modern Devout offered an arguably advanced but no less practical piety (one based on imitating Jesus himself), a small but noticeable number of voices evinced a different approach to the Christian life, one involving an unmediated experience of the divine.[1] We thus call these voices "mystics."

The later middle ages, when there was a great flourishing of mysticism, was a time of leanness. In the fourteenth and fifteenth centuries, western Europe was in the throes of the Hundred Years War (1337–1453). Likewise, the Black Death (the bubonic plague) was decimating every country it entered. Social unrest showed itself in the Peasants' revolt (1381). Starting in 1309, the papacy abandoned Rome for a palace in Avignon in France and then in 1378 was divided between two popes (one in Rome and one in Avignon) and then comically between three popes. And, if a divided papacy did not disintegrate the church from the top, several border-pushing/orthodoxy-challenging popular movements questioned its authority from below. As discussed in the next chapter, this was the age of the Waldensians, Lollards, and Hussites. It was in this restless era that mysticism boomed; in other words, during an intense storm, some men and women turned inward. These mystics, then, can be viewed as *reformers* if we recognize their agenda as an alternative or, more often, a supplement to the tangible patterns of piety described in chapters 1 and 2 (e.g., the sacraments, relics, and the saints). In other words, the mystics describe an intimate experience of the divine that came to them through something other than accepted norms. Therefore, such spiritual patterns may be viewed as transgressive.[2] It will become obvious in this chapter, likewise, that we cannot describe mysticism, even with the confines of a specific region and time, as a coherent movement. These voices, which included men and women, emerged within other

recognizable bodies and movements—among the mendicants and beguines for example. This chapter, while not a complete study of all the diverse voices typically labeled as mystics in the later middle ages, outlines the challenge that certain mystics posed. The argument here is that mystics often overlapped and were indebted to one another, but just as often their ways of thinking, praying, and writing were contradictory. It is more accurate to think of their contributions peppering the movements this study examines rather than a uniform movement of their own; they are interwoven among a complex array of spiritual voices, some more readily identified as mystics than others, rather than a well-defined, neatly circumscribed body of writers.

THE DIONYSIAN PATTERN

Among mystics, it is not uncommon to find a three-fold pattern of ascending stages of prayer. There are several variations, however. One example is *synergia* (joining with God), followed by *henosis* (oneness with God) and then finally *koinonia* (community with God). In the late medieval west, a more common articulation was purgation, illumination, and union. The foundations of that approach emerged in Pseudo-Dionysius, a shadowy figure, probably from Syria, likely writing in the late fifth century. For most of the middle ages this writer was assumed to be the Dionysius converted by Paul's preaching at the Areopagus in Athens (Acts 17:34). It was the humanists, including Erasmus, who debunked that widely held myth; thus the label "Pseudo-Dionysius" (false Dionysius). He is best known for blending a Neo-Platonist understanding of the universe with Christianity. What does that mean? Late Ancient Neo-Platonism, in short, entailed the belief that there is a true "heavenly" realm of intellectual or spiritual truth far above this material world and that the material world is but a copy of the disembodied spiritual truth high above. Blending those ancient Greek philosophical presuppositions with Christianity resulted in a vision of God at the top of several hierarchies (heavens upon heavens). In some respects, Pseudo-Dionysius stands behind almost all post-biblical Christian mysticism. He even articulated the division discussed in chapter 3 between cataphatic spirituality and apophatic spirituality. He wrote that certainly there is a *via affirmativa*, a way of describing God through symbols and attributes. This is often described as cataphatic spirituality. Ultimately, however, that cataphatic spirituality is something of a tease. God, Pseudo-Dionysius wrote, is beyond all the images and categories we might have. According to Pseudo-Dionysius, the *via negativa* approaches God as he truly is, that is, beyond our rational knowledge. This is known as apophatic spirituality, the unknowing of God, a setting aside of all preconceptions.[3]

Chapter 4
MYSTICISM AND GENDER

Henry of Ghent, a contemporary of Aquinas and a student of Albert the Great, wrote in the late thirteenth century that women could only be teachers by special grace from God. In other words, a woman could not simply ascend to the work of teaching through normal channels. In some rare cases, however, God himself intervenes and selects a woman for a special purpose. This paradigm was widely accepted and female mystics themselves usually upheld the distinction. Of the scores of existing texts by female mystical authors, only one did not *apologize* for being a woman: Marguerite Porete. It simply became expected for a female mystic to include some admission that she was a lowly woman, but God had revealed a vision to her. One certainly can speculate how much of this was convention and how much of it they really believed. Moreover, the production of many of these texts involved male chaplains, evincing the possibility of the women's ideas being carefully filtered. That knee-jerk reaction may be a bit too simple. One should be extremely careful not to project twenty-first century gender sensibilities onto the middle ages. A persistent theme within the texts themselves is that of the "lowly woman" who alone was spiritually prepared for the *hidden things* of God. The feminine was understood to be, in other words, *receptive*. The point is to be humble, passive, and open to the God who fills; the proud, on the other hand, cannot receive the things of God. A woman's lowliness, then, was construed as the very thing that opened her up to that which men longed to receive. Catherine of Siena (1347–1380) had mystical experiences which empowered her to challenge prideful men during the scandalous Avignon papacy (1309–1377) and later the Great Western Schism (1378–1417) which featured multiple popes. In her visions, Christ said to Catherine, "To confound their arrogance, I will raise up women ignorant and frail by nature but endowed with strength and divine wisdom."[4] Because of her humility, Catherine was to a be a vessel for Christ's reformation of the papacy. The language of the "lowly woman" was not window-dressing, a necessary nod to a patriarchal culture. If we dismiss the gender sensibilities of medieval Christians as backward, we risk missing this critical feature of mysticism.[5]

There is also a great deal of gender malleability. The soul, *anima*, was understood as feminine—and this was true for both men and women. Even male mystics sometimes wrote of themselves using female pronouns, describing themselves as brides. Bernard of Clairvaux very often used this kind of language in his commentary on the Song of Songs; he longed to be a bride made ready for the Bridegroom Christ. Beginning in the nineteenth century, scholars have described this language as "bridal mysticism." That categorization, however, may miss the ubiquity of this phenomenon and how it was not limited to mystics. In fact, being a bride of Christ/marrying Jesus was a feature of popular religion in late medie-

val Europe; all baptized Christians, lay and ordained, could see themselves as brides of Christ.[6] Notwithstanding, when we do spot what those nineteenth-century scholars called "bridal mysticism" in works by writers like Bernard of Clairvaux, the stress is often on being receptive and passive, generally feminine virtues, and those virtues were being applied to men. On the other hand, there was also a paradigm of seeking and searching for God, a characteristic often recognized as associated with men. But there are instances of female writers like Hadewijch of Brabant (d. 1248) describing themselves in masculine language, as questing knights seeking God. Mysticism, then, allowed female writers (even if the production of their work involved a male chaplain) to be more involved in the creation of patterns of piety and devotion in the later middle ages than any other period in Christian history save possibly for our own. In the words of McGinn, this was a time of a certain democratic spirituality in which there was a notable increase in accounts of mystical experiences, especially among women.[7]

RETURNING TO GOD

One of the best examples of female mystics in late medieval Europe is Mechthild of Magdeburg (c. 1208–c. 1282), a woman who spent most of her life as a beguine. She began experiencing visions at age twelve, and later under the spiritual direction of the Dominicans she recorded them in a journal. The first five books of the journal were transcribed and appeared later in Latin as *The Flowing Light of the Godhead*. The text took thirty years to complete, roughly 1250 to 1280. At the end of her life, during increased suspicions about beguines, Mechthild decided it was best to enter an established order, becoming a Cistercian nun at age seventy-one. As for *The Flowing Light of the Godhead*, it contains almost every kind of literary genre used in the later middle ages: plays, lists, poems, songs, narratives, and dialogues. A deeply allegorical book, Mechthild even claimed that to understand it rightly, one needs to read it nine times! The focus of the book is on the soul returning to its origin within God. Here is one of the central themes of Rhineland mysticism, this notion that creation was an overflowing of God himself, that the origin of the cosmos was God boiling over in love. Thus union with God was conceived as the return of the soul to its place within God. This is not exactly heterodox, but it is adventurous.[8]

A careful distinction needs to be made here. Bernard of Clairvaux had specified, and it was widely accepted, that the goal of the Christian life is a union of one's will with the will of God, not a union of one's substance with the substance of God. One does not merge with God. Rather, one harmonizes the will, and this is achieved, according to different ascetical writers, through a variety of practices and above all grace from God

himself. Through all eternity, however, one remains a distinct being; one never dissolves into God. Mechthild and many others danced precariously along this line. She writes that for the soul to return to God, one must become exceedingly low so that God may fill the individual up. Writing about this union, she sings "Lord, your blood and mine are one, untainted. Your love and mine are one, inseparable. Your garment and mine are one, immaculate. Your mouth and mine are one, unkissed. Your breast and mine are one, not caressed by any man but you alone."[9] Mechthild also explains that God distances himself from the soul to purify the soul, readying the soul to return to God. Gregory the Great had said something similar, that in the inner council of the Trinity, the soul finds its truest existence. But what about the distinction between harmonizing the will and dissolving into God? There was an enormous fear that missing this distinction could lead one to believe that she had really merged with God and was therefore no longer liable to any laws or discipline. This could lead one to the much-feared Heresy of the Free Spirit, heretics who believed that they had achieved a spiritual enlightenment, were beyond the church and its sacraments, and were consequently liberated from most elements of morality. After all, if one has joined with God, "sin" no longer even exists conceptually. In the later middle ages, then, church authorities were vigilant to ensure that spiritual writers focused on the harmony of the will, not absorption into God. It should be added that some scholars have questioned the nature of the Heresy of the Free Spirit as a real phenomenon, suggesting that it may have existed more in the fearful imagination of members of the church hierarchy. Notwithstanding that caveat, the very idea of such a heresy, real or imagined, helped to shape the late medieval religious landscape.[10]

Mechthild did not dance along that border between orthodoxy and heresy alone. Undoubtedly the most important figure among the medieval German mystics was the Dominican Meister Eckhart (c. 1260–1327). Johannes Eckhart was educated by the Dominicans at Cologne and entered the Order of Preachers at Erfurt. He had a fairly impressive career: service as prior of the Dominican House at Erfurt, superior of the order in Saxony, vicar-general of the order in Bohemia, and teaching engagements at the universities of Paris, Strasbourg, and Cologne. Eckhart is also known for the spiritual direction he gave to nuns and beguines. He was an extremely popular preacher, and some of his ideas about the soul's return to God were enigmatic enough to have him tried for heresy by the pope himself in 1327. In the middle of the proceedings, though, Eckhart died. But his works were so well known that the issue needed resolution. In March 1329, Pope John XXII released the bull *In agro dominico* which cut a middle path: Eckhart was personally cleared, but a portion of his writings were declared heretical.

What was Eckhart actually teaching? Most of his works are sermons, although they seem more like philosophical-ascetical meditations. He

had a speculative posture, asking broad, difficult questions beyond the realm of the practical. But Dominicans had not previously been given to lengthy contemplation. Thomas Aquinas had written that short intercessory prayers are best; make your petition and when the mind starts to wander, say Amen. For Thomas, such a pattern illustrates humanity's dependence on God. That is certainly not a description of Eckhart. Like Mechthild, Eckhart believed that creation was an act of God overflowing in love. So, all of creation—including human beings—preexisted within God. According to Eckhart, because souls existed before physical birth within God, their destiny is to return to God, even being a part of God. Eckhart was certainly diverging from other mystics who, while believing that the soul has some inherent orientation toward God, more often spoke of union with God as conforming the mind and the will to God's mind and God's will. For Eckhart, though, the soul goes back to being God; he describes returning to the undifferentiated Godhead. The human person, he believed, was meant to return to God, not live as a separate creature. To achieve this, one must engage in detachment—give up everything that leads to distinction, all that makes one unique. One should even give up particular spiritual disciplines (here is an obvious divergence between Eckhart and the practical sensibilities of, for example, the Modern Devout). The goal is to make one's self not simply humble, but empty and detached; this process is often described with the German term *Gelassenheit*. Only when one is totally receptive to God can God enter and, in the language of Eckhart and others, "be born within." In ridding one's self of distinctions and attachments, one reaches a still silence, inside and outside, and God who is also still and silent can be born within.[11]

Eckhart was terrifically influential on many later German mystics (some scholars even refer to an "Eckhartian school"). The two obvious examples are Henry Suso and John Tauler. Henry Suso (c. 1295–1366) was educated at the Dominican house at Cologne and then spent most of his life at Constance as prior of the Dominican community. Suso was very much a pastor and spiritual director, and he left a variety of texts— treatises, letters, and sermons. His best-known work, the *Horologium Sapientiae, the Clock of Wisdom* (1339), argues that the spiritual life should rhythmically bring one closer and closer to God in much the same way as one's mortal life ebbs out, tick by tick of the clock. One sees here his commitment to Eckhart in a number of ways, most clearly in Suso's discussion of detachment. But in the *Clock of Wisdom* Suso diverges from Eckhart by combining that emphasis on detachment with two other usually unrelated tendencies, bridal mysticism and affective suffering more akin to Franciscan mystics. The motif of preparing one's self as a bride for Christ, being passive and receptive to him, termed "bridal mysticism" by scholars since the nineteenth century, was found among earlier high medieval spiritual writers like Bernard of Clairvaux. Among Franciscan

mystics, though, there was a deep almost painful identification with the suffering flesh of Christ, the paradigm being Francis himself who was marked with the stigmata, miraculous wounds where the crucified Jesus was also wounded. These two themes, bridal mysticism and affective suffering, are not usually related. And, moreover, neither of the two are found in Eckhart. In short, Suso displayed remarkable creativity in drawing on a variety of mystical traditions.[12]

John Tauler (1300–1361) presents a similar story, although the only texts we have from him are eighty sermons. Tauler entered the Dominican order at a fairly young age and then spent most all of his life preaching in or around Strasbourg. His sermons were first collected into a print edition in 1498, a collection which had a remarkable influence on the young Martin Luther. Tauler most likely knew Eckhart personally as they spent time in the same Dominican community. His work was certainly in the tradition of Eckhart and he openly defended Eckhart from the pulpit. In Tauler one certainly finds the kind of detachment which was the centerpiece of Eckhart's ascetical program. However, Tauler used more images in his preaching, a path Eckhart may have judged a distraction from the true image-less abyss of the divine. Tauler, then, was more concrete, earthy, and practical.[13]

At the close of the thirteenth century and the beginning of the fourteenth, Mechthild of Magdeburg and Meister Eckhart had taken common Dionysian patterns in a new direction, skirting the line of heresy with new understandings of the soul returning to God and how that is achieved. Suso, Tauler, and others, for example the Dutch mystic Jan van Ruusbroec, then took that achievement and crossed other horizons, blending other mystical sensibilities to offer more options for the Christian life. Mystics, as previously noted, were certainly not mainstream. But the flowering of mystical voices in the later middle ages alongside the more familiar patterns of piety described in chapters 1 and 2 made for a complex landscape, one rife with competing answers to what an authentic engagement with the God of Jesus Christ looks like.

LUTHER AND THE MEDIEVAL MYSTICS: A CASE STUDY

One towering figure of the sixteenth century was a consumer of this altstream, but a close analysis reveals doubts about the relationship between the early sixteenth century reformations and the late medieval German mystics. Martin Luther was a deep admirer of Tauler, believing that Tauler was the author of a text within the late medieval German mystical stream called the *Theologica Germanica* (in German, *Theologia Deutsch*). As it turns out, Luther was wrong about its authorship, which remains a mystery. Luther had the *Theologia Deutsch* published twice, in 1516 and 1518, and later in the seventeenth century, Lutheran Pietists

latched on to it as well. It was written by a priest of the Teutonic Order in Frankfurt, a monastic military order. Most of the references are from scripture, mainly Paul, and the author has a deeply Augustinian view of human nature, original sin, and grace. A major feature is the contrast between the fallen Adam and the glorified Christ: where Adam was willful, Christ was submissive. As sons of Adam, our nature is so wounded that we are blind to our situation and the devil prowls around us. The *Theologia Deutsch* shows its debt to earlier mystics, including Eckhart, by using the Dionysian model of successive steps until one reaches union with God. But, in an Augustinian fashion, the author always circles back to grace and how grace identifies one with Christ. The author also takes a swipe at reason and has a very low view of natural theology. He even writes at one point, "the Devil and nature are one."[14]

In a letter to his friend George Spalatin, Luther declared that Tauler's sermons contain "pure and solid theology." Luther went on to say that he knew of no writing in either Latin or German which more closely agreed with the Gospels. And when he defended the ninety-five theses, he proclaimed that there was more good theology in the works of Tauler than in all the scholastic theologians combined. Luther noted that only Augustine and the Bible had taught him more about God than the *Theologia Deutsch*. With this kind of praise along with the Augustinian streak in the *Theologia Deutsch*, it has become common to link Luther with late medieval German mystics. A closer look reveals a serious break between Eckhart and Tauler on the one hand and Martin Luther on the other.

First, there is a high degree of nativism to Luther; simply put, he liked that the *Theologia Deutsch* was German. Luther also wanted to say that his reform program had historical precedent, and in his native land no less. Regarding substance, though, what Luther liked about the voices in this tradition was their distinctly non-scholastic method and their personal treatment of religion. Luther also loved their focus on passivity, especially the emphasis on God giving grace to the humble. When Luther surveyed the ascetical landscape of his moment, this emphasis appeared to him as a strong alternative to mainstream spirituality which he judged to be moralistic and based on works rather than faith. Nevertheless, there were essential elements in the tradition of Eckhart and Tauler that Luther had to reject firmly. A clear example is the concept of a spark or power residing in the soul. For Luther, this was unacceptable; it was a Pelagian anthropology that posited something good within the human person that needs cultivation. In his lectures on Romans in 1515, Luther said, "They believe that because the will has that spark it is, although feebly, inclined to what is good, and they dream that this little motion toward doing the good, which man is naturally able to make, is an act of loving God above all things."[15] Luther insisted on the individual's inability to move toward the good on his own—human nature naturally moves in the opposite direction, gorging on wickedness; we turn in on ourselves (*incurvatus in*

se). The contemplative, on the other hand, sought to cultivate good works in the search for grace, and this cultivation was central to the contemplative program. In fairness, these good works were often interior habits of mind as opposed to (crass) exterior good works. For Luther that made no difference. They were all works, and according to Luther no level of effort, no personal improvement plan, can atone for sin. For Luther, saving faith comes by hearing God's word (*fides ex auditu*): one intellectually hears the word, recognizes his sinfulness (again, an intellectual movement), and thereby does the only thing he can do, trust in the savior. Thus, faith is born through the word. In a copy of one of Tauler's sermons (the man he purported to adore), Luther even corrected the medieval preacher in the margin. Where Tauler said that a spark of soul makes a person a spiritual being, Luther scribbled instead faith. Luther also described faith as the agent of a mystical marriage between Christ and the soul—one of a handful of strikingly mainstream medieval religious concepts which Luther heartily retained. According to Luther, one does not progressively become more like God—more holy—to know God, but rather offers simple faith.[16]

Likeness to God had been the cornerstone of much monastic spirituality: through rigorous physical and intellectual exercises one burns away the dross and then one is able to live the divine life. But this model which we can describe as "like attracts like" was not limited to monks. Jean Gerson (1363–1429) the great chancellor of the University of Paris had written much earlier "our becoming like God is the cause of our union with him." The goal of mysticism as well as the traditional forms of piety described in chapters 1 and 2 above was to achieve such a likeness with God that one can have union with God. And as Christ himself had taught that God is love, the central religious concept was love (*caritas*). The way of salvation could be defined as faith formed by acts of love. Faith alone, from a medieval perspective, was only an intellectual assent to the data, an assent that could be made by one who was still very far from being pure and godly. For the medieval Christian, this was unformed faith. After all, it was not faith but love that bound the three persons of the Trinity together; and it would be love that would bind the soul to God. One medieval formula puts it this way: the Holy Spirit is himself uncreated love (that is, the reciprocal love between God the Father and God the Son); sacramental grace is created love; and meritorious works are acts of love. With sacramental grace (created love) and meritorious works (acts of love), then, the residue of a pre-fallen purity—the spark—can be fanned into a flame and grow to such a state that it will become like God and thus find unity with God.

Martin Luther rejected this whole schema. This was a very personal issue for him: no matter how hard he tried to fan the spark, no matter how hard he tried to be God-like as a precondition to union, he felt he was making no progress. And this failure caused a psychological break.

So, Luther distanced himself both from the anthropological premise as well as the soteriological premise shared by most (but certainly not all) medieval mystics, scholastics, and monastics. For Luther, the human person is always dissimilar from God. In his comments on Psalm 50, Luther wrote "it is not he who considers himself the most lowly of men, but he who sees himself as even the most vile who is most beautiful to God."[17] For Luther, *unlikeness* was the central principle: to be truly conformed with God means to agree with God's judgment, that every human being is sinful, while also believing and trusting in God's promise to save sinners nonetheless. For Luther, the key issue is trust—the move from a state of doubt to a state of confidence. The question was not whether one is inwardly or outwardly righteous. That was the medieval question, and it was answered differently by a variety of medieval voices. For Luther, no one is righteous, inwardly or outwardly. And not only is the individual not righteous, but there is also nothing she can do about it. For Luther, the focus is taken off the sinner (whose unrighteousness is beyond question) and put on God himself. The question then becomes is God to be trusted? One of the great insights from the late twentieth-century historian Heiko Oberman was Luther's debt to a stream of late scholastic theology known as nominalism. Figures like William of Ockham (c. 1285–1347) and Gabriel Biel (c. 1420–1495) had stressed that salvation depends entirely on God's sovereignty. One is saved, then, simply because God declares it so. Luther was in some respects pushing nominalism to its arguably natural conclusion: there is nothing human beings do to make themselves like God, but rather God comes to save wretched sinners who are nothing like him. In the process, however, God merely declares the sinner justified and it is so, hence the term "nominalism." If God were to declare black to be white, then it would be so. For Luther and the nominalists before him, the case is the same for salvation.[18]

Despite his praise for the *Theologia Deutsch*, his emphasis on passivity, and his finding God in dereliction, Martin Luther decisively moved away from some of the core convictions of Tauler, Eckhart, and the Rhineland mystics. Can we also say, then, that, by extension, Luther was disconnected from most late medieval mystics? A cautious yes seems reasonable. However, the reception of medieval mystical texts by sixteenth and seventeenth century Protestants did not begin and end with Martin Luther; later evangelical theologians, both mainstream and pietist, would draw from the mystics. Certainly, we should be wary of having Luther speak for all Protestants.[19] Likewise, as will be discussed in the conclusion of this chapter, it is problematic to speak definitively or categorically of all mystics.

MYSTICISM, REFORM, AND THE LIMITS OF CATEGORIES

In what ways were late medieval mystics reformers? And, to return to some of the questions at the outset of this chapter, in what ways do categories fail us? The Dutch mystic Jan van Ruusbroec (1293–1381) composed his mystical writings while living out a reform agenda. After twenty-five years in active parish ministry, the Flemish priest became convinced that clergy needed to be more attentive to meditation. So, he and a group of like-minded clerics withdrew to a forest hermitage near Brussels; they were recognized as a priory in 1349. It was in this context that Ruusbroec wrote texts that were similar to those of the Rhineland mystics. Although likely visited by Tauler and Geert Groote (the founder of the Brethren of the Common Life, a movement discussed in the next chapter), Ruusbroec rarely left his monastery. That fact should not limit our understanding of him as a reformer; he was ultimately offering a challenge to the accepted patterns of Christian life. In the next century, Nicholas of Cusa, the reformist German cardinal wrote against what he believed were false mystics, those who veered toward pantheism, that is seeing God within his own creation (here he may have had Ruusbroec in mind). But in this effort, Cusa was not rejecting mysticism but rather clarifying what he believed to be authentic mysticism. From Cusa's perspective, true mystics joined knowledge with love, intellect with affection, rather than separating those aspects of the human person. Ruusbroec and Cusa are merely two examples of mystics engaged in a reform project; their respective engagement with mysticism was an outgrowth of those efforts.[20]

When studying Christian mysticism, it is notoriously difficult to speak in generalizations, to make blanket statements about "the mystics." Yet there is always the temptation to create "schools," categories through which we can class these fascinating voices. It is helpful to remember that speaking about "mysticism" is a nineteenth-century phenomenon, a product of the early academic discipline of religious studies (as opposed to the discipline of theology). Certainly there are occasions where it can be reasonably accurate to describe a cluster of spiritual writers as related, possibly even as a school. The Rhineland mystics of the fourteenth century are a fair example. However, such a project can easily distort the role these women and men played within other movements and reformist projects. For example, many of the nuns closely related to the Rhineland mystics were Dominicans. But they were not simply passive recipients of the wisdom of Eckhart and his imitators. One of the reasons why there were so many Dominican nuns in the diffuse family of Rhineland mystics is because there was a boom in Dominican convents in Germany at the close of the fourteenth century. And that boom was the result of beguines seeking security in their religious vocation within recognized religious orders in light of the Council of Vienne and the general apprehension

that beguines might veer into heterodoxy without adequate supervision (the kind women got in the formal orders).

Even with that caveat about Dominican nuns, it is not unreasonable to speak cautiously of a Rhineland school. It is much more difficult, however, to write about an "English school" despite the number of important mystical writers in late medieval England. In his *The Fire of Love* (c. 1343) the solitary hermit Richard Rolle (c. 1290–1349) advocated the superiority of the contemplative life over the "infinite questionings" of most scholastic theologians. He wrote of an actual burning sensation the closer he drew to God, a physical manifestation that differentiated him from other English mystics. Another English mystic Walter Hilton (1340–1396) felt that Rolle's focus on physical manifestations might lead a seeker away from God. His *Ladder of Perfection* (c. 1390) was written apparently for an anchoress, a solitary woman who lived in an enclosure as part of a parish church. No other mystic of the late middle ages surpassed the clearly Augustinian sensibilities of Hilton. While he uses the familiar Dionysian stages, these have much to do with the restoration of the image of God in Jesus. Hilton has no patience for the sort of rapture that Rolle describes, and, also unlike Rolle, Hilton describes the withdrawing of God, a sense of abandonment, as part of the process of perfection. Hilton is also much more encouraging of people in the active life (as opposed to contemplatives). Yet another voice from the same time and place is the anonymous author of the *Cloud of Unknowing*, a collection of bits of advice most likely from a Carthusian. In many respects, it is a practical text; it offers a method of quiet prayer centering on a word or phrase and putting all other cares under a "cloud of forgetting" in order to be receptive to God. A tally of English mystics must also include Julian of Norwich (1342–c. 1423), an anonymous anchoress; we call her "Julian" simply because she was enclosed at the church of St. Julian in Conisford in Norwich. In 1373, when she was thirty years old, she was very ill and began to receive a series of sixteen visions which she recorded as her *Showings of Divine Love*. Over the next twenty years she revised her text; the original is known as the "short text" and the revision, the "long text." The dominant motif is a sharing in the suffering of Christ, the Man of Sorrows. When the priest visiting her sick-bed held a crucifix before her, she saw blood pour down Christ's face. This vision was followed by another vision of God's all-embracing love: she saw a small thing in her hand, no bigger than a hazelnut, and God revealed to her that it was the whole of creation. This small vulnerable thing, she understood, is safe-guarded by God's love. Julian's *Showings* has much to say for the impatient and even those in despair, reminding them to trust in a merciful God who means to save. Thus, Julian's well-known conclusion of deep faith: all will be well, and every kind of thing will be well.[21]

As important as these late medieval English voices are, they are disparate; it is distortive, therefore, to class them together as an "English

school." It is may be more accurate to think of Julian within the context of the parochial Christian experience, particularly as she stresses the common Man of Sorrows motif and her anchor-hold was a presence like the relic shrines and the tabernacle in a parish church. The alternative, to swoop her up into a pantheon of the "English school," may be somewhat ham-fisted, a dreamy romanticism about England separated from the rest of Europe (with modern-day parallels about English identity, English moderation, and Anglicanism). Likewise, it may be more accurate to think of the *Cloud* author in the context of medieval Carthusian spirituality, a broader European phenomenon and one with a reformist agenda itself. Hilton ought to be seen among his fellow Augustinians and their witness to grace and the restored image of God in Christ. Rolle, too, should be understood in the drive for simplicity that made him and so many others in late medieval Europe take up the life of a hermit. These English mystics were voices that challenged and offered new songs, but the ear is strained to hear them as a harmonious "English school." The same then should be clear about mystics more broadly and their role within reform movements in the middle ages and early modernity.

Among these voices we find a buffet of ideas, affinities, predilections, and ways of thinking about God that are hardly complimentary; sometimes there is overlap and even indebtedness and sometimes outright rejection. These sensibilities, however, are peppered through the movements under examination in this book. In the later middle ages, then, the mystics added competing answers to the question of what a meeting with the God of Jesus Christ looks like; their voices, like those of Bernard, Kempis, or Luther, stand no less at the intersection of religious change and practice, the intersection of reform and spirituality. While some had places of leadership, others stood on the fringes. Often teetering on heresy, these late medieval voices regularly challenged the status quo and, by finding their authority and legitimacy in direct experiences of the presence of God, they drew into question the location and nature of authority in the church and the Christian life.

NOTES

1. Bernard McGinn, *The Essential Writing of Christian Mysticism* (New York: Random House, 2006), xviii–xviii; Idem, *The Flowering of Mysticism: Men and Women in the New Mysticism, 1200–1350* (New York: Crossroads, 1998); Idem, *The Harvest of Mysticism in Medieval Germany* (New York: Crossroads, 2005).

2. Sara Poor and Nigel Smith, "Introduction," in *Mysticism and Reform, 1400–1750*, ed. Sara Poor and Nigel Smith (Notre Dame: University of Notre Dame Press, 2015), 1–28.

3. Colm Luibheid, ed., *Pseudo-Dionysius: The Complete Works* (New York: Paulist, 1987); Denys Turner, *The Darknessof God: Negativity in Christian Mysticism* (Cambridge: Cambridge University Press, 1995).

4. Jörg Jungmayr, ed., *Die Legenda Maior des Raimond von Capua* (Berlin: Weidler Buchverlag, 2004), 2.1.122.

5. John Arnold, "Heresy and Gender in the Middle Ages," in *The Oxford Handbook of Gender in Medieval Europe*, ed. Judith Bennett and Ruth Karras (Oxford: Oxford University Press, 2013), 496–510.

6. Rabia Gregory, *Marrying Jesus in Medieval Early Modern Northern Europe: Popular Culture and Rleigious Reform* (Farnham, Surrey: Ashgate, 2016).

7. Sara Poor, *Mechthild of Magdeburg and her Book: Gender and the Making of Textual Authority* (Philadelphia: University of Pennsylvania Press, 2004); Amy Hollywood, *The Soul as Virgin Wife: Mechthild of Magdeburg, Marguerite Porete, and Meister Eckhart* (Notre Dame: University of Notre Dame Press, 1995); Alison Weber, "Gender," in *The Cambridge Companion to Christian Mysticism*, ed. Amy Hollywood and Patricia Beckman (Cambridge: Cambridge University Press, 2012), 315–57; Rosalyn Voaden, *God's Words, Women's Voices: The Discernment of Spirits ion the Writing of Late-Medieval Women Visionaries* (Woodbridge, Suffolk: Boydell, 1999), 7–40.

8. Frank Tobin, ed., *Mechthild of Magdeburg, The Flowing Light of the Godhead* (New York: Paulist, 1998).

9. Tobin, *Mechthild*, 96.

10. Robert Lerner, *The Heresy of the Free Spirit in the Later Middle Ages* (Notre Dame: University of Notre Dame Press, 1972).

11. Bernard McGinn, *The Mystical Thought of Meister Eckhart: The Man from whom God hid Nothing* (New York: Crossroad, 2001), 114–61; Edmund Colledge and Bernard McGinn, trans. *Meister Eckhart* (Mahwah, NJ: Paulist, 1981).

12. Frank Tobin, ed., *Henry Suso: The Exemplar with two German Sermons* (New York: Paulist, 1989); Heinrich Suso, *Wisdom's Watch upon the Hours*, trans. Edmund Colledge (Washington, DC: Catholic University of America Press, 1994).

13. Maria Shrady, ed., *Johannes Tauler: Sermons* (New York: Paulist, 1985).

14. David Blamires, trans., *Theologia Deutsch – Theologia Germanica: The Book of the Perfect* Life (New York: Altamire, 2003).

15. Wilhelm Pauck, ed., *Luther: Lectures on Romans* (Philadelphia: Westminster, 1961).

16. Steven Ozment, *The Age of Reform, 1250–1550* (New Haven: Yale University Press, 1980), 239–44.

17. Ozment, *Age of Reform*, 240, fn 55.

18. Heiko Oberman, *The Dawn of the Reformation* (Edinburgh: T&T Clark, 1992), 126–54; David Bagchi, "Sic et Non: Luther and Scholasticism," in *Protestant Scholasticism: Essays in Reassessment*, ed. Carl Trueman and Scott Clark (Carlisle, UK: Paternoster 1999), 3–15; Volker Leppin, "Luther's Roots in Monastic-Mystical Piety," in *Oxford Handbook of Martin Luther's Theology*, ed. Robert Kolb et. al (Oxford: Oxford University Press, 2014), 49–61.

19. Heinrich Bornkamm, *Luther und Eckhart* (Stuttgart: Kohlhammer, 1936); Steven Ozment, *Mysticism and Dissent* (New Haven: Yale University Press, 1973); Bernard McGinn, "Mysticism and the Reformation" *Acta Theologica* 35 (2015), 50–65.

20. Alois Maria Haa, "Schools of Late Medieval Mysticism," in *Christian Spirituality: High Middle Ages and Reformation*, ed. Jill Raitt (New York: Crossroad, 1987), 140–75; Rik Van Nieuwenhove, *Jan van Ruusbroec, Mystical Theologian of the Trinity* (Notre Dame: University of Notre Dame Press, 2003).

21. Barry Windeatt, ed., *English Mystics of the Middle Ages* (Cambridge: Cambridge University Press, 1994); Bernard McGinn, "The English Mystics," in Raitt, ed., *Christian Spirituality*, 94–207.

FIVE

The Spirituality of Late Medieval Reform Movements

Pushing the Boundaries

Although the mystics discussed in the preceding chapter provided an important renegotiation of the tradition, far more influential on the mainstream of Christian life in the later middle ages were a series of reform movements emerging and active from roughly 1300 to 1550. We can imagine four concentric rings of acceptability: the Brethren of the Common Life and the more diffuse movement known as the *Devotio Moderna* are at the center; the humanists in the next ring out; Beghards and Beguines in yet another ring; and then the Wycliffites and Hussites are on the outer ring. While that is a helpful visual, discussion of these four movements will proceed chronologically along with a short but important section on the fifteenth-century movement known as conciliarism and the reforms meant to heal the Great Western Schism (1378–1417). Across these movements it becomes clear that the boundaries against which they pushed (and at times transgressed) were in fact legacies of earlier reform movements already discussed.

THE RICH SOIL OF THE LOW COUNTRIES: BEGUINES AND BEGHARDS

The Low Countries of the later middle ages provided fertile soil for religious innovation and reform, particularly for clusters of men and women living in semi-monastic communities. We have already met many of them in earlier chapters: Hadjwich of Brabant, Juliana of Cornillion, and Mechthild of Magdeburg are just a few. However, we need to consider

the contours of this popular phenomenon, noting especially that a discussion of Beguines also raises the broader subject of gender, female spirituality, and women in reform. The Gregorian Reform of the eleventh century had a primitivist impulse. Later in the twelfth and thirteenth centuries that same impulse took on the language of "the apostolic life" (*vita apostolica*), a construal of earliest and authentic Christianity usually tied to poverty. The mendicants, for example, felt that being beggars linked them to true apostolic Christianity. In the fourteenth and fifteenth centuries, Beguines certainly reflect this same primitivist sensibility. Clusters of semi-monastic lay women living together but not infrequently working in the world, Beguines represented a genuine women's movement and not simply an appendage to an originally male program. The question of their origins is instructive. A myth emerged in the thirteenth century that a reformist priest in the Low Countries, Lambert le Bégue (1131–1177), founded their movement as part of his wider preaching campaign among lay-people, urging them to read scripture in the vernacular, make good confessions, and engage in penance. Although a real person who was accused of heresy, Lambert le Bégue was surely not the founder of this movement and the invention of the story itself highlights church leadership's anxious desire to institutionalize the Beguine movement in part by fabricating a male clerical founder.

In truth, just before 1200, lay women in the southern Low Countries took up residence together in an imitation of monastic life. For most of their history, there was no formal rule and, while they emphasized apostolic poverty, they were not predominantly beggars like the mendicants. Instead they usually worked manually, as seamstresses for example, to earn a living. Praised by clerics like Cardinal Jacques de Vitry (d. 1240), they engaged in prayer together, made time to discuss their spiritual progress within the household, and often read scripture in vernacular translation. Being a Beguine was not a lifelong commitment, and many left after a period for married life or for admission to a traditional convent. They wore plain lay clothes, could own property as individuals, and were free to go in and out of their beguinages, as their semi-monastic homes were known. In its early years, the movement took on different forms: some were reclusive, for example, while others served in hospitals. Described as "holy maidens," these women challenged accepted categories of female spirituality: they were not part of a recognized religious order. The Fourth Lateran Council (1215) meeting around the same time as their initial emergence had stressed the need for an approved rule. The Beguines, though they spread from the Low Counties to Germany and France, were hardly an order, but rather informal communities. Their critics, unsettled by the lack of oversight, called them "Beguines" as a pejorative term, though the word later gained respectability.[1]

By the middle of the thirteenth century, Beguines were becoming more organized. In the Low Countries, a beguinage might be a large

complex of buildings, although they never reached that size in other parts of Europe. Papal and episcopal protections were extended to specific communities here and there, but the structures of church life simply did not have a mechanism to recognize a movement like this. For this reason, some clerics regularly pressured the Beguines to morph into one of the established orders or become an order with a recognized rule. One solution was to grant parish status to large beguinages as a means of control. Church leaders feared that a community of women living without a rule might slip into heresy and moral failings. Beguines, then, often relied on sympathetic male supporters, particularly confessors. While it was not uncommon for Beguines and the nuns of formal orders to be literate (sometimes in both their vernacular and Latin), some of the mystics among them engaged in symbiotic relationships with male confessor-scribes: the female mystic achieved security while the male confessor gained spiritual status. Marguerite Porete (1250–1310), a Parisian woman long assumed to have been a Beguine, failed to find that kind of security. Found guilty of the Heresy of the Free Spirit, the belief that one lost personhood (annihilation) in union with God and was therefore liberated from all laws, she was burned at the stake. Suspicions about such heresy and lack of oversight led to the Council of Vienne (1311–1312) condemning heresies like the Heresy of the Free Spirit, a phenomenon the council tied to Beguines. The council issued a serious prohibition of Beguine activity and some Beguine fellowships decided to fold into more formal religious orders. In the early fourteenth century, for example, a cluster of Beguines near Nuremberg was incorporated as a convent of second-order Dominicans. According to one account, when they gathered for the first time to sing the choir office according to the Dominican pattern, the choir mistress, who evidently was not Latinate, miraculously translated a portion of the Latin liturgy. That memorable experience, which caused the other sisters to collapse in ecstasy, was long understood as a divine confirmation of their entry into the Dominican order. While the Council of Vienne laid down prohibitions on the Beguines, the council fathers also, perhaps in a contradictory way, affirmed that women are free to live together and engage in lives of devotion. But their living together as quasi-nuns had contributed to the emergence of the movement in the first place. Bishops were to continue to monitor such clusters of women to ensure that they expressed no controversial ideas about the nature of God or the fate of one's soul in union with God. In this respect, Beguine houses continued to exist after the council although under stronger regulation.[2]

Older scholarship portrayed the Beguines as a pressure release for spirituality in light of economic conditions. As many of the traditional convents required a dowry, poor women became Beguines instead. That description, however, not only ignores the evidence we have of women from all economic backgrounds, including aristocrats, joining Beguine

communities, it also sidelines Beguine spirituality. They blended, in rather creative and ultimately provisional ways, the active life and the contemplative life. Their context will be helpful: Beguines were an urban phenomenon and like other movements emerging in the thirteenth century, there was a desire to engage in asceticism while facing ever more deeply into the world instead of retreating from it. Beguine spirituality then emphasized the suffering humanity of Christ, works of charity and mercy, study of scripture, and often confession to one another, sidestepping clerical authority. While they surely prayed together, their life was not the same as that of their cloistered female counterparts who kept the canonical hours with rigor. Aside from the exceptional mystics among them, the Beguines are often studied by reading the hagiographic accounts of them written by their confessors and admirers. Jacques de Vitry's biography of Mary of Oignes (1177–1213) is perhaps the most famous. Mary convinced her husband to foreswear sex, joined a Beguine fellowship, and devoted her life to prayer; she was rewarded with ecstatic visions of God, particularly while she meditated on the passion of Christ. Biographers like Jacques de Vitry, however, often romanticized their subjects, particularly their overcoming sexual temptation. Thus, the bridal mysticism described in the preceding chapter and portrayals of such "holy women" need to be evaluated alongside the vernacular texts we have from the women themselves in the thirteenth century, forms of literary expression unavailable to earlier generations.[3]

THE MODERN DEVOUT

Geert Groote (1340–1384), originally from Deventer in the Low Countriesthe, was a deacon and popular preacher who had spent some time among the Carthusians. The central theme of his teaching was a contempt for the world (*contemptus mundi*) in favor of an interior piety. In many respects Groote was reprising older monastic sensibilities, priorities which reigned prior to the rise of the mendicants. Groote had a practical, unspeculative devotion, and by the time he died in 1384, a group of his close followers had started living together in Deventer. Led by a priest, Florens Radewijns (1350–1400), they held property in common, thus gaining the name Brethren of the Common Life. By 1450, there were about 100 such communities, male and female, in the Low Countries and in Germany. The sisters came to outnumber the brothers three to one; this may point to the sister-houses becoming an outlet for women who may have joined a Beguinage were it not for the opprobrium that fell on them following the Council of Vienne. Keeping the canonical hours and spending set periods of time studying and working, the pattern of life among these semi-religious brothers and sisters was unremarkable. They specifically did not beg, as the mendicants, but rather worked manual tasks.

The brothers often served as copyists and the sisters produced lace. While such labor supported them financially, it was also construed as a spiritual devotion; working with their hands, often repetitively, could focus the inner person toward God (connecting exterior with interior). The brother-houses often provided seminars for boys on Sundays, encouraging them to devotion. What they achieved was a revival of old-fashioned monasticism but at a comparatively informal level. Their practical ascetical program was known as the *Devotio Moderna*, adherents being appropriately called the Modern Devout. For the most part, they wished to return to a simple life marked by prayer, study, work, and community. And like so many reformist groups, the Modern Devout anchored their agenda for spiritual progress in a primitivist conception of the early church, the *vita apostolica*.

A combination of factors, however, led to opposition. As discussed, the fourteenth-century Lowlands was something of a hot-house for unsupervised mystics and informal bands of lay-people gathering for devotion in private houses. Back in 1311, the Council of Vienne condemned the Beghards and Beguines, doubting their orthodoxy. Likewise, the mendicants wanted to stifle the emergence of any new orders. Suspicion reigned. Therefore, many of the Modern Devout, both men and women, folded into the Augustinian Canons whose practical spirituality seemed familiar. This allowed them to continue their program but with security and newfound respect. So, in 1394, they formed what was known as the Windesheim Congregation of the Augustinian Canons Regular, effectively becoming a subset or branch of the Augustinian Canons. Multiple houses entered a union with Windesheim; by the next century the union included close to one hundred communities in the Low Countries and in Germany, although only thirteen of them were convents. This did not mean, however, that the Modern Devout were merely swallowed up in the Augustinian Canons and Canonesses. In 1417 the Modern Devout won considerable support at the Council of Constance, including the chancellor of the University of Paris, Jean Gerson. In the fifteenth century, many of the brothers and sisters of the Common Life continued their agenda of living as simple, self-sufficient communities without the formal vows of the Augustinians. They remained committed to their parish churches and declared their obedience to their local bishops. While they were still not a formal religious order (like Windesheim), many did use their time in the sister-houses or brother-houses as a testing ground for a religious vocation, many going on to join a monastic or mendicant order, the Augustinians being a favorite choice.

The Modern Devout stressed the relationship between the inner life and the external life, sometimes critical of Christians who were whitewashed tombs, beautiful on the outside but full of corruption inside. It is important to note that the Modern Devout's emphasis on interiority did not take them out of the world; indeed, they were involved in teaching,

working, and living in public view. Their concern was to connect the inner and the outer life as one. Moreover, unlike the Franciscans, the focus was simplicity, not poverty. Groote taught that one should learn to live without worldly comforts in order to be emotionally and spiritually detached from them, not that objectively having such possessions was itself bad. This contempt for the world, though, was not aimed at slipping into mystical rapture or affective ecstasies. In ascetical terms, the Modern Devout were practical and their goal was to imitate Christ. This imitation comes through a daily round of spiritual reading, meditation, prayer, and contemplation—all of which are interrelated. Here an adage of the earlier Carthusians was certainly in play: spiritual reading prepares for meditation, meditation prepares for prayer, and prayer prepares for contemplation. The corollary, according to Guigo II (d. 1188), master of the Grand Chartreuse, is that reading without prayer is arid, meditation without reading is erroneous, prayer without meditation is tepid, meditation without prayer is fruitless, and contemplation without prayer is rare or miraculous.[4]

The Modern Devout were adept at developing techniques for prayer. For example, one method was to stroke the thumb across the other fingers while reciting the psalms, and on each finger the devotee would remember a prayer intention. Each brother and each sister were to keep a notebook recording *raparia*, adages or ideas which helped them in their prayer. Then, at different times, everyone would share what was helping them in their prayer-life. This rhythmic, practical spirituality not only eschewed affectionate raptures, but also the speculative theology of scholasticism. Thomas Kempis, a figure discussed below, wrote "What good does it do to speak learnedly about the Trinity if lacking humility you displease the Trinity. . . . What would it profit us to know the whole Bible by heart and the principles of all the philosophers if we live without grace and the love of God." Thus we can speak, in a very general but not air-tight way, of the Dominicans' speculative tendencies, the Franciscans' affectionate sensibilities, and the Modern Devout's emphasis on the practical.[5]

The most important name among the Modern Devout is Thomas Kempis (c. 1380–1471) and the most important book of the movement was his *Imitatio Christi*, a work which has in fact been published more often than any other book save for the Bible itself. Thomas Hamerken, better known as Thomas of Kempis or Thomas Kempis, was educated at Deventer among the Brethren of the Common Life and then joined the Augustinian Canons at Zwolle. This house was one of several communities that collectively made up the Windesheim Congregation, a subset of the Augustinian Canons. He took the Augustinian habit in 1406 and spent the rest of his life there, often being sought out as a spiritual director. Regarding the *Imitatio Christi*, we cannot say without doubt that Thomas Kempis was the author. At the very least we can say that in the

1420s he was the editor of the text, a compilation of earlier wisdom which reflects the unoriginal nature of the Brethren of the Common Life. One very likely theory is that the *Imitatio Christi* was drawn out of those notebooks of *raparia* that each brother was to keep. The text is divided into four books. The first, "Helpful Counsels," focuses on clearing one's heart and mind and, importantly, one's daily life from the obstacles in the way of imitating Jesus. The second book, "Directives for the Interior Life," focuses on clearing the conscience. Third, "On Interior Consolation," shifts genre, presenting itself as a dialogue between a disciple and Jesus and the emphasis is on desiring Jesus over everything else. The fourth book, "On the Blessed Sacrament," continues this dialogue, sharing how to prepare to receive the Eucharist. This is bound up in wanting nothing above Christ and the fourth book stresses how one is joined with God in the Eucharist and thereby grows in obedience to God.[6]

We have so far distinguished the practical spirituality of the Modern Devout from other contemporary groups, the Franciscans and Dominicans, and emphasized that it was shared by the broader Augustinian tradition—both the Augustinian Canons and the Augustinian Friars. But there is another comparison to be made. Looking forward, a reasonable question is to what extent did the spirituality of the *Imitatio Christi* influence a later and rather famous Augustinian Friar named Martin Luther. First, Luther shared with the Modern Devout an intense focus on Christ's passion, particularly his crucifixion. A focus on the sufferings of Jesus, the "Man of Sorrows" is of course a late medieval commonplace in both art and literature and the *Imitatio Christi* was both a product of that period as well as a tool to reinforce its sensibilities. In the sixteenth century that fixation only intensified, Luther himself being known for his "theology of the cross." Beyond this, however, there is a major rupture between the ascetical program of the Modern Devout generally and the *Imitatio Christi* specifically on the one hand and Martin Luther on the other. The *Imitatio Christi* works by fusing the knower and the known, the disciple and the crucified Christ himself. Luther, while focused on the crucified Christ, approached him from an entirely different perspective. For Martin Luther, there is no moral sense to the cross. Testified to in scripture, it was a payment made by Christ to atone for the sins of humanity. In other words, the cross is not about an interior experience but an external promise. To borrow from another historian: for Luther, faith is defined not as a process of internalization of paradigmatic acts, but rather as a perception of meaning and as trust in God's promise. For Luther, seeing the cross offers a deepening awareness that Christ—a figure at a particular moment in history—has accomplished something on one's behalf. For the Modern Devout, though, seeing the cross was an invitation to participate in the sufferings of Jesus, to walk the paths that he walked. Their practical goal, unlike Luther's, was to be joined to God through imitating

Christ, joining in his sufferings, dying with him daily to live in him eternally.[7]

REFORMATION IN HEAD AND MEMBERS: CONCILIARISM

At the same time Beguines and the Modern Devout emerged in northern Europe to offer new outlets for Christian practice, the hierarchy of the church, specifically the papacy, crashed into a series of challenges. At the start of the fourteenth century, the pope was an international political player like other monarchs, and Pope Boniface VIII (r. 1294–1303) found himself in a grand wrangle with King Philip IV of France over taxes and church revenues. This struggle included Boniface making claims to universal spiritual and temporal authority (over kings and emperors) in his bull *Unam Sanctam* (1302) and the dramatic kidnapping of Boniface by Philip's henchman Guillaume de Nogaret in the following year. Though released, Boniface died within a month. In 1305, however, the archbishop of Bordeaux was elected Pope Clement V (r. 1305–1314) and this new French pope filled the college of cardinals with his fellow countrymen and, in 1309, moved the papal court to Avignon. While technically in the Holy Roman Empire, Avignon was situated on the border formed by the River Rhône and was for all practical purposes a French community. For the next sixty-eight years, the popes—who were still the bishops of Rome and rulers of the papal states in central Italy—would reside in Avignon, a phenomenon which the Italian humanist Petrarch (1304–1374) called "the Babylonian Captivity," a reference to the time the Jews spent in exile (585–536 BC). During those years, the bureaucracy and fiscal savvy of the papal court grew by leaps and bounds, drawing seemingly ordinary administrative matters which would previously have been handled by local bishops to the papacy and then, of course, exacting fees. Also, when it came time to install new bishops, the popes pushed their own candidates against those of the monarchs. Curiously enough, the papal candidates were often better educated and skilled, as the local candidates were usually the younger brothers of nobility. The perceived avarice of these politically pro-French popes living in Avignon far from the apostolic city of Rome was a scandal, one which led to cries for the reform of the papacy itself, not just in terms of residence but in manner of life.

In 1377, due in no small part to the pleas of the mystic Catherine of Siena (discussed in chapter 4), Gregory XI (r. 1370–1378) returned the papal court to Rome, a city which had severely deteriorated over the past seventy years. Unfortunately, Gregory died soon after the move and the Roman mob rose up and demanded that the cardinals elect an Italian and not another Frenchman. In response, they elected the Italian Urban VI (r. 1378–89) who was, in an epic sense, the wrong man at a critical mo-

ment: he was brutish, acerbic, and even struck one of the cardinals. Within months, the French cardinals abandoned Rome, declared that Urban's election was forced on them by the mob and therefore null, and elected Clement VII (r. 1378–1394) who swiftly reestablished a papal court at Avignon. As each kingdom and territory in Europe decided which pope—Roman or Avignonese—to support as the true heir of St. Peter, the western church was divided in two. England for example supported the Roman pope while France supported the one in Avignon. This moment was therefore known as "the Great Western Schism." It should not be confused with the "Great Schism" which separated the Greek church in the east from the Latin church in the west in 1054 (see chapter 3 and the discussion of the Gregorian reforms).

Various solutions for healing the Great Western Schism emerged at this moment, the most workable being to call a General Council of the whole church. In 1408, both the Avignon and Roman colleges of cardinals (because now there were two of those bodies as well) agreed to call a council to solve the problem and to bring about much-needed reform. Gathered in 1409, the Council of Pisa deposed the Roman and Avignonese popes and elected a new pope. But neither the Roman pope nor the Avignonese pope accepted this, resulting now in three popes: Roman, Avignonese, and Pisan, each with loyal supporters and cardinals. With the scandal magnified, the Emperor Sigismund (r. 1410–1437) worked with the Pisan pope, John XXIII, to call a new council, the Council of Constance (1414–1418). In a striking turn of events, that gathering deposed and imprisoned Pope John, deposed the Avignonese pope, accepted the resignation of the Roman pope, and elected Martin V (r. 1417–1431) thus bringing the schism to its close.

The call for a council to resolve this sorry situation was not simply expedience. Many voices wanted to re-envision how the church should live and they rallied for the primacy of councils. This was known as concilliarism.[8] Since the high middle ages, certainly since Innocent III and the Fourth Lateran Council of 1215, the popes had claimed to hold *plenitudo potestatis*, complete authority over the church. The Concilliarist theologian and chancellor of the University of Paris Pierre d'Ailly (1350–1420) nuanced this claim by arguing that the whole church as a corporate body—including every baptized man, woman, and child—has *plenitudo potestatis*, and is represented and speaks through a council. The pope still has authority, but in an administrative sense. According to d'Ailly, full authority belongs "inseparably" to the whole church, "representatively" to a general council, and "separably" to the pope (meaning he may be deposed by a council). Jean Gerson (1363–1429), a student of d'Ailly and his successor as chancellor of the University of Paris, was the seminal voice at the Council of Constance. He argued that several circumstances would warrant the calling of a council against a pope's wishes and would even empower a council to depose a pope. Some of

Gerson's circumstances included if a pope becomes insane, slips into heresy, or is held hostage by heathens. Taking their cue from Gerson, the Council of Constance issued two critical decrees on this subject: *Haec Sancta* (1415) declared that a General Council has authority directly from Christ and therefore all faithful Christians, including the pope, must obey its decisions while *Frequens* (1417) took the amazing step of calling for a general council every ten years. It should also be noted that this advocacy for councils followed along the familiar lines of primitivism we have observed throughout this book. The hope was, in the words of Nicholas of Cusa, to return the church to its first form.[9] In the wake of Constance, however, both *Haec Sancta* and *Frequens* were sidelined by a resurgent papacy. Martin V fulfilled his duty by calling the Council of Basel in 1431 but the council splintered and a new pope, elected on Martin's death, swayed public opinion with the possibility of reunion with the Greeks. While that reunion did not last, the papacy was once more supreme and in 1460 Pope Pius II issued his bull *Execrabilis* condemning the idea that councils are above popes. As the sixteenth century opened, then, the popes were often shrewd politicians who expanded the papal monarchy. Fantastic examples include the Borgia pope Alexander VI (r. 1492–1503), infamous for siring children during his papacy, and the "warrior pope" Julius II (r. 1503–1513) who personally led troops into battle twice. Concilliarism reached a low ebb when the Fifth Lateran Council (1512–1517) declared the pope' supremacy over councils and his sole authority to convoke, transfer, and close them.

That trajectory, however, was not predestined; there were real possibilities for conciliarist reforms in the early fifteenth century. The Council of Constance had a three-fold agenda: resolve the schism by unifying the papacy, purge the church of the heresies of Wycliffe and Hus (who were themselves reformers; see the next section of this chapter), and bring about much needed reform in church structure and morals. But what reforms were the conciliarists seeking? Obviously, these voices, often university theologians, wanted to see the papal monarchy checked by a representative council. But there was more. A common phrase, one that appeared in *Haec Sancta*, was reform "in head and members," meaning that reform must be exacted at the upper echelons of the hierarchy and in the life of the local parish. More prayerful, educated, and morally-upright priests would lead to prayerful, catechized, and morally-upright Christians. The same would be true of bishops, cardinals, and popes. Pluralism, for example, the practice of one cleric having multiple offices for the revenue (and consequently neglecting the actual dioceses, monastic houses, and parishes) was a specific target. And we should not be at all surprised that the primitive church was regularly invoked as the goal and paradigm. Often, though, some who recognized the need for reform focused only on the "members," rather than the "head." Clear examples have been discussed above—the Beguines and the Modern Devout. We

should not miss that at roughly the same time the "head" was split into three (i.e., three popes), the Modern Devout turned inward, focusing on personal reform and utilizing an interior piety. At that moment, likewise, many monastic orders faced a call for stricter observance of their foundational rules, a phenomenon known as "observants."

Education was also a concern. The study of canon law was the road to clerical advancement, but many felt that priests needed better pastoral training and so manuals began to appear, for example, John Mirk's *Instructions for Parish Priests* (c. 1400). Pierre d'Ailly was quite concerned with training in scripture and improved preaching. Gerson called for a seminary in every diocese (foreshadowing the work of the sixteenth-century Council of Trent), pressed that larger parishes should develop theological schools, and, likewise, worked to root out (as best he could) the odious problem of sexual abuse of schoolboys. Conciliarists, though, were committed to reform not only in members but in the head too, and the idea that a council is superior to the pope was a refrain that appeared again among sixteenth-century reformers, both Catholic and evangelical. Those calls in the sixteenth century were therefore not new, but rather a continuation of earlier conversations about the way the church ought to live.[10]

BURNING CONVICTIONS: WYCLIFFITES AND HUSSITES

We should begin our discussion of the Wycliffites (aka Lollards) and Hussites by recognizing that most of the old narratives of the sixteenth-century reformations begin by characterizing two men, John Wycliffe in England and Jan Hus in Bohemia (today the Czech Republic) as proto-protestants. In other words, the story of these men has often been used as prologue to a greater story which begins with Luther and his Ninety-Five Theses. If, however, we see the reformation movements of the sixteenth century as both plural and part of a series of reform movements stretching back to the eleventh century, then we can see Wycliffe and Hus in their own context. We will find that, even though Wycliffe had notable similarities with sixteenth-century reformers, at times the movement he inspired had more in common with other contemporary movements for religious change, even the Cistercians, than with Martin Luther or John Calvin.

John Wycliffe (1330–1384), who was a contemporary of Geert Groote and who died in the same decade Thomas Kempis was born, was the *cause celebre* of reform movements in both fourteenth-century England and Bohemia while also, perhaps unwittingly, playing a role in the political controversies of his day. A secular priest who achieved the doctorate in 1372, Wycliffe engaged in a number of high-profile disputes in Oxford through that decade. Over the course of a career which included teaching

and preaching in academic and parish settings, Wycliffe argued that the Bible alone was the source of Christian teaching, that the power of the papacy was not founded in scripture, that priests in sin could not validly celebrate the sacraments, that clerics ought not to own property, and that the church ought to submit to secular justice. He denounced devotion to the Eucharist and challenged the doctrine of Transubstantiation. He argued that the Eucharist was growing in superstitions and he believed the Mass was increasingly divorced from what he saw as its moral and spiritual effects. By the mid-1370s, however, Wycliffe was also in the service of the powerful duke of Lancaster, John of Gaunt, and when the hot-headed theologian was summoned to appear before an assembly at St. Paul's Cathedral in London in 1377 to account for his potentially heretical ideas, Gaunt appeared with him, turning the meeting into a fiasco: the duke threatened to drag the bishop of London, William Courtney, out by his hair. The bishops then appealed to Rome with Wycliffe's most offensive text *De Civili Dominio* as their evidence. Although Pope Gregory XI (r. 1370–1378) demanded that Wycliffe confess his errors, by the time the papal bulls against him reached England, the aged King Edward III had died and Gaunt was the protector of the new boy-king Richard II. Wycliffe was thus protected from all ecclesiastical courts.

Pope Gregory died a year later, having just moved the papal court back to Rome from Avignon, and Wycliffe was excited by the election of Urban VI (r. 1378–1389) who seemed favorable to reform. Wycliffe even wrote to Urban defending his ideas. The church in the west, though, was not on the precipice of reform, but rather schism. As discussed above, Urban was a brute elected under pressure and many cardinals fled Rome and elected a competitor pope, Clement VII, who took up residence once again in Avignon. Wycliffe left Oxford in 1381 for parish work in Leicestershire and the last years of his life proved to be remarkably productive, all while engaged in active ministry. In early 1382, Bishop Courtenay was made archbishop of Canterbury and in May convened a council to extirpate the spread of Wycliffe's ideas. Notwithstanding a freak earthquake during the meeting, the so-called Earthquake Council was a success: Courtenay began his campaign to root out Wycliffism at Oxford itself. The man whose name the movement bore, however, died peacefully in his parish two years later in 1384.[11]

Even before his death, Wycliffism had taken on a life somewhat apart from the voluminous Oxford scholar. In the summer of 1381 a popular uprising initially about taxes spread through much of the southeast, eventually burning a path to London. Known as the Peasant's Revolt, the mob had as one of their leaders a priest named John Ball who seemed to be influenced by Wycliffe. Thus, over the next century, Wycliffism was fearfully associated with revolt, agitation, and assaults on the status quo. The movement also acquired the epithet "Lollards," a word that may mean "mumbler." Lollardy was not the only reformist phenomenon tied

to Wycliffe. In 1382, King Richard II married the queen of Bohemia thus drawing a good number of visiting Bohemian theology students to Oxford where, although Wycliffe had left, his ideas remained. Soon enough the theologians of the Charles University in Prague were enamored with Wycliffe's perspective. Jerome of Prague (c. 1373–1416) and Jan Hus (c. 1373–1415) thus became major advocates for a reform program inspired by Wycliffe. To this day the largest collection of Wycliffe's writings is held by the Charles University. The Hussites drew the ire of both the emperor as well as the pope, and Jerome and Hus were executed for heresy—Hus dramatically so at the Council of Constance in 1415. That same council, meeting some thirty years after Wycliffe's death, declared him to be a heresiarch (the founder of a heretical movement) and ordered his bones to be exhumed and burned.

What of the image of Wycliffism as proto-Protestantism? And what of Lollard spirituality? First it should be clear that Wycliffe and Wycliffism are not coterminous. The man himself was incredibly productive and also developed in his thinking over time. The movement was diffuse and complex, not easily distilled into a few markers. That, however, is not the only caveat about studying Wycliffe. It is also common to draw a line from the man and the movement to sixteenth-century reforms. The Protestant hagiographer John Foxe (1516–1587) certainly included Wycliffe in his *Book of Martyrs* while Foxe's co-religionist John Bale dubbed Wycliffe "the morning star of the reformation." English translations of the Bible inspired by Wycliffe cropped up during the 1390s, evincing both his and the movement's commitment not only to scripture, but also to reading scripture, as the foundation of Christian life and thought. Two hundred and fifty of these translations remain, a phenomenal number for a medieval text. By comparison, there are only sixty-four copies of Chaucer's *Canterbury Tales*, a work from the same period. However, Wycliffe himself was not committed to a *sola scriptura* theology, nor did he believe that the reader only needed faith to comprehend the Bible properly. His being a forerunner of Luther is not black and white.[12]

Looking in the other direction, Wycliffe himself was not completely novel: the Waldensians starting in the twelfth century called for vernacular translations, an egalitarian church, and moral reform. Turning to yet another subject, Wycliffites had the same hunger for an apostolic life that energized many of the medieval groups we have encountered in this study; Wycliffe's animus against religious orders was not because of their way of life, but rather their adherence to a man-made rule. In his opinion, scripture itself contains the only truly Christian *regula*. Similar to the Franciscans, Lollards were very concerned about evangelical poverty. They diverged, however, by interpreting the gospel command to be poor in spirit, not necessarily in material possessions. On the other hand, this did not stop many Wycliffites from demanding the church give up property. Wycliffites also aimed to develop rules of life that would allow the

cultivation of holiness, making them remarkably similar to the Modern Devout and the Beguines and Beghards. In some respects, we can even argue that they shared a commitment to a regulated life with the Cistercians. This quest for spiritual perfection, however based on scripture, was hardly the aim of Martin Luther. In yet another area of convergence and divergence, toward the end of his life Wycliffe did begin using the language of "antichrist" in relation to the papacy, a typical habit of later Protestants. But for most his career he recognized the spiritual primacy of the Roman see at least for practical purposes.[13]

It should be clear that the Wycliffites prized scripture above all things; Wycliffe even understood himself as simply expositing the "logic of scripture," often focusing on scripture through the lens of law and command. While the Modern Devout focused their pastoral reflections on the seven deadly sins and the seven virtues, Wycliffite literature swells with discussion of the commandments, Matthew 19:17 "if you will enter into life, keep the commandments" being a favorite passage. This sense of pure living was bound up with their sense of being an embattled minority and part of the "true church of those that shall be saved." Lollards, like Wycliffe himself, were committed to a predestinarian theology, but one not all that dissimilar from Augustine and other medieval Christians. Their perspective was that God has chosen some for eternal life, but others are left to perdition. This is surely not the "double predestination" one finds in later Reformed theology. For Wycliffe and the Lollards, the damned are responsible for their own damnation and, moreover, no one knows into which category he or she falls. One, therefore, strives to keep the commandments and perseveres in hope. While they judged confession to be a good thing, the Lollards regularly challenged that such had to be made to a priest. On trial, one Wycliffite woman even said that she had never wronged a priest, so she had no reason to confess to one.[14]

Even with the long list of errors developed by bishops and popes, Lollardy resists neat definitions. While they certainly read Wycliffe's writings, the movement found popularity among tradespeople and artisans rather than academics. Never all that organized, Lollardy often flared up and was put down through the fifteenth century. It should be noted, perhaps by way of summary, that Lollards, for the most part, did not "break away" from their parishes or communities so much as not fully participate in them. By identifying the true church as invisible and by giving spiritual priority to the immaterial and internal (privileging the quality of one's disposition, for example, rather than the tangible act of receiving the sacraments or offering money for the poor), they challenged the stable structures of church life. Legislation passed in 1401 brought the practice of burning heretics to England, and the first victim was John Badby, a tailor convicted of Lollardy in 1409. Likewise, Archbishop Thomas Arundel forbade the translation of scripture into the vernacular, a prohibition targeting Wycliffites and which would be supported by the

crown for a century. Perhaps Lollardy's lasting contribution was the sense that practice and belief ought to be grounded in scripture. Only in a qualified way can we say this movement paved a path for Protestantism.[15]

The Hussites in Bohemia, while related, are a slightly different story. Unlike the Lollards, the Hussites were able to rouse an entire nation, providing a rallying point for Czech identity. Jan Hus, who eventually became rector of the Charles University, became an ardent defender of Wycliffe's ideas by 1403. In particular, Hus latched onto Wycliffe's ideas about dominion. Wycliffe had taught that God has dominion over all things in heaven and earth, and all ownership among men is secondary, a work of stewardship perhaps. He also argued that one's authority was based not on any inherent right (whether noble descent or even priestly ordination), but rather on moral worthiness. Certainly when this sensibility was applied to the sacraments, they sounded like the Donatists of the fourth century, heretics who had taught that only the morally upright among the clergy could provide valid sacraments. Augustine, among others, had written firmly against this view, insisting that the sacraments rest on Christ's grace for sinners, not on human worthiness. Whether Wycliffe and Hus were truly guilty of Donatism is debatable. It seems beyond argument, however, that morality was central for them both. Bohemian theology even stressed that faith was initiated by works, an articulation quite distant from Luther's "faith alone." The law of God was at the heart of both movements in England and Bohemia.[16]

Hus gained a number of followers, rallying around ideas that sprang from Wycliffe: naturally they called for vernacular translations of scripture and worship in the common tongue, were animated against monasticism, pilgrimage, and relic cults, and most notably they demanded that all communicants receive the chalice at the mass, an element normally reserved for the celebrating priest. As a result of this demand, the Hussites were also known as Utraquists, meaning in both kinds, and Calixtines, from the Latin word for chalice. For his bold preaching, Hus was summoned to appear before the Council of Constance (see the preceding section of this chapter). Before he left for the council, Hus had the archbishop of Prague write a letter affirming that Hus diverged from Wycliffe in one critical area: unlike Wycliffe, Hus did not reject transubstantiation. When Hus appeared before the council, he tried in vain to redeem Wycliffe's teachings and on July 6, 1415, Hus found himself burned at the stake. This execution, though, galvanized his followers in Bohemia and by 1420, there were violent revolts. Hus' followers even had a radical subset called Taborites who wanted to build a sort of eschatological utopia. In that same year, the Hussites developed the Four Articles of Prague as a summary of their demands: the chalice must be given to all, the preaching of God's word must be free, clergy must give up pomp and live modestly, and sin must be purged from society. At the Council of

Basel in 1431, the mainstream Hussites presented these four points, and the Catholics acquiesced at least to the first article about the chalice. This in effect granted the Bohemian church a degree of practical leeway. In other words, out of practical necessity, the Hussite church was recognized by, though independent of, Rome. Without a bishop, their candidates for the priesthood still received episcopal ordination, but curiously in Venice. The radical wing, however, refused compromise and formed the Unity of the Brethren, a movement later known as Moravians (see chapter 11). Despite the burning of Hus, the bloody revolts, and the Bohemian church's ongoing semi-independence (which is usually stressed by historians), Basel marks a rare moment of accepting diversity in the late medieval church, possibly a kind of mixed economy within the Latin west that proved impossible a century later.[17]

SPIRIT OVER FLESH: HUMANISM

A hallmark of the Modern Devout was their stress on interiority, or at the very least connecting the outward, practical habits of life with a sincere interior disposition. That emphasis on the interior was certainly shared by a late medieval reform movement which is often understood to birth "early modernity" itself, Humanism. Beginning in southern Europe, specifically within the context of late medieval universities, Humanism first manifested as a shift in academic curricula. All the variants of medieval scholastic theology had operated by attempting to systematize the general, supposedly immutable truths of natural philosophy. Humanism, on the other hand, refocused on human interactions. Humanists looked at a text and asked: What is the context? Who was the original audience? For whom was the ancient author writing? Scholastics did not usually ask questions like these. So, Humanists would take the same texts read by the scholastics (scripture for example) but approach them quite differently. This movement, therefore, was interested in the mundane life of the laity, the everyday experiences of women and men out in the world. While Humanism emerged in the fourteenth century among Italians like Francesco Petrarch (1304–1374), it spread north in the following centuries and raised considerable challenges to scholasticism there as well as in Italy. The movement even numbered the sister of King Francis I of France, Marguerite de Navarre (1492–1549). Her poetic *Mirror of the Sinful Soul* (1531) explores a personal relationship with God through familial archi-types found in scripture, for example, Moses' sister Miriam, the mother with a dead child before Solomon, and the Prophet Hosea's adulterous wife. These stories, rich with pathos, spoke at the level of human relationships, and Marguerite's *Mirror* is a clear example of the Humanist reorientation.

While there are scores of other Humanists to discuss, the focus of this section will be on the star of the movement, one who best captured its contours and sensibilities—the sixteenth-century Dutch priest Desiderius Erasmus (1466–1536).[18] Born in Holland, Erasmus was educated in a school led by the Brethren of the Common Life. In 1486, he entered an Augustinian priory and five years later was ordained priest. He then studied in Paris at the Collège de Montaigu (the same school which would later educate both John Calvin and Ignatius of Loyola). Erasmus became an early modern celebrity for his scholarship on the early church Fathers and for his biting wit in more popular texts. He was a universal European, unbound by nationality, whose works were read across the continent and in Britain. In the early sixteenth century, Erasmus was a much-sought celebrity and a constant guest in locations ranging from the home of his good friend Sir Thomas More, the Lord Chancellor of England, to the publishing houses of Basel. For this reason, in 1987, the modern European Union selected Erasmus as the name and poster-face for their higher education exchange program. He was, fundamentally, a textual scholar and his single greatest work was his Greek New Testament published in 1516. This was followed by a nineteen-volume critical edition of the works of the fourth-century church Father Jerome. Erasmus left a total of thirty folio volumes of critically edited patristic texts. Among his original works, *Praise of Folly* (1509) and *Colloquies* (1519) mocked the mainstream religious conventions of his day as superstitious. His writings were so popular that even Pope Leo X (r. 1513–1521) reportedly found Erasmus accurate and funny. Beyond his wit, however, these works reveal a mainstay of Humanism: a hunger for an imagined golden age marked by an apostolic simplicity free from the complexities of scholasticism, the perceived superstitions of most late medieval devotions, and the pomp of the contemporary church's hierarchy. And like other Humanists, Erasmus emphasized a practical Christian morality. For example, his *Enchiridion Militis Christiani*, or in English *A handbook for the Christian soldier* (1503) was meant to persuade a man to ethical living. This would prove a critical difference from one of Erasmus' contemporaries.[19]

When, in 1517, Martin Luther (1483–1546), a rather obscure professor from a new university in Wittenberg, caused a sensation by challenging the practice of selling indulgences, Erasmus thought he had found a kindred spirit in his own attack on clericalism and ritualism. Luther, on the other hand, later admitted that he was suspicious of Erasmus. The German monk thought that Erasmus reduced Christ to an ethical exemplar rather than a gracious savior. Here we find the unmistakable chasm between Erasmus and Luther. While Luther saw humanity as deadened by sin and in desperate need of God's gracious intervention, Erasmus believed that each individual has the potential for good and for evil. In his estimation, by doing good, one becomes good; by doing evil, one be-

comes evil. According to Erasmus, sin impedes the individual in the pursuit of the good Christian life. For Luther, however, sin is more than an external stumbling block to doing good things; sin envelopes humanity as an existential condition (comparable to disease or addiction) and only God can pull humanity out of sin's death grip. As was custom, the two men engaged in a controversy through written polemical texts in the mid-1520s; the subject was whether and to what degree human beings are neutral agents, the freedom or bondage of the will, the nature of sin, and the process of salvation. Erasmus argued for the freedom of the will and that Christians cooperate with Christ. Luther argued instead that the human will is in bondage to sin and Christ is the gracious liberator. As noted, Luther was already skeptical of Erasmus. In 1517, the same year he wrote the Ninety-Five Theses, Luther confided to a friend:

> I am now reading Erasmus and each day my estimation of him decreases. I am pleased that he exposes the ignorances of the monks and priests, but I fear that he does not sufficiently promote Christ and the grace of God. . . . Although it is with a heavy heart that I sit in judgement on Erasmus, I must warn you not to accept everything you read [from him] uncritically. These are perilous times in which we live, and I now can see that not everyone is a Christian or truly wise just because he can read Greek and Hebrew. St. Jerome had five languages, yet he did not equal Augustine who had only one, although Erasmus has seen the matter differently. But the judgement of one who attributes something to the will of man [in salvation] is one thing, and that of him who confesses nothing but grace another.

In short, Luther cast Erasmus as a Pelagian who taught salvation through works rather than grace, a depiction not entirely undeserved. Luther, however, was not his only critic. Erasmus also succeeded in arousing suspicion among Catholic authorities. After his death in 1536, Erasmus was cast as the inspiration for the reformations of the sixteenth century (a designation Luther may have found odd). Consequently, in 1559, Pope Paul IV banned his works. Later, after the Council of Trent concluded in 1563, some of Erasmus' works were permitted to circulate in Catholic countries but only in edited forms.[20]

In his *Enchiridion*, Erasmus addresses humanity's internal warfare, the struggle each individual has with sin. He writes that each person is divided between a lower carnal self and a higher rational spirit. This kind of anthropology and attitude to the material world shows very clearly Erasmus' fondness for the early Christian writer Origen (d. 253) and for the Platonizing tendencies of some of the early church Fathers, certainly those who had lived in Alexandria, Egypt. And Erasmus would instill this sensibility among the early Reformed, especially Ulrich Zwingli and Johann Oecolampadius, and through them the Anabaptists—all of whom had a low view of the material world and an exalted view of a Platonic spiritual reality. This attitude was distant both from the earthy world of

medieval devotion and the equally earthy vision of Martin Luther. For Erasmus, every person must make a free choice between the pull of the carnal body and the pull of the higher rational spirit. To make the right choice (that of the spirit), the Christian has two principal weapons in his armory: knowledge and prayer. Prayer is a transcendent experience, getting increasingly farther away from the material world. Knowledge, understood as discrimination, is cultivated by reading scripture and then pagan poets and philosophers, and then thirdly some of the early church Fathers, more Jerome and Origin and to a lesser extent Augustine. This path of prayer and reading, he says emphatically, is not a course of study but a method to refashion one's life. We cannot forget that Humanists, much like the Modern Devout, were imminently practical. But from this same posture, Erasmus ramped up his criticism of rote prayers, or mumblings as he called them. That kind of devotion was driven, he writes, by the spirit of the world, not the higher spirit. This Platonic dualism pervades Erasmus' thinking: for Erasmus, the "Christian Soldier" averts the world, the flesh, and the devil by a particular way of ethical living, and thereby he continually ascends higher and higher. It is likely that the *Enchiridion* inspired the artist Albrecht Dürer to produce his "Knight, Death, and Devil" (1513). The evocative image depicts a questing knight beleaguered by Satan and his own mortality. See figure 5.1.

Erasmus did not write systematic theology. For him, Christianity was oriented toward the Christian life, its practices and moral habits. We heard, above, Luther's condemnation of Erasmus as potentially Pelagian. But Erasmus had a response to that kind of critique. In a letter in 1529, he wrote:

> Look around on this "Evangelical" generation, and observe whether amongst them less indulgence is given to luxury, lust, or avarice, than amongst those whom you so detest. Show me any one person who by that Gospel has been reclaimed from drunkenness to sobriety, from fury and passion to meekness, from avarice to liberality, from reviling to well-speaking, from wantonness to modesty. I will show you a great many who have become worse through following it. . . . The solemn prayers of the Church are abolished, but now there are very many who never pray at all.[21]

On the one hand, Erasmus did not want people mumbling rote prayers. In his *Colloquies*, for example, he called rosary beads "snake eggs" and portrayed pilgrims as fools. But, on the other hand, Erasmus was supremely interested in practice, even if it might devolve into external formalism or gross superstition. So, in Erasmus' estimation, Luther's talk of faith and grace was not producing changed lives—and that was, for Erasmus, the whole point of Christianity.

To understand Erasmus and, by extension, Humanism, it is critical to recognize his stress on the cleavage between spirit and flesh. While em-

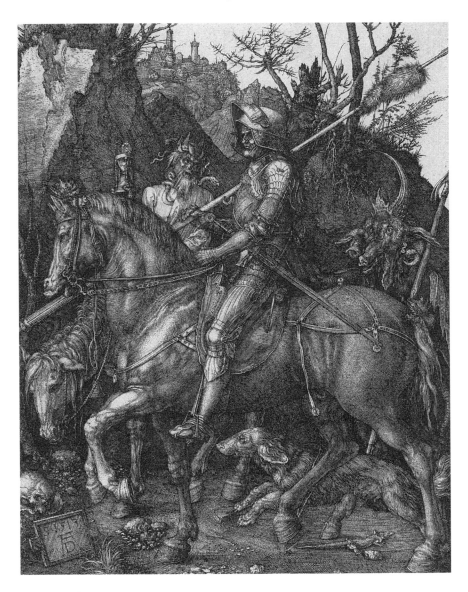

Figure 5.1. Albrecht Dürer, Knight Death and the Deviol, 1513. Harris Brisbane Dick Fund, 1943, Metropolitan Museum of Art, New York, NY. Accession Number: 43.106.2. https://www.metmuseum.org/art/collection/search/336223.

phasizing practice, his goal was not a retreat into medieval forms of asceticism so much as privileging everyday life as ruled by the spirit not the flesh. This was, for Erasmus, the "philosophy of Christ." In varying degrees, this emphasis on a higher spiritual sensibility that transcends

the material world will be present among the early Reformed, especially Ulrich Zwingli, as well as the Anabaptists. In a later chapter, we will naturally find the Reformed more interested in the allegorical sense of scripture, especially on the question of what Jesus meant when he said "this is my body," than the Lutherans who were more attached to the literal. Likewise, in their sacramental theology and their perspective on art and sacred space, both the Reformed and the Anabaptists eschewed the material, sometimes drawing very hard-lines between spirit and flesh. The fountainhead for this thinking was Erasmus.[22]

PUSHING THE BOUNDARIES

The fourteenth and fifteenth centuries are paradoxical. On the one hand, as Eamon Duffy has shown us, many Christians were completely happy with the rich devotional life of their parishes, the mass, their shrines, community ales, etc.[23] At the same time, however, there were several high-profile movements for reform, many of which clearly utilized the same language of primitivism and a vision of the apostolic life used by high medieval reform movements, for example the Benedictine renewal led by the Cistercians or the rise of the mendicants in the twelfth and thirteenth centuries. The irony is that those boundaries pushed against in the later middle ages by Beguines and Beghards, the Modern Devout, the Conciliarists, the Wycliffites and Hussites, and the Humanists were boundaries established by earlier reformist groups. Moreover, just like earlier movements, many of these late medieval movements overlapped. The Conciliarist Pierre d'Ailly and John Wycliffe were certainly not friends—but they were both concerned with the state of the church, education, and the moral life. The same could be said of Humanists and the Modern Devout. Similarly, the English poet William Langland, while likely not an Lollard, displayed many of Wycliffe's concerns in his popular poem *Piers Plowman*, a text quoted by none other than John Ball, one of the leaders of the Peasants' Revolt of 1381. All of this highlights a common vocabulary of reform in the fourteenth and fifteenth centuries, a spirit—at times iconoclastic—looking for new ascetical avenues, purified forms of the Christian life, and fresh-yet-old conceptions of true apostolic faith. This is not to say, as older textbooks have, that these movements simply *presaged* the sixteenth-century reformations, but rather that there was an ongoing stream of reform movements at work both challenging old boundaries and conceiving new ones according to primitivist impulses.[24]

Chapter 5

NOTES

1. Walter Simons, *Cities of Ladies: Beguine Communities in the Medieval Low Countries, 1200–1565* (Philadelphia: University of Pennsylvania Press, 2001), 24–34; Phillip Sheldrake, *Spirituality and History* (London: SPCK, 1991), 141–67; Tanya Miller, *The Beguines of Medieval Paris* (Philadelphia: University of Pennsylvania Press, 2014), 1–13; Ernest McDowell, *The Beguines and Beghards in Medieval Culture* (New Brunswick, NJ: Rutgers University Press, 1954).
2. Simons, *Cities of Ladies*, 118–43; Penelope Galloway, "Discreet and Devout Maidens: Women's Involvement in Beguine Communities in Northern France, 1200–1500" in Medieval Women in their Communities, ed. Diane Watt (Toronto: University of Toronto Press, 1997), 92–115; Claire Taylor Jones, *Ruling the Spirit: Women, Liturgy, and Dominican Reform in Late Medieval Germany* (Philadelphia: University of Pennsylvania Press, 2018), 1–13; Anne Winston-Allen, *Convent Chronicles: Women Writing About Women and Reform in the Late Middle Ages* (University Park, PA; Pennsylvania State University Press, 2004).
3. Caroline Walker Bynum, "Religious Women in the Later Middle Ages" in *Christian Spirituality: High Middle Ages and Reformation*, ed. Jill Raitt (New York: Crossroad, 1987), 121–39; Dennis Devlin, "Feminine Lay Piety in the High Middle Ages: The Beguines," in *Medieval Religious Women*, ed. John Nichols and Lillian Shank (Kalamazoo: Cistercian, 1984), 183–96.
4. Alister McGrath, *Christian Spirituality: An Introduction* (Oxford: Blackwells, 1999), 85.
5. Otto Grundler, "Devotio Moderna" in Raitt, ed., *Christian Spirituality*, 176–93; John Van Engen, *Devotio Moderna: Basic Writings* (New York: Paulist, 1988), 12–35; Idem, *Sisters and Brothers of the Common Life: The Devotio Moderna and the World of the Late Middle Ages* (Philadelphia: University of Pennsylvania Press, 2008); Wybren Scheepsma, *Medieval Religious Women in the Low Countries* trans. David Johnson (Woodbrdridge, UK: Boydell, 2004); Bernard McGinn, *The Varieties of Vernacular Mysticism (1350–1550)* (New York: Crossroad, 2012), 96–124.
6. John-Julian, *The Complete Imitation of Christ* (Brewster, MA: Paraclete, 2012).
7. Steven Ozment, *The Age of Reform, 1250–1550* (New Haven: Yale University Press, 1980), 96–98.
8. Francis Oakley, *The Conciliarist Tradition: Constitutionalism in the Catholic Church, 1300–1870* (Oxford: Oxford University Press, 2003), 20–110.
9. Paul Avis, *Beyond the Reformation? Authority, Primacy and Unity in the Conciliar Tradition* (London: T&T Clark, 2006), 71–108; Phillip Stump, *The Reforms of the Council of Constance (1414–1418)* (Leiden: Brill, 1994).
10. Christopher Bellitto, "The Reform Context of the Great Western Schism," in *A Companion to the Great Western Schism* ed. Joëlle Rollo-Koster and Thomas Izbicki (Leiden: Brill, 2009), 303–31.
11. Stephen Lahey, *John Wyclif* (Oxford: Oxford University Press, 2009), 1–31; Richard Rex, *The Lollards* (New York: Palgrave, 2002), 25–53.
12. Lahey, *John Wyclif*; Kathleen Kennedy, *The Courtly and Commercial Art of the Wycliffite Bible* (Turnhout: Brepols, 2014).
13. Fiona Somerset, *Feeling like Saints: Lollard Writings after Wyclif* (Ithaca, NY: Cornell University Press, 2014); Patrick Hornbeck, *What is a Lollard? Dissent and Belief in Late Medieval England* (Oxford: Oxford University Press, 2010).
14. Patrick Hornbeck, Stephen Lahey, and Fiona Somerset, eds., *Wycliffite Spirituality* (New York: Paulist, 2013), 7–44; Wendy Scase, "Lollardy" in *Cambridge Companion to Reformation Theology*, ed. David Bagchi and David Steinmetz (Cambridge: Cambridge University Press, 2004), 15–21.
15. Robert Lutton, *Lollardy and Orthodox Religion in Pre-Reformation England* (Woodbridge, Suffolk: Boydell and Brewer, 2006); Peter Marshall, "Lollards and Protestants Revisited" in *Wycliffite Controversies* ed. Mishtooni Bose and Patrick Hornbeck (Turnout: Brepols, 2011), 295–318; Kantik Ghosh, "Wycliffism and Lollardy," in Miri Rubin

and Walter Simons, eds., *The Cambridge History of Christianity: Volume 4 Christianity in the West, 1100–1500* (Cambridge: Cambridge University Press, 2009), 433–45.

16. Thomas Fudge, "Hussite Theology and the Law of God," in Bagchi and Steinmetz, eds., *Cambridge Companion to Reformation Theology*, 22–27; Idem, *Jan Hus: Religious Reform and Social Revolution in Bohemia* (New York: Taurus, 2010), 75–94; Craig Atwood, *The Theology of the Czech Brethren from Hus to Comenius* (University Park, PA: Pennsylvania State University Press, 2009), 21–102; Diarmaid MacCulloch, *Reformation: Europe's House Divided* (New York: Viking, 2003), 36–39.

17. Atwood, *Theology of the Czech Brethren*; Thomas Fudge, *The Trial of Jan Hus* (Oxford: Oxford University Press, 2013), 1–30.

18. William Bouwsma, "The Spirituality of Renaissance Humanism," in Raitt, ed., *Christian Spirituality*, 236–51; Albert Rabil, *Renaissance Humanism: Foundations, Forms, and Legacy* 3 vols. (Philadelphia: University of Pennsylvania Press, 1988).

19. Laurel Carrington, "Desiderius Erasmus," in *The Reformation Theologians*, ed. Carter Lindberg (Oxford: Blackwell, 2002), 34–48; Erika Rummel, "Theology of Erasmus," in Bagchi and Steinmetz, eds., *Cambridge Companion to Reformation Theology*, 28–38.

20. Ozment, *Age of Reform*, 290–92; Gordon Rupp and Philip Watson, eds., *Luther and Erasmus: Free Will and Salvation* (Philadelphia: Westminster Press, 1969)

21. James Estes, ed., *The Correspondence of Erasmus: Letters 2204–2356* (Toronto: University of Toronto Press, 2015), 94–95.

22. John Payne, *Erasmus: His Theology of the Sacraments* (Richmond, VA: John Knox, 1970), 97–230; Alister McGrath, *The Intellectual Origins of the European Reformations* (Oxford: Blackwell, 2004), 34–66; James Tracy, "Ad Fontes: The Humanist Understanding of Scripture as Nourishment for the Soul," in Rait, ed., *Christian Spirituality*, 252–67.

23. See chapters 1 and 2 as well as Duffy, *Stripping of the Altars*.

24. Helen Barr, ed., *The Piers Plowman Tradition* (London: Dent, 1993); Andrew Cole, "William Langland and the Invention of Lollardy" in *Lollards and their Influence in Late Medieval England*, ed. Fiona Somerset, Jill Havens, and Derrick Pittard (Woodbridge, Suffolk: Boydell, 2003), 37–58.

SIX

Sixteenth-Century Reformations

The Sacraments

The sixteenth century witnessed multiple reform movements, not simply one monolith called "the Reformation." In 1517, Martin Luther, an Augustinian Friar and professor at the new university of Wittenberg, raised questions about the sale of indulgences. By 1519, that initial concern had led him to challenge contemporary models for soteriology, that is, the wing of theology which studies how God saves, the nature of grace, and humanity's role (or lack thereof) in the process. Through the 1520s different reformers emerged across Europe, but these figures were hardly at unanimity with Luther's conclusions or his ongoing efforts to change Wittenberg's life and practice. The next several chapters of this study will highlight that diversity as we examine the relationship between practice and early modern reform movements. For most sixteenth-century reformers, the sacraments, particularly the Eucharist, were center stage for this dispute. Just as the mass had been the crossroads for spirituality in the middle ages, it was also the gravitational center for changes in practice and belief in the early modern world. Reform programs in the sixteenth century were deeply invested in both the theology of the sacraments as well as their correct administration. How many sacraments are there? What are their purposes? How does God operate through them? As most evangelical reformers accepted only two sacraments—the Eucharist and Baptism—those will be the focus of this chapter.

Chapter 6

LUTHER: LIKE FIRE IN IRON

At the dawn of the sixteenth century, transubstantiation was in fact not the explicit teaching of the western church. As discussed above, Lateran IV (1215) rejected a spiritual conception of the Eucharist and declared that the elements undergo a change. However, Lateran IV did not formally canonize, in Aristotle's terms, that the substances change while the accidents (touch, appearance, taste) remain the same. Writing during the council, Cardinal Peter of Capua listed three ways Lateran IV's decree could be interpreted: (1) consubstantiation, the idea that Christ comes alongside the elements; (2) annihilation, that the bread and wine simply cease to be and Christ occupies the space left behind; or (3) transubstantiation, the idea that the substance changes, but the external accidents do not. The last of these three had been espoused by Peter Lombard and Hugh of St. Victor in the twelfth century. But while Peter of Capua himself openly preferred transubstantiation, he insisted that all three models were within bounds. In other words, Lateran IV did not canonize transubstantiation. Even Innocent III who presided over the council wrote that while he did not like consubstantiation, it was not heretical. Likewise, within a few years, both Albert the Great and the *Glossa Ordinaria* (a major scholastic compilation) admitted that consubstantiation was not heresy. However, a generation later, Thomas Aquinas (1225–1274) interpreted Lateran IV as formally endorsing not simply a physical change, but specifically transubstantiation. Aquinas was also very likely the first theologian to formally call consubstantiation heretical. And in his wake, most theologians (including Luther himself) believed that Lateran IV had more or less taught that transubstantiation is the sole option. Luther passionately affirmed that he was consistent with the pre-Lateran IV church, even agreeing with the condemnation of Berengar of Tours. The Wittenberg reformer declared, in the words of *Ego Berengarius*, that he ground Christ with his teeth. When the Council of Trent did make transubstantiation the only acceptable model, they believed that they were simply reaffirming Lateran IV. It should be added, of course, that the common people usually perceived the elements to be the body and blood of Jesus in the most corporal sense without need of a theological rationale.[1]

To understand Luther on the Eucharist, the seminal text is *The Babylonian Captivity of the Church*, the middle of Luther's three so-called "Reformation texts" of 1520.[2] Here he wrote that the pope is a dictator holding the mass captive in three specific ways: (1) withholding the chalice from the laity; (2) requiring Christians to believe transubstantiation as an article of faith; and (3) teaching that the mass is a work and a re-sacrifice of Christ to atone for sins. Regarding the first captivity, he argues that a general council should resolve the problem. Likely thinking of the Hussites, he insisted that lay-people should be given the chalice, but they should not take it by force. This sense that the sacrament should be of-

fered in both kinds would become not only a theological commonplace for all Protestants, but also lead to changes in practice. The shallow chalice simply could not hold enough wine, so deep communion cups appeared. Some, like the example from England in figure 6.1, have reversible covers which could serve as plates for the bread.

Regarding the second captivity, Luther rails that Thomas Aquinas did not base his opinion on scripture but on Aristotle. He carefully says that one can believe in transubstantiation, but Christians ought not be compelled to believe it as a necessary article of faith. He argues that transubstantiation, a complex doctrine, is not understood by the people and this leads them to idolatry as a result, worshiping creature instead of creator. Luther proposes that Christ's real presence—the "grammatical" meaning of Christ's words in the Gospel passages and in Paul's first letter to the Corinthians—is like iron and fire being together in red-hot iron. Christ is in, with, and under the elements which never themselves disappear. While this conception is often categorized as consubstantiation (and not without warrant), we should note that Luther never described his teaching on the Eucharist with this term. In *The Babylonian Captivity*, he praises the simple people who have always rested their faith on Christ's real presence and not concerned themselves with transubstantiation. The third captivity, Luther maintained, was the most wicked of the three; it birthed a host of abuses as the mass was turned into merchandise. Here Luther worked out his definition of a sacrament: it is a promise made by God with a sign attached. The Eucharist, for Luther, is God's promise of salvation and the only preparation for receiving it is faith that God's promises are trustworthy. Moreover, the Eucharist is a gift freely given to those who will but believe in the promise. The sign attached, then, is Christ's own body and blood. It is critical, Luther stresses, to see that the mass is something Christians *receive* in faith from God, not a sacrifice a priest *offers up* to God. Christians only offer up prayers. Ceremonies themselves, Luther concludes, are fine so long as they do not obscure the promise of forgiveness which he holds out as the core of the gospel.[3]

How did those ideas shape Luther's reform of the liturgy? In the early 1520s, the Wittenberg professor was not terribly interested in liturgical revision. He knew that the liturgy needed to be reformed—particularly when it came to the canon of the mass—but he was apprehensive. This was because Luther's agenda was about faith, teaching that Christ justifies sinners who offer nothing but trust. That was central for Luther. He did not want other communities adopting his Wittenberg liturgy and thinking that was the central piece for joining his project for reform. It was the other way around—he wanted people to understand his teachings about grace alone (*sola gratia*) and from there liturgy was secondary. In short, Luther feared making a liturgy a mark of evangelical orthodoxy. He also wanted to be very careful about alienating "weaker brethren," people who could accept new teachings faster than new patterns of wor-

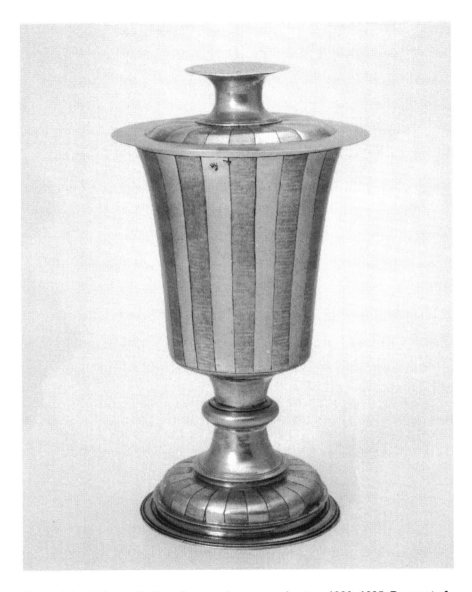

Figure 6.1. Valerius Sutton, Communion cup and paten, 1630–1635. Bequest of Irwin Untermyer, 1973, Metropolitan Museum of Art, New York, NY. Accession Number: 1974.28.152a, b. https://www.metmuseum.org/art/collection/search/205655.

ship. Very early though, Luther was committed to including a sermon without fail no matter the liturgical event. For the word of God to penetrate the heart, the word must be opened by a preacher. In the Eucharist,

the word of God is consumed through the ear and then through the mouth—and, again, the word is trustworthy.

In 1523, Luther at last released his *Formula Missae*, a conservative adaption of the mass. Still in Latin, little was changed save that Luther vigorously purged all sacrificial language. That was critical: for Luther, the mass is not something Christians do to appease God; it is rather a gift to Christians who receive in faith. In 1525, vernacular liturgies were coming out of Zurich, Strasbourg, and Nuremberg, and Luther felt the need to offer a German mass as a stabilizing force. In the preface of the 1526 *Deutsche Messe*, Luther cast a long-range vision, suggesting that there should be three forms of service. First, he wrote, the *Formula Missae* would continue as a pastoral allowance for those people who still wish to hear the service in Latin (plus it would be helpful for school-boys learning that language). Second, however, the principal worship would be his new German Mass. Third, Luther wrote that one day in the future worship in house churches would emerge for seriously committed individuals. He admitted, though, that those kinds of serious Christians were not yet around. Over a century later, Lutheran pietists would look to this very proposal as they formed conventicles (home groups) for Bible study, prayer, and hymn-singing. For sixteenth-century evangelicals in Wittenberg, though, the main event was to be that German service. Two points stand out about Luther's vernacular liturgy. First, like the *Formula Missae*, this German mass is still fairly conservative: Luther envisions altars, candles, and vestments. Second, the elements are still elevated, not to worship them but rather, as Luther said, to serve as a pictorial *anamnesis* (remembering), a visual way to recall the sacrifice of Calvary for the sake of poor sinners.[4]

ZWINGLI: BADGES OF REDEMPTION

It is a mistake to use the terms "Calvinist" and "Reformed" interchangeably. Calvinism is a subset within the larger Reformed tradition, a form of early modern Christianity which displayed three similar though distinct theories of the sacraments, specifically of the Eucharist: (1) Ulrich Zwingli's memorialism, (2) Heinrich Bullinger's parallelism, and (3) John Calvin's instrumentalism. These will be detailed here in chronological order. To outline the theology of the Zurich reformer Ulrich Zwingli, we begin with a Humanist lawyer in the Netherlands, Cornelius Hoen (1440–1524). A correspondent of Erasmus, Hoen landed in jail for heresy in 1522, dying there two years later. In 1521, however, Hoen wrote a letter to Martin Luther, emphasizing a non-physical interpretation of the Eucharist. Luther rejected it outright and the letter-carrier, Hinne Rode, traveled south, first to Basel where he shared it with the reformer Johann Oecolampadius (1482–1531) and then to Zurich, handing it over to Ulrich

Zwingli (1484–1531). Both Swiss reformers took immediate liking to the letter and Hoen's ideas appear in almost all of Zwingli's later sacramental writings. The Eucharist, according to Hoen and then Zwingli, is a pledge for the forgiveness of sins. As symbols, the bread and wine point to something else, Christ. The bread and wine are not that to which they point. Nor do they participate in that to which they point. These material elements *remind* Christians that they are forgiven. Hoen compares the Eucharist to the ring in marriage: a ring is not the marriage itself nor does the ring mystically participate in the marriage; it reminds the wearer and others that the wearer is married. Both Bernard of Clairvaux and Thomas More had deployed this ring metaphor, so it was not original. However, they would have rejected the notion of the Eucharist as only a symbolic memorial. By making this comparison with a wedding ring, Hoen was describing the Eucharist as a symbol of an absent reality. Adoring the bread, therefore, makes one no better than pagan idolaters.[5]

A scripture passage connected to this memorialist understanding is Matthew 24:23: if anyone says that Christ is here do not believe him. On this reading, Christ himself warned against exactly the claims made by both papists and Lutherans. Central to Hoen's and Zwingli's Eucharistic theology, though, was their Humanism: unlike Luther, they celebrated allegorical readings of scripture, particularly the colorful imagery that Jesus uses in the Gospels. They saw no difference between Jesus' words "I am the true vine" and "I am the gate," on the one hand, and his words "This is my body," on the other. Perhaps the most important element Zwingli drew from Hoen, however, was his interpretation of the word *est* (is) as meaning *significat* (signifies). When Christ said, "this is my body," Hoen and Zwingli insisted that what Jesus meant was "This *signifies* my body." This interpretation fits perfectly with Zwingli's exegesis of John 6, the lengthy chapter where Christ talks about his body and blood being true food and says, moreover, "it is the spirit who gives life; the flesh is of no avail." John 6 became Zwingli's touchstone, highlighting Zwingli's firm divide between the spiritual and the material.

In 1526, Zwingli felt the need to write an accessible German treatise on the sacraments, and he proclaimed that Catholic and Lutheran conceptions of the bodily presence of Christ are not only wrong, but injurious to the concept of "sacrament" itself. Here Zwingli rejected transubstantiation, consubstantiation, and annihilation. One classically Reformed argument against Christ's bodily presence (an argument shared by all three Reformed streams discussed here) is based on Christ's accession to the right hand of the Father as described in Acts. How can he be there and on the altar? In these disputes, Lutherans came up with a response, one with which Erasmus also toyed: because Christ is fully God and fully human, they argued, his divine nature allows his human nature to be everywhere. In other words, Christ's divine nature gives his human nature ubiquity. This is known as the communication of attributes (*communicatio*

idiomatum). The Reformed, however, countered that this solution causes Christological problems: it blurs the two natures into one nature. This, the Reformed insisted, was too close to the early church heresy called Monophysitism which claimed Christ had only one divine nature. Such a teaching had been roundly condemned by the Council of Chalcedon in 451. In addition to rejecting transubstantiation, consubstantiation, and annihilation, Zwingli also rejected an idea posed by Andreas Karlstadt, Luther's former assistant who became an Anabaptist. Karlstadt suggested that when Christ said, "this is my body," he was actually pointing to his body and was not talking about the bread at all. Zwingli found that answer equally unsatisfying (because there is no hint of such an action in scripture) and, as a Humanist exegete, resolved the whole question of the Eucharist by reading the text as allegory.[6]

At the metaphysical level, though, Zwingli's goal was to separate the physical, external sign and the spiritual reality to which it points. It is, he argued, faith in Christ's sacrifice that saves; the Lord's Supper is a way which the community signifies that spiritual reality. As flesh is of no avail, the elements achieve nothing. But just as Zwingli and other Reformed theologians accused the Lutherans of Christological problems, they too slipped in another direction. If the Lutherans had blurred the two natures in their teaching about ubiquity, possibly veering into Monophysitism, the Zwinglians seemed to sever the two natures: for Zwingli, the Christian can experience only Christ's divine, spiritual nature, not his fleshly human nature. The Lutherans argued that not only did this ignore the clear words of scripture, Zwingli was dividing Christ's human nature from Christ's divine nature. This seemed like a reprise of yet another early church heresy, Nestorianism which had taught that Christ was two separate persons—one human and one divine—only held together by God's will. And just like Monophyistism, Nestorianism had also been condemned by the Council of Chalcedon in 451. So, as the Reformed accused the Lutherans of blurring Christ's two natures and thus being guilty of Monophysitism, the Lutherans accused the Reformed of separating Christ's two natures and thus being guilty of Nestorianism. Once more we see sensitivity to primitive Christianity, even the lessons learned through wrangles with heretics.

Zwingli spent far more time discussing what the Eucharist is not than what it actually is. However, he was not entirely negative. For the Zurich reformer, the sacraments are best understood as badges comparable to the red cross worn by Swiss soldiers. Receiving the Eucharist broadcasts to God, the world, and one's fellow Christians that one is part of God's covenantal people. Sacraments are "signs by which a man proves to the church that he either aims to be, or is, a soldier of Christ, and which informs the whole church, rather than yourself, of your faith." Christ is present among them, spiritually, but this has little to do with the elements of bread and wine. Interpreting John 6, Zwingli argues that when

Christ talks about eating his flesh and drinking his blood, he meant "believing in him as the one who has given his flesh and blood for our redemption and the cleansing of our sins." No external rite—the water of Baptism or the bread and the wine of the Supper—can save; faith alone saves. This motif shoots throughout Zwingli's work: the separation of the physical and the spiritual; and only the spirit can give life.[7]

In 1529, Zwingli at last came to public loggerheads with Luther. Philip of Hesse, one of the Lutheran princes, feared Catholic military encroachment and lobbied for a Protestant union. So, he invited both Luther and Zwingli to the city of Marburg for a formal conversation—the Marburg Colloquy. They found themselves in wide agreement, until they came to the Eucharist, a disagreement which revealed profoundly different ways of approaching scripture and the relationship between the physical and the spiritual. Luther dramatically wrote on the top of the table where they sat the words *hoc est enim corpus meum*, this is my body. Insisting on a literal reading of these words, Luther would not budge on the bodily presence of Christ in the Eucharist. Some reformers present at that gathering had high hopes for unity, notably Martin Bucer of Strasburg (1491–1551) and Luther's assistant Philip Melanchthon (1497–1560). They would leave Marburg disappointed and Philip of Hesse's fears soon became a reality: in 1531, Catholic military forces entered the territory of Zurich. Having been a military chaplain, Zwingli rode into battle with the troops, dying on the field in the Second War of Kappel. Luther, in his characteristic bile, said that it was God's judgment. As a result, the twenty-seven-year old Heinrich Bullinger took Zwingli's place as chief pastor of Zurich.

Liturgically, Zwingli left behind a very different way of observing the Lord's Supper. In 1524, with the city council's assistance, he had made an orderly purge of relics and images and by 1525, Zwingli had persuaded the council to abolish the mass entirely. During Holy Week, that spring, the people experienced their first evangelical, vernacular communion: the young received on Maundy Thursday, the middle-aged on Good Friday, and the older folks on Easter Sunday. From then on, Zwingli required the people to receive quarterly. While Lutheran clergy often used vestments and altars, a minister of Zurich, wearing the black gown of a scholar, would stand behind a wooden table set among the people in the nave. Although an accomplished musician himself, Zwingli allowed no music in worship. Instead, words and silence paired together. The minister would read the institution narrative from 1 Corinthians, and then the people would receive while an assistant would read from John's Gospel.[8]

SACRAMENTARIANS IN THE EARLY ENGLISH REFORMATION

Zwingli's ideas about the Eucharist did not stay confined in Switzerland. In England, as the 1520s pressed on, some English evangelicals flirted in varying degrees with Zwingli's conception of the Eucharist. One of Zwingli's tracts, *De vera et falsa religione comentarius* became the primary source for a vernacular English tract by George Joye, "The Souper of the Lord" (1532). Note that this is well before Henry declared himself supreme head of the Church of England. At that same moment, William Tyndale, the biblical translator, was being extremely careful about his thoughts on the Eucharist. Another early English evangelical, John Frith, had already been confined to the tower of London for espousing an understanding of the sacrament akin to Zwingli's, a position known in England as Sacramentarianism. Joye's text set off alarm bells for Henry's Lord Chancellor, Sir Thomas More (1478–1535) who published a response, "Answer to a Poisoned Book." A master at rhetoric, More was pithy, targeting a literate laity who could be seduced by Joye (and Zwingli behind him). More wrote that the Sacramentarians would take away Jesus' flesh and blood, offering instead nothing more than a meal in an ale-house, poison for the soul, and no substitute for the mass. Here is More the Humanist using his skill to make other Humanists like Zwingli look pretentious and out of touch with the rough and sincere faith of everyday Christians who need Christ's presence. The bodily presence of Christ in the Eucharist, according to More, was something people experienced in the same way that Londoners saw wrestlers at Clerkenwell, one of More's commonplace allusions. The Lord Chancellor intended to write further pieces on the subject, but wound up in the Tower himself when he rejected the Act of Supremacy in 1534. More was beheaded the next year.[9]

THE AUGSBURG CONFESSION

In 1530, Emperor Charles V summoned the Lutheran princes to an imperial diet in the city of Augsburg so they could justify their differences from him in religion. Philip Melanchthon wrote a text, in two parts, for the princes to offer as their confession of faith, the Augsburg Confession. The first part dealt with doctrine, and the second part with areas where reform was needed—specifically the Eucharist in both kinds, clerical marriage, mass as a work, confession of sins to priests, fasting, monastic vows, and the power of the church. Regarding the Eucharist, Melanchthon walked a tight line, aiming for moderation. In describing Christ's presence, his goal was principally to differentiate the Lutherans from the Zwinglians and the Anabaptists. Critically, Melanchthon wrote that

Christ is *given* in the elements. This was a moment of clarity, and various editions of the Augsburg Confession appeared in print in the succeeding years. However, in one edition published in 1540, Melanchthon himself changed the word *given* to *exhibit*, a change intended to build a bridge with the Reformed. John Calvin, for example, signed the 1540 version, an edition known as the *Variata* as opposed to the original version known as the *Invariata*. Altering the Confession created a rift among Lutherans. Melanchthon was on one side and on the other stood hard-liners, known as Gnesio-Lutherans led by Matthias Flacius (1520–1575). A generation later in 1580 the Lutherans compiled the Book of Concord, a collection of litmus test documents for being an orthodox Lutheran. Critically, the original *Invariata* was used, a vindication for the Gnesio-Lutheran position that Christ is given, not merely exhibited. Melanchthon has come down in history as one who could compromise and work for consensus. Similarly, among the Reformed, Martin Bucer of Strasbourg was very careful about a gradual reform agenda. He even allowed the elevation of the host through the 1520s. The sixteenth century, however, was an era for clear-eyed idealism, rather than compromise.[10]

BULLINGER AND CALVIN: PARALLELISM AND INSTRUMENTALISM

While Lutherans and Catholics had different ways of articulating the bodily presence of Christ in the bread and wine, under the broad umbrella of the "Reformed" tradition, there are three distinct models for the sacraments: memorialism, parallelism, and instrumentalism. We have already discussed Zwingli's memorialism and now we turn to Bullinger and Calvin. Starting in the 1530s, reformers began to write confessional statements, documents around which Christian communities could rally and fashion an identity. A clear example is the Augsburg Confession. Others include the two Helvetic Confessions (1536, 1561), the Geneva Confession (1536), the Zurich Confession (1545), the Swiss Agreement (1549), the Belgic Confession (1561), the Book of Concord (1580) and the decrees of the Synod of Dort (1617).[11] There are rich stories behind each of these. The events surrounding the Swiss Agreement (*Consensus Tigurinus*), however, help us to see the Reformed tradition coalesce in the middle of the century and that story draws into relief the other two Eucharistic theologies within the Reformed tradition, those of Bullinger and Calvin.

After Zwingli's death, Heinrich Bullinger (1504–1575) felt the pastoral need to uphold his predecessor's legacy. Zurich was beleaguered and unity was important. However, Bullinger differed from the former chief pastor, believing that more is happening in the Lord's Supper than the

church making a memorial testimony. Bullinger believed that God moves toward his people in the sacrament, that he does pour out grace in the Eucharist. But Bullinger wanted to be specific: this outpouring does not happen through the bread and wine; consuming the elements parallels the spiritual gift of grace. The reformer of Geneva, John Calvin (1509–1564), though, offered yet a third model. Early on, in the 1530s, leaders in Zurich and Basel were suspicious of Calvin, believing him to be a crypto-Lutheran. In the first edition of his signature work, *Institutes of the Christian Religion* (1536), Calvin stumbled between Luther and Zwingli on the Eucharist, unable to articulate a clear position. By the final edition in 1559, Calvin described God using the elements as vehicles for Christ's spiritual presence, as *instrumenta*, instruments. Martin Bucer, the reformer of Strasbourg, held this perspective and likely influenced Calvin during the years the French refugee spent in that great city (1538–1541).[12] Between the first and final editions of his *Institutes*, Calvin released a helpful treatise on the Eucharist in 1541, the year after he signed the Variata version of the Augsburg Confession. In his 1541 treatise the Genevan reformer openly rejected both a Lutheran confusion of sign and signified and a Zwinglian separation of sign and signified. Here Calvin describes the sacraments, specifically the physical elements of the Eucharist, as channels or conduits for God's grace. That was quite welcome among the moderate Lutherans. But Calvin wanted to be clear: the Eucharist does not offer the corporeal presence of Jesus. Christ's physical body, Calvin insisted, is in heaven, and salvation depends on that.[13]

In the early 1540s, Calvin, similar to bridge-builders like Melanchthon and Bucer, held out hope for unity with the Lutherans. Those efforts were rendered moot, however, when Luther in 1544, just two years before his death, condemned all of the Reformed in his *A Brief Confession Concerning the Holy Sacrament*. Luther even went to the trouble of declaring Zwingli and Oecolampadius (both of whom were long dead) enemies of the sacrament.[14] Finding ecumenical efforts rebuffed, Calvin and others shifted to solidifying the disparate Reformed tradition, a movement far more theologically diffuse than the Lutherans. This goal of Reformed unity grew in urgency by the end of the decade. In 1547, Emperor Charles V won a stupendous victory at Mülberg over the coalition of Lutheran princes known as the Schmalkaldic League. Luther had died and the league was in shambles; Bucer fled Strasbourg for England at the invitation of the reformer and archbishop of Canterbury Thomas Cranmer. The writing was on the wall: the Swiss Reformed needed to achieve unity because they were next. Catholic armies would soon march on the Swiss cantons. The key obstacle in the 1540s was that Zurich, Bern, Schaffhausen, and other Reformed cities suspected Calvin of being a crypto-Lutheran. They cringed at Calvin's use of the word instrument, rejecting the notion that God uses physical things to offer spiritual grace. Calvin and Bullinger had a productive meeting in 1549, but they could not

achieve a published agreement until 1551. In the end, Calvin sacrificed the words "instrument," "present," and "offer" as well as the phrase "through the sacrament." Thus, the Swiss Agreement which achieved critical unity for the Reformed was a victory for Bullinger. Even so, Calvin never stopped using instrumental language in his polemical writing against the Gnesio-Lutherans.[15]

LUTHER AND BAPTISM

The focus of this chapter thus far has been the Eucharist, though along the way different sensibilities about the sacraments more generally have emerged. We are now well-positioned to consider different perspectives on Baptism among sixteenth-century reformers, exposing a diversity of doctrinal conceptions, practices tied to Baptism, and approaches to the pastoral context. Among the Lutherans, three things mark out their approach: the washing away of Original Sin, Baptism as beginning the process of regeneration, and liturgical conservatism. What of Luther himself on the subject? Theologically, Luther is often presented as moving through three distinct phases. Scholars often designate his work during the period before the 1519 Heidelberg Disputation when his break with the papacy was in the offing as the "Young Luther." For example, he allowed for a high degree of human activity in the process of justification. Typically, scholars will speak of the "Reformation Luther" emerging after 1519. During the 1520s, Luther swept aside notions of humans cooperating with God. Human beings, Luther now argued, are unable to do anything for themselves; God radically and graciously intervenes. Moreover, even after the intervention of justification, the Christian remains *simul iustus et peccator* (simultaneously justified and sinful). Luther's theology is often described as "forensic," meaning it uses the imagery of a courtroom. Accordingly, Christ imputes his own "alien righteousness" to the condemned sinner, justifying him by covering or cloaking him— thus the judge, God the Father, only sees his son's righteousness. Even so, the justified sinner is still a sinner in actual practice (under the cloak) until God remakes her at the end of all things. For this reason, the work of Baptism—the Christian's rebirth—is not fully complete until the *eschaton*, Christ's return in glory. Baptism, instituted by God in Christ, is the sign attached to God's promise of salvation. This is Luther's trademark language on the sacraments: sign attached to promise. For Luther, the water certainly does not possess magical properties, but neither is the sacrament simply a badge marking the covenant. For the Reformation Luther, faith drives the sacrament, not the sacrament itself. Moreover, faith is a gift from God which returns to God those whom God has chosen. It is entirely God's work, a free gift.[16]

Luther, though, moved into a third phase after the 1520s, what scholars have traditionally called the "Mature Luther." He had stressed active faith so much that it seemed he was downplaying the objective rites plainly commanded in scripture. He therefore felt it necessary to distinguish his teaching on Baptism from both that of the Anabaptists and the Reformed. The so-called Mature Luther felt that these "enthusiasts" wrongly divorced the physical from the spiritual, opening the dread possibility of laying aside the sacraments entirely (his fear would become a reality among seventeenth-century Quakers). Luther insisted that the Holy Spirit is active in the physical elements of the sacraments and thus he elevated the power and necessity of the rites themselves as part of God's work of salvation. Another difference between the Reformation Luther and the Mature Luther is the subject of infant baptism. If faith is the driver, particularly so for the Reformation Luther, how can infants be baptized? The Reformation Luther had said the faith of those gathered around the infant counts. The Mature Luther instead looked to the objective affirmations of God's work in the sacrament itself.

It would be wrong to see these phases as airtight and disconnected. A very good example is the enduring relevance of his *Babylonian Captivity of the Church* (1520), a text produced relatively early in his career as a reformer. Here when Luther talks about Baptism, he contrasts it with monastic vows, a potent comparison given his background as an Augustinian Friar. Such vows obscure Baptism, leading one to believe that these will somehow accomplish more than Baptism. Luther insists that it is Baptism that binds one to Jesus; entering religious life and its vows add nothing. For Luther, Baptism is a washing away of Original Sin and more: Baptism is death and resurrection; Adam dies and Christ rises in his place. This central motif of Baptism was repeated in later Lutheran texts, especially the Small Catechism which Luther produced in 1529 to instruct the common people. The baptized Christian is in effect drowned and reborn, and Luther recommended full immersion if possible. From an ascetical perspective, Luther writes that Christians ought to renew their baptisms by daily returning to faith. In fact, when Luther himself felt temptation he would shout "I am baptized!" and, pastorally, he commended mediating on the reality that one has been baptized. Melanchthon repeated all this in the Augsburg Confession of 1530 and even went a bit further, saying that religious vows are invalid because they seek to supplant what God has already done in Baptism.[17]

As we have seen, Luther was conservative about liturgy. He notably retained exorcisms (casting out the devil) in his Baptism rite. However, he did away with the medieval practice of separate gender-specific exorcisms for male and female infants. Perhaps his most important contribution was a prayer, the *sindflutgebert*, that speaks of the universal flood in Genesis and portrays the church as Noah's ark. This prayer even appeared in some later Reformed liturgies.

Almighty eternal God, who according to Your righteous judgment condemned the unbelieving world through the flood, and in Your great mercy preserved believing Noah and his family, and Who drowned hardhearted Pharaoh with all his host in the Red Sea and led Your people Israel through the same on dry ground, thereby prefiguring this bath of Your baptism, and Who through the baptism of Your dear Child, our Lord Jesus Christ, has consecrated and set apart the Jordan and all water as a salutary flood and a rich and full washing away of sins: We pray through the same Your groundless mercy, that You will graciously behold this [name] and bless him with true faith in the Spirit, so that by means of this saving flood all that has been born in him from Adam and of which he himself has added thereto may be drowned in him and engulfed, and that he may be sundered from the number of the unbelieving, preserved dry and secure in the holy ark of Christendom, serve Your name at all times, fervent in spirit and joyful in hope, so that with all believers he may be made worthy to attain eternal life according to Your promise; through Jesus Christ our Lord. Amen.[18]

Despite this prayer's influence, Martin Luther consciously decided not to invest energy in liturgical change. As a result, the regional or territorial churches that aligned with Luther varied in their formulas for Baptism. In Saxony, the men tasked with reforming the liturgy, Melanchthon, Justus Jonas (1493–1555), and Johannes Bugenhagen (1485–1558), stayed close to Luther's rites of the 1520s. In Nuremberg and Brandenburg, Andreas Osiander (1498–1552) devised rites that were arguably more conservative. To the south, one finds liturgies influenced by the Reformed in neighboring Switzerland. In Cologne, Archbishop Hermann von Wied (1477–1552) invited Martin Bucer to produce new liturgies for what was ostensibly a Catholic territory in 1545. Thomas Cranmer watched carefully from England as his fellow archbishop produced a revised liturgy, something Cranmer would do only a few years later in his Book of Common Prayer. Hermann's missteps and his own cathedral chapter's obstructionism proved instructive; he was deposed and excommunicated in 1546 and the cause in Cologne was lost.

THE REFORMED AND BAPTISM

If washing away Original Sin, regeneration, and liturgical conservatism marked Lutheran baptisms, the diverse voices under the Reformed umbrella more often stressed the covenant. We begin again with Ulrich Zwingli, the humanist reformer who privileged the spiritual over the material. Differing starkly from Luther, the chief pastor of Zurich in the 1520s dialed back the emphasis on Original Sin and saw outward signs as only symbols for the work of the Holy Spirit. To be succinct, Zwingli made Baptism the rite by which a person is identified, both to God and

the world, as a member of the church, just as regular participation in the Lord's Supper testified to God and the world that same individual's ongoing corporate membership and fidelity. As discussed above, Zwingli compared sacraments to the badges worn by Swiss confederate soldiers, outward marks which signify an internal, spiritual reality. This sacramental theology firmly separates the sign and that which it signifies. To confuse sign and signified would wrongly intersect the merely material with the divine Spirit (again, the flesh is of no avail, John 6). Sacraments are, accordingly, symbols for the work that the Holy Spirit does on souls. In addition to this hard division between the physical and the spiritual, Zwingli's sacramental theology is strongly corporate in character, as opposed to being focused on the individual. Christians in the Eucharist pledge membership in God's covenantal people just as God pledges to be the God of that same people. The same covenantal thinking, which echoed the nature of the relationship between Biblical Israel and God, carries through into Zwingli's understanding of Baptism.

It should not surprise us, then, that under Zwingli's nose a group of people started to wonder if Baptism, if conceived as the sign by which one commits to the body, should include a mature profession of belief. To the north, Luther's Wittenberg colleague Andreas Karlstadt had come to this conclusion, and, likewise, the former vice-rector of the University of Ingolstadt, Balthasar Hubmaier (1480–1528) declared that Baptism involves a public profession of faith before the assembled church. In January 1525, one of Zwingli's students, Conrad Grebel (1498–1526) re-baptized another adult, George Blaurock (1491–1529). By the middle of the 1520s Anabaptists (re-baptizers) were already tied to radical insurrection and social disorder in the minds of Catholic, Lutheran, and Reformed leaders.[19] So in response to this outcropping of Anabaptism, the Zurich City Council threatened anyone participating in re-baptisms with execution. With cruel irony, the method prescribed was drowning. In January 1527, the council edict was carried through for the first time on Felix Manz (1498–1527) who, like Grebel, had been a student of Zwingli. Manz was taken to a boat docked in Lake Zurich where, with his hands bound between his legs, he was drowned.

In the two years between the council's decision and this first execution, Zwingli tried to persuade the Anabaptists of their errors; the same man who had inspired many of them now tried to steer them from the conclusions they felt were the logical next step. In his efforts, Zwingli wrote tracts on Baptism which are rich resources for early Reformed sacramental theology. His goal was to move away from both Catholic and Lutheran understandings without leading to what is often called "believer's baptism," that is, requiring a mature confession of faith. First, he rejected the traditional teaching that Baptism cleanses Original Sin, insisting that Christ abolished the power of external rites. Here he divorced himself from both Catholic teaching and Luther. For Luther, sign

and signified are always in relationship; the sign participates in that which it signifies. For Zwingli the two are disconnected. Instead of a cleansing, Zwingli presents Baptism as a covenantal sign, the mark of membership in God's people. Drawing on Colossians 2:11–12, he insisted that Baptism is the successor to circumcision and therefore is the mark of being within the covenantal community. Critically, however, Zwingli argued that Baptism neither gives faith nor confirms the presence of faith. That is an entirely separate spiritual reality. No external rite can achieve it; only the Spirit can give or strengthen faith. Baptism initiates one into the community, symbolizing a commitment to life within the covenantal people.

Everything said thus far was adopted by the Anabaptists. Where they go wrong, Zwingli argued, was in the ordering. Baptism, he wrote, is about a promise to live in the future as part of the Christian community. Zwingli claimed that the Anabaptists were instead asking for perfection first in order to be baptized. Perhaps more importantly, adult-only Baptism rests on a different understanding of the church. For Zwingli, the church is certainly a covenantal community, a body of persons obligated to one another and to God just like Biblical Israel. But it is also a mix of persons whose true elect status is known only to God. The Anabaptists claimed otherwise, that the church is a community of the those who have made their visible commitment, in other words, the perfect. This was a different ecclesiology. Carrying through the comparison with circumcision, Zwingli argued that just as Jewish children were given the sign of covenantal membership (regardless of their personal election and surely prior to any ability to make a profession of faith), so the children of Christians should have the covenantal sign of Baptism. He dismissed Anabaptist arguments about Christ never baptizing infants by pointing out that Jesus did not have women at the Last Supper and no one thought this meant woman were unwelcome at communion. For good measure, he adds the biblical images of Christ blessing children and the household baptisms described in Acts, baptisms which would have included children.[20]

A survey of other Reformed voices will be helpful before focusing on John Calvin. In the Reformed tradition post-Zwingli, we should recall the differences between memorialism, parallelism, and instrumentalism; these models are pertinent for Baptism as well as the Eucharist. We have seen the way Zwingli insisted on a clear divide between spiritual realities and the external signs in both the Lord's Supper and Baptism. And just as Bullinger departed from his predecessor regarding the Eucharist, so too did he depart from him regarding Baptism. Heinrich Bullinger believed that God does do something when a person is baptized, but the conferral of grace is not tied to the physical experience; the grace comes parallel to the water rite.

Bullinger's perspective on Baptism would find an historic articulation later in the century in the Second Helvetic Confession (1566) just as his perspective on the Eucharist had won out in the Swiss Agreement (1549). The instrumentalism of Martin Bucer and John Calvin found more traction in the Church of England, but not until later in the century. In the 1540s, Archbishop Cranmer, among other early English reformers, was persuaded in the direction of Bullinger. By the end of the century, however, we find the language of instrumentalism in the writing of Richard Hooker and then, in the seventeenth century, instrumentalism is on display in both the rites and catechism of the 1662 edition of the Book of Common Prayer. For most of the continental Reformed, however, parallelism seemed the safest theological course: God, they agreed, was at work in the sacraments but not through physical elements like bread, wine, or water. Among the so-called scholastic Reformed theologians of the seventeenth century we find parallelism becoming an orthodoxy. For example, the Puritan William Ames (1576–1633) and the authors of the *Westminster Directory* (1644) argued that inward grace does not coincide necessarily with the outward act. These theologians often describe the sacraments as seals of an existing spiritual reality.[21] This is the long-term outworking of Bullinger's theological model. On the other hand, the logical end of Zwingli's memorialism is found among the Quakers of the seventeenth century. If Baptism is merely a symbol and externals accomplish nothing, then why do them at all? Quite naturally, then, we find Quakers, among other radicals in seventeenth-century England, giving up entirely on sacraments, stressing instead an interior, inner light.[22]

CALVIN AND BAPTISM

A careful reading of Calvin reveals that, much like Luther, he went through three discernable phases. First, the Calvin of the early 1530s was influenced most by Luther, regularly drawing from Luther's Small Catechism among other works. As a result, many of the Reformed suspected Calvin of crypto-Lutheranism. By the late 1530s, though, Calvin was moving more in line with Zurich, writing that the sign cannot be confused with the thing signified and stressing a spiritual, non-material valence to the sacraments. This is manifest in a Baptism rite he produced around this time, a liturgy rich in covenantal language which emphasized membership in God's people. After a sojourn in Bucer's Strasbourg, however, Calvin entered his third phase, one marked by instrumentalism. In the final edition of *The Institutes of the Christian Religion* (1559), Calvin teaches that the elements are means of grace, instruments for God's work. In the mature Calvin, there is a pronounced connection between Baptism and God's work of washing away sin. At times this language is just as strong as Luther's depiction and certainly would have

given Zwingli serious misgivings. Calvin, however, wanted to be clear that salvation itself is achieved through God's election and his work of regeneration occurred throughout life.

This brings up an important pastoral issue. If salvation is achieved only through God's secret election, then there is no such thing as an "emergency Baptism" for a mortally-ill newborn. Therefore, we find Calvin as a pastor counseling parents in those tragic situations to be at peace: their dead child was and is in the hands of the sovereign God. This would be true had the child lived and been baptized. While God is at work in the sacrament, salvation itself was decided before all time. Recent research has shown how Reformed pastors took care in negotiating this new perspective with families.[23] Calvin explains that, if a child survives and is brought to Baptism, God is still at work; Baptism is no less an instrument for God's grace. In the prayers he wrote for Baptism, Calvin requests that God will through this sacrament bring forth good fruit in due time. In other words, his prayer is that when the child comes of age, she will glorify God, a journey set in motion at Baptism. In his *Institutes*, Calvin rejects the Zwinglian conception that the sacrament is merely an outward show. Rather, God works through the elements. Critically, the process of regeneration (rebirth) only starts at Baptism, continuing through the whole of life. This is similar to Luther's perspective, however for the Wittenberg reformer the Christian life is a continual return to the crisis (Luther's own experience being paradigmatic) and grace springing anew for the sinner who cannot help herself. For the Reformed, however, the expectation that the baptized Christian will grow daily in grace and holiness is a bit more emphatic. Consider here the later ascetical sensibilities of many Puritans.[24] Moreover, for the Reformed, this journey toward the full stature of Christ (Ephesians 4:13) happens within the church, the covenantal community. This is true for all three streams of Reformed theology and thus the logical need to end private baptisms.

Like Zwingli before him, Calvin also engaged the Anabaptists on the nature of the sacrament. In his *Brief Instruction on the Arming of all the Faithful*, he writes that, as Baptism is a seal on the promise of justification by faith to believers and their children, it is not right to deny children or their parents the consolation that comes not by mature commitment, but by God's free grace. Calvin repeats Zwingli in several ways: Baptism is comparable to circumcision; the absence of women at the Last Supper does not bar them from the Eucharist, but the Anabaptists' approach to Baptism if applied to the Eucharist would limit the Lord's Supper only to men; and there are the household baptisms in Acts. Moreover, Calvin highlights that there simply is no passage of scripture that reads "only baptize adults" or "wait for a mature, adult profession." Putting aside the absence of evidence in scripture that the first apostles only baptized adults and assuming that was the case, would not the change to allowing infant baptisms in the late first or early second century merit someone

noticing that monumental change? Assuming the Anabaptists were right about some post-apostolic corruption, why did no one seem to notice? Why is there no record of this wrong turn? The silence of scripture and the historical record led Calvin to believe that the question of mature personal assent is a false-starter and fundamentally misunderstands the way God saves.[25]

THE EXORCISM CONTROVERSY

Following the Peace of Augsburg (1555), territories within the Holy Roman Empire could be Roman Catholic or Lutheran. While the choice was up to the prince, being Reformed was not an option. That meant in practice that there were some Lutheran princes who were actually quietly Reformed, subtly allowing Reformed theology and practice into their lands through the back door. Liturgically and theologically, one telling area was in the use of exorcisms in Baptism. The Lutherans had retained that aspect of the rite, one that had been part of the medieval liturgy. Before pouring water, the pastor ordered the devil to leave the child. From a Lutheran perspective, keeping exorcisms emphasized the universal problem of Original Sin, that every person from birth is a captive to the devil. For the Reformed, however, Baptism is about covenant, and while the elect status of the candidate is known only to God, it would be offensive to say that a person who was chosen before all time was ever in the captivity of Satan. Exorcism, then, was no small ceremonial detail; it spoke deeply about the process of salvation.

In the 1550s, Duke John Frederick of Saxony dismissed a pastor, George Merula, for abandoning the exorcism rite and causing a furor. This was the beginning of a controversy that continued to erupt for the remainder of the century with exorcism becoming the mark of Lutheran orthodoxy. Theodore Beza (1519–1605), chief pastor of Geneva after Calvin's death in 1564, observed in 1586 that the quarrel was "whether holy baptism is a bath of rebirth and a renewal in the Holy Spirit, or whether it is simply a sign that signifies and seals our filial relationship to God." Tracts on the subject appeared as did loud accusations of crypto-Calvinism and professions of fidelity to the late Martin Luther. Some of these accusations were ultimately justified. Around 1600, in Anhalt, the prince really was a crypto-Calvinist. Not only did he order the end of exorcisms in Baptism, he also removed religious art, Latin hymns, vestments, and altars. The Reformed Heidelberg Catechism replaced Luther's Small Catechism while common bread replaced wafers in the Eucharist. Duke John George insisted that these changes were the natural next step of the reformation. In the seventeenth century, Elector John Sigismund of Brandenburg appropriated for himself the mantle of Luther, claiming that his push for Calvinism was a *completion* of the reformation. Many of his

pastors, however, chose to refuse baptism unless they could include the exorcism rite. The situations in Anhalt and Brandenburg are only two examples. The controversy eventually subsided in the late seventeenth century when the Lutherans themselves dropped exorcisms during the rise of pietism and rationalism.[26]

REAL PRESENCE

The reformations of the sixteenth century were not about one issue, but rather a galaxy of concerns that could at once align and separate different communities. And the coverage in this chapter has focused primarily on Magisterial Protestants (Lutherans and Reformed) with, regrettably, only passing reference to Anabaptists. Much as the sacraments had been the crossroads for medieval Christian life—in theological reflection, devotion, art, community-formation, and even the right-ordering of the cosmos—so too were they the meeting ground for a diversity of concerns in the sixteenth century. Controversies about the sacraments were surely about how to worship God rightly, but they were also about what it meant at a very elementary level to be a Christian, to be saved and re-created by God, and the nature of the individual's relationship to the Body of Christ, the church. Older studies of the sacraments in the early modern world, often written in the nineteenth and early twentieth centuries, often suffer from philosophical categories and language not used by sixteenth-century reformers or their communities. Therefore, the hazards of anachronism along with perpetuating polemical disagreements in the present day (post Vatican II) are legion. The early modern concern with the Word may be a helpful avenue to conclude. Reformers were concerned with the way God mediates his presence, and despite their great differences in hermeneutics and liturgical application, most agreed that God speaks his Good News (gospel) via a living person, a preacher opening the scriptures before an act of table fellowship. The Holy Spirit does his work, faith emerges, and one receives the gift of Christ himself. Across sixteenth-century reformations, the preaching of the word was understood to reveal the Word made flesh, whose body and blood continued to play a critical role in salvation.[27]

NOTES

1. James McCue, "The Doctrine of Transubstantiation from Berengar through Trent: The Point at Issue," *Harvard Theological Review* 61 (1968), 385–430.
2. The other two are *An Address to the German Nobility* and *The Freedom of a Christian*.
3. Martin Luther, "The Babylonian Captivity of the Church," in *Martin Luther: Selections from his Writings* ed. John Dillenberger (New York: Anchor, 1962), 249–359; Volker Leppin, "Martin Luther" in *A Companion to the Eucharist in the Reformation*, ed.

Lee Wandel (Leiden, Brill: 2014), 39–56; Gordon Jensen, "Luther and the Lord's Supper," in *Oxford Handbook of Martin Luther's Theology*, ed. Robert Kolb et al. (Oxford: Oxford University Press, 2014), 322–33.

4. Martin Luther, "*Formula Missae* and *Deutsche Messe*," in *Liturgies of the Western Church*, ed. Bard Thompson (Cleveland: Meridian, 1961), 95–140; Thomas Shattauer, "From Sacrifice to Supper: Eucharistic Practice in the Lutheran Reformation," in Wandel, ed., *Companion to the Eucharist*, 205–30; Brian Brewer, *Martin Luther and the Seven Sacraments* (Grand Rapids: Baker, 2017), 192–225.

5. *Cornelius Henri Hoen (Honius) and His Epistle on the Eucharist (1525)* ed. Bart Spruyt (Leiden: Brill, 2006).

6. Amy Burnett, *Karlstadt and the Origins of the Eucharistic Controversy* (Oxford: Oxford University Press, 2011).

7. Ulrich Zwingli, "On the Lord's Supper," in *Zwingli and Bullinger*, ed. G. W. Bromiley (Philadelphia: Westminster, 1953), 176–238; W. P. Stephens, *Zwingli: An Introduction to his Thought* (Oxford: Oxford University Press, 1992); Carrie Euler, "Huldrych Zwingli and Heinrich Bullinger," in Wandel, ed., *Companion to the Eucharist*, 57–74.

8. Ulrich Zwingli, "The Zurich Liturgy," in Thompson, ed., *Liturgies of the Western Church*, 141–58.

9. Thomas More, *The Answer to a Poisoned Book*, ed. S. M. Foley and Clarence Miller (New Haven: Yale University Press, 1985).

10. *The Augsburg Confession of the Evangelical Lutheran Church*, ed. Robert Kolb and Timothy Wengert (Minneapolis, MN: Augsburg Fortress, 2000); Euan Cameron, "The Possibilities and Limits of Conciliation: Philip Melanchthon and Inter-Confessional Dialogue in the Sixteenth Century," in *Conciliation and Confession: The Struggle for Unity in the Age of Reform, 1415–1648*, ed. Howard Louthan and Randall Zachman (Notre Dame: University of Notre Dame Press, 2004), 73–88. See the essays on various Lutheran theologians, including Luther, Melanchthon, and Flacius in *The Reformation Theologians*, ed. Carter Lindberg (Oxford: Blackwell, 2002).

11. B. A. Gerrish, "The Lord's Supper in the Reformed Confessions," in *Major Themes in the Reformed Tradition*, ed. Donald McKim (Grand Rapids: Eerdmans, 1992), 245–58; Idem, *Thinking with the Church: Essays in Historical Theology* (Grand Rapids: Eerdmans, 2010), 229–58. See also the essays on various Reformed theologians, including Zwingli, Bullinger, and Calvin in Lindberg, ed., *The Reformation Theologians*; Richard Muller, "John Calvin and Later Calvinism: The Identity of the Reformed Tradition," in *The Cambridge Companion to Reformation Theology*, ed. David Bagchi and David Steinmetz (Cambridge: Cambridge University Press, 2004), 130–49.

12. Nicholas Thompson, *Eucharistic Sacrifice and Patristic Tradition in the Theology of Martin Bucer, 1534–1546* (Leiden: Brill, 2005).

13. John Calvin, "The Clear Explanation of Sound Doctrine Concerning the True Partaking of the Flesh and Blood of Christ in the Holy Supper," "Short Treatise on the Holy Supper of Our Lord and Only Saviour Jesus Christ," in *Calvin: Theological Treatises*, ed. J. K. S. Reid (Philadelphia: Westminster, 1954); Idem, *Institutes of the Christian Religion*, Book IV, XVII (Of the Lord's Supper); B. A. Gerrish, *Grace and Gratitude: The Eucharistic Theology of John Calvin* (Minneapolis: Fortress, 1993); Thomas Davis, *The Clearest Promises of God: The Development of Calvin's Eucharistic Teaching* (New York: AMS, 1995).

14. Joseph Tylenda, "The Ecumenical Intention of Calvin's Early Eucharistic Teaching," in *Reformatio Perennis*, ed. B. A. Gerrish (Eugene, OR: Pickwick, 1981), 27–41.

15. Paul Rorem, *Calvin and Bullinger on the Lord's Supper* (Nottingham: Grove, 1989); Timothy George, "John Calvin and the Agreement of Zurich (1549)," in Idem, ed., *John Calvin and the Church: A Prism of Reform* (Louisville: Westminster John Knox, 1990), 42–58.

16. Berndt Hamm, *The Early Luther: Stages in a Reformation Reorientation* (Grand Rapids: Eerdmans, 2014).

17. Philip Melanchthon, "Augsburg Confession" and Martin Luther, "Small Catechism," in *Confessions and Catechisms of the Reformation*, ed. Mark Noll (Grand Rapids, MI: Baker, 1991), 101–4, 59–80; Brewer, 164–91; Jonathan Trigg, *Baptism in the Theology of Martin Luther* (Leiden: Brill, 2001).

18. *Luther's Works*, ed. Ulrich Leupold (Minneapolis, MN: Fortress Press, 1965), vol. 53, 107–8.

19. Daniel Liechty, *Early Anabaptist Spirituality* (Mahwah, NJ: Paulist, 1994).

20. Ulrich Zwingli, "Of Baptism," in *Zwingli and Bullinger*, ed. G.W. Bromily (Philadelphia: Westminster, 1953), 119–75.

21. Gordon Jeanes, *Signs of God's Promise: Thomas Cranmer's Sacramental Theology and the Book of Common Prayer* (London: T & T Clark, 2008); Brooks Holifield, *The Covenant Sealed: The Development of Puritan Sacramental Theology in Old and New England, 1570–1720* (New Haven: Yale University Press, 1974).

22. Bryan Spinks, *Reformation and Modern Rituals and Theologies of Baptism: From Luther to Contemporary Practice* (Aldershot, UK: Ashgate, 2006), 31–100.

23. Karen Spierling, *Infant Baptism in Reformation Geneva: The Shaping of a Community, 1536–1564* (Aldershot, UK: Ashgate, 2005).

24. Dwight Bozeman, *The Precisionist Strain: Disciplinary Religion and Antinomian Backlash in Puritanism* (Chapel Hill: University of North Carolina Press, 2004).

25. John Calvin, *Institutes of the Christian Religion*, trans. Henry Beveridge (Grand Rapids, MI: Eerdmans, 1989), Book IV, Chapters XV (Of Baptism), XVI (Paedobaptism), 512–55.

26. Bodo Nischan, "The Exorcism Controversy and Baptism in the Late Reformation," *Sixteenth Century Journal* 18 (1987), 31–50.

27. Thomas Davis, *This is My Body: The Presence of Christ in Reformation Thought* (Grand Rapids, MI: Baker, 2008), 13–17.

SEVEN

Sixteenth-Century Reformations

Preaching, Sacred Space, and Music

What was the actual experience of liturgy and corporate devotion during the reformations of the sixteenth century? What was it like to gather as a community for worship and how did different reformers conceive the nature and purpose of worship? This chapter addresses the related aspects of preaching, space, and music to offer a portrait of the everyday spirituality emerging from the sixteenth-century reformations. Central to these three areas was the word. In the sixteenth-century imagination, the written text of scripture was the ultimate, perhaps sole, litmus test for truth, right practice, and right belief. This was an age, then, of the word; it was a logo-centric era. At times this meant open conflict with the visual and aural experience of Christian practice. Vibrant images were whitewashed, and texts were painted in their place. Polyphony which had blurred the clarity of sung words was often abandoned for musical styles which matched one note for one syllable thereby allowing the words to be clearly received—that passive posture so favored by many evangelicals. Preaching the word became equal to the sacraments and in some instances arguably greater than the Eucharist and Baptism. The discussion here seeks to understand how the word was spoken, heard, or sung and in what setting.

PREACHING

In an age focused on the word, preaching was a central priority for all reformers. Much like the Dominicans (the Order of Preachers), early modern reformers saw preaching itself as a devotional activity. Among

many Protestants, however, the sermon took on an indispensable, even sacramental role in the act of worship, a major break from the medieval pattern. For centuries, the priest's primary vocation was to celebrate the mass, not necessarily to preach. Thomas Aquinas, for example, ordered the purposes of the priesthood clearly as (1) to offer sacraments and (2) to prepare the people to receive the sacraments. Preaching by the high middle ages, therefore, had become a rarified skill for specialists (often the friars). To be clear, the average priest did not preach, and the mass did not usually include a sermon. A sermon could even be an extra-liturgical activity, often outdoors where large crowds could gather to hear the visiting specialist preach from a pulpit built for the occasion. Even when they did preach, clergy often relied on manuals designed to provide stories and teaching aids. The two best examples are the thirteenth-century *Golden Legend* by the Dominican archbishop of Genoa, James of Voragine (c. 1230–1298) and the fourteenth-century *Festial* by an English Augustinian Friar named John Mirk (c. 1380–c. 1420).[1]

To examine preaching in the sixteenth century, a helpful place to begin is with the question of exegesis and biblical commentary. Among Protestant reformers there were what can be described as two ideological streams, both of which were extremely concerned about the place of scripture in the Christian life. On the one hand, there was the Augustinianism of Luther, a sensibility that stressed the fallen nature of humanity, a distrust of natural reason (Luther, characteristically, called reason a whore), and a commitment to God's clear revelation of himself in scripture. Note the Lutheran principle of *sola scriptura*, that the plain words of scripture form the unadulterated source for belief and practice. Luther railed about generations of infidelity to God's written word, an adulterous disloyalty which has in turn led to trust in works over faith, the greatest of all sins in Luther's estimation. On the other hand, there was the Humanist stream, a sensibility deeply aware of historical and cultural context and the distance between the text and the contemporary reader. Renaissance Humanists, which included Catholics and Protestants, conceived the problem of their time slightly differently than Luther: the "middle ages" (a term they coined) stood between the present age and the apostolic church. The Humanists therefore had a burning desire to overcome that distance, to go back to the sources (*ad fontes*) in their original languages. For Luther, the word has a natural immediacy and accessibility, but it needed to be unfettered, released from the captivity of popes and sophistical priests who had hidden the word from God's people. For Humanists, however, including John Calvin, the situation was more complicated. They believed the word needs to be understood in its literary and historical context so that its true meaning would come to light. The failed colloquy of Marburg captures the difference: Luther and Zwingli read Christ's word "this is my body" in very different ways.

Humanists like Erasmus, Zwingli, and Calvin made full use of the four senses of scripture. What are these? The literal sense describes the surface meaning of the story. For example, when the text reads that Jonah was in the belly of a fish, it means that Jonah was in the belly of a fish. This does not, as is often wrongly understood, necessarily imply *history*, though it can. The allegorical sense identifies a network of metaphors drawing into relief a doctrinal teaching. Jonah's three days in the fish may be an allegory for Christ's three days in the tomb followed by his resurrection. The moral sense searches the text for a life lesson. Jonah disobeyed God when he refused to go to Ninevah, resulting in his being swallowed by the fish; we ought to obey God lest we suffer similar misfortunes. The anagogical or eschatological sense exposes God's intention to judge and renew creation at the end of time. Perhaps Jonah being in the belly of the fish is like all of creation yearning for the liberation promised at the end of time when Christ will come to put things right. It is important to recognize that not all passages of scripture can be read through all four senses; often one or two senses are commendable over the others. There was an early modern couplet that helped contemporaries remember these four senses: the letter teaches what has happened; allegory what one believes; the moral meaning what one does; the anagogue where one is going. While Zwingli and other Humanists celebrated the four-fold sense, Luther embraced the literal. Although he did not formally reject the other three, the Wittenberg reformer was hesitant to use them when the literal would suffice. For example, he reserved allegory primarily for the Old Testament. We should make no mistake: while quite different, both the Lutheran approach and the Humanist approach were deeply committed to putting the text at the center of Christian life and practice.[2]

Not only reading, but rightly understanding the written word became the overarching passion of the Protestant Christian, from the Lutheran to the Reformed to the Anabaptist. This cognitive activity reflected the operational assumptions of much of Protestantism. Consider Luther's own understanding of justification as a concept, an idea which God imputes: God declares the unrighteous to be righteous and this makes it so, much as he created by *speaking* at the beginning of time. As many scholars have lately noted, this perspective is fairly consonant with much of that subset of medieval scholasticism known as nominalism: words create reality rather than merely reflect it.[3] At a broad level, Protestant spirituality can be described as focused on ideas and their transmission via printed words which can be consumed by the individual. A prayer written by the English reformer and archbishop Thomas Cranmer for the second Sunday of Advent reads "Blessed Lord which hast caused all holy Scriptures to be written for our learning: Grant us so to hear them, read, mark, learn, and inwardly digest them, that . . . we may embrace and ever hold fast the blessed hope of everlasting life." The request is for personal study of

the text—God, please help us with our homework! Although Protestant pastors surely celebrated the sacraments, there was a clear shift in vocational emphasis. The pastor's work was no longer primarily about offering the sacraments, as Peter Lombard and Aquinas had taught, but about interpreting the word written. The pastor became something comparable to a Jewish rabbi or a university professor; he was to be a scholar, trained in many languages, who helps others understand the text.[4]

Worship, likewise, took on a didactic element as churches started to look more and more like classrooms. This had implications for the sacraments, which for the Lutherans was defined as signs attached to verbal promises. The word *digest* in Cranmer's prayer illustrates how the Eucharist was often construed: the word of God comes first through the ear via the sermon (Romans 10:17) and then through the lips via bread and wine. God's word is *digested* in both cases. At the beginning of the sixteenth century, the mass had been ubiquitous and sermons a rare treat from specialists. At the close of the century, among Protestants of all stripes, the sermon was indispensable while the Lord's Supper not nearly as common. This does not mean the Eucharist was unimportant; we could interpret communion as being so important that it required weeks of preparation. The sermon, though, was the weekly nourishment.

Luther himself never wrote a tract about preaching, but he insisted that every liturgy, including daily services, should have an expository sermon. To worship God, then, meant to open his word. And Luther's commitment certainly bore fruit: the Wittenberg reformer left a mountain of sermons. By 1525, over 1,800 editions of Luther's writings had appeared and two out of every five texts are sermons—and Luther did not die until 1546! Close to half of the writings left by Luther are sermons, the collections of which are known as Postils. According to Luther, for the word to affect people's lives, it must be preached with passion. The preacher, in Luther's view, was an instrument for God himself. A sermon was also a spiritual experience for both congregation and preacher and neither has full control of what the word will accomplish. The theology ran this way: when the word is proclaimed, Christ is objectively present, but God himself must enter the hearts of the listeners. Luther wrote: "It is easy enough for someone to preach the word to me, but only God can enter it into my heart. He must speak it in my heart, or nothing at all will come of it." To interpret scripture rightly, a preacher must be alive to the Holy Spirit, and the interpretation must happen within the faithful community, the church, which is, according to Luther, the "gate of salvation." Luther, in his preaching, was aware of classical rhetoric, but he hated methods. He often delighted in tensions: between works and faith, law and gospel, wrath and grace. And he was also quick in his sermons to point out the enemies of the gospel, that is, fanatics, spiritualists, and papists. Luther loved dichotomies![5]

Another of Luther's legacies is his insistence on expository preaching, that is, the sermon should not simply teach a doctrine or some aspect of church life but must exegete scripture. That does not preclude sermons on doctrine, church life, or other topics. But even so, every sermon must explain the biblical text. That became non-negotiable, even if the sermon was for a feast day (those that Lutherans retained). People should come away from every sermon with a deeper grasp of the written word. Beyond this, the development of a distinctly Lutheran style in preaching was left to Philip Melanchthon. Unlike Luther, Melanchthon wrote treatises on preaching and his emphasis was how the sermon could teach the Christian faith (again that didactic element). While later sixteenth- and seventeenth-century Lutheran sermons engage much more in polemics with the Reformed over things like the nature of the Eucharist, the basic commitment to exegesis and teaching the faith remained constant.[6]

Among the Reformed, we find a similar focus on scripture, but the classic Lutheran love of tense dichotomies (law vs gospel, works vs faith) is not the controlling motif. Luther loved that tension; it governed his theology, his ascetical and practical sensibilities, and indeed his whole worldview. For the Reformed, the emphasis was on the covenant and on enlivening the covenantal people. God's people grow cold in their faith — so the preacher has an obligation not only to open the word but to add *vehemence*, to use Calvin's French word. Such intensity was so that God's word might penetrate the heart. The Genevan reformer wrote that the preacher speaks in two voices: one to exhort and encourage the godly, and the other to ward off wolves who might prey on God's flock. Preaching therefore became a central part of the urban experience of Reformed communities, the cities and towns of Switzerland and the Rhine river valley. In cities like Bern, Zurich, and Geneva, the city governments issued mandates for regular preaching and paid for lectureships too.[7]

The Reformed preferred a *lectio continua* model, that is, preaching straight through the Bible, start to finish, as opposed to using a lectionary cycle which supplied lessons for seasons and feasts. For example, when Calvin returned to Geneva at the invitation of the city council in 1541, having been ejected three years earlier, he mounted the pulpit and opened the Bible to exactly where he had left off preaching in 1538.[8] Reformed clergy also took on an exhausting preaching schedule. Calvin typically delivered two different sermons on Sundays, and then every other week he preached each morning at dawn, Monday through Saturday. His sermons usually lasted around forty-five minutes. He preached roughly 286 sermons per year, almost 4,000 in total in his time in Geneva. Heinrich Bullinger, however, outstripped Calvin and all the other reformers in preaching: from 1531 to 1537 (the year he began to share his pulpit in the Grossmünster), Bullinger preached almost every day. Over the course of his long career in that city (dying in 1575, a decade after Calvin), Bullinger preached between 7,000 and 7,500 sermons. His pub-

lished collection of fifty sermons, *The Decades*, was quite popular in England; Archbishop John Whitgift required clergy without university degrees to read it and make a report to their regional archdeacon, a kind of continuing education.[9]

In terms of exegesis, most Reformed preachers allowed for all four senses of scripture; certainly Zwingli and Calvin were Humanists unlike Luther. However, by the end of the sixteenth century most Reformed preachers were economic with allegory. William Perkins' *The Art of Prophesying* (published in Latin in 1592, English in 1606) emphasized context: in his preparations, the preacher is to examine a verse and ask "who, to whom, upon what occasion, at what time, in what place, for what end, what goeth before, what followeth." Among the Reformed, there was also the phenomenon, born in Zurich, known as prophesyings. These were public sermon workshops where preachers would engage in mutual critique. During the reign of Mary Tudor (1553–1558), English Protestant exiles in Zurich and other Reformed cities witnessed these workshops; when the exiles returned home to England in the reign of Elizabeth, they brought the idea back with them. Elizabeth, however, was not a fan, viewing them as avenues for sedition. When she ordered them suppressed in 1577, her archbishop of Canterbury Edmund Grindal refused to obey. He believed they were important helps for clergy to improve their most sacred task, opening the word. Grindal was suspended for his defiance, dying just a few years later in 1583.[10]

Having detailed the Reformed on the continent, we should expand on the state of preaching and scripture exposition across the English Channel. We therefore wind back to the beginning of the sixteenth century to note the work of two biblical translators. William Tyndale (c. 1494–1536) was in Worms in 1525 when he published the first complete New Testament in English. This was prior to Henry's breach with Rome and the pious Catholic king had no patience for translating scripture, which he viewed as radicalism. Archbishop William Warham and Thomas More condemned Tyndale's work, and then, when Henry did break with the papacy, Tyndale bungled the opportunity to return to the king's good graces by denouncing the divorce. Henry's agents tracked him down on the continent, and he was tried for heresy near Brussels in 1535. Tyndale was executed by a combination of strangling and burning. Another Bible translator had better fortunes with the crown. In that same year, Myles Coverdale (1488–1568) was in Zurich where he translated and published the first complete English Bible in 1535. By 1539, he was back in England and involved with the production of the first English Bible authorized by a monarch, the "Great Bible." Henry's mind had changed on the subject. Later under Queen Elizabeth, Coverdale became bishop of Exeter. These fits and starts eventually led to a number of English translations: the Great Bible (1539), the Geneva Bible (1560), the Bishop's Bible (1539), and then the Authorized Version (1611). The last one, usually known as the

King James Bible, proved to be unpopular and had to be legally mandated. At the start of the seventeenth century, the translators used strongly institutional words like "church," "priest," and "bishop" for the Greek words *ekklesia*, *presbyteros*, and *episkopos*. Puritans thought "congregation," "elder," and "pastor" were better choices.[11]

When considering preaching itself in early modern England, a good place to begin is the Book of Homilies. In the later middle ages, as noted above, preachers utilized sermon collections like Mirk's *Festial*. But even with these books, preaching was still not the work of the average priest. By the end of the sixteenth century, though, every cleric was expected to preach on a regular basis. How was that monumental change to happen, especially since only a portion of the English clergy had enough training from either Oxford or Cambridge to preach? The bulk of them would need assistance if they were to become regular preachers. So, in 1547, during the reign of the Protestant boy-king Edward VI, the regime issued the First Book of Homilies, twelve pre-packed sermons on various topics. While some high-ranking and well-educated clergy were issued licenses to preach their own sermons, the vast remainder would choose homilies from the book to read to their people. This was also a method of doctrinal control in the middle of nation-wide religious change; in this way, the Reformed Edwardian regime (and later the Elizabethan regime too) could ensure that only certain ideas were expressed from the pulpit. While multiple authors were involved in the book's production, none of the homilies are signed; Archbishop Thomas Cranmer most likely wrote five of them. The dozen selections ranged from "Of the Salvation of Mankind" to "Of Christian Love" to "Against Whoredom and Adultery." The topic of the Eucharist, a hot subject in the sixteenth century, was studiously avoided. This is most likely because English Reformed leaders like Cranmer were waiting carefully to see the outcome of the much-wonted conversations between Calvin and Bullinger on the continent on the tricky subject of the Eucharist; Cranmer did not want to speak too soon and foul their efforts to unify Reformed Protestants.

A Second Book of Homilies was issued a generation later in the reign of Elizabeth. Appearing in 1571, this book had an additional twenty-one sermons. The first and second Books of Homilies were part of a program to mainstream the experience of hearing sermons. By the 1580s, preaching was popular. Puritan-oriented parishes would hire "lecturers" to serve on their staff; these were clerics whose only job was to preach. This is the inversion of the chantry priests, clergy whose only job was to say mass. Larger churches, like St. Paul's Cathedral in London, had a sermon every day. There was also the phenomenon of "sermon-gadding," that is, going from church to church to hear more sermons. Again, we see an inversion: pious Christians around 1500 ran from altar to altar to see the elevation; pious Christians around 1600 ran from pulpit to pulpit to hear the word preached. In fact, by the turn of the century, the English clerics

Richard Hooker (1554–1600) and Lancelot Andrewes (1555–1626) both complained about an addiction to sermons. Bishop Andrews wrote that it seemed people thought that "Sermon-hearing is the *consummatum est* of all Christianity," that is, the highest fulfilment of being a Christian. Quoting the Epistle of James, he added that Christians ought to be doers and not hearers only of the word.[12] The irony is that Andrewes was likely one of the greatest English preachers of the seventeenth century.

Not only did public appetite for sermons grow over the sixteenth century, the ability of preachers blossomed, and their styles changed. Hugh Latimer (1485–1555) was the star English preacher of the early sixteenth century. Latimer was licensed by the University of Cambridge to preach anywhere in England, resulting in his becoming a celebrity and then bishop of Worcester in 1535. In an unusual move, he resigned his bishopric because he disagreed with a conservative swing within Henry's church in 1539. This effectively made him a strange animal: a wandering bishop-preacher. His style can be described as populist; he was a people's preacher, not a scholar's preacher. His works show little poetry, little eloquence, and almost no structure. He often simply fed on the congregation's energy. At the end of the century, we find Richard Hooker preaching in a totally different style. Hooker was Master of the Temple, meaning chaplain to a law school in London. His style was systematic, his sentences balanced, and his content subtle, careful, and doctrinal. His contemporary Isaak Walton reports that when Hooker preached, he almost did not move his body, his eyes being fixed in one place. The historian Horton Davies discerned that in the middle of the sixteenth century, England needed the fiery prophet: Latimer was brusque, his sermons could be racy, and he denounced wickedness, injustice, and superstition. By the end of the century, England needed consolidation, preachers like Hooker who could tie up loose ends. In the next generation, however, we find yet another style in preachers like Andrewes, Donne, and George Herbert (1593–1633). Their sermons were luxurious flights, often squeezing an hour of poetic reflection from one or two words. The listener was drawn deeper and deeper into nuance, imagery, and mystery. To continue Davies' comparison, in the seventeenth century, England needed something of the holy otherness of God from its preachers whose sacred task remained to open the word.[13]

SACRED SPACE

Changes in physical spaces for devotion and liturgy are never just about moving furniture. Changes like this point to how space was (and is) construed. Is a church, for example, *domus dei*, the house of God with some intrinsic holiness based on consecration or perhaps ongoing use? Or is a building, regardless of ornament or configuration, *domus ecclesiae*,

the house of the church, a building which simply hosts the worshiping community? During the reformations of the sixteenth century there were various perceptions of the right ordering of sacred space and the attendant role of art, but then there was also the complicating question of the nature of holiness in the material world.[14]

In the later middle ages, there was a high degree of anxiety about idolatry, a concern that challenges rather sloppy portrayals of medieval spirituality as wholly superstitious. Fear of offering worship to a creature as opposed to the divine creator (the definition of idolatry) was not limited to the apophatic sensibilities of the Cistercians. This fear was equally present within the pragmatic sensibilities of the Modern Devout. The goal for most careful theologians was to defend the correct use of art in devotion, giving rise to a whole genre of literature in the fifteenth century defending the role of images. The most common argument may be termed the *libri laicorum* argument, that is, that figurative art—mosaics, frescoes, stained glass, carved wood and stone that represent something—is the text for the illiterate. Lay-people who could not read scripture could "read" the rood screen and learn the story of the crucifixion. They could "read" the doom image over the west door and learn about the coming judgment of Christ. The *libri laicorum* argument has a venerable history, dating back to Gregory the Great c. 600. There is, however, something of a plot hole here. Art functioned within a highly affective ascetical context. People used art regardless of their literacy; even Christians who could read engaged with art, often using art to offer devotion. Considering books of hours, the literate owner would pray the Magnificat (Mary's song in Luke 1:46–55) on the recto page (right-hand page) and then meditate on an image of Mary on the verso page (left-hand page). In other words, people prayerfully engaged with art even when they could read. Art, therefore, was not exclusively or even principally a teaching tool. Excepting Cistercians, it is reasonable to pose that a completely literate medieval community would still have their sacred spaces filled with art. This reality did not, however, stop advocates for religious art using the *libri laicorum* argument.

The Lollards of the fourteenth century had serious concerns about religious art as spirit-less wood and stone, even while reluctantly admitting that images can teach. Apologists for art often responded to such critiques by deploying traditional arguments about *dulia* (worship given only to the Trinity) and *latria* (veneration which ought to be given to the saints), a distinction formally made in 787 at the Second Council of Nicaea. Sometimes, however, the apologists simply retreated and forgave poor folks who were unquestionably committing idolatry, claiming that at least their hearts were in the right place. And, they continued, at least the statue in question was of a saint and not a pagan deity. In fact, some late medieval apologists redefined idolatry by limiting it only to pagan images. Regardless of strategy, the late medieval defenders of sacred art

had to deal with the reality that there were lots of people who did regard images as sources of power. Devotional art enjoyed a boom in the fourteenth and fifteenth centuries, and there was an increase in carved statuary and paintings. Moreover, painted tears on a painted virgin could seem quite real in the flickering candlelight. All the apologists seem to have agreed that images allow a devotee to enter a moment in scripture or in a saint's life. When one meditated on the rood image, one could stand with Mary and John at the crucifixion. The English mystic Julian of Norwich tended to use a near-technical word for this activity, beholding, and it certainly is reminiscent of practices recommended by the fourteenth-century writer Ludolf the Carthusian and later in the *Spiritual Exercises* of Ignatius of Loyola. To behold an image in this sense verged on a creative act; beholding meant to enter the moment represented, engaging it and its characters. Images did not function as "art" in the contemporary sense, that is, artifice meant for pleasure, challenge, evocation, or teaching. These works of art were conceived as sources of power and authority, loci of holiness.[15]

What then were the approaches of sixteenth-century reformers? Erasmus, though he had sympathy for the iconoclasts, believed that the violent removal of art was immoderate. In a different vein, Luther firmly rejected the call of Andreas Karlstadt and the Anabaptists to rid churches of their ornaments. Luther's verdict was that works of religious art, while potentially troublesome, were *adiaphora* (things indifferent which can be retained or rejected depending on taste or circumstance). While Luther knew that art could be a nuisance, he also saw the way art could edify and contribute to solemnity. We should recognize that Luther's primary concern was almost always his theology of justification and whether a person had faith in the saving work of Christ. Everything flowed from there. To risk simplifying: practice, for Luther, was always second to his theology of the cross and trust in Christ's righteousness imputed to the sinner. While Luther retained vestments, candles, and stone altars, he rejected consecrations of sacred space, declaring that consecration rites were tools the pope has wickedly used to control the church. Instead, Luther argued that space is consecrated by use; when the assembled Body of Christ uses a space for worship then that space takes on a sacred quality.[16]

Beginning in the 1520s, different territories within the Holy Roman Empire adopted Luther's movement for reform. However, each territory developed its own "church order" (*kirchenordnung*), a liturgy with an attendant policy on sacred space. In this context, Luther should be understood specifically as the reformer of Wittenberg and the *inspirer* of reformations in other territories and cities, rather than the *arbiter* of all practices that later bore the label "Lutheran." While there was a wave of iconoclasm in Wittenberg in 1521, that was hardly a representative example for the wider Lutheran movement. Consider instead the city of Nu-

remberg which was inspired by Luther's reformation in 1525. There, quite remarkably, the city's major churches—the Frauenkirke, St. Lorenz, and St. Sebaldus—were hardly touched; their ornaments, shrines, and altars weathered the rise of Lutheran Protestantism unscathed. The grand sacrament house in St. Sebaldus' Church continued to tower some sixty feet above the high altar. And the shrine of St. Sebaldus itself, a work finished by Peter Vischer only in 1519, went untouched. What did change, however, were the attitudes and practices surrounding the altars and shrines. Luther himself was clear that trafficking in relics, especially insinuating that their veneration could have anything to do with one's salvation, was a devilish deceit. Moreover, Lutheran literature was clear that the building was not a locus of power, but rather the place where the Body of Christ assembles for prayer and preaching, for the right administration of word and sacrament. Lighting candles before images stopped; processions to and around shrines stopped; blessings that used to occur at different statues stopped. These things became furniture. They added to the solemnity of the place and were preserved, even cherished—but now as decoration. In the religious imagination of the Lutherans, such works had no authority or power. The shrines, altarpieces, and statues of Nuremberg became the backdrop for Lutheran worship. At the same time, there was also a flourishing of new Lutheran art, often biblical in orientation, from people like Lucas Cranach (1472–1553). This art was to teach, offer encouragement, and even inspire.[17]

The Reformed likewise addressed this subject, but with some notable differences. Shrines, they felt, were monuments to counterfeit gods and the contents of the reliquaries dubious at best. Perhaps taking a cue from Luther's own acerbic wit, John Calvin was especially humorous on the topic in his 1543 *Treatise on Relics*, a text that went through six editions in French and was translated into Latin, German, and English. If one adds up all these supposed relics, Calvin wrote, one must conclude that each apostle had four bodies. Noting the multitudes of shrines purporting to hold milk from the Virgin Mary's breasts, Calvin commented that had the Virgin been a cow and milked her entire life she could not have produced such copious amounts. And he delighted to inform readers about the inspection of one reliquary in Geneva: the much-venerated and even kissed relic said to be the arm of St. Antony turned out to be a stag's penis. The relic culture came to an end in Reformed territories, but the Reformed were perhaps even more vehement when it came to art. They had an antipathy to images that verged on the violent, and in many places Reformed iconoclasts led systematic campaigns to destroy figurative art.[18]

In Zurich, the target seems to have been those objects that "consumed" money that could have been spent on the poor, the true images of God. With the city council's approval in 1525, Zwingli led an orderly purge; one night his team locked church doors and quietly performed

their surgery. Zwingli's approach to art was consistent with his method of reading scripture and his sacramental theology: one ought to focus on higher, unseen spiritual realities than the plain words, the material bread and wine, or the pictures seen by your eyes. For Zwingli, art was a distraction from the spirit. In Basel, the purge was far from orderly. There was a sudden burst of iconoclasm and it coincided with the pre-Lent festivities of Carnival in 1529. During the days building to the Lenten fast, Carnival was not simply a time for indulging in drink and rich food; it was a time of inversion, of lampooning power structures before the sobriety and order of Lent. This could not have been a more potent time for a new perspective on art, works which reinforced the power of the church and the hierarchy of the medieval cosmos. Again, these bits of wood and stone were not conceived simply as art, but as loci of power. When it became clear to many in Basel during the riotous days of Carnival that such statues did not contain a divine presence, the common layfolk pillaged their churches to dethrone the idols. In one instance, the iconoclasts took a crucifix into a tavern and interrogated it in kangaroo court fashion. When the crucifix gave no answer, they threw beer in its face. This was not the real Jesus, they thundered, but a fraud.[19] For the rest of the century, wherever the Reformed took root, images were rooted out. Examples from a later generation include the image-smashing that erupted across Scotland in 1559, the consequence of the incendiary preaching of John Knox. Note also the *beeldenstorm*, the "storming of the images," a wave of iconoclastic riots that washed through the Netherlands in the summer of 1566.[20]

However, thinking more about that beer splashed at a crucifix in 1529 in Basel, it is important to understand that these iconoclasts helped to birth modern sensibilities about art. Christians today, even those of a deeply Protestant sensibility, may be aghast at the idea of throwing beer at an image of Jesus—but that is because contemporary Christians see such works as artifice, as representative, and surely not as divine. By the early twentieth century, figurative art had returned to almost all Protestant traditions, but it was conceived in a completely different way. For that to happen, the idols had to be dethroned. For his part, Zwingli acted on his Humanist and Platonic sensibilities: the spirit gives life, not the flesh. Calvin, however, developed a more nuanced approach to art largely based on his anthropology, his understanding of the human person. As humans are made in the image and likeness of God, Calvin wrote, so the individual naturally yearns for God. This connection means that human beings have an inborn sense of God (*sensus divinitatis*). However, the fall and the ubiquity of original sin (Genesis 3) have radically limited that the natural human ability to reach God. This kind of brain damage is known as the noetic effect of sin. So, the innate sense of the divine is like a radio that only picks up pops and clicks. Consequently, the human person madly seeks after God, but without a way to find God, creates idols

instead. The natural human instinct for God is in fact the fountainhead for idolatry; Calvin even said that the human heart is an idol factory. This problem is overcome in Jesus Christ who is the visible image of the invisible God (Colossians 1:15). Art, for Calvin, could not simply be *adiaphora*, as Luther thought. For Calvin, images get right to the center of the human predicament. While Reformed Protestants from central Europe to the Netherlands to Scotland surely celebrated their fidelity to the second commandment, their antipathy to religious art reflected, in a deeper sense, the Reformed understanding of the human condition.[21]

Reformed spaces for worship then are quite similar to patterns described earlier among the Cistercians; it is no accident that Calvin was a great admirer of Bernard of Clairvaux. Reformed communities in Switzerland, France, Britain, and the Netherlands white-washed images on walls, knocked out stained glass, and pulled down statues. Altars had to go, and simple communion tables appeared in their place. When the Reformed constructed new spaces, as was the case among French Huguenots, they built what amounted to classrooms; worship was, after all, centered on the scholar-pastor opening the word of God while an hourglass, attached to the pulpit, would mark his time. Pews became a common feature as members of the congregation needed to sit and hear the teaching offered from the pulpit rather than mill about in a nave waiting to see an elevated host through a rood screen. Some pews in England were privately built by the social elite, evincing their rank in the community. That practice would continue in churches on both sides of the Atlantic well into the nineteenth century.[22]

In England during the reigns of Edward VI (1547–1553) and Elizabeth (1558–1603), the established church's attitude toward art and sacred space was, for the most part, consistent with other Reformed churches. In 1538, Henry VIII ordered the removal of "abused" images and thus the Marian shrine at Walsingham, Becket's shrine at Canterbury, and the Holy Rood of Boxley all came down. When the nine-year old Edward became king in 1547, his regime led by men like Archbishop Cranmer set about a more vigorous purge, dismantling what was left. During the short reign of Mary, the Catholic queen tried to rebuild shrines, but the Edwardian iconoclasts had pulled down a thousand years' worth of sacred art and Mary could not put it all back overnight. When Elizabeth became queen in 1558, she resurrected Reformed antipathies to images, issuing an order to remove them. Once more the prepackaged sermon against idolatry from the Book of Homilies rang from English pulpits. However, Elizabeth's regime insisted on the continued use of the white vestment for clergy called the surplice, and in some instances clergy wore copes, large cape-like vestments. For a time, the queen personally retained a small silver cross in her chapel. Even so, altars were long-banished. The Book of Common Prayer called for a communion table placed length-wise in the chancel or out in the nave; people would kneel around

it to receive Holy Communion. Boards were hung on the east wall displaying the Ten Commandments, the Creed, and the Lord's Prayer. While the rood screen remained, the cross and statues of Mary and John were replaced with the royal arms.[23]

How, though, did a space become "sacred?" Luther and Calvin both abandoned rites for consecration, and that was also the case in England and Scotland. A pan-Protestant perspective was that space was defined by its utility as opposed to any sense of inherent sanctity or liturgical consecration. This of course did not preclude outfitting space with ornaments, making it suitable for prayer, sacrament, and the exposition of God's word. John Whitgift, Elizabeth's archbishop of Canterbury in the 1580s and 1590s, was fond of Pauls' words "let all things be done decently and according to good order" (1 Corinthians 14:40). Consistent with Reformed and Lutheran theology, the Book of Common Prayer did not have a rite for consecrating sacred space. However, that was to change in the seventeenth century. Starting in the 1620s, a group of clergy worked for an increase in ceremony and art in the Church of England. Often known after their principal leader, Archbishop William Laud, the Laudians rebuilt stone altars and even composed novel consecration liturgies. This was a shift in the Church of England's understanding of space, a move away from the Reformed vision of Thomas Cranmer back in the 1550s.[24]

MUSIC

By the sixteenth century, music had occupied a central place in Christian devotion for centuries, stemming from Jewish Temple worship which featured the singing of psalms. Theologians had long acknowledged music's evocative power; Augustine famously said that when one sings, he prays twice. Music even had an eschatological dimension. The words of the *sanctus* sung at the Eucharist (Holy, Holy, Holy, Lord God of Hosts . . .) were the very words both Isaiah and John the Divine heard when they caught a glimpse of the heavenly throne room (Isaiah 6:3, Revelation 4:8). The Eucharist, then, could be conceived as a foretaste of the marriage of heaven and earth in Jesus Christ. The question of how Christians ought to use music in worship was no small matter for sixteenth-century reform movements. All the early modern reformers recognized the power of music—that it can grip the heart and harness affections, that it can teach and catechize, that it can bind a community together. But they also believed that music can seduce and lead astray, that it can cloud and obscure the pure word of God.[25]

In the 1520s, European Christians were familiar with vernacular songs which could be sung during mass or as separate devotional exercises. But, to some extent, these were inconsequential to the liturgy itself. Even

the hymns during mass were something to occupy the people while the priest went about the actual "work." Liturgical music was in Latin and it was sung by professional and semi-professional choirs. Moreover, it often was sung over the priest who said mass as an individual exercise. Not only Protestant but also Catholic reformers were eager to change these patterns. By the middle of the tumultuous 1520s, some reformers, notably Ulrich Zwingli, wanted to abolish liturgical music altogether, preferring the sober dance between words and silence. Ironically, Zwingli was himself an accomplished musician. However, he banned all singing and instrumental music in the churches of Zurich, and the organ in the Grossmünster was removed. Luther, though, understood the arts to be a gift from God. Granted they could be perverted, Luther nevertheless thought the arts could be reformed and put to good use. An axiom held by some reformers ran *abussus non tolit usum*, abuse does not take away use. In 1524, Luther wrote in a newly printed German hymnal, "I am not of the opinion that all the arts should be stricken down by the Gospel and disappear, as certain zealots would have it; on the contrary, I would see all the arts, and particularly music, at the service of him who created them and gave them to us."

The first printed collection of German hymns, *The Book of Eight Songs*, appeared in 1524 and people latched onto them. In Göttingen, where the evangelical reformation had made only partial headway in 1529, Catholics organized a procession to pray against the sweating sickness. At one intersection in the town, however, the Lutherans blocked them, singing Luther's German translation of the *De Profundis*, Psalm 130. The Catholic procession then re-routed, but when they reached their conclusion and began to sing the *Te Deum* in Latin, the Lutherans showed up again also singing *Te Deum*, but in German. Surely the most iconic hymn of the sixteenth-century reformations was Luther's own *Ein Feste Burg ist Unser Gott*, A Mighty Fortress is our God. The tune familiar to many Christians today, however, is a variation composed much later by the Lutheran J. S. Bach. Luther's own music for the hymn, often known as the "rhythmic tune," is upbeat and bouncy. Perhaps the most characteristic element of Lutheran music was the emergence of the chorale, sung portions of scripture in which different voices sing as the Biblical characters. Christ's passion was the favorite source for composers, a reflection of Luther's primary focus on the cross. Music from this early period became a mark of Lutheran identity for centuries, as Swedish Lutheran troops during the Thirty Years War in the seventeenth century sang Luther's hymns, and Bach, in the eighteenth century, incorporated the same materials in his magnificent *St. Matthew Passion*.[26]

Among the Reformed, Zwingli's ban on music did not hold. Most of the Reformed believed that the hymn book for Christians was at the center of the Bible, the psalter. This was consistent with Reformed theology: the people Israel had the psalms as their hymnal, and so God's New

Israel, the covenantal people known as the church, would use the same psalms for their worship. Calvin himself was at the forefront of this endeavor. In 1539, while he was in Strasbourg, Calvin published a book of seventeen metrical psalms, five by Calvin himself and the other twelve by the French Humanist poet Clement Marot (1496–1544). That psalter and its successors would become as iconic for the Reformed as the chorale for the Lutherans. The second Genevan psalter, the *Pseaumes Octante Trois de David* (1551), featured tunes that would come to be known across Europe and would be associated with Reformed Protestants. In fact, during the French Wars of Religion, one night during the siege of the Huguenot-held city of Nimes, Catholic troops tricked the guards and gained entrance by singing metrical psalms.

Perhaps the most telling aspect of Reformed psalm-singing was that each note was to match a syllable as best as possible. Music was not to obscure the words, but rather help spread them and assist people in digesting them. Again, we see that *ideas* are at the core of Protestant spirituality. That same Reformed sensibility about music was welcomed in the Church of England in the mid-sixteenth century. According to the first Book of Common Prayer (1549), several portions of the liturgy were to be sung by the priest or the "clerkes," a term referring to a body of semi-clerical singers. Within the communion service, eight items were sung: the Introit, Kyrie (optional), Gloria in Excelsis, Creed, Offertory, Sanctus, Agnus Dei, and the Post-Communion. While the prayer book did not provide the actual music for these parts, John Merbecke (1510–1585) produced his *Book of Common Praier Noted* just a year later, and it reflects Cranmer's Reformed sensibilities. As Merbecke himself was a convinced Reformed Protestant, every syllable matches a note. Unfortunately, Merbecke's work was for the 1549 book, a liturgy which proved only to be an interim rite. When the 1552 Book of Common Prayer appeared, the musical elements were greatly reduced, although not eliminated. At communion, the Gloria in Excelsis, instead of being a piece sung by the "clerkes" at the beginning of the liturgy, became instead a concluding hymn of thanksgiving for the whole congregation to sing.

It was the psalter, however, that formed the bulk of the Church of England's singing following the introduction of the 1552 prayer book. Thomas Sternhold, a minor courtier, had produced a book of metrical psalms in 1548, and, although he died the next year, his book was expanded by a schoolmaster named John Hopkins. With the help of the publisher John Day (the same publisher who produced John Foxe's *Book of Martyrs*), the Church of England was given the Sternhold and Hopkins *Book of Metrical Psalms*. While far from quality (John Wesley later called it doggerel), it gave the average Christian an outlet for singing. Reformed Protestants construed "worship" as something not simply for the Sunday service, but something done daily through regular life, and these psalms were consequently sing-able in any context. The memorable tune for

Psalm 100 in Sternhold and Hopkins, "Old 100th," was drawn from the second Genevan psalter (1551); later still the tune became the setting for what is known even today among Protestants as "the Doxology." The easy beat reflects not just a community gathered for liturgy, but men and women at work. One can imagine men laboring at the docks singing the psalm according to this memorable tune. Worship, in this sense, happened all the time.[27]

Later in the sixteenth century, the contributions of Thomas Tallis (c. 1505–1585) and his student William Byrd (c. 1539–1623) highlighted the clear divide between the worship life of parish churches on the one hand, and on the other hand the cathedrals, royal peculiars like Westminster Abbey, the larger college chapels at Oxford, Cambridge, and Eton, and a small handful of what we might call "minster" churches. In the average English parish church, psalm-singing was the near-exclusive form of church music; it was the psalms which formed the average member of the Church of England's sense of how to sing to God. In the cathedrals and other elite churches, however, there were musical settings for choirs. And it was for these unique churches that Tallis was writing in the middle of the century and Byrd at its close. It was as if, in terms of church music, the Church of England had a two-tiered life. Even in a large and well-to-do parish, one rarely heard sung canticles. However, if one went to her diocese's cathedral, there she could hear rather complex settings of the Magnificat, the Nunc Dimittis, and other canticles. Tallis and Byrd both produced polyphonic pieces for the English Church, continuing a tradition somewhat at odds with the established church's mostly Reformed sensibilities. This "cuckoo in the nest" (Diarmaid MacCulloch's description) was one element among several others that would eventually distinguish the Church of England from other members of the international communion of Reformed churches and lead to the gradual emergence of a self-consciously distinct tradition known as Anglicanism in the seventeenth century.[28]

In addition to his compositions for elite settings, Tallis made an important contribution to that Reformed mainstay of psalm-singing in 1567. Matthew Parker (1504–1575), Queen Elizabeth's first archbishop of Canterbury, published a psalter, and Tallis provided eight tunes for the book. While these settings breached the one-note-per-syllable principle, Parker argued that the tune and the words should match in mood—a sad tune should go with a sad psalm while a joyful tune should go with a joyful psalm. Parker described the tunes: "The first is meek, devout to see; the second, sad, in majesty; the third doth rage, and roughly brayeth; the fourth doth fawn, and flattery playeth; the fifth delighteth, and laugheth the more; the sixth bewaileth, it weepeth full sore; the seventh tradeth stout, in forward race; the eight goeth mild, in modest pace." Despite this effort, the divide between the parish tradition of music and the cathedral tradition was unmistakably clear by the seventeenth century. It was not

without precedent, then, that during the Civil Wars of the 1640s and the Protectorate of Oliver Cromwell in the 1650s, Puritans destroyed organs and banned everything but the metrical psalms; the organ pipes at Westminster Abbey were themselves melted down. At the Restoration of the monarchy in 1660, however, organs came back and were used with renewed vigor as the cathedral-style of church music came to increasingly dominate the practice of the wider Church of England.[29]

Among Roman Catholics, neither hymn singing, nor chorales, nor psalms were the order of the day, but rather music for the new Tridentine Mass. The Council made good on trends set in motion in the eleventh-century Gregorian Reform: a uniform mass for the whole Catholic world appeared in 1570. Perhaps the most notable name in the effort to provide music for the new mass is that of Giovanni Palestrina (1525–1594). He spent most of his career in the city of Rome itself and produced hundreds of pieces of sacred music. His opus includes 35 settings for the magnificat, 11 litanies, and 105 settings for the mass. There is a fable that the Council of Trent was thinking of banning polyphonic music and Palestrina wrote a mass setting specifically to sway the council fathers. This is a myth: the council never did anything about music and that particular mass setting, the Mass for Pope Marcellus, was written much earlier.

THE WORD

The sixteenth-century reformations were, across the board, invested in both the individual and the community reading, marking, and inwardly digesting the "word," a place-holder for the whole of the Bible, its exegesis, and a body of doctrine. While it would be easy to construe these reform movements as moving away from life-shaping practices toward the simple affirmation or rejection of propositions (ideas), that would be grossly reductionist. Instead practice was re-envisioned toward the appropriation of the word, an appropriation which was first intellectual and then affective. The task of clergy was redefined as that of teaching the word; worship spaces were reordered to better achieve that appropriation of the word while the role of art was renegotiated or eliminated; and music, however powerful and evocative, was to carry the word to hearts and minds alike.

NOTES

1. Carolyn Muessig, ed., *Preacher, Sermon, and Audience in the Middle Ages* (Leiden: Brill, 2002); Leith Spencer, *English Preaching in the Late Middle Ages* (Oxford: Oxford University Press, 1993).

2. Timothy George, *Reading Scripture with the Reformers* (Downers Grove, IL: Intervarsity, 2011), 26–43; Richard Muller and John Thompson, eds., *Biblical Interpretation in*

the Era of the Reformation (Grand Rapids: Eerdmans, 1996); Donald McKim, ed., *Calvin and the Bible* (Cambridge: Cambridge University Press, 2006).

3. Heiko Oberman, *The Dawn of the Reformation* (Edinburgh: T&T Clark, 1992), 126–54; David Bagchi, "Sic et Non: Luther and Scholasticism," in *Protestant Scholasticism: Essays in Reassessment*, ed. Carl Trueman and Scott Clark (Carlisle, UK: Paternoster 1999), 3–15.

4. Frederick Barbee and Paul Zahl, *Collects of Thomas Cranmer* (Grand Rapids: Eerdmans, 1999), 4; Darlene Flaming, "The Apostolic and Pastoral Office: Theory and Practice in Calvin's Geneva," in *Calvin and the Company of Pastors*, ed. David Foxgrover (Grand Rapids, MI: CRC, 2004), 149–72; Jaroslav Pelikan, Valerie Hotchkiss, David Price, *The Reformation of the Bible / The Bible of the Reformation* (New Haven and Dallas: Yale University Press and Bridwell Library, 1996).

5. Fred Meuser, "Luther as preacher of the word of God," in *Cambridge Companion to Martin Luther*, ed. Donald McKim (Cambridge: Cambridge University Press, 2003), 136–48.

6. George, *Reading Scripture with the Reformers*, 171–98; Robert Kolb, *Martin Luther and the Enduring Word of God* (Grand Rapids, MI: Baker, 2016); John O'Malley, *Religious Culture in the Sixteenth Century: Preaching, Rhetoric, Spirituality, and Reform* (Aldershot, UK: Ashgate, 1993).

7. Bruce Gordon, *Calvin* (New Haven: Yale University Press, 2009), 140–43; Larissa Taylor, *Preachers and People in the Reformations and Early Modern Period* (Leiden: Brill, 2001).

8. Elsie McKee, ed., *John Calvin: Writings on Pastoral Piety* (New York: Paulist, 2001), 14–15; T. H. L. Parker, *Calvin's Preaching* (Louisville: John Knox, 1992).

9. Diarmaid MacCulloch, *All Things Made New: The Reformation and its Legacy* (Oxford: Oxford University Press, 2016), 230–36.

10. Bruce Gordon, *The Swiss Reformation* (Manchester: Manchester University Press, 2002), 232–39; Patrick Collinson, *Archbishop Grindal, 1519–1583: The Struggle for a Reformed Church* (Berkeley: University of California Press, 1979).

11. Kevin Killeen and Helen Smith, "Introduction," and Lori Anne Ferrell, "The Church of England and the English Bible, c. 1559–1640" in *The Oxford Handbook of the Bible in Early Modern England, c. 1530–1700*, ed. Kevin Killeen, Helen Smith, Rachel Willie (Oxford: Oxford University Press, 2015), 1–18, 261–71.

12. Horton Davies, *Worship and Theology in England: From Cranmer to Hooker, 1534–1603* (Princeton: Princeton University Press, 1970), 228–54; Arnold Hunt, *The Art of Hearing: English Preachers and their Attitudes, 1590–1640* (Cambridge: Cambridge University Press, 2010).

13. Davies, *Worship and Theology in England: From Cranmer to Hooker*, 246–54; Susan Wabuda, *Preaching during the English Reformation* (Cambridge: Cambridge University Press, 2002); Lori Anne Ferrell and Peter MacCullough, eds., *The English Sermon Revised: Religion, Literature, and History 1600–1750* (Manchester: Manchester University Press, 2000).

14. Will Coster and Andrew Spicer, "Introduction: The Dimensions of Sacred Space in Reformation Europe," and Beat Kümin, "Sacred Church and Worldly Tavern: Reassessing an Early Modern Divide," in *Sacred Space in Early Modern Europe*, ed. Will Coster and Andrew Spicer (Cambridge: Cambridge University Press, 2005), 1–16, 17–38; Andrew Spicer, "Sites of the Eucharist," in *A Companion to the Eucharist in the Reformation*, ed. Lee Wandel (Leiden: Brill 2014), 323–64.

15. Kathleen Kamerick, *Popular Piety and Art in the Late Middle Ages: Image Worship and Idolatry in England, 1350–1500* (New York: Palgrave, 2002), 21, 154.

16. Vera Isaiasz, "Early Modern Lutheran Churches: Redefining the Boundaries of the Holy and the Profane," in *Lutheran Churches in Early Modern Europe*, ed. Andrew Spicer (Aldershot, UK: Ashgate, 2012), 17–37.

17. Bridget Heal, "Sacred Image and Sacred Space in Lutheran Germany," in Coster and Spicer, *Sacred Space*, 39–59; Jennifer DeSilva, "'Piously Made': Sacred Space and

the Transformation of Behavior," in *The Sacralization of Space and Behavior in the Early Modern World*, ed. Idem (Aldershot: Ashgate, 2015), 1–32.

18. Robert Bartlett, *Why Can the Dead Do Such Great Things: Saints and Worshippers from the Martyrs to the Reformation* (Princeton: Princeton University Press, 2013), 88–89.

19. Lee Wandel, *Voracious Idols and Violent Hands: Iconoclasm in Reformation Zurich, Strasbourg, and Basel* (Cambridge: Cambridge University Press, 1994).

20. Andrew Spicer, "Iconoclasm and Adaption: The Reformation of the Churches in Scotland and the Netherlands," in *The Archaeology of the Reformation, 1480–1580*, eds D. Gaimster and R. Gilchrist (Leeds: Maney, 2003), 29–43.

21. Carlos Eire, *War Against the Idols: The Reformation of Worship from Erasmus to Calvin* (Cambridge: Cambridge University Press, 1986); Christopher Joby, *Calvinism and the Arts: A Re-Assessment* (Leuven: Peeters, 2007).

22. Christian Grosse, "Places of Sanctification: The Liturgical Sacrality of Genevan Reformed Churches, 1535–1566," in Coster and Spicer, eds., *Sacred Space*, 60–80; Christopher Marsh, "Sacred Space in England, 1560–1640: The View from the Pew," *Journal of Ecclesiastical History* 53 (2002), 286–311; Raymond Mentzer, "The Reformed Churches of France and the Visual Arts," in *Seeing beyond the Word: Visual Arts and the Calvinist Tradition*, ed. Paul Finney (Grand Rapids: Eerdmans, 1999), 199–230.

23. Margaret Aston, *England's Iconoclasts: Laws against Images* (Oxford: Oxford University Press, 1988); Idem, *Broken Idols of the English Reformation* (Cambridge: Cambridge University Press, 2016); Calvin Lane, "Before Hooker: The Material Context of Elizabethan Prayer Book Worship," *Anglican and Episcopal History* 74 (2005), 320–56.

24. Andrew Spicer and Sarah Hamilton, "Defining the Holy: The Delineation of Sacred Space," and Andrew Spicer, "'God will have a house': Defining Sacred Space and Rites of Consecration in Seventeenth-Century England," in *Defining the Holy: Scared Space in Medieval and Early Modern Europe*, ed. Andrew Spicer and Sarah Hamilton (Aldershot: Ashgate, 2005), 1–26, 207–30.

25. Hyun-Ah Kim, *Humanism and the Reform of Sacred Music* (Aldershot, UK: Ashgate, 2008).

26. Scott Hendrix, ed., *Early Protestant Spirituality* (New York: Paulist, 2009), 182; Rebecca Oettinger, *Music as Propaganda in the German Reformation* (Aldershot, UK: Ashagte, 2001); Alexander Fisher, *Music and Religious Identity in Counter-Reformation Augsburg 1580–1630* (Aldershot, UK: Ashgate, 2004); Christopher Brown, *Singing the Gospel: Lutheran Hymns and the Success of the Reformation* (Cambridge, MA: Harvard University Press, 2005).

27. Horton Davies, *Worship and Theology in England: From Cranmer to Hooker, 1534–1603* (Princeton: Princeton University Press, 1970), 386–91; Beth Quitslund, *The Reformation in Rhyme: Sternhold, Hopkins and the English Metrical Psalter, 1547–1603* (Aldershot, UK: Ashgate, 2008); Hannibal Hamlin, *Psalm Culture and Early Modern English Literature* (Cambridge: Cambridge University Press, 2004).

28. Diarmaid MacCulloch, *The Later Reformation in England* (New York: Palgrave, 2001) 24–47; Ian Green, "'All people that on Earth do dwell Sing to the Lord with a cheerful voice': Protestantism and Music in Early Modern England," in *Christianity and Community in the West*, ed. Simon Ditchfield (Aldershot, UK: Ashgate, 2001), 148–64; Jonathan Willis, *Church Music and Protestantism in Post-Reformation England* (Aldershot, UK: Ashgate, 2010).

29. Davies, 389; Robin Leaver, *Goostly Psalmes and Spiritual Songs: English and Dutch Metrical Psalms from Coverdale to Utenhove, 1535–1566* (Oxford: Oxford University Press, 1991); Nicholas Temperley, *Studies in English Church Music 1550–1900* (Aldershot, UK: Ashgate, 2009).

EIGHT

Sixteenth-Century Reformations

Pastoral Care and the Life Cycle

Pastoral care—defined here as the rituals, counsel, or forms of caring support which occurred at moments of life transition, moments which often involved the church community—evinces the relationship between practice and belief arguably more than any other topic for examination. It is in this arena that we can glimpse the complicated modes of religious change in early modern Europe and see new rhythms of individual and corporate life emerge. In short, when we look at (1) Christian formation among both children and adults, (2) the practices surrounding marriage and how marriage itself was reconceived, and (3) how sickness, death, and burial was reordered, we find that reformation programs in the sixteenth century were rarely top-down affairs, but instead involved negotiation with women, men, and children. People had been shaped by certain rhythms of life (often rhythms set by earlier reform agendas!), and they were not passive recipients of "legislation" in the sixteenth century. Likewise, as in previous chapters, we will again see the word-centered, intellectual nature of Protestant ritual and pastoral care. With a stress on the personal appropriation of the gospel (conceived as Christ's atoning death for the sinner), something that usually came through reading scripture or hearing sermons, one may suspect a certain "rise of the individual," a harbinger of modernity. Standing against that neat assessment, however, remains the public nature of rites and the role of community.

Rituals like baptisms, churchings for women after childbirth, weddings, visitations of the sick and dying, and burials were moments for lay-people to affirm a reform program, dissent from it, or, perhaps more often, engage in ambiguous renegotiation. These became moments where one not only transitioned in life-stages but also proved her or his confor-

mity to or dissonance with a reform agenda.[1] Pastoral care takes us out of abstraction and into the ordinary experiences of women and men, families and children, as they not only faced religious change but contributed to the emerging shape of the Protestant "denominations" we know today. Just as with chapters 6 and 7, it should also be admitted (rather than simply assumed) that this chapter will often focus on the magisterial Protestant reformations of the sixteenth century.

DISCIPLINE AND CONFESSIONALIZATION

The subject of forming children in the Christian faith during and in the wake of the sixteenth-century reformations is intimately related to the subject of the ongoing formation and disciplining of adults. We miss something if we see the religious education of children apart from what was happening to entire communities. As a theoretical lens used by historians, confessionalization refers to the process by which church and civil leaders codified reform movements into concrete, visible church bodies through disciplinary measures, often using summations of correct doctrine, "confessions," to check conformity. This primarily happened in the second half of the sixteenth century after the 1555 Peace of Augsburg placed so much *de facto* religious authority in the hands of local princes and magistrates. Even so, the project of teaching the new faith, with magistrates and clerics working closely together, had begun as early as the 1520s. And this process resulted in the "denominations" one encounters today. Major reformers composed summary statements of orthodox belief (often intentionally rejecting other bodies). In response, individuals and communities rallied around these "confessions." If one asks, what does it mean to be a Calvinist? An answer may be to accept the Belgic Confession (1561). If one asks, what does it mean to be a Lutheran? An answer may be to accept the Book of Concord (1580). Part of the confessionalization project, then, was distilling these confessional statements into catechisms for children, texts which could be used by pastors as well as parents in their shared task of forming Christians who at a personal level bought into a reformation project.[2]

A mechanism for seeing these texts shape real life were consistories, boards which examined the faith and practice of everyone in a community. While present across Lutheran and Reformed communities, consistories had varying degrees of influence, given that different reform movements had different attitudes toward discipline. Owing to Luther's "two kingdoms doctrine" in which God operates through two somewhat independent arms, the church and the state, the Lutheran clergy had much less disciplinary authority. Among the Reformed, there were two different models, one epitomized by Zurich and England and the other by Geneva. In both cases, civil and church authorities were quite unified.

In England and Zurich, the "Godly magistrate" ruled both church and state. In exercising this ministry, the magistrate was counseled by the clergy, an office not unlike other civil offices; the church was thus a wing of a "Godly" government. In Geneva, on the other hand, particularly by the 1540s, the company of pastors held incredible sway and, for all intents and purposes, was in the driver's seat. While consistories across Lutheran and Reformed territories were hardly uniform in nature, a look at the Genevan consistory will be a helpful example, particularly as its work highlights the formation of both children and their parents.

The Genevan consistory was a tribunal which policed the moral life of the community; Calvin himself was an active member from its launch in 1541 to his death in 1564. Here is perhaps the source of the caricature of Calvin and the Calvinists as dour prudes, paranoid that someone somewhere might be having a good time. The consistory called in people for dancing, playing cards, skipping worship, and of course illicit sex. It should also be noted, though, that there was a pastoral dimension to their efforts; the consistory worked toward reconciliation and dispute resolution. Perhaps more pointedly, they were keen to examine how parents were raising their children as orthodox Reformed Protestants. They worked in earnest to eliminate baptism by midwives: such denied the community orientation of Baptism, led people to believe that the rite itself and not God's election was what secured salvation, and was shrouded with popish superstition. The consistory was also acutely concerned about the practice of baptizing stillborn infants, a practice not uncommon in the later middle ages. The consistory also worked to end naming children after saints, especially St. Claude, who was venerated in the region; the board required parents to choose only biblical names. During the 1560s, 97 percent of children baptized in Geneva received biblical names, a precipitous drop from half of all children having a saint's name in the previous generation.[3]

The consistory also asked parents how they were teaching their children the faith. Many offered the grating answer that they were teaching their children what their parents had taught them, that is, the Lord's Prayer, Creed, and Ave Maria, all in Latin. Prior to the sixteenth century, religious instruction was largely in the hands of both parents. Protestant reformers affected two changes in this respect. First, the emphasis shifted to the father as pastor of the home, and this was certainly not limited to Calvinists. Luther had described parents, especially fathers, as apostles, bishops, and priests to their children. The Genevan consistory also evinced a fear common among sixteenth-century reformers that women were more prone to pass Catholic superstitions to their children. Secondly, for all their talk about parents as pastors, the Genevan consistory (consonant with other Reformed and Lutheran authorities) emphatically required children to come to catechism classes led by the pastor. This is the Protestant face of clericalism, as clergy encroached on what had been

a parental responsibility. On the other hand, a charitable interpretation would be that the clergy ensured "quality control." Regarding pedagogy, weekly catechism was largely memorization of answers to set questions, perhaps showing again the intellectual nature of sixteenth-century reformations, a habit shared with Roman Catholic reformers in the production of their catechisms and religious instruction (see chapter 9).[4]

People wrestling with religious change were not raw material to be shaped at will, however. There are stories across the continent of physical altercations at baptisms. In Geneva, one set of parents wrestled their child back from the pastor who wished to name him Abraham while they wished to give him the popish name Claude. On the other hand, Anabaptist parents were willing to go to jail rather than see their infant children baptized. In England, reformers were not comfortable with midwives performing the rite, but unlike other Reformed liturgies, the Book of Common Prayer allowed for emergency baptisms. That practice and the sign of the cross made over the infant in Baptism in the prayer book rite encountered Puritan scorn. With midwifery under episcopal supervision since the reign of Henry VIII, baptisms in the seventeenth century were not infrequently made by clergymen who made house-calls, not unlike physicians. Put simply, the experience had changed in unexpected ways. Similarly, churchings, the purification rite for women following childbirth, changed but in a way not simply directed by theologians. Before the sixteenth century, it was a cleansing ritual akin to Levitical prescriptions in the Old Testament. Most reformers wanted to do away with such a popish ceremony and its definitions of clean and unclean. However, in England it was repurposed as a thanksgiving rite, praising God for delivering the woman through the dangers of childbirth. While feminist historians have construed this as a misogynistic tool for controlling women, David Cressy has demonstrated how many women looked forward to it and how it was a public ritual in which other women were quite prominent.[5]

In short, a top-down model of religious change in pastoral care and religious formation leaves something to be desired. Most people were neither passive recipients of religious change nor completely resistant. A "popular politics" model offers some nuance: women, men, and perhaps children too engaged with consistories, disciplinary bodies, liturgical prescriptions, and the experience of catechism to emerge not quite as what theologians could mass-produce out of raw materials but new kinds of Christians nonetheless. To return to the question of confessionalization and the formation of women, men, and children, perhaps being a Lutheran or Reformed Protestant was more than simply declaring adherence to a confessional statement. It was about being formed in a community where that confessional statement was one of several critical elements, not the controlling element.[6]

MARRIAGE

Part of the so-called Gregorian Reform of the eleventh century was the norming of celibacy for all clergy, not simply monastics. This was part of an agenda which assumed that monasticism was the superior mode of Christian life and perhaps the only way one could make spiritual progress. In the early modern period, however, there was a rethinking not only of the propriety of married clergy, but of celibacy, marriage, and family life. In scripture, Paul wished that more men had the gift of celibacy to hasten the mission of the church, but he counsels that those without the gift ought to marry (1 Corinthians 7:7). And Paul was not the only single man in scripture; Jeremiah, John the Baptist, and Christ himself were unmarried. Jesus, who called fishermen to leave behind their fathers' business, had likewise spoken about a new family formed not by blood, but by the Holy Spirit (Mark 3:35, Luke 14:26). And he taught that at the resurrection marriage will fade away (Matthew 22:30). To be clear, celibacy is not without biblical warrant. On the other hand, there remained the image of Adam and Eve, primordial man and woman in God's good creation. And Christ not only worked his first miracle at a wedding, but set high expectations for lifelong marital fidelity (Matthew 19:3-12, Mark 10:2). While there is not space to recount the patristic perspective, it is enough to say that among late ancient and early medieval Christians, marriage was increasingly seen in its role as a concession for sexual weakness as Paul had outlined; for most of the early church Fathers, celibacy was the superior lifestyle.

In the middle ages, it is important to remember the distinction between secular clergy and religious clergy. "Religious" implies those under a rule (monks and friars). Secular priests, on the other hand, refers to those not in religious orders, most of whom were engaged in parish ministry. An outcome of the Gregorian Reform was a certain *monasticisation* of the secular clergy, an impressment of seculars to live in a common house. Reacting against this, Luther, in 1520, urged marriage for pastors who felt that they did not have the gift of celibacy and within five years all the Wittenberg reformers had married, Luther himself marrying the former nun Katarina von Bora. In the early 1520s, though, there was still a theoretical respect for the gift of celibacy. Most reformers, including Luther, however, doubted that many truly had such a vocation; Luther estimated one in a thousand. Curiously enough, Luther retained the decidedly medieval notion of a spiritual marriage with Christ for all true Christians, including men and women joined in wedlock. That spiritual marriage between Christ and the disciple, then, was sealed by Christ's grace for the sinner. In an interesting reversal of medieval thinking, Luther lamented, in one of his table talks, how so many of Christ's brides (men and women) betray Christ by adulterously praying to the saints and engaging other forms of works righteousness, presumably including

celibacy! In other words, pursing holiness through celibacy could very well be an act of infidelity in one's spiritual marriage to Christ the gracious savior. It is better, most reformers reasoned, to be married and trust Christ's grace than remain celibate and trust in the cloistered life. They argued that God ordained the domestic sphere for the Christian to live, beget children, and teach them the faith. Here is the decisive shift: reformers began to move the halo—the honors and praises that had been normatively attached to the celibate life—to married life and the family. Heinrich Bullinger's 1540 *The Christen State of Matrimonye* (the most frequently published continental Protestant text in England during the reigns of Henry VIII and Edward VI) shifted the negative emphasis from marriage as a concession for sexual weakness to the positive image of marriage as a divine institution in creation.[7]

While Bullinger's was the most extensive treatment of marriage from the first half of the century, the first tract for clerical marriage appeared in 1521 from Luther's colleague (later to become an Anabaptist) Andreas Karlstadt (1486–1541). He argued that clerical celibacy was intentionally designed to increase the church's wealth: men and women were driven to sexual sin—fornication, sodomy, masturbation—and then had to pay for indulgences. All of this can be remedied quite naturally, Karlstadt wrote, by recourse to God's own institution of marriage. A century later, the theme of marriage's ability to curb sin was still strong; one English writer proclaimed that marriage prevents adultery, fornication, incest, rape, masturbation, and sodomy. In the 1520s, calls for clerical marriage ran alongside an invective against monastic life as diseased with sexual sins (part of the rhetoric which led to the dissolution of the English monasteries in the 1530s). Monks were presented as sodomites and, worse still, pederasts who preyed on young boys in the novitiate. Monasteries were now viewed not as superior places of spiritual growth but cesspools for the grossest forms of sexual sin. Karlstadt conceded that if someone honestly felt called to profess a celibate life, then he or she should be over sixty years of age, because (so he argued) only then do the fires cool off. Luther was initially more cautious. In the early 1520s, Luther distinguished between secular clergy, who probably should marry, and religious clergy who felt so called. By the middle of the decade, Luther abandoned this misgiving. Like Karlstadt, he conceded that if one earnestly feels called to a celibate religious life in community, a woman should wait until sixty, and a man should be seventy or even eighty. By the 1530s, Luther loudly equated monks with apostate Christians, even comparing monasteries to hell. It was the vow that bothered him so much, insisting that the unsurpassable vow for the Christian is at Baptism, a death to self/the old Adam and a spiritual marriage to Christ. Vows beyond that seek to outdo what God has done at Baptism and that, according to Luther, is reprehensible.[8]

What about the popular perception of clerical marriage? In one respect, clerical marriage was a legitimation of what was already happening illicitly, clerical concubinage. While illicit, that old practice was certainly no secret. At the start of the sixteenth century, it was commonly accepted that a priest would keep a *de facto* wife in his home. Many of the reformers wanted to make these concubines into "honest women." In Zurich, in 1526, the government gave clergy two weeks' notice: turn these women out of your homes or marry them. The emphasis in this first generation was not simply the propriety of clerical marriage, but marriage being the place where one builds up a believing family. The campaign for clerical marriage, however, had to keep going: curiously, people who had been comfortable with their priests quietly keeping a concubine did not readily accept their clergy publicly having wives.[9] Twenty years after his own marriage, Luther preached at the wedding of a cathedral dean who had been secretly married for seven years. Even after a generation, clerical marriage remained awkward. After the break with Rome in 1534, Henry VIII forbade his clergy from marriage, a decision which must have made for an uncomfortable honeymoon for his new archbishop of Canterbury. It is perhaps ironic that Thomas Cranmer had married while in Nuremberg campaigning for the King's divorce. Not until the reign of Edward VI were English clergy legally allowed to marry and their children legitimized. But even later in England things could be awkward. In the 1560s, Queen Elizabeth visited the home of Archbishop Matthew Parker (1504–1575) and fumbled to thank his wife for her hospitality: "Madam, I may not call you . . . Mistress I am ashamed to call you, but howsoever I thank you." After Parker, more than a century passed before Canterbury had another married archbishop. But this was mainly because the route to the episcopate not infrequently ran through being the master of a college at Oxford or Cambridge and, for practical reasons, one could not a have a wife and family in that setting. Notwithstanding, high-ranking English clerics did marry. Only around a third of Elizabeth's bishops were unmarried; Matthew Hutton, her last archbishop of York, was widowed twice and married three times.[10]

The issue of clerical marriage, though distinct, was related to the rethinking of marriage as the privileged manner of life. Starting in the 1520s, there was a frantic screed about how the clergy were on fire with unrequited natural sexual needs. Justus Jonas (1493–1555), a Lutheran reformer, argued, "if you are a man, it is no more in your power to live without a woman than it is to change your sex . . . that inborn desire and innate affection by which men and women desire one another is not in our power to control; it is the way God has created and made us." Luther argued that celibacy will not free up a cleric for work, but rather slow him down with desires. Having a wife allows the cleric to focus on his work with a clear head! It did not take long, though, for reformers to clarify that sex is not the only reason for marriage. Bucer wrote that if he

had the option of sex with three women every morning, trading them out every week for another three, he would not be interested. Marriage, he said, does more than alleviate lust. Luther, likewise, wrote that marriage is a shaping experience, including keeping a house together and bringing up children. Some reformers also argued that a married pastor will better understand the challenges faced by married couples. Ultimately, the reformers' concern about marriage was broader than their own situation. They argued that the domestic sphere is the place where men and women engage in the vocation found in God's good creation. It is the place where children are raised to be Godly, where the next generation is taught scripture and right belief. The seventeenth-century English cleric Jeremy Taylor (1613–1667) wrote that marriage is like a useful bee, building a home, forming societies, sending out colonies, and living out God's design in creation. The reformations of the sixteenth century did not simply allow for married pastors, but exalted the home as a place of virtue.[11]

WEDDINGS

Given how broad the subject of weddings is and limitations of space in this book, I have chosen to focus attention on England. First, according to the set formularies of the Church of England (the Book of Common Prayer, Canon Law, the Books of Homilies, and the 39 Articles of Religion), marriage was not a sacrament. According to these formularies, a sacrament, properly speaking, signifies Christ's work of atonement and it confers justification and grace. That made the Church of England mostly consistent with Lutheranism and Reformed Protestantism. However, this non-sacramental status did not mean that the Church of England (or other Protestants for that matter) understood marriage as merely culturally defined. In Zurich, Bullinger wrote that God himself "knitteth the knot" and that marriage reflects the covenant between God and his people. The Book of Common Prayer had the officiating minister read a preface at the beginning of the liturgy explaining to the bride, the groom, and the gathered congregation the nature of marriage: it is a way of life instituted by God himself in creation, blessed by Christ, praised by the apostles, and which symbolizes the union between Christ and his church. While not a sacrament, marriage is of divine institution, a grave matter not to be entered lightly. Most clerics also agreed that marriage ought to be handled by the church, reflecting both its public and religious dimension in Reformed theology. John Donne said that without public testimony and the blessing of the church, it "is but regulated adultery, it is not marriage."[12]

As the Church of England retained much of the traditional liturgical calendar, certain times were considered unsuitable for a wedding. With a few short windows, the first half of the year was largely off limits (from

Advent in December through the end of Eastertide in the late spring). Weddings could occur after Trinity Sunday, usually in early June, leaving the summer and fall available. This accounts for the tradition of being a "June Bride." Additionally, the Feast of the Nativity of John the Baptist (June 24) was construed as being particularly lucky for fertility. These prohibitions, however, were tradition, found neither in the prayer book nor canon law, and Puritan ministers railed against them as popish holdovers. By the end of the sixteenth century, clergy might turn a blind eye and officiate in one of the prohibited seasons, more likely Advent than Lent. But a century later, only the most scrupulous Anglicans observed even Lent as a time to avoid weddings. The prayer book and canon law, however, did require the banns of marriage, a public announcement for three weeks to prevent an impediment, that is, no current marriages, no consanguinity, and both parties being of age (fourteen for a boy, twelve for a girl, and parental consent if either is under twenty-one). The degrees of consanguinity, that is, being too closely related, were spelled out in a table which Archbishop Parker added to the prayer book in 1560, the Table of Kindred and Affinity. Other sixteenth-century reformers had produced similar tables, usually drawn from Leviticus 18. Luther, for example, repeated the biblical text in its singularly male orientation. Bullinger, though, expanded the list to include the implications for women. For example, where Leviticus stated that a man could not marry his mother, Bullinger reasoned that this also meant a woman could not marry her father. Following this expansive model, Parker's table listed thirty forbidden relationships including one's father's brother's wife (an aunt not by blood), deceased wife's sister (sister-in-law), and brother's son's wife (one's nephew's wife).[13]

Weddings had a community orientation. The published banns along with the minister asking the congregation if anyone has objections gave ample opportunity for the couple to be vetted. A further emphasis on community was struck when the rite was moved from its previous position at the church door to inside the church itself. The prayer book wedding service begins with the minister explaining to the whole congregation the purposes of marriage: (1) procreation of children and their Christian upbringing, (2) a remedy against sexual sin, and (3) the help and comfort husbands and wives afford each other. This list was a reiteration of Augustine's "goods of marriage." The father of the bride then "gives" his daughter away, vows highlight a life-long covenant, the groom presents the bride with a ring (which, though no longer blessed, endured Puritan critique as a popish-holder), and the minister declares them to be "man and wife." A final blessing comes with the grave warning, "what God hath joined together let no man put asunder."[14]

Divorce certainly occupied theologians at this moment; consider the task force which advocated Henry VIII's "great matter" and those Lutheran reformers tangled up in the bigamy of Philip of Hesse. Closer to

the ground, however, most reformers wanted stricter punishments for adultery, yet wider latitude for divorce. To the medieval grounds for divorce (adultery and impotence) the Lutherans added desertion. Reformed theologians like Martin Bucer, Peter Martyr Vermigli, and Heinrich Bullinger wrote that marriage could be dissolved for still other reasons. The Zurich authorities added extreme incompatibility, desertion, physical or mental illness, and fraud. A failed canon law change in England would have also allowed deadly hostility and prolonged abuse. All the major sixteenth-century reformers, however, permitted remarriage for the innocent party in cases of adultery.[15]

SICKNESS AND DYING

Death in the twenty-first century west is a sanitized experience, one removed from the everyday. Despite violence and terrorism reported in our media, the general pattern is for one to slowly divest from community, gradually retreating from the social world. This is more of a fading than a rupture. People of the premodern world, however, had an intimacy with death. Mortality rates, particularly among infants and women in childbirth, were astronomically higher and sickness itself more often led to death than recovery. How did the reformations of the sixteenth century alter perceptions of dying and death? How did burial practices and other liturgical observations change? And how did older patterns evolve or persist?

In the later middle ages, pastoral care for the dying included the priest hearing a final confession, anointing, and the viaticum (final communion). This combination of sacraments constituted "last rites." Neighbors seeing a priest on his way to a sick person's house, carrying a pyx, perhaps with an assistant ringing a bell, would fall to their knees to adore the Eucharistic presence, to recognize the impending rupture in their community, and to reflect on their own mortality. The aspiration of all Christians, before and after the sixteenth century, was for a good death— one marked by the presence of family, prayers, and the dying person exhibiting signs of peace and faith in her final hour. In the middle ages, the hour of death was understood as a time ripe for temptation, as the dying might succumb to despair (*desperare*, to give up hope). Late medieval images portray the dying man tempted by demons on the one hand and encouraged by saints on the other, the final gauntlet which would determine his destination, either hell or purgatory. One's hope was a short stint in purgatory, removing the dross of a sinful life before the beatific vision in heaven. On the other hand, there was no escape from hell and giving up hope during the final hour might consign one to the inferno.[16]

A genre of literature, the *ars moriendi* (art of dying), emerged in the later middle ages to address this situation. A help to priests certainly but also an aide to literate lay-folk, such treatises highlighted how suffering identified one with the saints who often endured gruesome deaths with fortitude and how one can avoid despair. With prayers for the dying and illustrations showing people dying well, this kind of literature did not disappear in the sixteenth century but rather evolved. The most obvious adaption is Luther's own *Fourteen Consolations* (1520; revised in 1535), a text modeled on a popular German tradition of fourteen guardian saints who worked against specific illnesses and calamities. Considering one area of engagement, Luther shared in the medieval estimation of suffering as a way God shows his glory in human weakness. He diverged from the tradition, however, by rejecting suffering as a path to improvement, building on inner strength. The dying man instead ought to see clearly that his only hope is in the grace of Christ. In this respect, the *Fourteen Consolations* are not meant to help the dying improve their attitude, but to trust in God.[17] Exhorting faith, usually by engaging scripture, was the all-encompassing vocation of Protestant pastors, and that was certainly true of their care for the dying. Calvin's liturgy (1542) and the Genevan church order (1541) both emphasize that the sick and dying must receive teaching at the critical hour. In 1547, Archbishop Thomas Cranmer, for example, did not offer the dying Henry VIII the last rites, but instead asked the king if he had faith in Christ. Henry, beyond speech, gripped the archbishop-cum-teacher's hand and squeezed a "yes."[18]

Cranmer's pastoral care for Henry, however, proved not to be his model for the Book of Common Prayer in 1549 or 1552. Although the 1552 book dropped anointing, both versions provided communion for the sick. That liturgy had stronger pre-reformation echoes than one might expect. The dying was encouraged to share in the sufferings of Christ, an act of imitation from which Luther may have shied away. Likewise, the prayer book allowed the dying to unburden sins privately to the minister, a rubric which later high-churchmen interpreted as allowing auricular confession on other occasions. Overall, however, the prayer book focused on the immediacy of death, encouraging frequent reception of communion because one might die unexpectedly. Likewise, the prayer book's litany prays against sudden death from everything from plague to lightning. The inculcation of virtue, however, was not universally rejected. There emerged a certain English Protestant *ars moriendi* in which we find the idea that a good life is the right preparation for a good death. Examples include Thomas Becon's *Sick Man's Salve* (1561), Christopher Sutton's *Disce Mori* (1600), and most famously Jeremy Taylor's *Holy Dying* (1651). In the seventeenth century, the Laudians augmented the prayer book with other materials like Lancelot Andrewes' manual for clergy visiting the dying. The Restoration-era bishop John Cosin (1594–1672) violated

Reformed sensibilities by devising a prayer for the dead, marking a significant departure from previous Reformed thinking.[19]

BURIAL AND THE DEAD

When one died in the later middle ages, a sequence of rites began the evening before the burial and, technically, ended a year or more later. Vespers of the dead, in the evening, was followed the next morning with matins of the dead and then the requiem mass. The body was then buried, often simply in a winding sheet. One of the critical shifts of late antiquity was relocating cemeteries, previously beyond the city walls, to inside urban communities. Ancient pagans felt this was unsanitary, criticizing Christians for holding rites on their martyr's graves. By the middle ages, though, the earth around sacred space—the churchyard—was considered the proper place for interment. Those of great rank in the church or social hierarchy might be buried within the building itself, proximity to the altar being a sign of prestige. Funerary monuments themselves could speak to the community: prior to the rise of Protestantism, these might bid the living to pray for souls in purgatory; after, to put their faith in Christ while there is still time. On either side of the sixteenth century, *memento mori* images (e.g., the dance of death) reminded Protestant and Catholic alike that death was imminent. Returning to medieval funerary rites, the offices of the dead and the requiem could be repeated a week later, a month later, and a year later. The mass itself, with intention to hasten the soul's release from purgatory, could be celebrated as many times as the living executors could pay. In the late fifteenth century, Piero d'Medici provided 12,000 masses at fifty-three different institutions for his father's release from purgatory.[20]

The ties between the living and the dead in the middle ages can be described as cultural, theological, and economic. And in each case, there was reciprocity: via a monument or mass, the dead gained fame while the living expanded their own place in the community; via prayers, indulgences, and masses, the dead slip from purgatory to become saints in heaven who in turn pray for the living. It is no understatement to say that Protestant reformers saw prayer for the dead as anathema. Reformed congregations, stretching from Scotland to eastern Europe, severely pared down burial rites. But the body still needed disposal. While there was variation, the example of Dutch Calvinists is helpful. The corpse was prepared and put in its coffin and the funeral party, dressed in black, solemnly processed to the cemetery. The church building played no part. Neither did the pastor; his presence was not to officiate but to offer comfort. A somber, minimalist burial was followed by a feast at the deceased's home. What purpose would prayer serve, the Reformed asked, if God had already passed judgment? While the Church of England had

more ceremony and a role for the clergy to play, the English burial office was brief and could bypass the church building entirely. Its conclusion speaks of election and the fulfilling of God's sovereign purposes—it was a rite for the living. If a sermon was offered, it could serve as a didactic exercise to teach the living about God's providence.

Places of burial were likewise reformed. In Scotland, Reformed theologians railed against burial in church buildings. One treatise declared that it was unseemly to bury a corpse in the place for preaching and the sacraments. This argument defined the space by its use: the church was not meant, the author continued, to be a burial ground. Like the late ancient pagans, Reformed Scots also deemed the practice unsanitary. This invective, however, did not prevent aristocratic Scots from pushing their right to be buried with their ancestors. At the beginning of the seventeenth century, King James VI tried to solve the problem by encouraging Scottish nobles to build sepulchers. In the Netherlands, though, burial within churches continued, primarily because the Dutch Reformed clergy had less control over church space. Among the Huguenots in France the tension had an entirely different face, a reversal of the situation in Scotland: the Huguenots stoutly insisted on their right to be buried in Catholic churches with their ancestors in the face of Catholic opponents who wished to prevent the interment of heretics.[21]

Other areas of adaption included the bell that was solemnly tolled at funerals across much of northern Europe. Meant to express communal grief, the bell could not help but evoke the old purpose of calling people to pray for the dead. Suicides, likewise, were not infrequently buried separately thus perpetuating medieval sensibilities about the afterlife and the nature of sacred space. A wonderful example of the persistence of popular religion is the continued belief that the soul lingered around the corpse for about a month, making churchyards places of spiritual potency, both good and ill. The churchyard also continued to highlight the communion of the saints, living and dead, a creedal belief even after the sixteenth-century reformations. The seventeenth-century Laudian bishop Matthew Wren (1585–1667) preached that Christ's church exists as a community and therefore the bodies of church members, women and men who had lived together, ought to be buried together; and when Christ returns in glory, Wren continued, they will rise together.[22]

MILESTONES IN LIFE

Reflecting on the nature of tradition, the twentieth-century Roman Catholic theologian and ecumenist Yves Congar wrote that a child receives the life of the community into which she is born. The child learns not simply by digesting ideas, but within concrete experiences as the riches of one generation are passed on by real, fleshy hands in the habits of

daily life. Reform movements in the sixteenth century could not stand—or even exist as movements for real change—by way of abstract doctrinal statements, codifications of ideas. Instead, new forms of culture had to emerge, and this naturally involved whole communities. In chapter 9, we will see something similar happening among Roman Catholics. In this space, however, we have walked through a variety of critical life-moments to see the connections, sometimes strained, between the theological vision of different reformers and their inculturation (not simply application). Rites of passage—those events circling around birth, childhood, marriage, and death—were opportunities for individuals to participate in larger discourses, registering their affirmation, rejection, or, more often, their ability to engage and adapt, thereby weaving new forms of Christian life and practice within community.[23]

NOTES

1. Susan Karant-Nunn, *The Reformation of Ritual: An Interpretation of Early Modern Germany* (New York: Routledge, 1997).

2. Heinz Schilling, "Confessionalization: Historical and Scholarly Perspectives of a Comparative and Interdisciplinary Paradigm," in *Confessionalization in Europe, 1555–1700*, ed. John Headley, Hans Hillerbrand, and Anthony Papalas (Burlington, VT: Ashgate, 2004), 21–35; Robert Kingdon, "Social Control and Political Control in Calvin's Geneva," *Archive for Reformation History* (1993), 521–32.

3. Jeffrey Watt, "Calvinism, Childhood, and Education: The Evidence from the Genevan Consistory," *Sixteenth Century Journal* 33 (2002), 439–56.

4. Timothy Wengert, "The Small Catechism," in idem, ed., *The Pastoral Luther* (Grand Rapids: Eerdmans, 2009), 201–52; Ian Green, *The Christian's ABC: Catechisms and Catechizing in England, c. 1530–1740* (Oxford: Clarendon, 1996), 93–229; Gerald Strauss, *Luther's House of Learning Indoctrination of the Young in the German Reformation* (Baltimore: Johns Hopkins University Press, 1978), 1–28, 108–31; Barbara Pitkin, "'The Heritage of the Lord': Children in the Theology of John Calvin," in *The Child in Christian Thought*, ed. Marcia Bunge (Grand Rapids, MI: Eerdmans, 2000), 181–86; Steven Ozment, *When Fathers Ruled: Family Life in Reformation Europe* (Cambridge, MA: Harvard University Press, 1983), 170–72. For confirmation, here passed over, see James Turrell, "'Until Such Time as He Be Confirmed': The Laudians and Confirmation in the Seventeenth-Century Church of England," *The Seventeenth Century* 20 (2005), 204–22; John Booty, ed., *The Book of Common Prayer, 1559* (Charlottesville, VA: University Press of Virginia, 1976), 282–89.

5. David Cressy, *Birth, Marriage, and Death: Ritual, Religion, and the Life Cycle in Tudor-Stuart England* (Oxford: Oxford University Press, 1999), 228–32; Booty, ed., *The Book of Common Prayer, 1559*, 269–81, 314–15.

6. Ethan Shagan, *Popular Politics and the English Reformation* (Cambridge: Cambridge University Press, 2003), 1–27; Jeffrey Watt, "Women and the Consistory in Calvin's Geneva," *Sixteenth Century Journal* 24 (1993), 429–39. See also the essays in Karen Spierling and Michael Halvorson, eds., *Defining Community in Early Modern Europe* (Burlington, VT: Ashgate, 2008).

7. Carrie Euler, "Heinrich Bullinger, Marriage, and the English Reformation: *The Christen state of Matrimonye* in England, 1540–53," *Sixteenth Century Journal* 34 (2003), 367–92; Kathleen Crowther, *Adam and Eve in the Protestant Reformation* (Cambridge: Cambridge University Press, 2010); Karen Spierling, "Honor and Subjection in the Lord: Paul and the Family in the Reformation," in *A Companion to Paul in the Reformation*, ed. Ward Holder (Leiden: Brill, 2009), 465–500.

8. Cressy, *Birth, Marriage, and Death*, 296; Steven Ozment, *The Age of Reform, 1250–1550: An Intellectual and Religious History of Late Medieval and Reformation Europe* (New Haven: Yale University Press, 1980), 383–84; Dorothea Wendebourg, "Luther on Monasticism," in Wengert, ed., *Pastoral Luther*, 327–54; Heiko Oberman, "Martin Luther contra Medieval Monasticism: A Friar in the Lion's Den," in *Ad Fontes Lutheri: Toward Recovery of the Real Luther*, ed. Timothy Maschke et. al (Milwaukee, WI: Marquette University Press, 2001), 183–213.

9. Marjorie Elizabeth Plummer, *From Priest's Whore to Pastor's Wife: Clerical Marriage and the Process of Reform in the Early German Reformation* (Farnham, UK: Ashgate, 2012), 11–90.

10. Eric Carlson, *Marriage and the English Reformation* (Oxford: Blackwell, 1994), 44–52; Helen Parish, *Clerical Marriage and the English Reformation* (Burlington, VT: Ashgate, 2000); Ozment, *Age of Reform*, 385–96; Brett Usher, *Lord Burghley and Episcopacy, 1577–1603* (New York: Routledge, 2016), 10; Jeffrey Watt, *The Making of Modern Marriage: Matrimonial Control and the Rise of Sentiment in Neuchâtel, 1550–1800* (Ithaca, NY: Cornell University Press, 1992).

11. Plummer, 245–84; Joel Harrington, *Reordering Marriage in Reformation Germany* (Cambridge: Cambridge University Press, 1995), 59–83; Ozment, *Age of Reform*, 389–96; Idem, *When Fathers Ruled*, 1–49; Erza Plank, "Domesticating God: Reformed Homes and the Relocation of Sacred Space," in *Emancipating Calvin: Studies on Huguenot Community and Culture in Honor of Raymond Mentzer*, ed. Karen Spierling, Ward Holder, and E. A. de Boer (Leiden: Brill, 2017).

12. Booty, ed., *The Book of Common Prayer 1559*, 290–96; Anthony Fletcher, "The Protestant Idea of Marriage in Early Modern England," in *Religion, Culture, and Society in Early Modern Britain*, ed. Anthony Fletcher and Peter Roberts (Cambridge: Cambridge University Press, 1994), 161–81.

13. Ozment, *When Fathers Ruled*, 44–66; Euler, 376; Cressy, *Birth, Marriage, and Death*, 285–315.

14. Booty, ed., *The Book of Common Prayer, 1559*, 290–96.

15. Robert Kingdon, *Adultery and Divorce in Calvin's Geneva* (Cambridge, MA: Harvard University Press, 1995); Herman Selderhuis, *Marriage and Divorce in the Thought of Martin Bucer*, trans. John Vriend and Lyle Bierma (Kirksville, MO: Thomas Jefferson University Press, 1999).

16. Peter Marshall, *Beliefs and the Dead in Reformation England* (Oxford: Oxford University Press, 2002), 6–46.

17. Jane Strohl, "Luther's *Fourteen Consolations*," in Wengert, ed., *Pastoral Luther*, 310–24; Austria Rennis, *Reforming the Art of Dying: The* Ars Moriendi *in the German Reformation, 1519–1528* (Burlington, VT: Ashgate, 2007); Brian Brewer, *Martin Luther and the Seven Sacraments* (Grand Rapids: Baker, 2017), 136–63.

18. Elsie McKee, *John Calvin: Writings on Pastoral Piety* (New York: Paulist, 2001), 291–93; Diarmaid MacCulloch, *Thomas Cranmer: A Life* (New Haven: Yale University Press, 1996), 360.

19. Hannah Cleugh, "'At the hour of our death': Praying for the Dying in Post-Reformation England," in *Dying, Death, Burial, and Commemoration in Reformation Europe*, ed. Elizabeth Tingle and Jonathan Willis (London: Routledge, 2015), 49–66. For Bucer's 1549 visitation instructions in which the Eucharist is prominent, see Scott Hendrix, ed., *Early Protestant Spirituality* (Mahwah, NY: Paulist, 2009), 131–39. For confession, see Ronald Rittgers, *The Reformation of the Keys: Confession, Conscience, and Authority in Sixteenth-Century Germany* (Cambridge, MA: Harvard University Press, 2004).

20. Bruce Gordon and Peter Marshall, "Introduction," in *The Place of the Dead: Death and Remembrance in Late Medieval and Early Modern Europe*, ed. Bruce Gordon and Peter Marshall (Cambridge: Cambridge University Press, 2000), 1–16.

21. Andrew Spicer, "'Rest of their bones': Fear of Death and Reformed Burial Practices," in *Fear in Early Modern Society*, ed. William Naphy and Penny Roberts (Manchester: Manchester University Press, 1997), 167–83; Penny Roberts, "Contesting Sa-

cred Space: Burial Disputes in Sixteenth-Century France," in Gordon and Marshall, eds., *Place of the Dead*, 131–48.

22. Cressy, *Birth, Marriage, and Death*, 379–473.

23. Yves Congar, *The Meaning of Tradition* (New York: Hawthorn, 1964), 22–25. See also James K. A. Smith, *Desiring the Kingdom: Worship, Worldview, and Cultural Formation* (Grand Rapids, MI: Baker, 2009); Pierre Bourdieu, *Outline of a Theory of Practice* (Cambridge: Cambridge University Press, 1977).

NINE

Sixteenth-Century Reformations

Early Modern Catholicism

This study has intentionally avoiding speaking of "the Reformation," but rather a series of movements for reform stretching from the eleventh century to the eighteenth. Moreover, the variety of early modern movements which are often pressed down and held together (at times awkwardly) under the heading "Protestantism" need to be seen not only in their rich variety and diversity but also alongside yet another contemporary movement for religious change, the early modern reforms of Roman Catholicism. While chapters 6–8 have focused on the spirituality of Protestant reform movements, particularly Lutherans and Reformed Protestants, this chapter examines the no less decisive changes emerging in the sixteenth century among Roman Catholics, a religious label which should be carefully avoided prior to the sixteenth century. The shape of the Roman Catholic Church today is, arguably, no less a product of the sixteenth century than that of the Lutheran and Reformed traditions. The universalizing Tridentine Mass, the emphasis on an educated priesthood and a well-catechized laity, new globe-trotting religious orders like the Jesuits, and baroque forms of sacred space like St. Peter's Basilica in Rome were hardly medieval conservations.

FINDING THE RIGHT NAME

Eamon Duffy has suggested that we refer to the patterns of spirituality inherited by most western Christians at the start of the sixteenth century (e.g., the medieval mass) as "traditional religion."[1] Those patterns are not coterminous with the Roman Catholicism we find at the close of the

century. An obvious example is that the medieval mass and the Tridentine Mass are very different phenomena. How, then, should we label what happened among Catholics in the sixteenth century? After all, they did not simply perpetuate "traditional religion." Multiple names have been used to label the Catholic experience, each helpful in catching a significant angle while falling short in other ways. The term "Counter Reformation," the oldest and most incendiary label, highlights the undeniable fact that many Catholics sought by different means to defend/conserve against Protestant challenges. However, that language paints Catholics as fundamentally reactionary and aiming to preserve something, i.e., late medieval patterns of belief and practice. Even a cursory review of the Council of Trent shows that to be false. "Counter Reformation" may also give the impression that the Catholic experience of religious change can be reduced to a dialogue with Protestants—one which was started by Protestants and in which Catholics are merely the obstinate foil. The Jesuits, for example, are often classed as part of the Counter Reformation when in fact members of that order were not stridently interested in meeting Protestant advances until some fifteen years after the Jesuit's foundation in 1540. The Society of Jesus was not founded for conservation and refutation. What about "Catholic Reformation" or "Tridentine Reform?" There is no doubt that reform efforts were achieving success; likewise, no one can doubt the importance of the Council of Trent. But equally so, those terms may miss some elements of continuity and over-emphasize a top-down model of change, a method for interpreting history whose limitations we have seen among Protestants. What about "Confessional Catholicism?" As discussed above, the shaping of "confessional" identity happened among both Catholics and magisterial Protestants. But, as also discussed, the confessionalization model may miss the role of "popular politics," those areas of resistance, negotiation, and adaptation. John O'Malley has suggested an umbrella term, "Early Modern Catholicism." It allows for continuity and change. It is neutral on the issue of the inevitability of reform. And it does not insinuate a model of active church leaders and passive lay-people, but considers experiences in all their complexity during a period of substantial change.[2]

A LONGER VIEW

The Council of Trent which spanned eighteen years, 1545 to 1563, is often seen as the defining aspect of early modern Catholicism, and one common but problematic way of framing the council is as a response to the emergence of Protestant reform movements. While there is no denying the importance of Trent for early modern Catholicism, a different and more accurate approach to frame Trent is to situate that body with the reforming legacy of the fifteenth-century councils (see chapter 5) and the

often overlooked Fifth Lateran Council (1512–1517). The councils of Constance (1414–1418) and Basel (1431–1449) discussed a variety of reforms—moral, theological, and structural. The conciliarist push to place councils as a regular check on papal authority was dealt several blows in the second half of the fifteenth century, most notably Pius II's bull *Execrabilis*. Then Lateran V was arguably the nadir for conciliarist hopes: that body declared the pope's supremacy over councils and his sole authority to convoke, transfer, and close them. However, Lateran V also demanded better education for clergy, inveighed against prelates holding multiple positions (benefices) for the revenues, and stressed the pastoral responsibilities of bishops. These reform efforts were happening before Luther published his Ninety-Five Theses. And, further, there was a legitimate diversity of opinions on theological topics. For example, there were different schools of thought on the question of how grace operates in the process of salvation. Thomists believed that initial grace is a free gift and then humans cooperate with God on the road to salvation. Nominalists thought otherwise, that human beings can prepare themselves for grace and to some extent merit it from the start. There was no single "medieval church" teaching on this subject. Trent, then, did not simply shore up a pre-existing orthodoxy in reaction to Luther.

Having recognized these trends, however, Protestant reform movements did have an effect on early modern Catholic thought and practice too. During the 1520s, a great deal of energy was directed against first-generation Protestant reformers. Johann Maier von Eck at the Leipzig Disputation, for example, pushed Luther into a corner, forcing the Wittenberg professor to challenge papal authority. Anti-Lutheran polemic dominated the 1520s. Catholic authors often took advantage of the Peasants' War: they called Luther both revolutionary and inconsistent, as he did not stand with the peasants whom, according to the Catholic controversialists, the unhinged monk had incited. During the 1530s, however, there was more interest in conversation, often facilitated by political leaders. Without a council to settle things, Emperor Charles V held colloquies, hoping for some common ground between Catholics and Protestants. Moderate Catholic reformers like Johann Gropper (1503–1559) and Gasparo Contarini (1483–1542) met with more conciliatory Protestants like Martin Bucer (1491–1551). Likewise, there was a circle of moderate humanists surrounding Cardinal Reginald Pole (1500–1558) in these years who were open to compromise. This hopeful phase ended with the failure of the Colloquy of Regensburg (1541) which could not articulate a satisfactory doctrine of justification. With the breakdown of the colloquies, the Council of Trent on the horizon, and imperial military intervention in the wings, Catholic theological writing entered a more propagandistic phase. For example, the years just before Trent, 1541–1545, witnessed a boom in the production of catechetical works.

Those were years of major engagement with Protestant reformers, however that should not blind us to the fact that there was still diversity among Catholics. Considering ecclesiology, Cardinal Thomas Cajetan (1469–1534), often considered the scourge of moderates, argued that when Peter received the keys from Christ in Matthew 16 he represented all the apostles. This certainly challenges the picture of Cajetan as an ultra-papalist. Considering scripture and tradition, Catholic authors attacked *sola scriptura* arguments by either equating the authority of tradition with the authority of scripture or, more remarkably, making an exclusive appeal to scripture, thus playing the game by Protestant rules. On the relationship between the sacrifice of the mass and the sacrifice of the cross, there was even less consensus. Some Catholics, like Eck, believed every mass to be a fresh oblation. Others, like Cajetan, preferred Thomistic terms, regarding the mass as an unbloody representation of the once-for-all sacrifice on the cross. The subject of soteriology and justification has perhaps wrongly dominated scholarship as the flashpoint of sixteenth-century reformations, allowing Lutheran concerns to set the agenda. In Catholic controversial literature in the mid-sixteenth century, the mass and the papacy (practices and structures) receive much more attention.[3]

Through those years, the 1520s to the 1540s, there were unambiguous appeals for a council. Luther, the Imperial Estates, and Charles V all called for such a gathering. Pope Clement VII (r. 1523–1534), however, feared what such an unwieldy assembly might do. At the Diet of Augsburg in 1530, the Lutheran prince Philip of Hesse managed to get the call for a council worked into the Augsburg Confession. Cardinal Lorenzo Campeggio (1474–1539), a delegate to that diet and a canon lawyer who had stymied Henry VIII's hope for a divorce just two years earlier, suspected Protestant calls for a council were simply a tactic to buy time. If the emperor acted decisively, Luther's reform movement would have been just another episode in the history of heresy. This stalling for a council allowed a theological drift among scholars to balloon into the movement it became, one with a developing ecclesiastical structure, liturgies, and patterns of church life separate from Rome. Campeggio believed that the Augsburg Confession with its ameliorating tone and the presence of Philip Melanchthon (that Protestant most known for moderation) disguised a ploy. It was not until 1536 that Pope Paul III tried to call a council in Mantua. By then, the Lutheran Schmalkaldic League declared that they would not accept a council led by the pope or one outside Germany. Much water had passed under the bridge by the time Trent came together in 1545, more than twenty years after Luther's excommunication and his calling the pope antichrist. Charles V had concluded his unsuccessful colloquies, attempts to settle matters through conversation and possible compromise at Worms (1540) and Regensburg (1541). By then not only had Lutheran and Reformed structures come into sight, the

Lutherans and Reformed themselves were concretely divided. And there was change within Roman Catholicism during those decades too. The pope had approved several new religious orders since Luther burst on the scene: the Theatines (1524), the Capuchins (1536), the Jesuits (1540), and the Ursulines (1544). The Roman Inquisition was reorganized in 1542. And the college of cardinals gained three important new members in those years: two reformers, Contarini and the English exile Reginald Pole, and that standard-bearing archconservative and first general of the Theatines, Gian Pietro Carafa (1476–1559). In short, much had changed since the early 1520s.

THE COUNCIL

With three distinct phases and a total of twenty-five sessions, Trent was about reform, not simply defending against Protestant threats. One thinks of Pole, Gropper, d'Etaples, Bricconet, and Contarini. Pole's opening address at the council called for more preaching, better pastors, and for high-ranking clerics to repent of complacency. However, as Protestants refused to recognize any council led by the pope, they were not represented, at least not in the first phase, 1545 to early 1548. Agreeing to alternate discussion between doctrine and reform measures, the council early on achieved a position on justification, that topic so central for Luther. Most Protestants held that, in the order of salvation, justification comes first, by unmerited grace alone through faith alone. Christ's merits are *imputed* to the elect sinner and the justified life flows, again by grace, into the sanctified life. Good works (holiness of life) do not cause one to be justified. It was the other way around: good works are the product of having been justified by God's grace. At the failed colloquy of Regensburg (1541), moderates like the Catholic Johann Gropper and the Reformed Protestant Martin Bucer hammered out a compromise formula in which grace is given at baptism, humans fall away because of post-baptismal sins, and Christ's righteousness is imputed to supplement the predicament. Trent considered this model, but it was once more found unsatisfactory—this despite some leading Catholic voices having an Augustinian accent that would have been familiar to many Lutherans (e.g., Pole). Instead the council pressed that Christians travel through life aided by imparted grace, not imputed righteousness.

The council also warned against private interpretation, stressing the pastoral ministry of bishops who regularly preach. This evangelical-apologetic-catechetical imperative then fell on all Catholic clergy. The council affirmed the canonicity of the apocrypha, declared the Latin Vulgate to be the church's standard edition, and observed that tradition and scripture ultimately coinhere. Addressing this subject, John Calvin in his *Acts of the Council of Trent with the Antidote* (1547) remonstrated that a host of

problems would come from the dangerous elevation of tradition to parity with scripture. Although he conceded the importance of the apocrypha, Calvin denied that those books could be used to establish doctrine. He also insisted that using the Vulgate was unacceptable in the face of better translations.[4]

The Council of Trent was shut down, however, in early 1548. With Emperor Charles's victory at Mühlberg over the Lutheran Schmalkaldic League in 1547, the pope feared both the plague and the emperor's strength. He moved the council to Bologna where it was suspended on February 1, 1548. A new pope, Julius III, reconvened the council in 1551. Charles was now riding high; the emperor forced Protestants to send representatives to the reopened sessions, although their presence had little effect. Their leadership had been scattered, Luther was dead, and in these years England was the only major Protestant kingdom. In this second phase, 1551–1552, the council formally endorsed the Thomistic doctrine of transubstantiation with its distinction between substance and accidents and anathematized other options. This brief middle phase, however, was cut short again by politics. In 1552, Charles' victory was reversed: the Catholic king of France, Henry II, put religion aside to ally with a resurgent Schmalkaldic League against the emperor. Now the Lutheran princes threatened to attack the council! Pope Julius suspended the sessions in 1552, dying three years later.

This time the interlude was going to be much longer. After the three-week papacy of Marcellus III, Cardinal Carafa, the austere co-founder of the Theatines and head of the remodeled Roman Inquisition, became Pope Paul IV (r. 1555–1559). Supposedly, when Ignatius of Loyola, the founder of the Jesuits, heard of Carafa's election, every bone in his body shook with fear. This new pope was famously opposed not simply to Protestant reform movements but also to many reform efforts within the Roman Catholic Church. And he was no friend to the emperor either. The council, as a result, was left in limbo and Emperor Charles, facing defeat after thirty years of wrangling with Lutheran subjects as well as popes, abdicated his crown. Before retiring to a monastery, one of Charles' final acts was the 1555 Peace of Augsburg by which each prince in the empire would choose the official faith of his own territory. The Latin summation of that settlement is *cuius regio, eius religio*, whose prince, his religion. In the long break between the second and third phases of the council, Mary Tudor and her cousin Cardinal Pole returned England to Rome for a brief period (1553–1558) while the grim Pope Paul IV issued the first index (a list of prohibited books), jailed the reform-minded Cardinal Morone, and prepared heresy proceedings against Cardinal Pole, despite his success in England. The archconservative pope burned bridges metaphorically until his death in 1559 when the people of Rome burned his palace literally.

So, by the third phase of the council, Lutheranism had achieved legal recognition in the empire and the political landscape had changed.

Charles V had been succeeded by his brother Ferdinand as emperor and by his son Philip as king of Spain. Catherine de Medici was regent in France and the French would have a large delegation at the council (previously it has been dominated by Italians). France had become conflicted over the presence of Reformed Protestants within its borders, the Huguenots, and the monarchy earnestly hoped for some form of reconciliation. Tensions, however, could not be resolved, even with a colloquy at Poissy (1561), and France roiled in "wars of religion." The reconvened Council of Trent was now terrifically larger in attendance, and one of their acts, a decree against iconoclasm, was due to the French bishops' experience of Huguenot invective against sacred art. The council fathers clarified, however, that art should not be superstitious, that depictions are to be clearly recognizable, and that images should elicit piety.

The chalice, likewise, received considerable discussion, as Bavarian and Imperial ambassadors pleaded for concession to the laity. After all, utraquism had been allowed in Bohemia in the fifteenth century. Notwithstanding these pleas, the council ultimately confirmed lay communion in one kind. Having already decided in favor of transubstantiation (answering the question of how Christ is present in the mass), the council affirmed the sacrifice of the mass (answering the question of why Christ is present in the mass). Back in 1520, in his *Babylonian Captivity of the Church*, Luther's had listed three ways the pope was holding the mass captive—the reservation of the chalice, transubstantiation, and the sacrifice of the mass. With this last decision, all three of Luther's accusations were formalized by Trent.

Provoking the most fireworks in the third session, however, was the tension between an episcopal party and a curial party. The episcopal party argued that bishops hold their office by divine right and only their diocesan assignment from the pope. The curial party (that is, papal court party) argued that such an understanding challenged the pope's status as the single vicar of Christ on earth. Talks ground to a halt. Only with the appointment of the bridge-building Cardinal Morone as council president did discussion make progress. Under Morone the whole divine right issue was side-stepped and the relationship between the pope and the bishops was left unanswered. The council, however, was clear that bishops should be pastors to their dioceses and reside in them. This countermanded the pattern of many great prelates from the fifteenth and early sixteenth centuries, men like Cardinal Ippolito d'Este who, though archbishop of Milan from 1520 to 1550, did not visit that diocese a single time during the thirty years he was their chief pastor. In their vision for bishops, the council fathers looked to the early church, especially the models of Ambrose, Augustine, and John Chrysostom. Bishops were also ordered to participate in triennial provincial synods and to form their own diocesan seminaries, colleges to train priests.[5]

Chapter 9

SPIRITUAL CURRENTS AFTER TRENT

After the council concluded in 1563, the pope retained the right to interpret its measures and a new congregation (an administrative unit of the papal curia) was set up for that purpose. The council had asked the pope to produce a Tridentine profession of faith and a catechism; these appeared in 1564 and 1566 respectively. They had also asked for a new breviary (book for daily prayer offices) and missal (book for the mass). Pope Pius V (r. 1566–1572) provided these in 1568 and 1570 respectively and these new liturgies became universal for the Roman Catholic Church into the twentieth century. This was one of the most important outcomes of the Council of Trent. As discussed in chapter 1, there had been five different families of western Catholic liturgies. These were forms for the same services, but each had their own characteristic features. The five "rites" were the Roman, the Gallican, the Mozarabic, the Celtic, and the Ambrosian. And then each rite had regional variations known as "uses" (for example, the uses of Salisbury, of York, and of Hereford were subsets of the Roman rite). An impulse of Catholic reformers in the sixteenth century was the push for common prayer, believing that the church ought to pray with one voice through a single liturgical pattern. Some Protestant reformers shared this sensibility, especially reformers in England. While the Reformed Archbishop Thomas Cranmer admitted in his preface to the Book of Common Prayer that liturgy can change and that each national church should devise worship patterns, he no less stressed the principal of prayer in common, hence the book's title. The Book of Common Prayer was revolutionary in replacing several different "uses" in England with one "use." The first edition of the prayer book in 1549 even had the word "use" in its full title—but as the "use" for the whole Church of England rather than simply that of Salisbury, York, Hereford, etc. The Council of Trent did likewise, but for the whole globe. All Roman Catholic priests would celebrate mass according to the same reformed Tridentine Missal. Imagine those new religious orders, especially the Jesuits, carrying Catholicism to new parts of the world. And with them came a new mass book which would streamline how all Catholics—from Rome to South America to Asia—met Jesus in the sacrament. In 1588, Pope Sixtus V founded the Congregation of Rites to carry out this universalizing vision. Calendars were purged of saints who received only local veneration in favor of more universally recognized saints, a pattern we witnessed back in the Gregorian Reform of the eleventh century. While a few exceptions were made for dioceses who could verify that their "use" was two centuries old (e.g., Milan), the universal Catholic Church would have a universal Catholic mass.

The new Tridentine Mass, while still the work of the priest and in Latin, was far more theatrical. Over the next two centuries, musicians like Mozart and Beethoven would write mass settings for multiple choirs and

orchestras while churches came to resemble baroque opera halls with golden statues of cherubs and saints in whirls of drapery framing the performance. In this respect, the mass was more engaging than when it was the mysterious work of the priest behind the rood screen. In a similar way, lay reception increased. It became not uncommon for lay-people to receive communion monthly (quarterly at least), a major change from the medieval pattern of receiving annually. Carlo Borromeo (1538–1584), the archbishop of Milan and the very model Tridentine bishop, responded to this increase in communions by popularizing the central altar Tabernacle for Eucharistic reservation. Previously, the sacrament was reserved in several places (hanging pyxes, sacrament houses, aumbries in the sacristy). Post-Trent, however, the priest would finish celebrating at the altar, but then commune people more regularly. This necessitated more consecrated hosts, thus the need for an easily accessible Tabernacle, one centered just above the altar directly in front of the priest. This would become the standard pattern in Roman Catholic Church architecture until the Second Vatican Council in the 1960s. Borromeo is also credited with the introduction of the confessional booth which spread throughout Europe, as priests, equipped with new manuals for how to hear confessions, were to teach the need for more regular recourse to this sacrament.[6]

In addition to a universal liturgy, one of the hallmarks of Catholic life following Trent was the push for more education, more catechism, more schools, and more preaching. While the universities of Louvain and Douai became major centers for Catholic biblical scholarship, the Roman Index banned vernacular translations of scripture. This left biblical literacy to the Latinate. On the other hand, the Jesuits, among other new orders, played an important role in educating the common sort. A catechism prepared by the Jesuit Peter Canisius (1521–1597) just prior to the publication of the Tridentine catechism remained popular in Germany into the nineteenth century. While Trent's catechism aimed to equip clergy, Canisius' work had pictures and was imminently accessible to the barely literate. Most catechisms included prayers like the Our Father, the Hail Mary, the Salve Regina, and the Confiteor. These were joined by the Apostles' Creed, the Decalogue, and a list of the seven sacraments. Jesuit pedagogical methods for children, including competitions, were roundly successful as was the new practice of "first communion" in which children had to receive instruction before receiving the Eucharist. This highlights the intellectual dimension of reform movements in the sixteenth century, both Protestant and Catholic. Faith was conceived as supremely knowable. Confirmation, an oft-neglected sacrament, was on the rise, mirroring the importance of catechism and "first communion" instruction. While vernacular Bibles were not easy to come by, there was a flood of communion preparation manuals, saints' lives, and meditation books for popular consumption.

Baroque spirituality blended education, personal appropriation, interiority, and the affections. For example, different religious orders, especially the Capuchins, developed missions to revive the faith of Catholic regions—what American evangelicals would call revivals. A carefully planned mission would last for a few weeks in a city or region and would feature preaching, catechizing, organizing new confraternities, masses, processions, and other theatrical spectacles. These included the new 40 Hours Devotion, a three-day vigil before the exposed host, and prayers before the holy *bambino*, a mannequin baby Jesus in the manger. Likewise, the Oratorians, led by Philip Neri (1515–1595) and Cardinal Caesar Baronius (1538–1607), celebrated the hallowed legacy of martyrdom, holy suffering, and the newly rediscovered catacombs of Rome. Dominicans and Jesuits fostered more devotion to Mary, particularly the rosary, while the shrine of Loreto which was thought to be the miraculously transported house wherein Gabriel announced the Incarnation to Mary became ever more popular. Confraternities were a major feature of Catholic life in this era. In Italy c. 1600 between one third and one fourth of all men participated in a confraternity at some point in life. Drawing members from across socio-economic lines, their focus was often on charity, the rosary, and devotion to Christ in the mass and/or Mary. Often overseen by the Jesuits, new organizations of penitents blended older confraternal sensibilities (banqueting, urban competitions) with reformist aims (supervision by clergy, communal use of the rosary).[7]

IGNATIUS OF LOYOLA AND FRANCIS DE SALES

Early modern Catholicism, especially after Trent, enjoyed a renewed morale, one that could be expressed in public ways and by lay people. The story of Ignatius of Loyola and his Society of Jesus and the story of Francis de Sales who was born toward the end of the century both offer a good picture of Catholic spirituality engaged with the world. Born wealthy in northern Spain and raised for court life, Ignatius of Loyola (1491–1556) was obsessed with chivalry as a young man. A thirty-year-old courtesan hoping to win glory in battle (not a professional soldier), Ignatius had his leg shattered by a cannonball in May 1521 during the French siege of Pamplona. During his convalescence, he requested books about chivalry but all that was available was James of Voragine's *Golden Legend* and Ludolf of Saxony's *Life of Christ* (*Vita Christi*), texts discussed in earlier chapters. Curiously, the Spanish translation of the Golden Legend which Ignatius read described the saints as "knights of God" serving the "eternal prince Christ Jesus" under his "ever victorious banner," themes that would saturate Ignatius' *Spiritual Exercises* and Jesuit identity.

The *Vita Christi* by the fourteenth-century Carthusian Ludolf of Saxony was a series of 181 meditations on different episodes in Jesus' life. Arranged chronologically, they move readers through the Annunciation, the Circumcision, the flight into Egypt, and so on. Ignatius likewise adopted this pattern for his *Spiritual Exercises*. The difference is that Ludolf gives lengthy details for each of these episodes while Ignatius wanted the exercitant (the reader of his *Exercises*) to let the imagination do a good deal of work during prayer. Ignatius also borrowed Ludolf's overarching theme: God, the creator of all things, receiving glory from his creation. This would become the unifying theme of Ignatius' work, and it bled into Jesuit identity; their motto is "to the greater glory of God" (*ad majorem dei gloriam*, abbreviated AMDG). Surprisingly, Ludolf's *Vita Christi* was likely Ignatius' primary source for the life of Jesus as opposed to scripture itself. The Spanish Inquisition firmly opposed vernacular translations of the Bible and Ignatius would not learn enough Latin to read the gospels for another four years. Later, Kempis' *Imitatio Christi* and a book of spiritual exercises by a fifteenth-century Benedictine Garcias de Cisneros would also become major influences on Ignatius. In 1521, however, after months of reading and re-reading the *Golden Legend* and the *Vita Christi*, Ignatius resolved to break with his old life.

After his recovery, Ignatius planned to follow Ludolf's example and recede from public life as a Carthusian. But first he wanted to make a pilgrimage to Jerusalem. On the way, he stopped at Manresa in Spain where he planned to stay only a few days. This stopover lasted eleven months, a period in which he lived as a hermit. At one point during this time, he felt God had abandoned him, but then came mystical illuminations, for example the harmony of the Trinity as three musical keys. The Dionysian pattern should be obvious. Jesuit retreat centers to this day are often named "Manresa" for this season in Ignatius' life. In 1522, Ignatius began recording things that helped his prayer life in a notebook. So, from Ludolf of Saxony, he had taken the formula of focusing on episodes in Christ's life, and from the *Devotio Moderna*, Kempis, and Cisneros, he adopted the practice of keeping a book of *reparia*. These notes became the *Spiritual Exercises*.

Ignatius then changed his plans to retreat from the world. And, critically, he began to see Jesus in a different way. Before Manresa, Ignatius understood Jesus a model for imitation. That had been central for earlier monastic spirituality, a tradition whose advocates exalted the cloister as the only path to true spiritual growth. Mendicants had challenged that model in the thirteenth century, but out of an imitation of the apostles who wandered the world (*vita apostolica*). Ignatius likewise sensed a call to wade into the world rather than retreat from it, but it was because of his new perception of Jesus. Now, he saw Christ as a great King, a quasi-military commander whose mission is to conquer the world. To accomplish that mission, King Jesus calls for enlistments, followers to fight with

him under his banner. Ignatius even describes two banners to fight under, either the banner of Christ or the banner of Satan.

To help others join Christ's army, Ignatius developed his greatest weapon, the *Spiritual Exercises* from his notes. After making his much-desired pilgrimage to Jerusalem, he decided that to be of meaningful service under Christ's banner, he needed an education. Now in his early thirties, Ignatius joined teenagers at the Spanish university of Alcala and then moved on to the University of Paris. Although we have no evidence that they ever had a conversation, Ignatius was at the same college in Paris at the same time as the fifteen-year-old John Calvin, the College du Montagu. Ignatius studied there for about a decade and made many friends, regularly leading them in the *Exercises*. The most notable was another Spaniard named Francis Xavier (1506–1552). In 1534, Ignatius gathered with a group of seven friends in a chapel at Montmartre where they pledged a life of strict poverty, devoting themselves to the welfare of others. This dream of a new religious society, however, did not materialize for another few years. After finishing their education, they agreed to gather in Venice in 1537 to inaugurate their new life with a pilgrimage; they specified that if they could not get to the Holy Land, they would go to Rome to put themselves at the direct disposal of the pope.

That is exactly what happened. On their way to the eternal city, they stopped at the town of La Storta and there Ignatius had a powerful vision of God the Father and Christ holding the cross. God the Father instructed Jesus to take Ignatius as his servant. From then on Ignatius had a powerful identification both with the Holy Name of Jesus and with the pope as Christ's personal vicar. This accounts for their new name, the Society of Jesus (Jesuits) and their loyalty to the pope. This commitment came specifically out of a devotion to Christ as their king who operated through his chief adjutant, the pope. In November 1538, they had an audience with Pope Paul III, presenting him with the constitution for their new society, the Five Chapters. Two years later, in 1540, Paul issued his bull *Regimini militantis Ecclesia*, approving eleven men as the Society of Jesus. They then elected Ignatius as superior general and made solemn professions.[8]

While Jesuits are often painted as the storm troopers of the counter reformation, that is somewhat misleading. Certainly, their organization and spirituality was militaristic (fighting under the banner of Christ). But little of the above narrative—Ignatius's conversion and mystical experiences, his development of the *Spiritual Exercises* and his spiritual direction, and the formation of the Society of Jesus—had anything to do with a polemical Roman Catholic response to Protestants. The Jesuits were drawn into the efforts of the counter reformation primarily because of their unwavering support for the pope as the vicar of Christ. While it is important to emphasize the absence of a polemical foundation, Jesuits did take to these efforts with verve. They became so connected to opposi-

tion to Protestantism that in England in the second half of the sixteenth century a Jesuit was conceived of as a combination of terrorist and assassin, particularly after the papal bull *Regnans in Excelsis* released English Catholics from their obedience to their own queen, making her fair game for any would-be marksman. The English government's response to Jesuit missionaries to England was to make them into martyrs. In his study of the Council of Trent, the Lutheran polemicist Martin Chemnitz even declared that the Jesuits were established for the "specific purpose of destroying the Churches that embrace the pure teaching of the Gospel."[9] Such was the Protestant perspective.

The Jesuits experienced rapid growth in their early years. By Ignatius' death in 1556, sixteen years after their foundation, the society had grown from less than a dozen members to 1,000 living in more than 100 houses. They had formed twelve geographical provinces, one of which was in the new world, Brazil. Each province had a superior who answered to the superior general in Rome who, in turn, answered directly to the pope. Like earlier religious orders, they were somewhat independent of the episcopal system. But, perhaps unlike earlier orders, they were at a constitutional level zealously loyal to the pope. One is reminded of standing papal legates who could countermand local bishops as well as the tensions in the Council of Trent between the episcopal and the curial parties. In other words, the Jesuits reflected much of late sixteenth-century Catholic life, e.g., uniformity and the immediacy of papal authority. The Jesuits excelled at missionary work, in education, and founding schools. In India, Francis Xavier famously baptized 10,000 people in a single month. By the time of Ignatius' death in 1556, the Jesuits had opened thirty-three colleges and Ignatius had approved another six. They believed, rather progressively, that to ensure a strong future, children must be educated in the arts, sciences, and the spiritual life. And at the center of that last objective was Ignatius' *Spiritual Exercises*.[10]

The *Spiritual Exercises* began as Ignatius's *reparia*, his notes about things that had helped him in his prayer life. Moreover, the *Spiritual Exercises* is not so much a book of meditations to be read privately, but a manual for spiritual directors working with exercitants. Ideally, one retreats from active life for about thirty days to discover, through four or five meditations each day, how he or she can personally please God. While a month was ideal, the Jesuits regularly offered shorter retreats lasting a week. During such a retreat, either full or abbreviated, an exercitant engaged different episodes in the life of Christ as launching pads for meditation. The process was to free the soul from "inordinate attachments," allowing the exercitant to seek out the divine will, the goal being to align her will, by steps and degrees, with the will of God. For this reason, the exercises are useful for people at crossroads in their lives, people needing to making clear decisions which will please God. The process is to be personalized too. Every exercitant will be challenged, but

a good director using the exercises will find the right level of challenge for those under his direction. The retreat element is also key; one must withdraw to a quiet place, just as Christ did. In the first week, the exercitant learns about the process, and then each day, several times a day, the exercitant performs an examination of conscience. With an increasingly clear evaluation of one's repentance (which can be monitored with a chart across days and weeks), the exercitant engages a series of meditations on the powers of the soul, on sin, and on hell itself. Each of these meditations involves colorful and imaginative elements, for example trying to hear the wailing in hell and smell its smoke and rot. This is the signature of the Ignatian method: one is drawn to feel the meditation, to sense a spiritual reality beyond the rational mind. And all of that is in week one.

In the second week, one meditates on Christ as King, the Incarnation, the Nativity, the Flight into Egypt, and Christ's obedience as a child. Then there is an intermission in the episodes to meditate on Christ and Satan as two commanders opposing each other in war. The sequence begins again with Christ's baptism, the calling of the disciples, the sermon on the mount, Christ walking on the sea, his preaching in the Temple, his raising Lazarus, and then Palm Sunday. The second week closes with a discussion about making good choices. The third week then picks up with Holy Week. After a contemplation of Christ in Gethsemane, one sees Christ standing successively before Annas, Caiaphas, and Pilate. Then comes the cross itself followed by the sepulcher and the Virgin Mary grieving. Week three ends with a discussion of food and abstinence, the point being to clear one's mind of all things except the will of God.

With this last meditation, one is supposed to be at a moment of surrender. In the fourth week, one sees the risen Christ and then his ascension; now the exercitant is meant to feel a visceral joy. Wrapping up week four and the whole process, one considers different methods of prayer for the impending return to the active life. One meditates on the Ten Commandments, the Deadly Sins, the powers of the soul, the five senses, how to discern spirits, how to deal with scruples, and the need for almsgiving. The genius of the *Spiritual Exercises*, this manual that traveled with the Jesuits all over the globe as they evangelized, built schools, and menaced Protestants, was to tap into the exercitant's own imagination and to focus all that energy into seeing Christ. In this way one climbs into the different episodes of Christ's life, increasingly surrendering one's will to King Jesus, all for God's glory, AMDG.[11]

At the beginning of the seventeenth century, a Jesuit spiritual director came upon a collection of notes written by the bishop of Geneva for a noblewoman. This Jesuit was so struck by the notes that he pressured the bishop to have them published. This is the origin of Francis de Sales' *Introduction to the Devout Life*. This text and Ignatius' *Spiritual Exercises* are

the most important early modern spiritual works for Catholics engaged in the active life. Francis de Sales (1567–1622) was born into a noble family in the duchy of Savoy, the region in western France closest to the Alps, near Geneva. Note that he was born after generations of reform movements and the Council of Trent itself. Ignatius' society had already traveled the world before de Sales matriculated at the University of Paris. There, however, in the mid-1580s, he had a faith crisis; he believed he was damned, resulting in physical illness. During his recovery, de Sales committed himself to Mary and came to believe that God had preserved him for a purpose. He took Holy Orders, and in 1602 was made bishop of Geneva. As that city was in its Protestant heyday, his office was basically a missionary position held at a distance, living in Annecy in France.

As described above, de Sales' *Introduction to the Devout Life* began as advice for a noble woman, Louise de Charmoisy, as some notes which he simply handed off to her Jesuit spiritual director. de Sales relented to their pressure to publish, and the first edition appeared in 1609. de Sales revised it three times, the final edition appearing in 1619. The book's central topics reflect de Sales' preoccupations in ministry: to strengthen devotion, to encourage everyday women and men in their prayer life, and to provide them with the best practical theology available. He even defined devotion not as the multiplication of rote prayers but as a simple, serious, and abiding love of God. Like the Jesuits, Francis de Sales did not believe that spiritual growth was only for those in religious or holy orders, but wanted instead to see Catholic Christians, including lay people, own the riches of asceticism in their mundane (worldly) lives.

The book is in five parts and, unsurprisingly, the traditional Dionysian ways of purgation, illumination, and unification stand in the background. To summarize, de Sales discusses how one disconnects from the proclivities of sin, how to raise the soul closer to God in prayer and sacrament, how to develop the virtues, how to avoid temptation, and finally how to form resolutions to remain in the devout life. This is a text meant for people who want a practical, realistic engagement with a life of holiness. Moreover, it marked a turning point in Catholic thinking—and de Sales admitted it in the text. He specifies in the preface that the *Introduction* is different from all the ascetical manuals that came before. This book, de Sales writes, "is to instruct those who live in towns, on farms, or at court, and whose situation necessitates that they live an ordinary life in external matters." The *Introduction*, then, is ascetical theology for the rest of us, those who hunger for a disciplined life with God but who have children to raise and farms or businesses to manage. de Sales does not try to remove such people from the world. Rather, he would have them burn more brightly in it. The goal of holiness of life, de Sales writes, is not easy for two reasons. First, there are many impostors who only have the appearance of holiness, mumbling prayers, for example, without a connection between the inner and the outer. Second, cultivating holiness takes

time; grace must bear fruit in charity and charity must be fanned into the flame of sanctity. Despite these challenges, de Sales insists that this pursuit of holiness can be done even in the most everyday of circumstance. Along with the theatrical Tridentine Mass, new confraternities, and Jesuits leading catechisms and retreats, de Sales' *Introduction*, a work written uniquely for an active lay audience, evinces that hopeful sense of lay engagement which so characterized early modern Catholic spirituality.[12]

TERESA OF AVILA AND JOHN OF THE CROSS

Despite the obvious early modern push for Catholicism to be intelligible and engaging for those in the active life, a contemplative stream that stressed stepping away from the world flowered in Spain, a country which witnessed a major swell of female mystics who reveled in self-abnegation and ecstatic worship.[13] The most prominent of these women also happened to be the central actor in a reform movement. As discussed in chapter 3, the Carmelites had initially been an order of contemplative hermits, but in the thirteenth century, after arriving in Europe from the Holy Land, they began to mimic other mendicants who spent their lives preaching, teaching, and caring for the poor. By the sixteenth century, some Carmelites wanted to return to those eremitical roots. That reform movement—in a century filled with so many reform movements—is the setting for our discussion of Teresa of Avila and John of the Cross.

Educated by Augustinian nuns, as a young woman Teresa of Avila (1515–1582) read the *Third Spiritual Alphabet* (1527) by the Spanish Franciscan Francisco de Osuna (1492–1540). Moved by his emphasis on passivity before God, Teresa joined the Carmelites in 1535 at age twenty. For the next two decades, she lived rather unexceptionally, save for a commitment to passive prayer. By the 1550s, though, she was frustrated with the laxity of her convent and by extension the whole order. Spiritual progress seemed a distant hope. Also, in the late 1550s, she experienced mystical visions of Christ, but many of the priests she spoke with doubted her, even suggesting these visions came from the devil. A Jesuit, though, took her seriously and encouraged her. The most iconic of her ecstatic visions was of an angel who repeatedly penetrated her heart with a flaming spear, an experience both painful and sweet. The sculptor Gian Lorenzo Bernini (who designed the colonnade of St. Peter's Basilica in Rome) captured this vision in a 1652 statue, a piece commonly described as orgasmic.

Buoyed by these visions, Teresa emerged at the center of a reform movement aimed at her own Carmelites. In 1562 with support from the local bishop, she left her community to form another house, one which would be committed to absolute poverty. Most noticeably, they would be shoeless, discalced. In 1567, the superior general of the Carmelite Order

gave her permission to establish more reform-oriented houses for both men and women. Unsurprisingly, sharp opposition appeared from other traditional Carmelites, but tensions abated some when, in 1580, Pope Gregory XIII formally separated the traditional Carmelites from Teresa's movement, known as the Discalced Carmelites. This separation was rather unique: instead of an entirely new order, the Discalced Carmelites became a province or subset within the wider order and were still answerable to the prior general of the Carmelites, an interesting mixed economy in an age of division.

Teresa died in 1582, just two years after the formal separation of the Discalced, but her young confessor John of the Cross carried on her work. Teresa's written works were published a few years later in 1588 and, without doubt, the most important of these is the *Interior Castle* (1577). The book describes a mystical journey that the soul takes to union with God at the center of the soul. Like Eckhart at certain points and with debts to Pseudo-Dionysius, Teresa imaginatively describes the soul as a castle with seven mansions. In the first three, the soul cultivates virtues and purges imperfections. But the experience is painful: Teresa writes, "Lord if this is how you treat your friends, no wonder you have so few of them." In the fourth and fifth mansions, the soul engages in passive recollection, something she learned from Osuna. By "passive" we mean it is a gift from God, and by "recollection" we mean a deepening sense of clarity about one's state and what God has done. In the fifth mansion, Teresa describes the "sleep of the faculties," and God entering deeply into the soul but not through the senses. The sixth and seventh mansions describe the unitive experience, one loaded with startling details: ecstasies, flights of the spirit, uncontrollable joy, some of the things Teresa had experienced in her visions back in the 1550s. She is also clear that this is only descriptive of her experience, rather than prescriptive. She consistently advises charitable works and trust in God even if one does receive visions. The *Interior Castle* culminates with a vision of the Trinity and then a spiritual marriage, her will being brought into conformity with the will of God.[14]

Sharing Teresa's reform agenda and serving as her confessor, Juan de Yepes (1542–1591) had entered the Carmelite monastery at Medina del Campo in 1563; he was professed the next year and began studies at Salamanca. Soon after his ordination to the priesthood in 1567, he considered leaving the Carmelites for the rigorous Carthusians. However, in that same year, he met Teresa who convinced him that their order could be reformed. Taking the vows of the Reform Carmelites, he became John of the Cross. Within a year, John and other men set up a Reform Carmelite friary in a derelict house near Salamanca. In 1571, he became the rector of the Carmelite College of the Reform in Alcala de Henares while also serving as confessor for Teresa's convent in Avila. While there, John had a vision of the crucified Jesus. He made a sketch of what he saw, and,

in the seventeenth century, that drawing was placed in an ostensorium. The sketch later inspired Salvador Dali's 1951 *Christ of St. John of the Cross*. During the tensions with the traditional Carmelites in 1577, a group of them imprisoned John in Toledo where he was whipped regularly. He escaped the following August and made his way south. There he led a small friary in the mountains of Andalucia and founded a Carmelite college. After the Discalced were separated from the traditional Carmelites, John had a major role in forming their constitution.

When John was held hostage in 1577, he began writing a poem, and then from 1579 to 1583 he wrote a commentary on that poem, *The Dark Night of the Ascent of Mount Carmel*. In addition to *The Spiritual Canticle* (1585) and *The Living Flame of Love* (1586), this was John's most important work. John also drew a picture called the "Mount of Perfection" as a teaching tool reflecting this project. The picture is of three roads leading to a mountain. Two roads on either side start broad, but they end in treacherous rocks. The middle road, though narrow and hard, ends in the *iuge convivium*, the heavenly feast. The text is divided into two parts, *The Ascent of Mount Carmel* and *The Dark Night of the Soul*. The influence of Pseudo-Dionysius is clear in *The Ascent of Mount Carmel*, as John writes that night symbolizes detachment and deprivation of the senses. But then John writes that detachment must be internalized: detachment is not simply the absence of things, but a conversion of desire. This has resonance with Humanist and Reformed understandings of the conversion of the heart. We can also compare the way thirteenth-century Dominicans approached the *vita apostolica* as living according to apostolic principles whereas contemporary Franciscans insisted on mimicking the apostles' outward poverty. While John advocated going shoeless, his real concern was for the heart to be truly barefoot.

In the second part of the work, *The Dark Night of the Soul*, the attention shifts from the soul's active cooperation with God through disciplines and the habituation of virtue to God working on the soul, a passive and painful experience. John was here evincing a concept common among mystics, dereliction, a sense that God has abandoned the mystic. Echoing Christ's words on the cross, "my God, my God, why have you forsaken me," some even believed accepting consignment to hell, should that be God's will, is a necessary part of the mystical path. While there are orthodox expressions of this *resignatio ad infernum*, it was condemned by the Roman Catholic Church in the seventeenth century during the Quietist controversy (see chapter 11). In *The Dark Night of the Soul*, John describes the painful work God does on the soul which now no longer actively cooperates but passively accepts. This pain leads, however, to union. In his *Spiritual Canticle*, John describes an anxiously searching bride (the soul) moving through stages until reaching a blissful marriage with God. Similarly, in his *Living Flame of Love*, John describes the Holy Spirit as a flame that gradually heats the inert log of the human soul until it is

engulfed in the fire that is God. This passionate search for renewal marked the exuberant mysticism of Teresa and John.[15]

EARLY MODERN CATHOLIC SPIRITUALITY AND REFORM

In 1541, Michelangelo Buonarroti completed his fresco over the altar of the Vatican's Sistine Chapel. Commonly called "The Last Judgement," the image shows Jesus, along with his martyred saints, returning in glory while the dead rise from their graves, some being pulled to Christ while others are pushed into hell. This was thirty years after he had finished the famous ceiling frescoes in the same chapel in 1512. Now on the other side of the emergence of Luther, so many diets and colloquies, the appearance of the Reformed and the Anabaptists, but still on the eve of Trent itself, Michelangelo's Christ signals triumph but also foreboding.[16] Older securities, certitudes, and patterns of life had been shaken. While much was done in response to Protestant challenges, a significant amount of change among Roman Catholics was also the fruition of slow-going tendencies visible since the Gregorian Reform of the eleventh century. While these were not predestined trajectories, the urge toward universalism and apostolic primitivism was clearly visible from those days of the new millennium through the sixteenth century. And women and men engaged those tendencies—those successive reform movements including Catholic reform in the sixteenth century—to birth new, vibrant forms of Christian life.

NOTES

1. Eamon Duffy, *The Stripping of the Altars: Traditional Religion in England, 1400–1580* (New Haven: Yale University Press, 1992).
2. John O'Malley, *Trent and All That: Renaming Catholicism in the Early Modern Era* (Cambridge: Cambridge University Press, 2000).
3. David Bagchi, "Catholic Theologians of the Reformation Period before Trent," in *Cambridge Companion to Reformation Theology*, ed. David Bagchi and David Steinmetz (Cambridge: Cambridge University Press, 2004), 220–32.
4. David Steinmetz, "The Council of Trent," in Bagchi and Steinmetz, eds., *Cambridge Companion to Reformation Theology*, 233–47. See also Martin Chemnnitz, *Examination of the Council of Trent* trans. Fred Kramer (St. Louis, MO: Concordia, 1971).
5. William Hudon, "The Papacy in the Age of Reform," and Francesco Cesareo, "The Episcopacy in Sixteenth-Century Italy" in Kathleen Comerford and Hilmar Pabel, eds., *Early Modern Catholicism* (Toronto: University of Toronto Press, 2001), 46–66, 67–83; R. Po-chia Hsia, *The World of Catholic Renewal 1540–1770* (Cambridge: Cambridge University Press, 2005), 10–25; Robert Bireley, *The Refashioning of Catholicism, 1450–1700* (Washington: Catholic University of America Press, 1999), 45–69; William Hudon, *Marcello Cervini and Ecclesiastical Government in Tridentine Italy* (DeKalb, IL: Northern Illinois University Press, 1992).
6. Joseph Jungmann, *The Mass of the Roman Rite: Its Origins and Development* (Notre Dame, IN: Ave Maria, 1951), vol. 1, 127–59; Harper, 155–65; Clifford Howell, "From Trent to Vatican II" in Cheslyn Jones, Geoffrey Wainwright, and Edward Yarnold,

eds., *The Study of Spirituality* (Oxford: Oxford University Press, 1986), 285–94; Foley, 272–78; Eamon Duffy, "Praying the Counter Reformation" in James Kelly and Susan Royal, eds., *Early Modern England Catholicism* (Boston: Brill, 2016), 206–25; John Headley and John Tomaro, *San Carlo Borromeo: Catholic Reform and Ecclesiastical Politics in the Second Half of the Sixteenth Century* (Cranberry, NJ: Folger, 1988).

7. Bireley, 96–120; Keith Luria, "'Popular Catholicism' and the Catholic Reformation," in Comerford and Pabel, eds., 114–30; Idem, "The Counter-Reformation and Popular Spirituality," in Louis Dupré and Don Saliers, eds., *Christian Spirituality: Post-Reformation and Modern* (New York: Crossroads, 1996), 93–120; Lance Lazar, *Working in the Vineyard of the Lord: Jesuit Confraternity in Early Modern Italy* (Toronto: University of Toronto Press, 2005); William Hudon, ed., *Theatine Spirituality* (New York: Paulist, 1996).

8. George Ganss, ed., *Ignatius of Loyola: The Spiritual Exercises and Selected Works* (New York: Paulist, 1991), 9–63; Joseph Tylenda, ed., *A Pilgrim's Journey: The Autobiography of Ignatius of Loyola* (San Francisco: Ignatius, 2001).

9. Thomas McCoog, *The Society of Jesus in Ireland, Scotland, and England, 1589–1597* (Burlington, VT: Ashgate, 2012) 143–203; Jonathan Wright, *God's Soldiers: Adventure, Politics, Intrigue, and Power: A History of the Jesuits* (New York: Doubleday, 2004), 13–41.

10. John O'Malley, *The Jesuits: A History from Ignatius to the Present* (Lanham, MD: Rowman & Littlefield, 2014), 1–54; Idem, *The First Jesuits* (Cambridge, MA: Harvard University Press, 1993), 165–242; John O'Malley, Gauvin Bailey, Steven Harris, and Frank Kennedy, eds., *The Jesuits: Cultures, Sciences, and the Arts 1540–1773* (Toronto: University of Toronto Press, 1999), 3 vols.

11. Ignatius of Loyola, *The Spiritual Exercises of St. Ignatius* trans. Anthony Mottola (Garden City, NY: Doubleday, 1964); John O'Malley, "Early Jesuit Spirituality: Spain and Italy" in Dupre and Saliers, 3–27; Philip Endean, "The Spiritual Exercises," in Thomas Worcester, ed., *The Cambridge Companion to the Jesuits* (Cambridge: Cambridge University Press, 2008), 52–67.

12. John-Julian, ed., *The Complete Introduction to the Devout Life* (Brewster, MA: Paraclete, 2013); Michael Buckley, "Seventeenth-Century French Spirituality: Three Figures," in Dupré and Saliers 28–68.

13. Stephen Haliczer, *Between Exaltation and Infamy: Female Mystics in the Golden Age of Spain* (Oxford: Oxford University Press, 2002), 3–27.

14. Kieran Kavanaugh, ed., *Teresa of Avila, The Interior Castle* (New York: Paulist, 1979); Edward Howells, *John of the Cross and Teresa of Avila: Mystical Knowing and Selfhood* (New York: Crossroad, 2002), 1–8; José Pereira and Robert Fastiggi, *The Mystical Theology of the Catholic Reformation* (Lanham, MD: University Press of America, 2006), 229–44.

15. Kieran Kavanaugh, ed., *John of the Cross: Selected Writings* (New York: Paulist, 1987); Jane Ackerman, "John of the Cross, the Difficult Icon," in *A New Companion to Hispanic Mysticism*, ed. Hilaire Kallendorf (Boston: Brill, 2010), 149–73.

16. John O'Malley, "The Council of Trent (1545–1563) and Michelangelo's *Last Judgement* (1541)" *Proceedings of the American Philosophical Society* 156 (2012), 388–97; Hsia, 159–60.

TEN
Spirituality and the Encounter
Opportunities for a Primitive Church

On August 3, 1492, the Franciscan Friar Juan Pérez blessed three ships about to set sail from Palos de la Frontera, a port near the southern tip of the Iberian Peninsula. Bank-rolled by Ferdinand, king of Aragon, and Isabella, queen of Castile, the crew of these ships were set to explore the far reaches of the Atlantic Ocean. Two months later, their admiral, an adventurer from the Italian city of Genoa, Christopher Columbus, stepped onto the island of Guanahani, an island in the Bahamas. When Columbus made his second voyage a year later, that same Franciscan, Juan Pérez, came along and celebrated the first mass in what would come to be known as the Americas.

1492 was a momentous year not simply because Columbus made his first voyage. The marriage of Ferdinand and Isabella some twenty years earlier had united two major kingdoms on the Iberian Peninsula, and in the same year they bank-rolled the Italian sailor, the joint crowns rejoiced at the fall of the Muslim Kingdom of Granada to their south. Back in 711 the Muslim Umayyad Caliphate (an Islamic state) advanced into the peninsula from Africa, and ever since the eighth century Christian kings had sought the *Reconquista*, the re-taking of Spanish land as Christian territory. With the fall of Granada in the southeastern corner of the peninsula in 1492, the *Reconquista* was complete, and Spain as we know it today was beginning to take shape—a shape that was both geographical and increasingly homogenous in religious practice. In that same year too, the joint government of Ferdinand and Isabella passed the Decree of Alhambra which expelled Jews from Spain. Because of the *Reconquista* and the Decree of Alhambra, tens of thousands of Jews and Muslims dodged expulsion by converting to Christianity. While such conversions

were not completely novel, the Spanish Inquisition (described below in chapter 11) regularly questioned their sincerity. Certainly 1492 was historic for those three culture-shaping events: Columbus departing for his first voyage, the triumph of the Reconquista, and the Decree of Alhambra. The following year, 1493, witnessed the promulgation of a truly map-changing papal bull. The Spanish-born Pope Alexander VI (r. 1492–1503) issued his bull *Inter Caetera*, a document which granted a quarter of the globe to "the most Catholic monarchs" Ferdinand and Isabella. Citing his right to do so by "the fullness of apostolical power," the pope gave those Spanish monarchs all "firm lands and islands" (effectively Central and South America) so that "the health of souls may be procured, and the barbarous nations subdued and brought to the faith." Later in the text the pope repeats that phrasing—subdue the native peoples and bring them to the faith—and, in nearly the same breath, praises Columbus for his military tactics, the building of fortresses with armed garrisons, and the plunder of natural resources. Commanding these "true Catholic" princes to send virtuous and learned clerics along with their explorers and colonists "to instruct the inhabitants in the Catholic faith and good manners," Alexander VI's bull blurs any imagined lines between missionary work, cultural dominance and conformity, and colonialism; *Inter Caetera* later served as a justification for the massacre of native peoples.[1] It is also an appropriate starting place for the complex story of the "encounter."

Historians today increasingly judge the term, "discovery" or "era of discovery" as inadequate. Those lands that were later called North and South America were well known to the native peoples who had lived there for millennia. The equally problematic term "conquest" or "era of conquest" was inherited from contemporary sixteenth-century Spanish writers and such language implies the superiority of the Europeans. But something was happening. It was an encounter—an encounter between civilizations, peoples, cultures, practices, and beliefs. Through this encounter older civilizations collided, and new cultures emerged. Bound up with the encounter were issues of colonialism, religious exchanges and the way Christian mission should be undertaken, issues of racial identity and racial superiority, and an emerging discourse about human rights. I wish to use "encounter," a term which in scholarly circles today usually pertains to the encounter between Europeans and the native peoples of North and South America, more broadly to denote a much larger encounter between European Christians on the one hand and cultures across the globe on the other, including cultures in Asia. Vasco da Gama's voyage around the southern tip of Africa to land in India in the same decade as Columbus' first voyages must be ranked as of equal importance in global history, and especially religious history. All of this, we should remember, happened at roughly the same time, from the close of the fifteenth century to the eighteenth. This chapter will consider three aspects of the enor-

mous story of the encounter. After providing, briefly, a general definition of Christian mission, we will trace Roman Catholic missionary efforts in Spanish settlements in the Americas, noting especially a debate about mass baptisms in Mexico. That will be followed by a closer look at the Dominican Friar Bartolomé de Las Casas' and his defense of Native peoples of the Americas in the sixteenth century, noting especially his directions for confessors. Then finally we will analyze the Jesuit way of inculturation in Asia, especially in seventeenth-century China, an approach famously connected to Matteo Ricci. Across these important highlights we will encounter that recurring thread of primitivism and the now-familiar search for the apostolic life.

SPIRITUAL CONQUEST?

Evangelistic mission, that is, seeking through various means to win converts to Christianity, is core to the Christian tradition. The New Testament and early Christian literature has mission as a foundational paradigm: Christ's Incarnation, as described in the mystical prologue of John's Gospel, is a movement from God to humanity to bring light and life; before ascending to heaven at the close of Matthew's Gospel, Christ commissions his apostles to make disciples of all nations; the Gospel of Luke and the book of Acts, written by the same author as a two-part story, begins in Jerusalem and then moves out to the ends of the earth; the story of Acts itself opens with the experience of Pentecost when the apostles miraculously speak in different languages to foreigners about God's work in Jesus's death and resurrection; and then there was Paul traveling the Greco-Roman world to win converts. One thinks especially of Paul's famous public speech in Athens in the marketplace known as the Areopagus. In Acts 17, Paul speaks approvingly of the Athenians' openness to religion, and that such religiosity—an innate sense of the divine—has rightly prepared them to accept Christianity. Notice, then, this positive assessment of other religions, although these are judged ultimately to be deficient and idolatrous if not brought to their natural end in Christianity.

By the second century there were already multiple approaches to the task of sharing the Christian message. The Roman philosopher and convert Justin Martyr (c. 100–165) provided an explanatory treatise (an *apologia*) of the new religion for the emperor himself. Much like Paul, Justin wrote that Christian rituals and ways of life are not so strange when compared with other religions of the late ancient Mediterranean. In other words, Justin pitched that pagan Romans were poised to accept Christ because of the seeds of religiosity planted by those pagan practices. On the other hand, Tertullian (c. 155–c. 240), a Christian in Carthage in northern Africa, had a more pessimistic view of the wider Greco-Roman

world. It was all tainted by idolatry, according to Tertullian, and Christians ought to separate themselves as much as possible from a cultural matrix that functioned like a spider's web. In short, one must turn her back on the old world completely and embrace the new. For centuries, arguably to the present day, Christians have wrestled to discern what elements of non-Christian culture to retain and what must be abandoned. Augustine wrote in the fifth century about using the best of ancient pagan philosophy, much as the Israelites, according to the book of Exodus, had taken gold from the Egyptians as they left slavery. In a similar way, when Pope Gregory the Great outlined plans for the conversion of England at the close of the sixth century, he instructed his monk-missionaries to repurpose pagan temples for Christian worship and to adapt whatever they could from Anglo-Saxon culture. And when that Christianized Anglo-Saxon culture in turn sent Boniface on mission to Germany in the eighth century, he cut down an oak sacred to pagans; the wood was then used to build a church.[2] At the start of the sixteenth century, then, an immense mission field opened, and those questions remained: what methods would be used to win converts? How would the Gospel be both linguistically and culturally translated? What parts of the converts' previous life could they retain, and which bits had to be abandoned? And just as importantly: what is the relationship between the missionary and the colonist, between the church's evangelism and the empire's expansion? The twentieth-century historian Robert Ricard coined the term "spiritual conquest" to describe the close, though at times strained relationship between Spanish colonization and Christian mission.[3]

Early on, the Franciscans and Dominicans came with the Spanish conquistadors, especially after 1500 when the Franciscan mission was established on the island of Hispaniola. When Hernán Cortés led his march on the Aztec Empire which culminated in the fall of their capital Tenochtitlan and its renaming as Mexico City in 1521, the Spanish were sure to demolish Aztec temples, massacre Aztec priests, and erect free-standing outdoor crucifixes to celebrate their triumph. The friars, for their part, understood their efforts along primitivist lines, viewing the natives as child-like and criticizing the early colonial authorities for their brutality. Acting in a benevolent though obviously paternalistic way, the friars hoped to establish a church not unlike that of the first apostles among the native peoples, women and men who they believed were not only innocent but eager for Christianity. By the middle of the century in Mexico, however, secular priests were arriving, dioceses were being established, and colleges and cathedrals were being built. New convents dotted the streets of Mexico City where, among other orders, Teresa of Avila's Discalced Carmelites continued their efforts for reform in the new world. Although Ignatius's *Spiritual Exercises* were popular among the nuns of Mexico, Teresa was the exemplar for their religious life by the seventeenth century. These nuns, however, were largely Spanish although

some convents accepted mestizas, that is, women who had a Spanish parent and an Amerindian parent. The convent of Santa Clara in Cuzco was founded specifically for mestizas whose conquistador fathers wanted to ensure that their biracial daughters were brought up to be Spanish and not native. Although there was talk early in the days of colonization about admitting Amerindian women as nuns, ultimately, they were barred from the cloisters until the eighteenth century.[4] This mirrored the bar on ordaining native men to the priesthood, a subject discussed below.

Iberian culture and the Iberian church was being replicated in Mexico. For example, church councils were held, and the topics discussed at these gatherings repeated many of the concerns being voiced at the Council of Trent on the other side of the Atlantic, e.g., the nature of bishops. Even the Inquisition was established in Mexico City and Lima in 1570.[5] In short, priorities were changing across the New World. It was clear that planting Spanish culture and institutions took precedence over missionary work among the native peoples. Moreover, the friars themselves became divided on the innocence and sincerity of the natives, some friars believing the converts to be opportunistic. Nevertheless, the Dominicans became known as defenders of the indigenous peoples. More will be said below when we focus on Las Casas. It should be clear too that explorers encountered a variety of peoples in the New World: the Tainos met by Columbus on the islands, the Aztecs in what would become Mexico, the Mayans on the Yucatan Peninsula, the Incas to the south, just to name a few. It has become a convention to refer to these peoples—who were all quite distinct—collectively as *Amerindians* much as we speak of Europeans or Africans.[6]

What, then, did conversion look like in the New World? In Mexico, certainly in the years immediately after the fall of Tenochtitlan in 1521, the friars faced the challenge of mass baptisms—that is, baptisms in large numbers—and the question of what parts of the liturgy could be omitted to expedite what could be an exceedingly onerous task. A Catholic baptism would normally entail an exorcism rite, the priest breathing on the candidate, applying saliva and salt, the consecration of the water, the water rite itself in the name of the Father, the Son, and the Holy Spirit, and then the application of the chrism oil, donning a white garment, and giving the newly baptized a candle. Each of these component parts included prayers and sometimes other blessings. Scholastic theologians, however, had long defined the water rite, performed in the name of the Trinity, as the essential part of baptism. If the other ritual aspects were missing, the baptism was still valid. The Franciscans, who had the dominant presence among the missionaries in early colonial Mexico, decided that at mass baptisms a few converts would have the full complement of ceremonies in a representative way, but then the scores of others would simply have the water rite in the name of the Trinity. There were rumors

that the Franciscans cut even more corners by baptizing using an aspergillum, a small wand used by priests to sling holy water in blessings but certainly not used to baptize people. The Dominicans disagreed with the Franciscan drive to abbreviate baptisms, but not simply out of a ceremonial litigiousness. Missionaries had observed the complex ritual life of the Amerindians in Mexico, noting especially their attention to detail and choreography. These were not a people who overlooked ritual action. The Dominicans feared that, after a generation, when the period of mass baptisms settled down into the situation more familiar in Europe with baptisms predominantly on an individual basis and overwhelmingly of the children of Christian parents, those same converts might notice all these ceremonies being done on their own children and wonder why such ritual acts were not performed upon them. Would they wonder: Why did I not receive the salt, the gown, or the candle? Would that observation—by people who did not miss ceremonial details—make them doubt the efficacy of their baptisms?[7]

The Dominicans' reticence to omit ceremonies was not entirely in response to the Amerindians in Mexico. There were similar anxieties in Spain at the same time, the early sixteenth century, because of the conversion of Muslims after the *Reconquista*. In Valencia there were reports of mass baptisms which not only omitted the chrism oil, but involved a broom being dipped in water and then waved about, slinging the water over the converts. The issue of how to handle mass baptisms, a concern on both sides of the Atlantic, received attention from theological faculties, church councils, the Emperor Charles V (who was also king of Spain), and the pope himself. A compromise was reached: each convert would undergo exorcism, the water rite, and receive chrism. However, some could be chosen as representatives and receive the salt, saliva, and gown. Another requirement was pre-baptismal instruction. As they argued out the issue for Emperor Charles, theologians in Spain drew on Thomas Aquinas when they insisted that the baptism of adult converts without instruction was a form of coercion and could be harmful in their ongoing formation as mature Christians. The Mexican Church Council of 1555, then, ordered that no adult may receive the sacrament without instruction. However, what constituted adequate instruction remained ambiguous. This topic will reappear in the discussion below of the Dominican Friar Bartolomé de Las Casas.

Another important angle to consider in this story about baptism in early colonial Mexico is the familiar rhetoric of primitivism. In the first third of the sixteenth century, the mendicant orders in Spain experienced reform movements oriented toward stricter observance of their respective rules. Teresa of Avila's reform within the Carmelites, described in the previous chapter, is but one example. Bound up in the language and self-perception of these movements was the notion of fidelity to the apostolic church. That sensibility was already paradigmatic for the friars be-

fore they set foot in the New World. Therefore, when given the opportunity to baptize scores of new converts at once, they could not help but envision reenacting the missionary efforts of the first apostles. One friar captured this attitude in his chronicle when he claimed that not since the days of the primitive church had missionaries baptized so many pagans at once. Some of the friars, especially those Observant Franciscans who were the heirs of the "spirituals" (see chapter 3), even saw their work in the New World as renewing the primitive church in preparation for the immediate return of Christ. The Observant Franciscans' commitment to radical poverty and simplicity, part of their perceived fidelity to Francis's initial vision, tied into the debate about the ritual shape of baptism: they argued that the simpler the ceremony, the more truly apostolic it would be.[8]

More needs to be said, however, about the Amerindians themselves and the experience of conversion. Certainly, some rejected Christianity, and they often suffered and died consequently. But there are arguably more complicated stories of the preservation of indigenous religion alongside outward conformity to the religion of the conquerors. On the Yucatan Peninsula in 1562, a cave was discovered full of idols ostensibly hidden there by Mayans who had converted to Christianity. Human skulls surrounded the idols and the Franciscan provincial Diego de Landa suspected that the Mayans, who had made a great show of conversion, were secretly practicing their old religion, including human sacrifice. As a result, 4,500 of them were interrogated under torture, many were flogged, and scores of them died.[9] Could this have been a form of outward conformity and quiet resistance? One thinks here of Calvin's disparaging label for Protestants who kept their true faith secret while outwardly conforming to Catholicism and attending mass: Nicodemites, after Nicodemus who visited Jesus only under the cover of night in John 3. Likewise, there was the phenomenon in Elizabethan and Stuart England of "church papists," people who were secretly Catholic but made an outward show of conformity by attending the Reformed worship of the Church of England (and, unlike the Catholic recusants who refused Protestant conformity, dodged heavy monetary fines).

It is helpful to once again apply the lens of popular politics, an interpretative model we have used previously, to examine the issue of conversion. We find, unsurprisingly, that the indigenous peoples had agency, that while some embraced the new faith and others firmly rejected it, many engaged in negotiation. As a result, new forms of religious expression—a new spirituality—emerged. Some of these new patterns might be labeled syncretic, a blend of previously held religious beliefs and practices on the one hand with the Spaniards' Catholicism on the other. The Maya often correlated the Virgin Mary, often depicted standing on the crescent moon in Christian iconography, with their moon goddess Ix Chel. Likewise John the Baptist was correlated with certain water deities.

In the mid-seventeenth century, there was a well-known healer and practitioner of Andean medical arts in southern Peru, Magdalena Callao. In addition to consulting rock formations, she invoked the name of God and the Virgin Mary in her practice.[10] Looking forward to the eighteenth century, a Peruvian man was convicted in 1740 of idolatry and imprisoned for smearing llama blood on the walls of a church. His purpose, though, was to strengthen the church by employing this traditional Andean practice. Around the same time in northern Mexico, the bishop of Oaxaca uncovered clandestine worship of traditional deities that incorporated, with adaptation, Christians songs which the Amerindians learned from Dominican friars. There is also the *Book of Chilam Balam of Chumayel*, a Mayan text from the eighteenth century that records traditional beliefs and practices of the Mayans along with a full-throated Christian prophecy that Jesus will return, nurture the Mayans, and banish the Spaniards. It is telling that this text was written in the Mayan language using the Latin alphabet.[11]

Notwithstanding the accounts of rejection, whether outright or clandestine, and the evidence of negotiation and adaptation, thousands of Amerindian individuals and communities accepted Christianity. Bound up with this conversion of the Amerindians was a repeated phenomenon in colonial Mexican culture: stories of miraculous apparitions. The most important of these—the Virgin of Guadalupe—has a rather complex story. Supposedly, an Amerindian convert named Juan Diego had multiple encounters with the Virgin Mary in 1531 who instructed him to tell Juan de Zumárraga, the first bishop of Mexico, that she wanted a shrine built for her on a certain hilltop. However, there is little evidence of this narrative prior to the 1640s. It seems more likely that there was devotion to Mary, by both the Spanish settlers and the Amerindians starting in the sixteenth century, and the story of Mary appearing to Juan Diego was later popularized as an apparition both unique to Mexico and symbolic of Amerindian conversion. In the twentieth century the image of the Virgin of Guadalupe became something of a national icon for Mexico and the shrine today is one of the most visited Christian sites in the world. While there are doubts about the Juan Diego legend (even if there was a Juan Diego), there was a deep sensitivity to miraculous apparitions in colonial Mexico. An Amerindian servant at the Franciscan monastery in Ocotlan encountered an apparition of the Virgin in 1541. Around the same time, there was an apparition of a crucifix at the Augustinian monastery in Chalma. In 1533 a cross appeared to a group of Amerindians practicing traditional rituals at Ocuilan and this ostensibly provoked conversion. In a similar way there was a story of the Virgin appearing in Peru near a *huaca*, a rock formation used in Inca devotion, presumably to signal the triumph of Christianity over indigenous religions.[12]

LAS CASAS AND HUMAN DIGNITY

In 1502, a young man traveled with his merchant father to the Spanish colony on the island of Española. What he later claimed to have witnessed in his new home may rightly be judged a horror show of brutality. According to his accounts, not only were the Tainos enslaved and worked to death, often in mines, they were tortured and killed in gruesome ways simply for sport. He recounted story after story of strangulations and burnings, of Spaniards cutting open the Taino's bellies, setting vicious dogs on them, stabbing their infant children or throwing them off cliffs. These disturbing stories were published years later, in 1552, in *A Brief Account of the Destruction of the Indies*, a work that generated the so-called "Black Legend" about Spanish cruelty. This narrative was then repeated for centuries by the Spaniards' political, economic, and religious adversaries, English Protestants.[13] The young man was Bartolomé de Las Casas (1484–1566), later a Dominican friar and bishop of Chiapas in southern Mexico, and his book appeared after he spent his life decrying such brutality and defending the Amerindians as having natural human rights.[14] His story, however, is not simply an early chapter in the modern discourse about human rights. We find in Las Casas' activism a discussion of what constitutes the right contours of Christian practice born of a reformist primitivism.

Las Casas was ordained priest in 1510, but even after the harrowing sights he experienced, he still retained Amerindian slaves. It was his encounter with the Dominicans on Española in that same year that eventually brought a more thorough conversion. Just before Christmas in 1511 the Dominicans brazenly preached that the Spanish settlers were in grave sin for their mistreatment of the indigenous people and were bound for hell itself. But this indictment for brutality was also a judgment on the Spaniards' negligence in Christian evangelism. That natural pairing is found in Las Casas' telling, found in his *Brief Account*, of the capture and execution of the Taino chief Hatuey on Cuba in 1512. A Franciscan begged Hatuey, tied to a stake, to be baptized and die as a Christian so that he might be with God in Heaven. The chief, according to Las Casas, asked the Franciscan if Spanish Christians go to Heaven. When he responded yes, Hatuey said he did not want to go where Spaniards go and thus died unbaptized. Las Casas believed the Spanish had not simply denied the Amerindians their dignity but also, in their cruelty, denied the mission of Christ. In his *Brief Account*, Las Casas describes yet another scene of brutality occurring a few years later, but here the offer of Baptism is accepted, a reversal perhaps of the Hatuey episode. Las Casas himself ran into the middle of a massacre of the natives, trying to stop the killing. One young native who had been mortally wounded by a Spanish sword fell into Las Casas' arms. Seeing that the man was near death, Las

Casas asked him if would receive Baptism to which he immediately agreed. He died as Las Cases administered the sacrament.

Las Casas then made it his life's purpose to defend the Amerindians: he journeyed to Spain where he pled for change before King Ferdinand in 1515 and there found support in the imposing figure of Cardinal Ximenes de Cisneros (d. 1517), regent of Spain and a devout reformer within the Franciscans. Las Casas was made "Protector of the Indians" and commissioned to oversee a reform effort in the Spanish colonies where he was to be assisted by a group of friars. When that effort failed to secure meaningful change, Las Casas, already a priest, joined the Dominican order himself and returned to Spain again to work the channels of power. After convincing Charles V to abolish Amerindian slavery in 1530 (but not African slavery!), Las Casas' influence even reached Rome. In his 1537 bull *Sublimis Deus*, Pope Paul III condemned the enslavement of the native peoples, declared them to be rational beings, and demanded increased efforts for their conversion. Note again the pairing: Amerindians should not be brutalized, but, likewise, not simply left alone—they should be evangelized. Some scholars have debated if Las Casas' efforts were, to borrow from a book title, simply another face of empire, one far gentler but no less colonial.[15] Here we should remember, however, the very nature of Christianity, discussed above, as a tradition irreducibly mission-oriented.

Las Casas was consecrated bishop of Chiapas in southern Mexico in 1544 and was engaged in the debate, discussed above, about mass baptisms. Not only was he a Dominican and rejected the Franciscans' abbreviations of the ritual, he was equally concerned about the question of pre-baptismal instruction for adult candidates. Here it is important to contextualize Las Casas as a disciple of that thirteenth-century Dominican theologian Thomas Aquinas who insisted in his *Summa Theologica* that human beings have rights by nature, that is, prior to their rebirth as Christians in Baptism. Therefore, Las Casas and others viewed adult Baptism without instruction as a form of coercion; they were vindicated at the Mexican Church Council of 1555 which required the instruction of adult converts. These struggles were happening alongside struggles in early modern Europe to bring about reforms within Roman Catholicism more generally — and not simply as a conservative response to Luther and other Protestant reform movements, but also as an attempt to renew a primitive apostolic church. Las Casas, for example, compared the Amerindians' simplicity to that of the Desert Fathers, those third- and fourth-century Christian monks whose holiness of life was often construed as the legacy of the first apostles. Las Casas' language about the Amerindians is even "edenic," summoning up the image of Adam and Eve in their original innocence. Like so many other Roman Catholic missionaries, Las Casas saw the missionary endeavor through a primitivist lens.[16]

Spirituality and the Encounter

Las Casas was not simply a social reformer, but a reformer of Christian practice. When, in the 1540s, the Spanish government weakened in its resolve to bring the conquistadors to heal, especially their rapacious grabbing of native wealth and lands, Las Casas naturally turned to his priest-craft not unlike those passionate Dominican preachers he heard in his youth. Good Catholics, even the conquistadors, expected the benefit of sacramental absolution, especially on one's deathbed. Between 1544 and 1546, Las Casas developed a set of rules for hearing confessions; the document circulated among the religious orders and then was published in 1552 as his *Rules for Confessors*. In short, Las Casas insisted that priests require real, material restitution to the Amerindians before declaring absolution. If the person acquired wealth from the natives, enslaved them, or took their homes, then they natives were to be repaid. Even if one sold a slave, the slave was to be located, bought back, and then freed.[17] Las Casas inaugurated these measures himself in his diocese at Easter when people expected to make their confession and receive communion. If that was not galling enough to the settlers, then having absolution denied on their deathbeds was even more infuriating. Confession and absolution, along with the reception of communion which followed either at Easter or on one's deathbed, was about reconciliation and the healing of a societal fabric—a society shared among human beings and between God and humanity. For Las Casas, restitution was a non-negotiable for sacramental absolution.

We might draw comparisons between Las Casas' *Rules for Confessors* and General William Tecumseh Sherman's promise of forty acres and mule to each black family in the wake of the American Civil War in 1865 or perhaps the Truth and Reconciliation Commission in South Africa which worked for restorative justice after the end of apartheid in the mid-1990s.[18] These examples, however, may miss the overarching sacramental sensibilities shared by Las Casas and the offending conquistadors. Absolution was connected to the restitution of the cosmos, God's creation put in right order. We should remember that Las Casas' activism was part of a larger discourse about Christian mission to the ends of the earth: how it should be executed, what strategies would faithfully yield conversions, and how the ongoing witness of the apostles could be spread among all nations. And this globalizing was also happening during a time of intense reform within Roman Catholicism.

MISSION AND INCULTURATION

How did the European missionaries and Amerindians together navigate Iberian culture? To what extent were converts expected to "Hispanicize," to take own Spanish and other European customs? One physical clue are the churches still standing, many built in an Iberian style.[19] Another obvi-

ous aspect was taking on Spanish names at baptism; one became Christian and Spanish in one ritual action. By the middle of the sixteenth-century the church also needed to consider candidates for the priesthood drawn from among the Amerindians, some of whom had been raised as Christians, some even being mestizo. The first and second Mexican Church Councils (1555, 1565), however, banned not only native candidates for the priesthood but also mestizos. While this prohibition was overturned in 1565, opportunities for Amerindians and mestizos to be ordained was slow-going. It would take another two centuries for the Spanish monarchy to require seminaries in all Spanish colonies and territories to have a quota for indigenous candidates for Holy Orders.

The pattern of mission pairing with colonial conquest which so characterized the encounter in the New World was present in Asia, but not nearly as central. The Portuguese explorer Vasco da Gama sailed around the Cape of Good Hope, the southern tip of Africa, and reached India in 1498. There, in the sixteenth and seventeenth centuries, Goa became an important trading center for the Portuguese, and with that city as a base, the Jesuits among others engaged in missionary work. The globe-trotting Francis Xavier (1506–1552), close associate of Ignatius of Loyola (see the preceding chapter), arrived on the Pearl Fishery Coast, the southern tip of India, in 1542 and performed not only mass baptisms but also sustained teaching and preaching. Over the next century the Jesuits—for the most part, though not uniformly—came to be identified with a strategy which present-day Christian theologians of mission would likely call inculturation. This twentieth-century term denotes the development of recognizably indigenous Christian practices rather than the layering of an alien culture on top of the indigenous one. The fundamental assumption here is that Christianity can be translated across cultures. For example, Anglican Christians in present-day Kenya do not simply use the English Book of Common Prayer translated in their language, Swahili. While that pattern had certainly been the case for much of the African Anglican experience during British colonial rule in the nineteenth and early twentieth centuries, today Kenyan Anglicans engage undeniably Christian ritual patterns that are also undeniably Kenyan. This is not syncretism, the blending of religious traditions, but rather Christianity drawing on and resonating with existing cultural sensibilities, some of which may have been shaped by other religious traditions (see the discussion above about Justin Martyr). Centuries earlier, the Italian Jesuit Roberto Nobili (1577–1656) engaged this very approach in southern India. He wore the clothes of the Brahmins, the priestly caste in Indian society, studied Sanskrit, and adopted Indian sensibilities about cleanliness and diet. While Nobili's attempts failed to draw large numbers of converts, this tactic proved successful later and in other areas, Japan for example.[20]

The Jesuits established a mission in Kyoto, the capital of Japan in 1559, and by the 1580s their approach was to live according to Japanese cultu-

ral customs and diet. They also built churches in Japanese architectural styles rather than importing European patterns as happened in the Americas. As discussed in the previous chapter, the Jesuits utilized military language and organization, owing in part to Ignatius' *Spiritual Exercises*. So, unsurprisingly, the Jesuits tapped into Samurai sensibilities, especially loyalty, in their explanation of the faith to the Japanese. However, there was still a reticence to train and ordain Japanese priests. That policy changed by the end of the century and native candidates were admitted to Holy Orders, but it came too late. There was a brutal repression in 1614 and only fifteen indigenous priests had been ordained. Through the next two centuries Japanese Christianity became an underground movement quietly sustaining itself among rural families. Nevertheless, when Japan opened to the west in 1868, a remnant was discovered. Once more negotiation had happened; perhaps we can again compare that phenomenon with "church papists" and "Nicodemites." We should also note that the presence of the Jesuits themselves in Asian missions signals a certain internationalism. This was not the case in the missionary work among the Amerindians, activities linked intimately with Spain. The Jesuits were certainly not the only missionaries in Asia, but their story, especially the Jesuit mission in China, captures best this method of inculturation, what became known in China as "the way of Father Ricci."

Matteo Ricci (1552–1610) was born near the Adriatic coast of Italy and studied in Rome; he entered the Society of Jesus in 1572. One of his teachers Allessandro Valignano became director of mission work in Asia for the Jesuits and Ricci joined the endeavor. Valignano espoused the "gentle way" of mission, a strategy requiring study of an indigenous culture's languages, politics, values, habits, and religious beliefs and practices. Ricci arrived in Goa in 1578, and he spent the next four years studying in India. By 1582, when he reached China, then under the rule of the Ming dynasty, Ricci had adopted the appearance of a Buddhist monk with shaved head. His older Jesuit colleague and fellow Italian Michele Ruggieri even developed a catechism which drew on Buddhist sensibilities. For some Chinese, devotion that utilized rosary beads and statues seemed quite familiar. On one occasion a convert who had attempted to purge his home of idols, reported to Ricci that his pregnant wife had saved one statue, an image of Guanyin, a female Buddhist deity. She wanted to ensure a safe delivery. Ricci suggested he exchange the image of one woman for another, the Virgin Mary. When the expectant wife gave birth to a healthy child and on the Feast of the Presentation of the Blessed Virgin, their commitment was sealed. The substitution—or at times elision—of Mary for Guanyin became somewhat common among the converts. Ricci and the other Jesuits also utilized western science as a draw: influential figures visited their home in southern China to see curiosities like printed books, astronomical instruments, maps, and clocks.[21]

In the early 1590s, Ricci shifted his strategy. Ruggieri had retired to Italy and Ricci came to understand that Buddhist clerics, while certainly numerous in Ming China, were from lower social strata and often poorly educated. Ricci, who wanted to be perceived as the equal of Chinese elites and thereby influence the channels of real power in China, decided to exchange the appearance of a Buddhist cleric for that of a Confucian scholar. He grew his hair and beard out and wore black silk. In 1595, Ricci had the opportunity to relocate to Beijing, the capital far to the north, and in 1601 he was became the first European to be granted admission to the Forbidden City, the government palace. He was already studying Confucian literature and he wrote extensively about what he saw of Chinese government, for example, how candidates for bureaucratic service were examined in their knowledge of Confucian philosophy. Ricci made a significant inroad at the turn of the century, not only impressing Chinese elites with his western curiosities and his abilities in science and mathematics, but in his genuine interest in their philosophy and religious practices. Ming China had three major religious groups: Buddhism, Taoism, and Confucianism. Confucianism, however, not only commanded the adherence of the Chinese literati, it seemed to Ricci to be more of a philosophy of natural law than a religion. Many people who espoused Confucian ideas readily turned to Buddhism or Taoism to fill in gaps about the afterlife for example. Confucianism, which emerged c. 500 BC, stressed harmony with nature, respect for authorities, especially parents, and loyalty; this seemed very similar to the late ancient Greek philosophy of Stoicism to Ricci. He even described the ancient fifth-century sage Confucius as "another Seneca," which is curious considering that the Roman stoic philosopher Seneca lived five hundred years after Confucius.

Ricci determined that he could use Confucianism as a helpful preparation for Christianity. Thus, while he eagerly formed relationships with high-profile Confucian sages, he developed an animosity against Buddhism and Taoism, even engaging in polemical debates with Buddhist abbots. He derided the Buddhist emphasis on escape / transcendence from the natural world. Instead, he presented Christianity as the cultivation of virtue, the alignment of one's will with the will of God who created the natural world, declared it very good in the Genesis account, and promises to restore it in Christ. At a larger level, however, Ricci operated with a grand theory of evangelization, and he drew on the image of early Christianity. He saw that a religion from the middle east had utilized the Greek language and Greek philosophy to enter the Mediterranean world. From there, that same religion, moving further west and north, pivoted again and utilized Latin. For Ricci, that same pattern needed to hold in Asia. In other words, Matteo Ricci's method of inculturation was primitivist; it was informed by a vision of the early church.[22]

Ricci's work in China did not net large numbers of converts. He aimed for those who influenced the wider culture, and, in that regard, Ricci was successful. The "wise man from the west," as he became known, was given a state-sponsored funeral after his death in 1610. In the generations that followed, his method persisted among the Jesuits. For example, in 1619, the Portuguese Jesuit Jean de Rocha published a manual for praying the rosary that captures Jesuit sensibilities within a Chinese context. Ignatius's *Spiritual Exercises* ties the visual with prayer; de Rocha's *Method of the Rosary* presents the reader with fifteen wood-cut prints of scenes from the life of Christ (the object of prayer in the rosary), but all the figures, including Christ and Mary, are obviously Asian. Even the settings for the scenes are decidedly Chinese.[23] Not all Catholic missionaries, however, agreed with the Jesuit approach to inculturation. Franciscans and Dominicans arrived in China in the seventeenth century and were aghast at what they saw as syncretism; this tension lasted for decades and was known as the Chinese rites controversy. Of particular concern were the persistence of ceremonies honoring the dead, including food offerings, which the Jesuits approved. When papal condemnations of such practices appeared at the opening of the eighteenth century, the Emperor Kangxi was infuriated by what he perceived to be an incursion from a western authority. In 1710, he forbade conversion to Christianity, but permitted the Jesuits to stay in China so long as they kept to "the methods of Father Ricci."[24] Although missionary work in China would founder from then until the nineteenth century, Ricci's legacy of inculturation—one based on an vision of earliest Christianity—is still present in China today.

PLUS ULTRA

According to legend, the phrase *non plus ultra*, nothing further beyond, was inscribed on the pillars of Hercules, the mythical gates on either side of the strait of Gibraltar, that water passage between the southern tip of the Iberian peninsula and north Africa. West of those mythical gates lay the Atlantic Ocean, a seemingly endless expanse. Europeans had accepted that there was nothing further beyond those western promontories. However, with Columbus sailing west to the "New World" and Vasco da Gama sailing south and then east to India and Asia, a new globalism "further beyond" was coming into sight at the beginning of the sixteenth century. When Charles, the grandson of Ferdinand and Isabella became king of Spain in 1516, he dropped the *non* and adopted as his motto *plus ultra*, further beyond.[25] This was the same Charles who became Holy Roman Emperor in 1519 and who wrangled with his Protestants subjects in Germany for the rest of his life. But *plus ultra* also signaled the greater vision of the *Reconquista*, the deliverance not just of the

Iberian peninsula but of the whole globe from the perceived darkness of pagan idolatry and Protestant heresy. Within the encounter, we find colonialism and Christian mission wrapped together. Likewise, we are well served to use the lens of popular politics: a more complete narrative of engagement shows not simply acquiescence, but also adaptation, negotiation, and even purposeful inculturation. Further, the encounter happened at a moment of reform within Roman Catholicism and it was intimately caught up in those movements. We should not be surprised, then, to find primitivist sensibilities and a yearning for the apostolic church coursing across the encounter, whether we are discussing Iberian missionaries, the agenda of Las Casas, or Ricci's attempts at inculturation.

NOTES

1. Joseph O'Callaghan, *Reconquest and Crusade in Medieval Spain* (Philadelphia: University of Pennsylvania Press, 2003); Robert Miola, ed., *Early Modern Catholicism: An Anthology of Primary Sources* (Oxford: Oxford University Press, 2007), 482–85.

2. Richard Fletcher, *The Conversion of Europe* (New York: Harper Collins, 1997); Martin Carver, ed., *The Cross goes North: Processes of Conversion in Northern Europe, AD 300–1300* (Woodbridge, UK: Boydell, 2003).

3. Robert Ricard, *The Spiritual Conquest of Mexico* trans. Lesley Byrd-Simpson (Berkeley: University of California Press, 1966).

4. Asunción Laverin, *Brides of Christ: Conventual Life in Colonial Mexico* (Stanford: Stanford University Press, 2008); Karen Melvin, "Priests and Nuns in Colonial Ibero-America," in Lee Penyak and Walter Petry, eds., *Religion and Society in Latin America* (Maryknoll, NY: Orbis, 2009), 100–14.

5. Osvaldo Pardo, *The Origins of Mexican Catholicism: Nahua Rituals and Christian Sacraments in Sixteenth-Century Mexico* (Ann Arbor MI: University of Michigan Press, 2004); Amos Megged, *Exporting the Catholic Reformation: Local Religion in Early Colonial Mexico* (Leiden: Brill, 1996)

6. Samuel Wilson, ed., *The Indigenous People of the Caribbean* (Gainesville, University Press of Florida, 1997).

7. Sabine MacCormick, "Limits of Understanding: Perceptions of Greco-Roman and Amerindian Paganism in Early Modern Europe," in Karen Kupperman, ed., *America in European Consciousness: 1493–1750* (Chapel Hill: University of North Carolina Press, 1995), 79–129; Robert Jackson, *Conflict and Conversion in Sixteenth-Century Central Mexico* (Leiden: Brill, 2013).

8. David Tavárez and John Chuchiak, "Conversion and the Spiritual Conquest," in Lee Penyak and Walter Petry, eds., *Religion and Society in Latin America* (Maryknoll, NY: Orbis, 2009), 66–82.

9. Hsia, *World of Catholic Renewal*, 189; Stuart Schwartz, *Victors and Vanquished: Spanish and Nahua View of the Conquest of Mexico* (Boston: Bedford/St. Martins, 2000).

10. John Chuchiak, "Christian Saints and their Intepretations in Mesoamerica," in David Carrasco, ed., *Oxford Encyclopedia of Mesoamerican Cultures* (Oxford: Oxford University Press, 2001), Vol. 3, 113–16.

11. J. Jorge Klor de Alva, "Spiritual Conflict and Accommodation in New Spain: Toward a Typology of Aztec Responses to Christianity," in George Collier, Renato Rosaldo, and John Wirth, eds., *The Inca and Aztec States 1400–1800: Anthropology and History* (New York: 1982), 345–66; Tavárez and Chuchiak, 77; Kenneth Mills, *Idolatry and its Enemies: Colonial Andean Extirpation and Extirpation 1640–1750* (Princeton: Princeton University Press, 1997); Timothy Knowlton, *Maya Creation Myths: Words and*

Worlds of the Chilam Balam (Boulder, CO: University of Colorado Press, 2010); Sabine MacCormick, *Religion in the Andes: Vision and Imagination in Early Colonial Peru* (Princeton: Princeton University Press, 1991); Hsia, *World of Catholic Renewal*, 189.

12. Tavárez and Chuchiak, 72–73; Stafford Poole, *Our Lady of Guadalupe* (Tucson: University of Arizona Press, 1995).

13. Shaskan Bumas, "The Cannibal Butcher Shop: Protestant Uses of Las Casas's "Brevísima relación" in Europe and the American Colonies," *Early American Literature* 25 (2000), 107–36.

14. Lawrence Clayton, *Bartolomé de Las Casas: A Biography* (Cambridge: Cambridge University Press, 2012); Bartolomé de Las Casas, *The Devastation of the Indies: A Brief Account* trans. Herma Briffault (Baltimore: Johns Hopkins University Press, 1992).

15. Daniel Castro, *Another Face of Empire: Bartolomé de Las Casas, Indigenous Rights, and Ecclesiastical Imperialism* (Durham, NC: Duke University Press, 2007). See also Lawrence Clayton, *Bartolomé de Las Casas and the Conquest of the Americas* (Oxford: Wiley-Blackwell, 2007).

16. Kristy Nabhan-Warren, "The Place of Las Casas in Religious Studies," in Santa Arias and Eyda Merediz, eds., *Approaches to Teaching the Writings of Bartolomé de Las Casas* (New York: Modern Language Association of America, 2008), 48–56.

17. Regina Harrison, "Teaching restitution: Las Casas, the *Rules for Confessors*, and the Politics of Repayment," in Arias and Merediz, eds., 132–40.

18. Ibid.

19. Gauvin Bailey, *Art on the Jesuit Missions in Asia and Latin America, 1542–1773* (Toronto: University of Toronto Press, 1999), 171–83; George Kubler and Martin Soria, *Art and Architecture in Spain and Portugal and their American Dominions: 1500–1800* (Baltimore: Penguin, 1999).

20. Alden Dauril, *The Making of an Enterprise: The Society of Jesus in Portugal, Its Empire, and Beyond, 1540–1750* (Stanford: Stanford University Press, 1996), 181–205; Ines Zupanov, *The Catholic Frontier in India (16th–17th Centuries)* (Ann Arbor: University of Michigan Press, 2005); Hsia, *World of Catholic Renewal*, 200–9

21. Liam Brockey, *Journey to the East: The Jesuit Mission to China, 1579–1724* (Cambridge, MA: Harvard University Press, 2007); Chün-fang Yü, *Kuan-yin: The Chinese Transformation of Avalokitesvara* (New York: Columbia University Press, 2001).

22. R. Po-chia Hsia, *Matteo Ricci & the Catholic Mission to China* (Indianapolis: Hackett, 2016), 21–36; Ibid, *A Jesuit in the Forbidden City: Matteo Ricci, 1552–1610* (Oxford: Oxford University Press, 2010); Paul Chung, "Mission and Inculturation in the Thought of Matteo Ricci," in Paul Chung, Kim Kyoung-Jae, and Veli-Matti Karkkainen, eds., *Asian Contextual Theology for the Third Millennium* (Eugene OR; Pickwick, 2007), 303–27; Mary Laven, *Mission to China: Matteo Ricci and the Jesuit Encounter with the East* (London: Faber & Faber, 2011).

23. Xiaoping Lin, "Seeing the Place: The Virgin Mary in a Chinese Lady's Inner Chamber," in Kathleen Comerford and Hilmar Pabel, eds., *Early Modern Catholicism* (Toronto: University of Toronto Press, 2001), 183–210.

24. Hsia, *Matteo Ricci & the Catholic Mission to China*, 38–39; Chung, 318–24.

25. *Bartolomé de Las Casas*, 152.

ELEVEN
Spirituality and the Bloody Theater
Martyrdom in the Middle Ages and Early Modernity

Reform movements, even today, give rise to incompatibility. To rightly understand premodern reformations, we have to accept that toleration and pluralism were not simply inconceivable but rather detested as denials of God's self-revelation. None of the voices studied heretofore had a vision for a society populated by multiple "denominations." Luther did not dream of a new separate church from the church led by the pope, nor did he believe in what we today call religious tolerance. The emergence of such a pluralistic society across the Atlantic would be an important element in the cross-confessional phenomenon of pietism in the eighteenth century. Not so, however, for medieval and early modern reformations. Had church and civil authorities forsaken executing heretics, they would have had to abandon their sense of responsibility to preserve right teaching and practice for their communities. Had martyrs themselves not been willing to die, they would have had to abandon their commitment to God's will however they conceived it. Had the writers of martyrologies not celebrated the witness of such women and men, they would have had to abandon the value, enshrined in scripture, of suffering for the truth. And for pluralism to function at the broader cultural level, the whole of Christian Europe would have had to completely ignore the loud symphony of saint-martyr narratives which for centuries had taught Christians to take up their cross and follow the bruised and bleeding messiah in a world opposed to God and his Christ.[1]

This chapter is something of a pause after four chapters on sixteenth-century reformations before moving forward to those pietistic groups just mentioned. Here we take a broad look at the spiritual implications of martyrdom for Christians across the sweep of the present study's param-

eters, that is, the middle ages and early modernity. Certainly, the question of what did it mean to be a martyr is an important one. But even more important are the psychological, cultural, and ascetical effects of reading martyr stories, singing songs about them, knowing the vile torments of opponents, and praying to the martyrs for their intercessions. As should be clear: martyrdom was a cross-confessional phenomenon, a factor for Catholics, Magisterial Protestants, and Anabaptists. And any primitivist reform movement, any agenda for the *vita apostolica*, would have the discourse of martyrdom at its heart. Martyr stories were the steady diet of Christian communities while no less than scripture itself commended the image of the true church as a people "on the run," a hunted and persecuted people who suffer for the sake of gospel truth.

THE BLOOD OF THE MARTYRS, THE SEED OF THE CHURCH

Martyrdom has been in the Christian lexicon since the early church. Even today it strengthens the identity not simply of individuals but of communities whose members believe that they are being persecuted for the sake of Christ, who himself suffered a humiliating death. In scores of places in scripture, the cross is presented as paradigmatic for the church. Jesus said the world hates me and so the world will hate you, but blessed are you who are persecuted for my sake. You will be betrayed even by your family, he prophesied, and some of you will be put to death.[2] These words rang true not only in the pre-Constantinian church, but into the middle ages. While formal persecution was not the norm for the average western Christian, the stories of the martyrs were vividly retold in sermons collections while church calendars provided several days every month to memorialize martyrdom. In a fascinating way this culture of blood and agony did not abate but expand. Margery Kempe's hope to suffer for Christ at the start of the fifteenth century, for example, was not unusual. By the later middle ages (roughly post 1300), Christian practice was focused directly, even in a hyper-realistic way, on the crucified Jesus. Churches grew crowded with martyrs in art, music, and ritual. Christians knew of Stephen's stoning, Bartholomew's skinning, and Lawrence being grilled alive. A spiked wheel signaled the story of Catherine, arrows that of Sebastian, and an upside-down cross that of Peter. This panoply of suffering saints surrounded the wounded messiah in the Christian imagination. Michelangelo's "Last Judgement" (1541) painted above the altar in the pope's own Sistine Chapel is a monumental display of Christ and his martyred saints. As John Calvin put it, the true church lives under the cross. We have to realize, however, that both Michelangelo and Calvin inherited that discourse, and not directly from scripture but rather from a seemingly inexhaustible stream of thought flowing across the whole of Christian history, a stream from which all western Christians in the six-

teenth century—Roman Catholic, Magisterial Protestant, and Anabaptist—would draw deeply.[3]

Jesus's command to take up the cross could take on different meanings in actual practice, ranging from enduring temptation and the mortification of the flesh on the one hand to suffering bodily martyrdom on the other. This was the warp and woof of earliest Christian identity, as the early church read scripture along with martyr stories almost as one united literary canon. The third-century Carthaginian church Father Tertullian famously wrote that the blood of the martyrs is the seed of the church. The discourse of Martyrdom, then, was constitutive. Other Fathers, like Cyprian in the third century and Jerome and Augustine in the fourth and fifth, envisioned what this vocation for the church would look like if active persecution faded. Much of monastic ascetical theology, as discussed above, emerged to fill the gap in place of such persecution. In the sixth century, Gregory the Great among others advocated for endurance in the face of temptation, self-renunciation, and supremely monasticism itself as the heir of early Christian martyrdom. Thus, monks came to be known as "white martyrs" as opposed to "red martyrs" covered in blood. That construal of martyrdom, however, did not preclude certain Christians suffering at the hands not of pagans, but of other Christians. The concept of heresy emerged in the early church, as Christian doctrine developed and was articulated through an episodic series of disagreements. What was to be done with heretics whose ideas—whose reform agendas—were judged toxic to the Christian community?

During the middle ages and through early modernity, the common form of execution for heretics was burning—a purgation of error—and the ashes were usually scattered in running water. Many of the reform movements discussed heretofore danced close to the line of such executions, sometimes crossing it. Just as the mendicants sought apostolic simplicity, so too did the Waldensians and Cathars—and all at the same time no less. It was in fact an encounter with the Cathars that inspired Dominic to take up the life of a wandering poor preacher. One man's reform, then, is another man's heresy. Likewise, these reform movements often left twin legacies, one more radical and another stable and domesticated. For example, many Franciscans were inspired by the legacy of the apocalyptic preacher Joachim of Fiore (c. 1135–1202) as well as the fraticelli, the Spiritual Franciscans committed to radical poverty. And more broadly, the popular impetus toward the apostolic life gave rise to smaller groups like the humiliati, clusters of laymen in twelfth-century Italian towns committed to manual labor and lay preaching. Among the Beguines one finds mystics skirting the borderland between reform and heresy. And in each of these episodes, bishops and others in authority attempted to either correct, domesticate, or eliminate.[4]

In 1231, Pope Gregory IX (r. 1227–1241) commissioned the Dominican prior of Regensburg along with a team of Dominicans to extirpate heresy

in southern France. This was the birth of the medieval inquisition, a company of clerics who could by-pass the local bishop to identify and root out heresy as one would cut out cancer. Suspects would not face witnesses against them, and, after the 1252 papal bull *Ad Extirpanda*, they could suffer torture. Heretics who recanted were given penances not dissimilar from those given in the normal course of confession. Those who did not recant were handed over to the civil authorities who did the actual dirty work of execution. In the later middle ages, however, recantation was the norm; and with the impressive rise of the mendicants, Cathars among others lost their cache. The papally led inquisition was remodeled in 1542 as a congregation of the Roman curia, a bureaucratic agency, and given the name "the Holy Office" (after further evolution today it bears the name Congregation for the Doctrine of the Faith). That body was successful in keeping Protestantism out of Italy, but had little authority beyond the Alps.

On the other hand, in 1478, the pope granted Ferdinand and Isabella, the "most Catholic monarchs of Spain" permission to root out heretics and nominally converted Jews (later this included nominally converted Muslims). Such a purgative agenda certainly needed vigor following the *Reconquista* and the Decree of Alhambra, both in 1492, as discussed in chapter 10. In its early years, the Spanish Inquisition was thorough and effective, particularly under the leadership of its first inquisitor general, Tomás de Torquemada (1420–1498). In those early years some 40 percent of those accused went to the stake. A generation later, however, its severity dropped significantly, but the image of the *auto de fe* lived on into the seventeenth century, especially in the Protestant imagination. The *auto de fe* was a carefully choreographed public spectacle: condemned heretics appeared in yellow cloaks and pointed hats, mass was celebrated, and the stake followed. But note that the goal of inquisitors, from the middle ages through early modernity, among both Catholics and Magisterial Protestants, was not burning, but a recantation. Burnings were damage control in the face of failure, a "public health initiative" according to Brad Gregory.[5]

MARTYRS IN EARLY MODERNITY

Depending on how one establishes the artificial borders of historical periods, we can date the first instance of martyrdom in early modernity either to Jan Hus who was burned by the Council of Constance in 1415 or to the burning of two Augustinian Friars who had adopted Luther's teachings in Brussels in 1523. After those two were executed, martyrdom was year after year a grisly yet identity-forming feature of Christian life, one continuing well into the seventeenth century when the whole of Christian Europe immersed itself in the Thirty Years War. And these

executions were not only gruesome, they were public, drawing hundreds, even thousands. They were spectacles entailing beheadings, burnings, hangings, even drawing and quartering. Perhaps most notably, they were orchestrated by and endured by all Christians, making both roles—condemned and executioner—a shared experience. One is tempted to say that the Anabaptists, famed for their non-resistance, were not involved in executing martyrs, but even they got blood on their hands. Although an early Anabaptist statement of faith, the Schleitheim Confession, had rejected violence in 1527, less than a decade later some thought otherwise. In 1534, a radical Anabaptist theocracy emerged in the city of Münster with a succession of apocalyptic leaders; the final one, John of Leiden (1509–1536), claimed to be the heir of the biblical King David, dismembered his opponents, and took sixteen wives. Communitarianism in imitation of the apostles prevailed, but not the primitivist commitment to peace most often associated with Anabaptist practice. When this "New Jerusalem" was finally put down by Catholic forces, John of Leiden was tortured for hours in public and his dead body hung in a cage. The gruesome specter of Münster would haunt later Anabaptists, a tradition that came to treasure sacrificial peace as a biblical mandate and mark of true Christianity.[6]

It is that kind of tradition-shaping impact that should concern us. Roman Catholics, Magisterial Protestants, and Anabaptists produced tracts and pamphlets about the faith of their respective martyrs, often with graphic details. They wrote songs and poetry celebrating them and commissioned paintings, sculptures, and woodcuts to visually transmit the testimony. And a new genre of literature, the martyrology, presented stories of the martyrs usually in the context of a sweeping vision of Christian history run up against the persistent forces of Antichrist. For example, following Charles V's military victory over the Lutheran Schmalkaldic League in 1547, two martyrologies appeared linking contemporary experiences with martyrs from the early church.[7] Again, this was a cross-confessional phenomenon. Stories and songs of the thousands of Anabaptists who were drowned to death in central Europe, of the dozens of Sacramentarians and Anabaptists who were burned in the 1520s under Henry VIII in England, of Catholics like Thomas More, Cardinal John Fisher, and Elizabeth Barton who were hanged or beheaded also under Henry VIII, of prayer-book Protestants like Hugh Latimer, Nicholas Ridley, and Thomas Cranmer who were burned alive under "Bloody Mary," of the Jesuits who were hanged under Queen Elizabeth, and of the roughly 17,000 Huguenots who were butchered across France during the St. Bartholomew's Day Massacre in August 1572 provided spiritual strength for their co-religionists and would-be followers in the way of true Christianity.[8]

To be clear, "martyr" is a conceptual category. The people who held Felix Manz under water in 1526, the man who lifted the axe over More in

1535, and the team who lighted the pyre under Cranmer in 1556 believed their work to be wholesome and necessary. For them, the people they butchered were not "martyrs" but rather toxins which needed purgation. Heretics would be ranked alongside accused witches and sodomites, violators of a social fabric who needed to be taken out of circulation for the good of society. These executioners sincerely believed that their opponents were so dangerous that it was not enough to censure, silence, expel, or jail them. No, this perceived danger rose to such a height that purgation was deemed necessary. Not infrequently they were to be killed in such a way as to teach a lesson to others who might be seduced down the same path. It was no coincidence that Anabaptists were routinely drowned—this was an intentional parody of their baptisms. Judgments were rendered for the world to see. When the city council of Geneva ordered the execution of Michael Servetus in 1553, it was partially to refute Catholic claims that Reformed Protestantism led to increasingly gross heresies. Servetus, who had denied the Trinity, had already been condemned by Catholic authorities in France; escaping prison, Servetus made the mistake of seeking refuge in Geneva. After turning up at a sermon delivered by Calvin himself, Servetus was arrested, and the city council, in a bid both to purify the city of heresy and to show Roman Catholics and Lutherans that the Reformed tradition was not a slippery slope to denials of the Trinity, burned him at the stake. To drive the point home, they fueled Servetus' pyre with copies of his heretical books.

Sympathizers, however, hailed the condemned as "martyrs." Now the conceptual framework changes. The man with the torch, the axe, the dunking pole—these are now construed as the hideous representatives of the world, the flesh, and the devil, the same powers that hated Jesus and nailed him to the cross. In this narrative, the one executed has been faithful and has spoken the truth which confounds the world. The whole phenomenon is wrapped in deeply Johannine sensibilities: light shines in darkness, and even though it appears that the darkness is winning, the darkness cannot overcome the light.[9] The condemned becomes a "martyr," a light shining in darkness. When the Protestant bishops Hugh Latimer and Nicholas Ridley were burned at the stake in 1555, Latimer famously shouted over to Ridley "we shall this day light such a candle, by God's grace, in England, as I trust shall never be put out." The irony, however, is that Latimer and Ridley had themselves been on the other side of the equation. Latimer, for example, preached at the burning of a Franciscan in 1538. That "candle" would burn brightly for English Catholic resistance in later generations. This evinces the remarkable similarities of conceptual thinking across confessions. In the early 1530s, Thomas More had energetically ushered many Protestants to the stake in England. But then, when the Catholic statesman rejected the royal supremacy, he found himself facing execution. While waiting for the axe-man in 1535, he wrote his *Dialogue of Comfort*, a text which would become central

to early modern Catholic sensibilities about martyrdom. Twenty years later, during the reign of Mary Tudor, the Catholic regime ensured that the Protestant Archbishop Thomas Cranmer had a copy of More's *Dialogue of Comfort* while he waited to be executed.[10] Tables turned and turned and turned. After all, this was the fruit of a shared inheritance from scripture and the early church which prized suffering for the sake of gospel truth on the one hand (the desire to be a martyr) and, on the other hand, the need to zealously guard the apostolic deposit (the desire to execute heretics). Moreover, it did not take early modern polemicists long to figure that out. Catholics for example developed arguments that those Protestants who went to the stake during the reign of Mary Tudor—some in dramatic fashion, kissing the stake and wearing white to appear like the white-robed army of martyrs in Revelation 7:14—were not true martyrs who go to their deaths somberly as Christ did, but were rather brash pseudo-martyrs.[11]

In the sixteenth and seventeenth centuries, not counting the St. Bartholomew's Day Massacre during which thousands of Huguenots were slaughtered across France in a nation-wide pogrom in August 1572 or the death tolls from the wars of religion in France or in the Holy Roman Empire, roughly 5,000 people altogether who were killed for heterodoxy. The lion's share were Anabaptists, roughly 4,000 of the 5,000. But that is the number of people who were killed. How many sang songs about those Anabaptists? How many read the story of Cranmer at the stake? How many prayed to Thomas More and John Fisher? Even though four out of five martyrs were Anabaptists, the discourse of martyrdom itself was much larger. Martyrologies were published with the unambiguous purpose of commemorating heroes, edifying fellow believers, denouncing opponents, and graphically convincing their readers that they held in their hands the true account Christian martyrs beginning with women and men in the early church and ending in their own day. The Lutheran Ludwig Rabus (1523–1592) who had assisted Martin Bucer in Strasbourg in the 1540s, produced his eight-volume work, *The History of God's Chosen Witnesses, Confessors, and Martyrs*, between 1552 and 1558. The seventy accounts he provided stretched from early Christian martyrs to those who suffered for Protestantism, a clear train in history of authentic apostolic Christianity.

While there were countless texts like this, Rabus' work was one of four major Protestant martyrologies from the second half of the sixteenth century, a critical time for consolidation among confessional groups, both Catholic and Protestant. The other three are the *Lives of the Martrys* (1554) by the French lawyer Jean Crespin (c. 1520–1572) who had joined his fellow countryman John Calvin in Geneva, *History and Deaths of the Devout Martyrs* (1559) by the Dutch Reformed cleric Adriaen van Haemstede (1525–1562), and certainly John Foxe's *Acts and Monuments* (1563), also known as Foxe's Book of Martyrs.[12] Foxe (1516–1587) had fled Eng-

land during Mary's reign but returned when Elizabeth became queen in 1558. Ordained soon after, Foxe produced his graphic collection of martyr stories linking the early church with his own day. The majority of these stories, though, were Protestants who suffered under "Bloody Mary." The book itself went through four editions in Foxe's life, and it was endorsed by the bishops of the Church of England. Its strength was its accessible language and woodcut images which could reach a wide audience. Foxe believed that if people knew history better—*the history he was narrating*—they would see the gospel truth and recognize papal malice over the ages. These stories of martyrs lead up to the pope being presented as Antichrist; and with a perceived increase in persecution, the reader was to believe that the end-times must surely be near. Foxe's project involved a team of writers including people going out to interview eye witnesses about executions during Mary's reign. But the finished product was most certainly an ascetical text—it inspired prayer and gave English Protestants a new army of saints to venerate and imitate.[13]

Foxe's account of Anne Askew's trial and execution in 1546 is the subject of ongoing debates among scholars. Askew had been part of a circle of evangelicals in London in the early 1540s and was even something of a preacher among them. This was during the final years of Henry VIII's reign when the king, though separated from Rome, seemed to be swinging in a more traditional Catholic direction (sans the pope of course). In these finals years the king allowed more conservative bishops to reign in progressive Protestants in the kingdom. Conservatives targeted Askew because she could possibly implicate leading evangelicals within Henry's regime, perhaps even Henry's last wife Catherine Parr. During interrogation, Askew was stretched on the rack to the point that both her hips and shoulders were dislocated, but she never gave up any names. She had to be carried to the stake in a chair because she could not walk. However, Foxe's account shows a woman not just keeping silent before her persecutors, but holding her own in theological debate with men, and scholars have debated the extent to which editors like Foxe crafted Askew's words later. Complicating things is the question of subverting gender norms: Askew, who had a checkered marital history (although she was the wronged party in a divorce) was not an especially attractive exemplar for Protestant womanhood. Askew's place in Foxe's parade of martyrs may be compared with his inclusion of the three women burned on the island of Guernsey in 1556 during the reign of Mary. Unlike Askew, they agreed to conform to Catholicism, but were burned anyway. A true horror show, one of the women turned out to be pregnant and gave birth during the execution. Although there was debate after this gruesome episode about whether the judges knew if she was pregnant (they would have had to wait until she was delivered to execute her), Foxe capitalized on the grisly scene. The baby boy was rescued but then thrown back in the fire, in Foxe's words, "baptized in his own bloud,

to fill up the number of God's innocent Sayntes." The woodcut image of this execution in Foxe's martyrology is perhaps the most grotesque in the whole book. But notice that these women were willing to conform; it is hard, therefore, to count them as exemplars. Foxe included this scene, apparently, not to praise their commitment but to elicit a visceral reaction against Catholics.[14]

Pathos was at the center of this material. *The Song of Elizabeth* is an Anabaptist hymn celebrating the "manly" suffering of a young woman in the circle of the Dutch reformer Menno Simmons (1496–1561) at the hands of Catholic inquisitors. With verses about thumbscrews and spurting blood, it climaxes with the heartfelt remembrance of how she called upon Jesus in her hour of pain.[15] Elizabeth likewise made an appearance in the most important Anabaptist martytrology of the seventeenth century, *The Bloody Theatre of the Martyr's Mirror* (first published in 1660). The work of Thieleman van Braght (1625–1664), this martyrology became a staple of Mennonite ascetical reflection. Perhaps the most famous account in this anthology is that of Dirk Willems, a Dutch Anabaptist waiting to be executed in the Netherlands in 1569. After escaping prison, he was chased by a guard across a frozen pond. When the guard slipped through the ice and started drowning, Willems turned around and saved his pursuer. Finding himself captured again, his kindness was rewarded with fire and the stake. See figure 11.1.

Among Anabaptists this story took on a life of its own, demonstrating how Willems shared the love of Christ even with his persecutors. This is salient for the whole of Anabaptist spirituality, a tradition that often contrasted the easiness of believing in Jesus with the challenge of actually following him. The Anabaptists (who, we remember, made up the bulk of executions for heterodoxy in the sixteenth century at a ratio of four out of five) thought Magisterial Protestants like Luther offered a counterfeit "sweet Jesus" to the true "bitter Jesus" of scripture who commands his disciples to take up their own crosses and follow.[16]

Among Catholics the martyrs did more than steel the resolve of others by their witness; seated in heaven they could intercede, an active and ongoing role somewhat different than what we find among Magisterial Protestants and Anabaptists. After Henry VIII executed Cardinal Pole's mother in 1541, the cardinal confidently declared that he had one more advocate in heaven. In his *Life and Death of Sir Thomas More*, Nicholas Harpsfield (1519–1575) wrote that More's decapitated head raised high on London bridge was not nearly as high as his place among the saints who intercede for true Christians at the right hand of Christ. Starting in 1535, practicing Catholicism was equated with treason in England; this was palpably the case in Elizabeth's reign when the pope's bull *Regnans in excelsis* (1570) absolved English Catholics of their legal loyalty to the queen. It appeared that Elizabeth was now a target for any would-be assassin of Catholic conviction. The government, therefore, responded

Figure 11.1. Jan Lukyn, Dirk Willems saving his pursuer, Thieleman van Braght, *The Martyr's Mirror*. **Courtesy of the Mennonite Library and Archives, Bethel College, Newtown, KS.**

with even more repression of Catholics in England. Under the Tudors more than two hundred English Catholics were executed on grounds of treason. For example, William Hart, a clandestine English priest, was discovered and subsequently beheaded at York in 1583. At the execution, faithful Catholics recovered his blood-stained shirt as a holy relic. The most famous Elizabethan Catholic martyr, the Jesuit Edmund Campion (1540–1581) was hanged, drawn, and quartered at Tyburn Tree (the traditional place of execution in London). Almost immediately after his death, Catholics claimed to have bits of his bones. The English College at Rome, a school established to train Englishmen for such dangerous missionary work and which boasted murals of Catholics martyred under the Tudors, was sent a piece of his ribs.[17]

I SEE HEAVEN OPEN

Men and women being burned alive, decapitated, hanged, or drowned is a grim part of religious history, and it should not be forgotten that people

continue to suffer in gruesome ways even today for their faith. Reform movements examined in this book naturally drew conflict and the phenomenon of martyrdom with its conceptual framework and *dramatis personae* logically followed. While the results were invariably the same (death), the executioner was viewed by some as the righteous purifier of the body of Christ and by others as the tool of Antichrist. Likewise, the condemned was viewed by some as a blasphemous perverter of the true faith and by others as the righteous martyr who would rather die than deny the gospel. What that conceptual framework produced was a body of material—songs, stories, prayers, relics—which shaped devotion, ritual, and personal and corporate identity. In short, the discourse of martyrdom stood at the intersection of spirituality and reform. And, to be precise, it dealt in the same grammar as virtually all reform movements in this study—the language of primitivism. The martyrologies presented contemporary martyrs in a carefully choreographed succession of witnesses going back to the early church. Their stories read like tropes with the same immutable characters appearing repeatedly, usually with potent words coming from the condemned. Often the martyrs, whatever their stripe, cry out using the words of Stephen the Protomartyr in Acts 7: "I see heaven open and the Son of Man standing at the right hand of God . . . Lord Jesus receive my spirit." The accounts we have of Thomas Cranmer, for example, have the dying archbishop do exactly that. Whether he did or did not say those words is somewhat irrelevant: Cranmer became Stephen for later English Protestants, a witness who gave his blood for apostolic truth.[18]

NOTES

1. Brad Gregory, *Salvation at Stake: Christian Martyrdom in Early Modern Europe* (Cambridge, MA: Harvard University Press, 1999), 346–47; Idem, *The Unintended Reformation: How a Religious Revolution Secularized Society* (Cambridge, MA: Harvard University Press, 2012).
2. Matthew 10:22, 16:24; Luke 21:16; John 15:18; Revelation 12:11.
3. Gregory, *Salvation at Stake*, 30–73.
4. Malcolm Lambert, *Medieval Heresy: Popular Movements from the Gregorian Reform to the Reformation* (Oxford: Blackwells, 1977), 189–214.
5. Gregory, *Salvation at Stake*, 342–52; Miri Rubin. "Choosing Death? Experiences of Martyrdom in Late Medieval Europe," in *Martyrs and Martyrologies. Papers Read at the 1992 Summer Meeting and the 1993 Winter Meeting of the Ecclesiastical History Society*, ed. Diana Wood (Oxford: Blackwell, 1993), 153–83; Christine Ames, *Righteous Persecution: Inquisition, Dominicans, and Christianity in the Middle Ages* (Philadelphia: University of Pennsylvania Press, 2013), 5–10; Joseph Pérez, *The Spanish Inquisition: A History* (New Haven: Yale University Press, 2005).
6. Matthew 5:44; Luke 6:27–36.
7. Robert Kolb, *For all the Saints: Changing Perceptions of Martyrdom and Sainthood in the Lutheran Reformation* (Macon: Mercer University Press, 1987), 37.
8. Barbara Diefendorf, *Under the Cross: Catholics and Huguenots in Sixteenth-Century Paris* (Oxford: Oxford University Press, 1991).

9. John 1:5.
10. MacCulloch, *Thomas Cranmer*, 582, 595.
11. Anne Dillon, *The Construction of Martyrdom in the English Catholic Community 1535–1603* (Burlington, VT: Ashgate, 2002), 18–71; Eamon Duffy, *Fires of Faith: Catholic England under Mary Tudor* (New Haven: Yale University Press, 2009), 171–87.
12. Gregory, *Salvation at Stake*, 165–96; Andrew Pettegree, "European Calvinism: History, Providence, and Martydom," in Robert Swanson, ed., *The Church Retrospective* (Woodbridge: Boydell, 1997), 227–52.
13. Elizabeth Evenden and Thomas Freeman, *Religion and the Book in Early Modern England: The Making of John Foxe's 'Book of Martyrs'* (Cambridge: Cambridge University Press, 2011), 320–47; Margaret Aston and Elizabeth Ingram, "The Iconography of the *Acts and Monuments*," in *John Foxe and the English Reformation*, ed. David Loades (Aldershot: Ashgate, 1997), 66–141.
14. Among others, see Thomas Freeman and Sarah Elizabeth Wall, "Racking the Body, Shaping the Text: The Account of Anne Askew in Foxe's 'Book of Martyrs,'" *Renaissance Quarterly*, 54 (2001), 1165–96; Genelle Gertz, *Heresy Trials and English Women Writers, 1400–1670* (Cambridge: Cambridge University Press, 2012), 77–106; Megan Hickerson, *Making Women Martyrs in Tudor England* (New York: Palgrave Macmillan, 2005).
15. Hermina Joldersma and Louis Grijp, eds. and trans., *Elisabeth's Manly Courage: Testimonials and Songs of Martyred Anabaptist Women in the Low Countries* (Milwaukee: Marquette University Press, 2001), 115–21.
16. Timothy George, "Spirituality of the Radical Reformation," in *Christian Spirituality: High Middle Ages and Reformation*, ed. Jill Raitt (New York: Crossroads, 1987), 334–66; Gregory, *Salvation at Stake*, 197–249; David Weaver-Zearcher, *Martyr's Mirror: A Social History* (Baltimore: Johns Hopkins University Press, 2016).
17. Gregory, *Salvation at Stake*, 250–314.
18. MacCulloch, *Cranmer*, 603.

TWELVE

Religions of the Heart

New Movements of the Seventeenth and Eighteenth Centuries

By the time the reform movements which had begun in the sixteenth century (both Protestant and Roman Catholic) witnessed the opening of the seventeenth, they had calcified into what some have described as a return to medieval scholasticism. Polemical struggles were the way of life. Each church body produced confessional statements pushing toward doctrinal precision, rigorously defining boundaries along intellectual lines. Towering works of dogma were then built on these confessions. This was the backdrop for an explosion of movements beginning in the later seventeenth century and stretching into the eighteenth, voices which, though indebted to the movements of the sixteenth century (Luther, Calvin, etc.), felt there was something missing, specifically an affective, emotional, and often personal commitment to Jesus Christ. This reorientation happened across European Christianity, among Protestants and Catholics, and spilled into the new world, providing the connection between the "classical" Protestantism of the sixteenth century and present-day evangelicalism. Using a model advanced by Ted Campbell, namely, that very different Christians felt that a role for the affections was missing from the late sixteenth-century calcification of Christianity (also known as the era of confessionalization), this chapter covers a wide array of groups which emerged simultaneously and often cross-fertilized.[1]

Chapter 12

SEVENTEENTH-CENTURY ENGLAND

In 1553, when King Edward VI died at age sixteen, his reformation projects were cut short by the accession of his eldest half-sister, the Catholic Queen Mary. During Mary's reign, most of the leading lights of Edward's reformation program, fearing execution at the stake, fled England for Protestant safe-havens on the continent. When the queen died of cancer only five years later in 1558, the accession of the middle half-sister Elizabeth was perceived by many as a return to those earlier reformation projects. Those Protestants who had fled to safe-havens like Zurich or Geneva came flooding home believing that their efforts could resume. But Elizabeth instead froze the unfinished Edwardian project in amber. For the balance of her reign, 1558–1603, "Puritans" chafed at using the Book of Common Prayer which they saw as rife with popish ritual holdovers (the white surplice worn by clergy, the ring in marriage, feast days like Christmas, emergency baptisms) and they balked at the lack of preaching. Puritanism was a phenomenon located squarely within the established church, and it featured voices calling for internal reform. Only later, with the emergence of Presbyterianism in the 1570s, was there a sense of forming a parallel church governed by the "classis," groupings of like-minded churches and clergy who self-disciplined.

By the 1590s, Puritans had lost the fight to change the state church. Critical leaders like Thomas Cartwright (c. 1535–1604) had been jailed and the sinking of the Spanish Armada in 1588 was popularly viewed as God's approval of the Elizabethan status quo. Without much hope for structural change in the Church of England, the Puritans made a turn inward: if they could not change the church, they would change themselves. They focused on preaching toward individual edification, spiritual counsel, fasting, meditation, examining one's experience of sin and grace, refraining from work and recreation on the Sabbath, and even encouraged semi-separation from ungodly neighbors. This "practical divinity" flowed from late-sixteenth century advocates like Richard Greenham (1535–1594) to figures in the seventeenth century, like the Presbyterian Richard Baxter (1615–1691), whose book *The Reformed Pastor* offers methods for holiness of life and assiduousness in prayer. John Bunyan (1628–1688) likewise wrote a grand allegory of the Christian life as a pilgrimage seeking God. *Pilgrim's Progress* (1678) emphasizes struggle and the cultivation of virtue. Puritan communities, when they could make demands of their members, often required signs of one's assurance for admission. Was all this a return to works righteousness?[2]

Puritans were not the only ones dissatisfied with the Church of England's status quo. In the 1630s, English churches in many places witnessed an increase in ceremony, ritual, and what looked to be Catholic clericalism. This was a move in the extreme opposite direction of the Puritans. Wooden communion tables were replaced with stone altars,

and new rails cordoned them off as holy space. Images formerly cast down as popish idolatry reappeared in stained glass, carved wood, and stone statuary. Unlike the Puritans, the advocates for this other reform movement wanted more ritual, not less; they wanted consecrations for new churches, women to wear veils at the churching rite (the thanksgiving after childbirth), and an end to extemporaneous prayer. They stressed the authority of clergy and, in their call for more rituals as paths one could actively take toward holiness, they appeared to diverge from Reformed teachings about God's election as the key to salvation. These were the Laudians, so named for William Laud (1573–1645), archbishop of Canterbury from 1633 until his beheading during the Civil Wars. Also known as the Caroline Divines, the Laudians included the poet-priests John Donne (1572–1631) and George Herbert (1593–1633). Little united them theologically save for their commitment to "the beauty of holiness," an increase in ceremony. Herbert's book, *The Country Parson*, is strikingly similar to Baxter's efforts. While they conceptualized ministry differently, both Herbert and Baxter wanted to raise the stakes of holiness and commitment among their people. A generation later, Jeremy Taylor (1613–1667) produced his *Rule and Exercise for Holy Living* (1650) and *Rule and Exercise for Holy Dying* (1651), texts which stress the development of virtues and the responsibilities of discipleship. Some scholars suggest that this discipleship was a return to medieval patterns of asceticism.[3] As many Laudians held high office in the Church of England, especially in the 1630s, they often had to wrestle with the stark reality that they were departing from patterns of life established during the sixteenth-century reformations. In general, the Laudians claimed that they were achieving a closer approximation of the early church than had Cranmer and the Tudor reformers. In one tract from the 1630s, for example, Bishop Francis White defended a long list of ceremonies (e.g., mixing water with wine at the Eucharist, facing east for prayer) by referring to examples from the early church.[4]

Both Puritans and Laudians exhibited discontent with the status quo in England and the autocratic King Charles I proved incapable of managing the situation. Tensions spun out into civil war between the king and a Puritan-dominated parliament through the 1640s: the monarchy collapsed, parliament abolished both the Book of Common Prayer and episcopacy (the office of bishop), and a Puritan dictatorship headed by the former parliamentary general Oliver Cromwell (1599–1658) emerged in the 1650s. In those years, a great wave of different radical groups washed over England. While Congregationalists advocated for an ecclesiology located in the individual community, the Ranters believed they were free from laws, taught amoralism, and believed in a kind of divinization of true Christians in this life. The Family of Love, a group often shrouded in mystery for historians to this day, were mystics who had moved secretly among more orthodox Protestants since the middle of the sixteenth cen-

tury. The Quakers, initially led by George Fox (1624–1691), divided the spirit from the flesh to such an extent that sacraments seemed unnecessary to them, calling instead for the cultivation of an inner light. Later adopting the name the Society of Friends, Quakers welcomed suffering and openly taught perfectionism; the word "grace" is completely missing in Fox's journal, a prime source for early Quaker thought. In their worship, they sat in silence waiting for a prophetic word from the Holy Spirit. When the monarchy was restored in 1660, the established Church of England reappeared with its prayer book and bishops, but now it had a decidedly Laudian veneer. Anglicanism would thenceforward appear to be a blend of Reformed and Catholic sensibilities (certainly not the intention of Cranmer back in the sixteenth century). Thus, the common though not unproblematic description of Anglicanism to this day as a *via media* (middle way) between Protestantism and Catholicism. By 1688, the Act of Toleration created the category of "dissenter," allowing women and men to choose their own churches while simultaneously privileging Anglicanism as the official state church.[5]

GERMAN PIETISM

In 1580, the Book of Concord defined what it meant to be a good Lutheran, setting a bulwark against Roman Catholics, the Reformed, Anabaptists, and any who would teach works righteousness.[6] By the end of the century, however, two figures appeared whose ideas would grow to push against Lutheran orthodoxy. Between 1605 and 1610, the Lutheran theologian and former student of Melanchthon, Johan Arndt (1555–1621) published *True Christianity*, a book of devotion that also protested dogmatic fights. He felt polemical struggles were drawing people away from an imitation of Christ. Influenced by the *Theologia Deutsch* and the *Imitatio Christi*, Arndt's work emphasized the personal appropriation of Christ's atoning death and how that ought to bear good fruit in one's life. This contrasts with the Lutheran emphasis on the external atoning death of the savior. The other figure is more curious: Jacob Boehme (1575–1624) was a shoemaker who claimed that, on two different occasions, he was overwhelmed by divine visions. These resulted in a mysticism of repentance, rebirth, and union with divine wisdom. His convoluted writings cover astrology, cosmology, and how the human person, containing inner light, may be transformed. These are topics foreign to Luther's emphasis on passive reception of justification.[7]

Arndt and Boehme stand as precursors for the movement known as Pietism, but there is yet another background element: the Thirty Years War. The Peace of Augsburg (1555) determined that each territory in the Holy Roman Empire (i.e., central Europe) would follow the religious preference of the local prince or magistrate. The famous tagline ran

"whose prince, his religion." The options were Lutheran or Catholic. The year 1618 marks the breakdown of that settlement when the new prince of Bohemia commanded his Lutheran subjects to become Catholic. Though he was within his rights, his nobles responded by throwing his representative out a third-floor window (the so-called "defenestration of Prague"). This started a domino effect of military conflicts including civil war within the empire and the emperor's struggles with other nations, principally Denmark, Sweden, and France. It ended in 1648 with the Treaty of Westphalia, long after the deaths of the people who started the war. For three decades armies devastated the same lands and, by the end, the population of Germany decreased by a third. This was widely perceived as a war provoked by dogmatic precision; the resulting exhaustion led many to focus on daily life and morality instead of doctrine.[8]

Scorched earth proved to be fertile ground for the emergence of pietism. With Boehme and Arndt in the background, the seminal figure of Pietism was Philip Jakob Spener (1635–1705). In 1675, Spener, the senior pastor of Frankfurt, published an introduction to Arndt's sermons. He republished it the following year as *Pia Desideria: or Heartfelt Desire for a God-pleasing Improvement of the true Protestant Church*. Addressing clergy, Spener insisted that something must be done about the lack of personal discipleship. The church is sick, he writes, and he prescribes six steps. First, the Bible must factor more largely in Christian life. While sixteenth-century reformers knew the importance of scripture study, Spener writes, Lutherans now simply memorize their catechisms—a paltry substitute for reading and meditating on God's word. Second, Spener advocates empowering lay leadership as the priesthood of all believers. Third, every Christian should connect faith with practice; this must be taught and preached. Fourth, he writes that Christians need to be more gracious in controversies, both with other Christians as well as non-Christians. Fifth, clergy must live sincere lives, modeling for their people. To make this happen, the universities need to be reformed with attention to prayer, scripture study, and practice. And finally, preachers should focus on bringing out good fruit in the lives of their congregations, rather than demonstrate erudition.

Spener also advocated for voluntary home fellowships with Bible study, the sharing of personal testimonies, and hymn singing. Pietist hymns were marked by personal engagement with Christ's suffering, evocative images, and language meant to elicit an emotional response. Consider the lyrics of "O Sacred Head Sore Wounded," a hymn sung by many Christians today during Holy Week: the words speak of personal responsibility for putting Christ on the cross, and Christ dying "for me." Also, as these conventicles were domestic gatherings, lay people were in leadership, and sometimes (certainly not with church approval) those leaders were women.[9] Spener very consciously linked the phenomenon of the *ecclesiola in ecclesia* (church within the church) to something Luther

himself had said in the *Deutsche Messe*, his plan for German worship in 1526. In his day, Luther retained a Latin liturgy as a pastoral concession for the older generation but offered a German service as the principal form of worship. However, Luther also proposed that a third form ought to emerge in the future, a pattern in which lay people would worship together in their homes. The Wittenberg reformer did not believe this was going to happen anytime soon. Spener, now more than a century after Luther, believed the time had come.[10]

While Spener was constantly criticized by more traditional Lutherans, he was neither a radical nor a separatist. In addition to the *Pia Desideria*, another of his legacies was his influence on the University of Halle, specifically his landing an important teaching post for another major Pietist figure, August Hermann Francke (1663–1727). Building on Spener before him, Francke emphasized a personal experience of sorrow over one's sins (*busskampf*) leading to a personal experience of new birth (*wiedergeburt*). Francke, however, presented it as a datable experience, something one could recall and describe for others as the moment one was born again. God initiates this, to be sure, offering grace. But then the Christian must follow Christ not only as gracious savior but also as sovereign lord. In the traditional language of Christian soteriology (how God saves), these early voices of Pietism did not deny the conventional Lutheran understanding of justification but rather were much more interested in sanctification, the Christian life.[11]

Francke's emphasis on growth also posed a challenge for traditional Lutheranism in that he and other Pietists were far more welcoming of the "third use of the Law." Lutherans had seen biblical law as (1) a basis for civil law (principally in organizing biblical Israel) and (2) as a mirror of sinfulness which sobers the sinner and drives him or her to a gracious savior. When the sinner hears the Ten Commandments, he will see his failure and inability to keep the law and, without any other recourse, trust in Christ. But, showing theological debts to Philip Melanchthon, the Formula of Concord (1577) included a third use for the law, as a guide to the Christian life. After meeting the savior, the law provides the content of the Christian moral life. Granted, the demands of the law are achieved by grace, but the demands are no mere hyperbole. Traditional Lutherans, characteristically on guard against works righteousness, often stressed the first two uses and showed less interest in this "third use." Francke, however, was worried about Christians who stand still in their faith, showing no diligence in spiritual growth. Consequently, Francke turned the Pietism of Halle toward missionary efforts, founding schools and orphanages.

Spener and Francke are representative of "Church Pietists," people who were committed to traditional forms of Protestantism. However, there were others who believed that one must leave these bodies to achieve holiness. If sixteenth-century Christians had taught their great-

grandchildren of the seventeenth century anything, it was that when one had trouble with the church, one option was separation. If those very churches of the sixteenth century, themselves born of separation, had not formed the true church, then perhaps yet another separation was needed. And on and on it went. Such separatists, known as "Radical Pietists," often had eschatological sensibilities; they believed (as had Luther) that the end was near and part of Christ's return would be the formation of the true apostolic church. This distinction between Church Pietists and Radical Pietists is complicated because Pietism also emerged among Reformed Protestants who likewise manifested Church Pietists and Radical Pietists. The former French Jesuit Jean Labadie (1610–1674) is perhaps the best example of a Reformed Radical Pietist; his followers gave up on all outward ceremonies and focused on inner experience.

Locating the origin of Radical Pietism is difficult.[12] One contender is the circle formed in Frankfort in the 1670s by the layman Johann Jakob Schütz (1640–1690). They rejected the orthodox Lutheran Church and formed the Saalhof circle, named for the estate where they met. One of their members, Johanna Eleonora Petersen (1644–1724) wrote about her visions pointing toward God's universal restoration of creation. One vision of a father, mother, and son led her to see the Holy Spirit in feminine terms, the Heavenly Sophia. Reflecting the importance of Bible study within the conventicles, Petersen believed that every individual has a unique interpretative gift and therefore reading scripture in community was a dialogical process. The Saalhof circle was just one of many Radical Pietist groups. Some of them stressed inner transformation. Others were deeply invested in the impending return of Christ. Others held their communities to strict ethical standards. By 1700 there were roughly three different streams of Radical Pietists who, influenced by Boehme, tended toward mysticism. Gottfried Arnold (1666–1714), for example, wrote of the Heavenly Sophia and even encouraged celibacy. A second stream followed the lead of English Quakers, rejecting all outward ceremonies and sacraments. A third stream merged Pietism with older Anabaptist sensibilities. Groups in this stream, like the Schwarzenau Brethren led by Alexander Mack (1679–1735), practiced baptism by immersion, foot-washing, and the Love Feast, an early Christian fellowship meal.[13]

In addition to seeking a deeper affective piety, these different groups were also concerned that the church, in its drive to articulate confessional statements in the latter half of the sixteenth century, had lost something of earliest Christianity, that recurring theme in this study. Church Pietists like Spener and Franke, for example, extended the early Protestant conviction about reading the Biblical texts in their original languages (*ad fontes*) to lay people, both men and women. Spener even sent his daughter to learn biblical languages with Johanna Peterson. Among the Radical Pietists this primitivist conviction only intensified. Gottfried Arnold's *The First Love of Jesus* (1696) was a study of the first four centuries of Chris-

tianity and, going through multiple editions in the eighteenth century, it had a lasting effect on other Pietists. The book, which draws on early church Fathers, became a touchstone for different Radical Pietist groups as they debated the shape and content of Christian practices like the Love Feast and Baptism. The question was, how did the early Christians perform these rites and order their common life? For example, what was the mode of baptism: immersion or pouring water? once or three times? forward or backward? Both Church Pietists and Radical Pietists were hoping to imitate earliest and, from their perspective, authentic Christianity.

Arguably the most well-known group of Radical Pietists were the Moravians. As described in chapter 5, the fifteenth-century followers of Jan Hus had demanded that the chalice be administered to lay people at communion and advocated for the moral reform of the clergy. A split among this reforming movement refused reconciliation with the western Latin church and formed the *Unitas Fratrum*, the Bohemian Brethren. Harassed out of Bohemia, they came to live in Moravia in the late sixteenth century. By the eighteenth century what was left of them, then known as Moravians, found shelter on an estate in Saxony known as Herrnhut in 1722. They were welcomed by its owner, Count Nicholas Ludwig von Zinzendorf (1700–1760). Already influenced by pietism before his guest's arrival, Zinzendorf became something of a pastor to them, a role formally blocked to him in the Lutheran Church because of his nobility. Under Zinzendorf's leadership, the Moravians formed schools, a press, and a common house as Herrnhut drew Christians from different confessions. Divided into "choirs" according to gender, age, and marital status, these people hungered for a regimented life, one marked by hourly prayer, Bible study, and the other trademarks of pietism.

In 1736, however, the Herrnhut Moravians and Zinzendorf were harassed out of Saxony. They dispersed in a variety of directions, some for Pennsylvania in 1741. Under Zinzendorf's leadership, the Moravians were especially interested in ecumenism, in drawing together all Christians in one body formed not on a confession, but on practice and the new birth. In the middle colonies of North America, this approach would become a draw for German-speaking Christians of all stripes. Like Spener, Zinzendorf was concerned that doctrinal precision muted Christian life. The count, however, pushed farther, suggesting that doctrine could be an obstacle to faith. Focused on experience, Zinzendorf taught that the Christian moves from a spiritual place of distress through different phases of faith, ultimately to a place of maturity in which she shares Christ with others. The Moravians echoed the medieval world not only in their quasi-monastic common life, but also in their attachment to the blood of Christ. They had songs, litanies, and images focused on the side-wound of Christ, even how the Christian hides in the wound or is born out of the wound. Scholars have speculated that these images bear striking resemblance to a vagina, thus the new birth imagery.[14] One clings to

the wound of Christ and emerges a new person, reborn from him. See figure 12.1. The Moravians influenced still other groups, most notably the Wesley brothers. Before proceeding to them, we ought to examine the Roman Catholic scene.

Figure 12.1. Allegorical image of the side wound of Christ, ink and watercolor on paper. Moravian Archives Herrnhut, TS.Mp.375.4.

JANSENISM AND QUIETISM

Two movements, Jansenism and Quietism, emerged as serious challenges within Roman Catholicism in the seventeenth century, although both understood themselves (much like German Pietism initially) to be faithful to their forebears in the sixteenth century. And while Jansenism and Quietism were very different from each other, both movements emphasized the affections, sincerity, and experience. Cornelius Jansen (1585–1638) was on the faculty of Louvain and, for only a few months before his death, served as bishop of Ypres in Flanders. His most important work, *Augustinus*, was a study of Augustine's theology of grace; it was published posthumously in 1640. Over the next decade, the book found adherents in the Low Countries and France with a center in the Cistercian convent of Port-Royal-des-Champs near Paris. Often compared with Calvin, Jansen taught that fallen humanity is restored by grace, but a special grace is also needed to overcome, in effect, the irresistible drive to evil. That special grace, then, is only offered to God's elect. The key difference between Calvin and Jansen is that, for Jansen, faith alone is insufficient for justification. One must actively cooperate by performing good works. Likewise, Jansen's followers judged practices surrounding penance and admission to communion too relaxed. The penitent must, they insisted, demonstrate an agonized sincerity. In a later

generation, some Jansenists would forgo communion for years because they believed they were not prepared. And, as we might expect, this vision of serious Christianity was framed as a revival of the apostolic life.

Jansen's ideas found opponents just as quickly, particularly among Jesuits. The faculty of Louvain condemned five points in Jansen's writing in 1649, and Pope Innocent X (r. 1644–1655) declared those same points heretical in his bull *Cum Occassione* (1653). Critics claimed that Jansen taught that predestined humans cannot resist grace and that Christ died for the elect only (which seemed quite Calvinistic). A tactful response came from the Jansenist Antoine Arnauld (1612–1694): he recognized the pope's authority to pass judgment against such ideas but rejected that those ideas were actually in *Augustinus*. Notwithstanding, through the next century popes and councils consistently rejected Jansenists and their combination of a near-Calvinistic understanding of predestination with a rigorist approach to the Christian life. Highlights of this struggle include the schism of the bishop of Utrecht, thus forming an independent Jansenist church in the Netherlands, and the demolition of the convent of Port-Royal-des-Champs. At their worst, Jansenists appeared morally smug, constantly concerned with one's degree of penitence. They regularly divided the spiritual from the carnal both in practice and in persons. In the eighteenth century, some Jansenists had ecstatic experiences in the cemetery of Saint-Médard in Paris where a particularly austere deacon had been buried. People spoke in tongues and convulsed while women claimed to be priests. Some asked to be kicked, cut, or even crucified as signs of their penitence. At their better moments, though, their inner conformity to Christ manifested not as combativeness but as a humble awareness of unmerited adoption by God. We find that posture in the seventeenth-century philosopher Blaise Pascal (1623–1662).

Pascal took up the Jansenist cause against the Jesuits and, after his death, the sisters of Port-Royal-des-Champs published his notebooks as *Pensées* (Thoughts). Suffering, Pascal wrote, was part of Christ's Incarnation: within Christ, corrupt human nature is overwhelmed by the divine nature. Thus, Christ suffers not simply on the cross, but in his Incarnation. The elect share in this suffering, resulting in moral seriousness. But Pascal was also concerned about assurance. Philosophical knowledge leads to skepticism, he argued, but a conversion of the heart brings peace. By comparison, this was exactly the kind of testimony which many Pietist groups wanted to hear. Pascal recorded a powerful experience on November 23, 1654 in his poetic "memorial," a scrap of paper which he kept with him as a reminder. He notes that it happened from half-past ten at night to half-past midnight, and the single word "fire" leaps off the page. Pascal describes certitude and joy knowing that his God is the God of Abraham, Isaac, and Jacob, not of philosophers.[15]

Jansenism shows some of the same tendencies as Protestant movements of this period, especially an emphasis on living the Christian life

with seriousness and how that should spring from a converted heart. Quietism manifests some of the same preoccupations but with very different results. The Spanish priest Miguel de Molinos (1628–1697) began teaching in Rome in 1663 and, spiritually indebted to the Spanish mystical revival discussed in chapter 9, he published his *Spiritual Guide* in 1675. Focused on mystical prayer, the book is often judged orthodox. However, Molinos came under fire, particularly from Jesuits, for his teachings in other venues. The issue was his presentation of passivity, the claim that on reaching mystical union, all activity including the sacraments are obstacles. To reach that state, one should avoid ascetic works (here the difference with the Jansenists) and focus on being passive before God. It was claimed that Molinos also taught that the soul progresses from a devotion to the church to a devotion to Jesus who is merely a reflection of God but not God (clear heresy) to a pure contemplation of the divine—at which stage the soul has ascended above the church and Christ himself. Again, that was the accusation, but it was enough for the Roman Inquisition to target Molinos. He was jailed in 1685, yet, true to his commitment to passivity, did not deny the charges. Before Molinos died in jail in 1696, Pope Innocent XI refuted these teachings, now called Quietism, in his bull *Coelistis Pastor* (1687).

By then, however, Quietism had already gained traction in Spain, Italy, and France, and the two figures most associated with the movement after Molinos demonstrate how some elements of mysticism, especially variations of things taught by the Discalced Carmelites, could be reworked and popularized for a lay audience. Jeanne Marie Bouvier de la Mothe, better known by her married name Madame Guyon (1648–1717), was a wealthy French widow who, after her husband's death in 1676, committed herself to a quasi-religious life (though not joining any order). Influenced by de Sales' *Introduction to the Devout Life* and Molinos' *Spiritual Guide*, she began a teaching ministry with her spiritual director in 1681. In gushing bravado, she wrote about progressing through stages until reaching a point of complete abandonment to God, a summit in which God has sole control even of one's bodily movements. While this echoes Teresa of Avila's spiritual marriage, Madame Guyon believed that God was speaking through her. The archbishop of Paris condemned her teachings, and in 1695 a conference gathered at Issy near Paris to pass judgment. Though Guyon assented to their articles, she proved unable to keep the peace and was jailed later in life.

At Issy, Guyon was defended by the other major figure among the Quietists, Francois Fénelon (1651–1715). A bishop and former tutor of the grandson of King Louis XIV, Fénelon's respect for Madame Guyon as a teacher saved her reputation. His writings, especially his book *Maxims of the Saints* (1697), focused on the concept of "pure love." Paralleling the thought of Francis de Sales and Bernard of Clairvaux, Fénelon ranked human motivations for loving God: (1) for the benefits one might receive

in this life, (2) for benefits in the future, and, (3) the highest motivation of all, simply for God himself. Fénelon described a "resigned" person as one who loves God equally in joy and pain, but still retains his own personal desires. An "indifferent" person has reached such an advanced state that she has no preferences. As we might imagine, Francois Fénelon was no friend of that other Catholic "religion of the heart," Jansenism, whose interest was in works and activity. Both movements, however, were seeking something beyond the sixteenth-century settlement of Roman Catholicism, either drawing on a combination of Augustinianism and a moral rigor equal to that of the medieval cloisters on the one hand or, on the other, a mystical abandonment to God not terribly unlike Teresa of Avila and John of the Cross. Both movements wanted growth in the Christian life.[16]

PIETISM AND REVIVAL IN THE TRANSATLANTIC

The twentieth-century historian Sydney Ahlstrom once wrote that religion in early America is best understood as a group of people having a conversation and then in the middle of the conversation some of them wander into another room in the same house where the same conversation continues.[17] That image captures the explosion of religious phenomena on either side of the Atlantic in the eighteenth century, movements which include the reworkings of the Puritan and Laudian legacies, the ecumenical spirit of pietism, what is known as "the Great Awakening," and the Wesleys and Methodism. German settlers in the eighteenth century, for example, arrived in both the southern and middle colonies, but especially on the frontiers of Pennsylvania, a colony founded by the Quaker William Penn in 1681. While the Church of England was formally established as the "state church" in the southern colonies and the Congregationalist and Presbyterian churches had similar status in the New England colonies, Pennsylvania was meant to be a place of tolerance. The middle colonies became a mixing ground where different confessions—Lutheran, Reformed, varieties of Radical Pietists like the Moravians, and certainly Quakers—would meet and cross-fertilize. The common language was the religion of the heart.[18]

The Moravians had high aspirations, sending missionaries from Germany to plant "colonies" along the Atlantic seaboard. Those in Bethlehem, Pennsylvania (founded 1741) and Salem, North Carolina (founded 1766) are the most obvious. Orthodox Lutherans back in Europe fretted that German settlers would be lured into Moravian excess, and so in 1742 they sent Heinrich Muhlenberg (1711–1787) to provide more traditional church life.[19] Trained at Halle, Muhlenberg was himself a Pietist, but he was a Church Pietist more in the mold of Spener and he retained a commitment to Orthodox Lutheranism. In addition to the Moravians, dozens

of other Radical Pietist groups made their way to the middle colonies in the eighteenth century. One of the more curious examples is the Ephrata Cloister, a semi-monastic community. In the early 1720s, Conrad Beissel (1691–1768), a former baker newly arrived in Pennsylvania, spent time among the Schwarzenau Brethren who had also migrated to Germantown. Beissel, who had drunk deeply from a variety of Radical Pietist sources, including Boehme, emerged as a leader among the Brethren. His teaching about the superiority of celibacy and observing Sabbath rest caused a fissure, and he and many of his followers founded a new community in Lancaster County. By the 1730s, they had built monastic houses; some men and women accepted celibacy while others, the "householders," had families. They engaged choral singing, the Love-Feast, and practices like anointing and the ritual holy kiss of peace. They wore plain dress, fasted, and expected the imminent return of Christ. And, of course, they believed this is how the first Christians lived. While the Ephrata Cloister looked like a monastic double-house (including married third-orders), they also practiced a gnostic mysticism drawn from Boehme as well as alchemy. Although the eccentric Ephrata Cloister drew many converts, they were not persuaded by the ecumenical siren-song of the Moravians.[20]

THE GREAT AWAKENING

To the north, in New England, another set of voices emerged in the early eighteenth century and, unsurprisingly, issues of the heart were central. Likewise, there was overlap, verging on ecumenism, with other groups. Here though, the great emphasis was on preaching. This movement among the descendants of the old Puritans is generally known as "the Great Awakening." Those Puritans who had settled New England back in the seventeenth century had largely been separatists from the Church of England, especially Congregationalists, who could not tolerate the steady rise in ceremony in the established church at the hands of the Laudians. Most of these separatists had envisioned the formation of a "godly" community, a new Israel at last rightly reformed. Here again we find the language of primitivism. As discussed above, various Puritans in England had developed a "practical divinity" which included Bible study, journaling about sin and personal experiences of grace, and conferences with other "godly" Puritans about their progress. Because of their imperative to read scripture, Puritans in England and New England boasted the highest literacy rates in the early modern Transatlantic world. But by the beginning of the eighteenth century, the Congregationalist Church was losing its lock on New England society. With the revocation of the Massachusetts Bay Charter in 1684, one no longer had to be a member of the Congregationalist Church to hold public office. Quakers

and other radicals cropped up in previously homogenous New England. A younger generation hesitated to follow in their parents' footsteps, and the Puritan monopoly was fading.

In the early 1730s, however, the young pastor of the Congregationalist Church in Northampton, Massachusetts, Jonathan Edwards (1703–1758) ignited a revival in the Connecticut Valley. Earlier, as a student at Yale, Edwards had a powerful conversion experience, a feeling of God's presence while reading 1 Timothy 1:17, and he applied that emphasis on experience in his preaching, tapping into the affections of his congregation. The "Great Awakening" which then spread across New England had a great deal to do with homiletic oratory, the art of persuasive preaching. The older Puritans had advocated what was known as the "plain style," a careful explication of doctrine neither floral (as the Anglican high-churchmen preached) nor enthusiastic. The preachers of the Great Awakening, however, moved their audiences at an emotional level. People wept as passionate preachers spoke about the "new birth." Edwards' sermon "Sinners in the Hands of an Angry God" used vivid imagery of hell-fire to change not only minds but hearts. Having preached that sermon at his own church, he delivered it again at Enfield, Connecticut, but there, before he could get to Christ's mercy, Edwards was interrupted by wails and the cry, "What shall I do to be saved? O, I am going to hell!" And conversions abounded. Unfortunately, this kind of preaching backfired. Edwards wanted to check his converts' commitment using the elements of old-fashioned Puritan "practical divinity," but his congregation felt this was too much, dismissing him in 1750. He later became president of the new Presbyterian college at Princeton, New Jersey.[21]

Beginning with Edwards' revival, the Great Awakening spread throughout New England and down among Dutch Calvinists in New York and Presbyterians in New Jersey. Edwards' dismissal, reflecting the tension between passionate conversion experiences and traditional patterns of sanctification and ascetical practice, was not the only point of conflict in this movement. The revivalist preachers of the Great Awakening were often known as "New Lights," distinguishing them from "Old Lights," the more traditional Congregationalist, Dutch Calvinist, and Presbyterian clergy who eschewed revival. The Presbyterian New Light preacher Gilbert Tennent (1703–1764) decried the Old Lights as Pharisees whose ministries were untouched by the Holy Spirit.

After Edwards, the most important figure of the Great Awakening was also a transatlantic figure, George Whitfield (1714–1770). Whitfield had a conversion experience while at Oxford in the 1730s and was ordained in the Church of England. By the 1740s, he took to open-air preaching, drawing crowds of hundreds. He was interested in the poor, especially marginalized coal miners near Bristol, as well as those aristocrats who would listen to him. The Countess of Huntingdon helped with the latter, building fashionable preaching chapels for itinerant preachers.

Religions of the Heart

With a message of repentance and faith, Whitfield was famed for his theatrics; supposedly he could make his audience cry by how he pronounced the word "Mesopotamia." He made several trips to America, there meeting both Edwards and Tennent. The Congregationalist Edwards invited the Anglican Whitefield to preach at his Northampton Church in 1740; Edwards himself was moved to tears. While Whitefield spoke to the heart and provoked conversions, he was a firm Calvinist, believing that Christ died only for the elect, a teaching which (as we will see) provoked division within the larger English-speaking revival movement.

BLENDING MOVEMENTS: METHODISM

The streams of belief and practice that ran into John Wesley were incredibly diverse, but the best way to understand his movement, the Methodists, is as a combination of the pietistic sensibilities of the Moravians, on the one hand, and the legacy of the old high-church Laudians, especially the moralist voices among them like Jeremy Taylor, on the other hand. Moreover, this cross-pollination happened within the fertile ground of revivalism on both sides of the Atlantic, soil tilled by Whitefield among others. We begin with Wesley's Anglican formation, winding back to a series of High-churchmen who suffered for the sake of conscience. In 1688, the Dutch prince William of Orange invaded England to oust King James II, a member of the royal house of Stuart. William was married to James' daughter Mary and his revolution was both welcomed by parliament and effectively "bloodless." However, several clerics, mostly high-churchmen, rejected the joint rule of William and Mary, insisting that they had taken vows to support James II as the legitimate monarch. Among them were nine bishops, including William Sancroft, the archbishop of Canterbury. These hold-outs were known as non-jurors.

The situation repeated itself a generation later. William and Mary were succeeded in 1702 by Queen Anne, also a daughter of James II. On Anne's death in 1714, the crown passed to a German cousin, George I of Hanover. But there was still a living member of the house of Stuart and a new crop of non-jurors emerged who felt conscience-bound to support that older dynasty, even at the risk of losing their livelihoods. Among them was William Law (1686–1761). In 1714, Law was expelled from his position at Cambridge University because he was unwilling to swear allegiance to George I. Bound up in Law's thinking and that of those earlier non-jurors was their conception of the primitive church as a body led by the apostles and actively seeking holiness. Leaving Cambridge, Law took up parish ministry in the Northamptonshire village of King's Cliffe. There he lived a devout life, founding schools and almshouses,

and teaching people about the virtues of temperance, humility, and self-denial.

Law was interested in corporate worship as an expression of inner commitment rather than just public duty. In his *A Serious Call to a Devout and Holy Life* (1728), he stressed the heart's orientation toward God in all actions. While God is merciful, he wrote, the aspiring Christian must at least have the intention not to sin in her heart. Law was emphatic that prayer must be joined with works; otherwise prayer is only "lip labor." This echoes the General Thanksgiving, a prayer added to the Book of Common Prayer in 1662 which implores God, "that we shew forth thy praise not only with our lips, but in our lives; by giving up ourselves to thy service and walking before thee in holiness and righteousness all the days of our life."[22] While Law sat lightly on forensic understandings of the atonement in which Christ's righteousness is imputed to sinners (preferring to talk about Christ being born within us), what connected him with the English-speaking revivalists was his morally rigorous standards for Christian responsibility and his focus on the heart's desire.[23]

A generation younger than Law but near-contemporaries of Edwards, Whitefield, and Zinzendorf, the Wesley brothers were the sons of an Anglican clergyman in Lincolnshire. By 1726, John Wesley (1703–1791) was ordained and elected a fellow of Lincoln College, Oxford. Around the same time, his younger brother Charles Wesley (1707–1788) matriculated at the university, and they formed a small devotional group. They were committed to Bible study and reading texts like Kempis' *Imitatio Christi*, Law's *Serious Call*, and Taylor's *Holy Living* and *Holy Dying*. And they offered mutual support in ascetical practices like fasting and regular reception of the Eucharist every Sunday. This was the "Holy Club," derisively called the Methodists, and it included the young George Whitefield. In 1735, the Wesley brothers were supported by the new Society for the Propagation of the Gospel in their missionary work in the colony of Georgia. Sailing to the colony, they were fascinated by a group of Moravians also on board their ship. In classic pietist fashion, one asked John if he had experienced new birth. When he returned to England, after bungling leadership of the Anglican parish in Savannah, John had a famous conversion experience. He went to a gathering of Moravians at Aldersgate Street in London on the evening of May 24, 1738. During a reading from Luther's Preface to Romans, Wesley experienced a "strange warming of the heart," a sense that Christ saved him from his sins.

In that same year, Wesley went to Herrnhut to learn more; and on returning to England, he set about organizing small groups, pietist conventicles. The Methodist "band-societies" were stratified: some were for newcomers, some for backsliders, still others for the advanced. Each was committed to mutual support in prayer, Bible study, good works, and an evaluation of progress. Wesley also published reading material for them, drawing from an incredible range of writers; his *The Christian Library* is a

digest of Christian ascetical theology, especially voices from the early church. An important element of Wesley's agenda was his conception of primitive Christianity. While Wesley was at Oxford, there was a resurgence of patristic scholarship and, as a result, he studied many early Christian texts, both Nicene and Pre-Nicene. Moreover, Wesley inherited not only the moralism of the non-jurors, but their distinctly high church ecclesiology based on a vision of early apostolic Christianity. Recent scholarship has highlighted how traditional accounts of Wesley's movement often overlook his Anglican, even non-juror context as the source for his primitive sensibilities, and some historians have worked in earnest to right our vision. Geordan Hammond, for example, has argued that we can find this primitivism, an important element of Wesley's movement, before his Aldersgate experience. Hammond interprets Wesley's mission to Georgia as an intentional attempt to restore the primitive church in the primitive wilderness.[24]

The band-societies, however, who gathered to live out Wesley's vision of primitive Christianity were not new churches, but parachurch groups. Wesley wanted his Methodists to keep participating fully in their local Anglican parish churches, including paying their tithe and receiving communion. That said, many Anglican clerics felt that the Methodists were wild enthusiasts and when the wandering Wesley came to town, the local vicar often greeted him with chill rebuff. Encouraged by his friend George Whitefield who traveled the country preaching revival, Wesley reluctantly took up preaching outdoors himself. Like earlier pietists, the Methodists utilized singing, and their hymns followed the pietist pattern, deploying emotionally charged imagery and language about personal experience. Wesley, who published a hymnbook for the societies, would often begin his outdoor preaching by singing to draw a crowd. Charles Wesley wrote more than 6,000 hymns and some of these are the best known in English-speaking Protestant churches to this day, including "O for a Thousand Tongues to Sing" and "Love Divine, All Loves Excelling."[25]

John Wesley, though, could be pugnacious in disagreement. He had a falling out with the Moravians over their "stillness" and passivity; they felt the need to wait on God whereas Wesley wanted to see action. While he stressed that God's grace initiates the process of salvation and ultimately brings a person to perfection, Wesley believed that the individual cooperates. Choices must be made, and Methodists came to be passionate about actively seeking holiness. When one comes to Holy Communion, for example, she participates in Christ; she dwells in Christ, and Christ dwells in her. Here Wesley was drawing from those old high-church moralists who emphasized the Christian's duty. For this reason, he has been labeled, perhaps inaccurately, as encouraging "works righteousness," a path to salvation not entirely caused by God. Wesley's most enigmatic idea was his belief that one could reach perfection in this life,

something he never claimed for himself. These issues—human cooperation and the attainability of perfection—brought Wesley into conflict with his Calvinist friend Whitefield by the end of the 1740s. On the subject of human cooperation, Wesley has come to be identified with the theology of the early seventeenth-century Dutch theologian Jacob Arminius (1560–1609) who had, to the horror of Calvinists, taught that man's free will plays a role in salvation. Thus, Methodists are often described as "Arminian" in theology. Whitefield and Wesley tussled through phases of mutual affection followed by mutual castigation.[26]

In both Britain and the new world, Methodist preachers were to be itinerates, focused on bringing about conversions but directing their listeners to the local Anglican vicar. And, as a parachurch movement, often domestic in manifestation, we should not be surprised how central women were in Methodism. Wesley even felt that women were more likely to respond to his message of the heart, something that delighted his detractors who defamed Methodists as giddy and fickle.[27] The effective breaking point with Anglicanism, though, came before Wesley's death. Wesley tried, in earnest, to persuade Church of England bishops to ordain Methodist preachers, especially for ministry in America. The bishops regularly refused, often citing the Methodist preachers' lack of education and their wandering lifestyle. Wesley wrote tersely to the bishop of London that he had seen fit to ordain and send to America men who knew some Greek and Latin "but who knew no more of saving souls than of catching whales."[28] Deeply frustrated, Wesley came to be persuaded that bishops and presbyters are of the same rank, yet another element of Wesley conceptualizing the early church. Wesley therefore held that it was within his right to ordain other presbyters in time of necessity. Believing that Christians were spiritually starving in the new world, Wesley consecrated Thomas Coke (1747–1814) to go to the new United States as a Methodist superintendent in 1784 (Coke later adopted the title bishop). This consecration, and Coke's subsequent consecration of another Methodist bishop, Francis Asbury (1745–1816), were within just a few years of the consecration of Samuel Seabury (1729–1796) by Scots bishops as the first bishop for American Anglicans coalescing as the fledgling Episcopal Church. By then a separation between Methodists and Anglicans was clear in the United States. In Britain, the fracture happened in 1795. Methodists on both sides of the Atlantic came to be known for their horse-riding preachers and outdoor revivals, the experience of the "second blessing" of perfection, and of course singing, which touched the heart.[29]

THE ONE THING MISSING

"Take my heart and let it be forever closed to all but thee," wrote the Methodist hymn-writer Isabella Wilson (1765–1807). Her words capture

the aspirations of the different groups explored in this chapter. Like so many pietistic voices before him, Wesley believed that preachers must tell people that real faith leads to holiness of life and practice. For Puritans and Laudians, for Church Pietists and Radical Pnietists, for Jansenists and Quietists, for New Lights and Methodists, the sixteenth-century reformations seemed to lack something—the heart. Some of these groups were willing to form new church bodies, just as had been done in the sixteenth century. Others wished to renew the legacy of earlier reformers. And certainly, the rhetoric of primitivism, a conceptualizing of the early church, was a prominent factor. Whether they formed new churches or worked for renewal within older bodies, these women and men were reformers themselves, crafting new ways to practice Christianity. As Charles Wesley sang, their hearts' desire was to be "lost in wonder, love, and praise."

NOTES

1. Ted Campbell, *The Religion of the Heart: A Study of European Religious Life in the Seventeenth and Eighteenth Centuries* (Columbia, SC: University of South Carolina Press, 1991).
2. Theodore Dwight Bozeman, *The Precisianist Strain: Disciplinary Religion and Antinomian Backlash in Puritanism to 1638* (Chapel Hill, NC: University of North Carolina Press, 2004), 169–86; Patrick Collinson, *Richard Bancroft and Elizabethan Anti-Puritanism* (Cambridge: Cambridge University Press, 2013); Alec Ryrie, *Being Protestant in Reformation Britain* (Oxford: Oxford University Press, 2013); Carl Trueman, "Lewis Bayly (d. 1631) and Richard Baxter (1615–1691)," in *The Pietist Theologians* ed. Carter Lindberg (Oxford: Blackwell, 2005), 52–67.
3. Kenneth Fincham and Nicholas Tyacke, *Altars Restored: The Changing Face of English Religious Worship, 1547–c. 1700* (Oxford: Oxford University Press, 2007), 176–273; Peter Lake, "The Laudian Style: Order, Uniformity, and the Pursuit of the Beauty of Holiness in the 1630s," in *The Early Stuart Church, 1603–1642* ed. Kenneth Fincham (Stanford: Stanford University Press, 1993), 161–85; Thomas Carroll, ed., *Jeremy Taylor: Selected Works* (New York: Paulist, 1990).
4. Francis White, *A Treatise of the Sabbath Day* (London: 1635), 99–103; Calvin Lane, *The Laudians and the Elizabethan Church: History, Conformity, and Religious Identity in Post-Reformation England* (London: Pickering & Chatto, 2013).
5. David Como, *Blown by the Spirit: Puritanism and the Emergence of an Antinomian Underground in Pre-Civil War England* (Stanford: Stanford University Press, 2004); Christopher Durston and Judith Maltby, eds., *Religion in Revolutionary England* (Manchester: Manchester University Press, 2006); Douglas Jones, "Debating the Literal Sense in England: The Scripture-Learned and the Family of Love," *Sixteenth Century Journal* 45 (2014), 897–920; Pink Dandelion, *An Introduction to Quakerism* (Cambridge: Cambridge University Press, 2007), 11–79; John Spurr, *The Restoration Church of England, 1646–1689* (New Haven: Yale University Press, 1991).
6. Robert Kolb and James Nestingen, eds., *Sources and Contexts of the Book of Concord* (Minneapolis, MN: Augsburg Fortress, 2001).
7. Johannes Wallman, "Johan Arndt (1555–1621)" in Lindberg, ed., *Pietist Theologians*, 21–37; Peter Erb, ed., *Pietists: Selected Writings* (New York: Paulist, 1983).
8. Douglas Shantz, *An Introduction to German Pietism: Protestant Renewal at the Dawn of Modern Europe* (Baltimore: Johns Hopkins University Press, 2013), 1–67.

9. Denise Kettering-Lane, "Philip Spener and the Role of Women in the Church: The Spiritual Priesthood of All Believers in German Pietism," *Covenant Quarterly* 75.1 (2017), 50–69.

10. Erb, 29–96; Shantz, 71–116; James Stein, "Philip Jakob Spener (1635–1705)" in Lindberg, ed., *Pietist Theologians*, 84–99; Campbell, 79–91.

11. Shantz, 117–43; Erb, 97–215.

12. Albert Outler, "Pietism and Enlightenment: Alternatives to Tradition" in *Christian Spirituality: Post-Reformation and Modern* ed. Louis Dupré and Don Saliers (New York: Crossroad, 1991), 240–56; Peter Yoder, "Rendered "Odious" as Pietists: Anton Wilhelm Böhme's Conception of Pietism and the possibilities of Prototype Theory" in *The Pietist Impulse in Christianity*, ed. Christian Winn, Christopher Gehrz, William Carlson, and Eric Holst (Eugene, OR: Pickwick, 2011), 17–26.

13. Han Schneider, *German Radical Pietism* (Lanham, MD: Scarecrow, 2007); Markus Mathias "Pietism and Protestant Orthodoxy" and Astrid von Schlachta, "Anabaptists and Pietists: Influences, Contacts, and Relations" in *A Companion to German Pietism, 1660–1800*, ed. Douglas Shantz (Leiden: Brill, 2015), 17–49, 116–38.

14. Campbell, 91–98; Craig Atwood, *Community of the Cross: Moravians Piety in Colonial Bethlehem* (University Park: Pennsylvania State University Press, 2004); Aaron Fogelman, *Jesus is Female: Moravians and Radical Religion in Early America* (Philadelphia: University of Pennsylvania Press, 2008).

15. Campbell, 18–29; Louis Dupré, "Jansenism and Quietism" in Dupré and Saliers, eds., *Christian Spirituality*, 121–30; Blaise Pascal, *Pensées* (New York: Penguin, 1966).

16. McGinn, *Essential Writings of Mysticism*, 501–17; Campbell, 29–36; Dupré, 133–41; Robert Edmonson and Hal Helms, eds., *The Complete Fénelon* (Brewster, MA: Paraclete, 2008).

17. Sydney Ahlstrom, *Theology in America: The Major Protestant Voices from Puritanism to Neo-Orthodoxy* (Indianapolis: Bobbs-Merill, 1967).

18. Jonathan Strom, Hartmut Lehmann, and James Melton, eds.t, *Pietism in Germany and North America, 1680–1820* (Burlington, VT: Ashgate, 2009), especially Hartmut Lehmann, "Pietism in the World of Transatlantic Religious Revivals," 13–21.

19. Craig Atwood, *Community of the Cross: Moravians Piety in Colonial Bethlehem* (University Park: Pennsylvania State University Press, 2004); Randall Balmer, *A Perfect Babel of Confusion: Dutch Religion and English Culture in the Middle Colonies* (Oxford: Oxford University Press, 1989); Stephen Longenecker, *Piety and Tolerance: Pennsylvania German Religion, 1700–1850* (Lanham, MD: Scarecrow, 1994).

20. Jeff Bach, *Voices of the Turtledoves: The Sacred World of Ephrata* (University Park, PA; Pennsylvania State University Press, 2003); Bethany Wiggin, "Sister Marcella, Marie Christine Sauer (d. 1752), and the Chronicle of the Sisters of Ephrata" in *Mysticism and Reform, 1400–1750*, ed. Sara Poor and Nigel Smith (Notre Dame: University of Notre Dame Press, 2015), 295–320.

21. George Marsden, *Jonathan Edwards: A Life* (New Haven: Yale University Press, 2003); Kenneth Minkema, "Jonathan Edwards: A Theological Life," in *The Princeton Companion to Jonathan Edwards* ed. Sang Hyun Lee (Princeton: Princeton University Press, 2005), 1–15.

22. Brian Cummings, ed., *The Book of Common Prayer: The Texts of 1549, 1559, and 1662* (Oxford: Oxford University Press, 2011), 260.

23. Paul Stanwood, ed., *William Law, A Serious Call to a Devout and Holy Life and The Spirit of Love* (New York: Paulist, 1978), especially the introduction by Austin Warren, "William Law: Ascetic and Mystic," 11–32.

24. Geordan Hammond, *John Wesley in America; Restoring Primitive Christianity* (Oxford: Oxford University Press, 2014); Ryan Danker, *Wesley and the Anglicans: Political Division in Early Evangelicalism* (Downers Grove, IL: IVP, 2016).

25. David Trickett, "Spiritual Vision and Discipline in the Early Wesleyan Movement" in Dupré and Saliers, eds., *Christian Spirituality*, 354–71.

26. Campbell, 115–29.

27. Paul Chilcote, ed., *Early Methodist Spirituality: Selected Women's Writings* (Nashville: Abingdon, 2007).

28. Richard Heitzenrater, *Wesley and the People called Methodists* (Nashville: Abingdon, 1995), 305–8.

29. Danker, 211–40; Randy Maddox, *Responsible Grace: John Wesley's Practical Theology* (Nashville: Abingdon, 1994); David Hempton, "John Wesley (1703–1791)" in Lindberg, ed., *Pietist Theologians*, 256–71.

Epilogue

Post Tenebras Lux?

To tell this story, the old border-walls of periodization have been pulled down. There was a time when one began a history of "The Reformation" with a short chapter about "forerunners," people who laid the groundwork for the main event, invariably Martin Luther. Wycliffe and Hus served as the overture for Act 1, "Luther nails the Ninety-Five Theses." That kind of narrative not only muzzled Hus and Wycliffe as reformers in their own right, often highlighting what they had in common with Luther and passing over their dissimilarities (e.g., Wycliffe's emphasis on moral rectitude), but also missed entirely a steady stream of reform movements stretching back for centuries all the way to the so-called Gregorian Reform. In recent years, historians have been increasingly careful to see sixteenth-century reform movements within the context of a Latin Christianity which century by century experienced reform movements. And while these movements were quite diverse, many of them shared a familiar primitivism, a call for a return to apostolic purity, the *vita apostolica*: the Gregorian Reform and the Benedictine revival at the start of the millennium, the new orders of the twelfth century (most notably the Cistercians, Carthusians, and Canons Regular), the mendicants of the thirteenth century, varieties of mystics, the Beguines and Beghards, the Modern Devout, the Wycliffites and Hussites, Concilliarists, and Humanists. These were legitimate reform movements, challenging their contemporaries to return to what they believed to be apostolic patterns of authentic Christian belief and practice. As such, the language of "reformatio" and "renovatio" was exceedingly familiar by the start of the sixteenth century and no novelty. The pervasive sense, long before Luther, was that corruption and degradation would be overcome through a return to primitive teaching and life, much of which was located in an engagement with scripture.[1]

One could argue that what made sixteenth-century reform movements different from earlier movements was the inability of the western church to find a way to contain them within the existing structures as it had with the Franciscans for example. The argument might run that each of the above-mentioned medieval reform movements found a place within the church led by the pope. However, that explanation misses again how those medieval reform movements—even the more acceptable

ones—caused Western Christianity itself to change. The church did not simply quarantine Francis of Assisi, his "little brothers," and their commitment to evangelical poverty. While his movement may have been domesticated and his potential for radicalism softened, the life of the church changed because of the Franciscan witness. And sixteenth-century reform movements (whether Magisterial, Anabaptist, or Catholic) did the same thing: Christianity in the west, including the papacy, was changed (quite literally, reformed) by these movements.

Another possible explanation for what exactly made sixteenth-century reform movements different is that, in a winding and perhaps indirect way, they birthed the pluralism so common in western countries to this day. This is where the period border on the other side of the sixteenth century should also come down: the stream of reform movements did not conclude with Luther, Calvin, or the Council of Trent, but rather flowed into the seventeenth and eighteenth centuries and crossed the Atlantic to boot. By the eighteenth century, Christians in many places were exhausted with coercive attempts, including war and forced conversions, to create uniformity. Instead they begrudgingly consented to live with measured degrees of tolerance—certainly not the tolerance many of us experience in the west today, but the building blocks were in sight. This is not to celebrate the inevitable birth of "modernity" with the Enlightenment as the climax. Indeed it should be admitted here in the epilogue, perhaps parenthetically, that this book has not treated those religious movements associated with the Enlightenment, most obviously Deism. But certainly, we could establish the recurring thread of primitivism among them too. Consider for example Thomas Jefferson's heavily redacted Bible; Jefferson removed all the miraculous bits to produce a Jesus who was a moral teacher. This was an attempt to find a Christianity behind Christianity, exemplifying perhaps the very summit of the primitivist impulse. Others wrote about Christianity being "as old as the creation" and worked to show the "reasonableness" of its moral outlines.[2]

To return, however, to those Christians exhausted with religious conflict, Brad Gregory has argued in a recent and not uncontroversial book that a transatlantic world facing profound religious diversity began to assume that major "life questions" could not be resolved and therefore pushed those questions to the margins. Over time, this marginalizing made the questions themselves almost irrelevant to large swathes of the western populace. Answers became matters of private opinion, leading to secularism and even the contemporary consumer culture—a world in which we insatiably seek out more and better "stuff." The Dutch, Gregory argues, privatized what we today call "religion" because to do so was good for business. Put differently, they quit killing each other over religion and went shopping instead. By the eighteenth century, "religion" was construed as a matter of private, individual, internal beliefs, something critically separable and ultimately separated from the rest of public life,

the sphere which the state then adroitly managed. This was true in largely Protestant nations like the nascent United States of America whose 1789 constitution envisions religious liberty along decidedly private lines. It was also true in largely Catholic nations whose civil leaders strong-armed the pope to suppress the transnational Jesuits in 1773. Can we argue, as Gregory does, that pluralism and secularism were the long-term, unintended consequences of the sixteenth-century reformations? Perhaps. But we might nuance that intriguing thesis by taking Constantine Fasolt's suggestion to widen our view. Perhaps reform movements beginning in the eleventh century led the way, along a winding path, to a pluriform religious landscape, a journey which began long before the sixteenth-century reformers. The outcome might be the same, but the responsibility is spread a bit more widely.[3]

To be sure there is much to distinguish sixteenth-century reform movements. One obvious example is the speed of religious change via new technology, the printing press. But in general, those period borders have done a disservice by falsely bracketing the "medieval" from the "Reformation." And they have served confessional aims. Those older presentations of "The Reformation" which began with a distortive overture of Wycliffe and Hus, were also interested in telling the story of a mythically monolithic "Protestantism," a tidy phenomenon which heralded the triumph of modernity over the dark superstitions of the equally monolithic "Middle Ages." It cannot be forgotten that people in the sixteenth century were engaged in writing history and they viewed themselves as birthing a new era, thus they fashioned terms like "Renaissance" and "Middle Ages." But they often did this for ideological even polemical purposes. Far from "objective," such histories were part of reform projects.[4] While I have used some of their phrases (e.g., middle ages), this study has worked in earnest to show how plastic and contrived such presentations often are. Such artificial period borders are easy (especially when it comes to scheduling college classes and publishing textbooks), but they perpetuate false boundaries, imaginary lines crafted for agendas.

Among those sixteenth-century writers who penned works of history for polemical/confessional purposes, "The Reformation" usually meant one of the magisterial movements, either Lutheran or Reformed. Anabaptists were painted on the margins as not true reformers but perverters of the real Reformation. And Catholics were presented as reactionary, perhaps simply perpetuating medieval superstitions. Consider here the nineteenth-century German historian Leopold von Ranke's term "Counter-Reformation" which characterized Catholicism in the sixteenth century as merely conservative opposition to Protestantism's real Reformation. Likewise, in the instances where such older presentations of "The Reformation" did not simply conclude in the 1550s or 1580s but went forward to the pietistic movements of the seventeenth and eighteenth centuries,

they did so largely to lament such groups as degraded forms of real or "classical" Protestantism. In all these cases, Luther (or perhaps Calvin) stands at the conceptual center bringing light and scattering darkness; everything either built toward or receded away from that center. Since the middle of the twentieth century, however, that kind of narrative has been recognized for its slanted perspective and how it serves the theological ends of certain Protestant churches, even to the extent of papering over significant nuances among the magisterial reformers, most notably perhaps forgetting that Luther would have considered today's pluralistic landscape of competing "denominations" a dismal failure of his efforts to reform the one church. As a result, this study has striven to recognize the plurality of reform movements before, during, and after the sixteenth century.[5] Not only have we discussed wave after wave of reform movements beginning in the eleventh century in this study, the discussion of what happened specifically in the sixteenth century has appeared as "sixteenth-century reformations" rather than "The Reformation." And while Luther and Calvin have appeared prominently in this book, they are not the conceptual center.

Finally, this study has also operated with two other related premises about how to approach religion. First, practice and belief are never isolated from one another. Moreover, practices are never the simple instantiation of an idea. Instead, there is a dynamic back and forth with practice informing belief and vice versa. Second, this study has tried to show that religious change was (and is) a messy business. Reform rarely meant moving from one tidy package of ideas and practices to another. Likewise, most people were neither passive recipients of religious change nor completely resistant. Being a Cistercian or a Lutheran was more than simply declaring adherence to a set of ideas. It was about being formed in a community where those ideas were one of several critical elements. In other words, reform is complicated because people are complicated and they have multiple motivations (possibly contradictory) for not only accepting a religious identity but also contributing to the ongoing fashioning of what it means to hold that identity.[6] In contemporary terms, Americans choose a church (if they desire one) for a combination of factors and not infrequently in spite of still other factors: the leadership, the worship, the music, the community, opportunities for their children, affiliations they inherited from parents or grandparents (with emotional attachments), advocacy for social justice or social conservatism, and for some lingering socio-political status if they live in the south or the midwest. That list must include adherence to theological propositions, but theology is certainly not the solitary item. While the factors were different in the centuries examined in this book, the situation was no less complicated. This is not in the least to downplay theology or intellectual history. Quite a lot of this book has tried to understand theology. But we

must recognize (again) the messiness of religious life and especially religious change. Thus, reform and spirituality have been studied together.

This book has appeared on the heels of the five hundredth anniversary of an Augustinian Friar and professor of scripture at an obscure German university offering ninety-five points (in Latin) for debate among theologians. While Luther's important doctrine of justification by faith was brewing in the background, the Ninety-Five Theses were written in response to a practice, the selling of indulgences to achieve release from purgatory and, perhaps more tangibly, to build something new in Rome, the monumental St. Peter's Basilica. And even for a text written for theological debate, the Theses conclude with issues of pastoral care — what is to be said, Luther asks, to laity who raise shrewd questions about seemingly indefensible practices. While this may be savvy rhetoric, theses eighty-one to ninety are nevertheless some of the most poignant lines of the entire text. There is talk of money and poverty, the nature of sacred space, the Eucharist, prayer, blessings, sin, death, judgment, the afterlife, and the ordering of the church's leadership and the common life of its people. This is the stuff not only of Martin Luther but of all the reform movements under investigation in this book, and the built-in solution was the same too: a return to apostolic purity and evangelical practice. That, however, is certainly not to say that all of these reform movements shared the same vision of the apostolic life. This book has tried in earnest to highlight their diversity: the antipathy to figurative art among Cistercians and Calvinists, the affective attachment to the suffering Christ among Franciscans and Moravians, the logo-centricism of most Magisterial Protestants, and the practical spirituality of the Modern Devout are but a few examples. Yet each movement rooted its characteristic practice — their spirituality — in a conceived recovery of the apostolic life. And each shared a familiar vision of a present darkness being scattered by a hopeful revival of an imagined primitive past. The motto of Calvin's Geneva then may capture the sensibilities, hopes, and dreams of all the reform movements we have encountered: *Post tenebras lux*, after darkness comes light.

NOTES

1. Gerald Strauss, "Ideas of *Reformatio* and *Renovatio* from the Middle Ages to the Reformation," in Thomas Brady, Jr., Heiko Oberman, and James Tracy, eds., *Handbook of European History, 1400–1600, Volume 2: Vision, Programs, and Outcomes* (Leiden: Brill, 1995), 1–30.

2. Matthew Tindale, *Christianity as Old as the Creation* (London: 1730).

3. Brad Gregory, *The Unintended Reformation: How a Religious Revolution Secularized Society* (Cambridge, MA: Harvard University Press, 2012); Constantine Fasolt, "Hegel's Ghost: Europe, the Reformation, and the Middle Ages," *Viator* 39 (2008), 345–86; Caroline Walker Bynum, *Christian Materiality: An Essay on Religion in Late Medieval Europe* (Brooklyn: Zone Books, 2011). See also Lee Wandel, *The Reformation: Towards a*

New History (Cambridge: Cambridge University Press, 2011); Jeffrey Burson and Jonathan Wright, eds., *The Jesuit Suppression in Global Context* (Cambridge: Cambridge University Press, 2015).

4. Peter Marshall, *1517: Martin Luther and the Invention of the Reformation* (Oxford: Oxford University Press, 2017); Bruce Gordon, ed., *Protestant History and Identity in Sixteenth Century Europe* (Aldershot: Ashgate, 1996), 2 Vols.

5. James Tracy, *Europe's Reformations, 1450–1650: Doctrines, Politics, and Community* (Lanham, MD: Rowman & Littlefield, 2006); Diarmaid MacCulloch, *Reformation: Europe's House Divided, 1490–1700* (New York: Viking, 2003); Carlos Eire, *Reformations: The Early Modern World, 1450–1650* (New Haven: Yale University Press, 2016); Eamon Duffy, *Reformation Divided: Catholics, Protestants and the Conversion of England* (London: Bloomsbury, 2017).

6. Ethan Shagan, *Popular Politics and the English Reformation* (Cambridge: Cambridge University Press, 2003), 1–27.

Appendix 1

Timeline

910: Founding of the Abbey at Cluny
1054: Great Schism dividing West and East
1059: Berengar of Tours swears *Ego Berangarius*
1066: Norman Conquest of England
1073–1085: Papacy of Gregory VII
1084: Founding of the Grand Chartreuse near Grenoble (Carthusians)
1098: Founding of the Cistercians at Citeaux
1108: Formation of the Abbey of Canons Regular of St. Victor in Paris
1135–1153: Bernard of Clairvaux preaches sermons on Song of Songs
c. 1150: Peter Lombard, *Sentences*
1209: Innocent III, according to tradition, verbally approved Franciscan's proposal for life
1215: Fourth Lateran Council declares change in Eucharistic elements
1216: Honorius III approves Dominican Order (bull *Religiosam vitam*)
1252: Innocent IV allows torture in some circumstances in heresy trials (bull *Ad Extirpanda*)
1264: Urban IV declares Corpus Christi a universal feast (bull *Transiturus*)
1265–1274: Thomas Aquinas, *Summa Theologica*
1272: Mechthild of Magdeburg, *Flowing Light of the Godhead*
1300: Boniface VIII proclaims first Jubilee, offering plenary indulgence for all pilgrims to Rome (bull *Antiquorum habet fida relation*)
1302: Boniface VIII declares salvation depends on submission to papacy (bull *Unam Sanctam*)
1303: Meister Eckhart is made provincial superior for Dominicans in Saxony
1309–1376: Avignon Papacy
1311–1312: Council of Vienne condemns Heresy of the Free Spirit, restricts Beguines
1346–1353: Black Death (Bubonic Plague)
1329: John XXII declares some of Eckart's writings heretical but clears Eckhart personally (bull *In agro dominico*)
1376: Catherine of Sienna influences Gregory XI to return papacy to Rome
1378–1417: Great Western Schism (multiple popes)

c. 1380: Formation of the Brethren of the Common Life
1381: Peasants' Revolt in England
1413: Margery Kempe sets out on pilgrimage to the Holy Land
1415: Council of Constance resolves the Great Western Schism, burns Jan Hus, declares Wycliffe a heretic (postmortem), declares primacy of councils
c. 1418–c. 1427: Thomas Kempis, *Imitatio Christi*
1431: Council of Basel permits Bohemian Utraquists to give chalice to laity
1469: Pius II condemns conciliarism (bull *Execrabilis*)
1472: Dante Alighieri, *The Divine Comedy*
1492: Ferdinand & Isabella financially back Columbus, eject Muslims and Jews from Spain
1493: Alexander VI grants much of the "new world" to Ferdinand and Isabella (bull *Inter Caetera*)
1508–1512: Michelangelo Buonarotti, Sistine Chapel ceiling
1516: Desiderius Erasmus publishes Greek New Testament with Latin Translation
1517: Martin Luther, *95 Theses*
1520: Leo X censures Luther (bull *Exsurge Domine*); excommunicates Luther next year (bull *Decet Romanum pontificem*)
1521: Hernán Cortés conquers Tenochtitlan (renamed Mexico City)
1524: Ignatius of Loyola, *Spiritual Exercises*
1525: Peasants' War in Germany
1527: Felix Manz executed for Anabaptism by Reformed in Zurich
1529: Marburg Colloquy: Luther and Ulrich Zwingli deadlocked over Eucharist
1530: Augsburg Confession of the Lutheran Princes
1534: Act of Supremacy; Henry VIII is head of the Church of England
1540: Paul III approves Jesuits (bull *Regimini militantis Ecclesia*)
1545–1563: Council of Trent; new universal missal; seminaries to be in every diocese; more preaching; stricter rules for enclosing nuns
1549: First edition Thomas Cranmer, Book of Common Prayer
1549: Reformed Swiss Agreement on Eucharist
1552: Jesuit Francis Xavier dies in China after missionary work in India and Japan
1555: First Mexican Church Council
1555: Charles V declares Peace of Augsburg ("whose prince, his religion")
1559: Final edition John Calvin, *Institutes of the Christian Religion*
1563: Heidelberg Catechism defines Reformed theology
1563: First edition John Foxe, *Book of Martyrs*
1570: Pius V excommunicates Elizabeth I of England (bull *Regnans in Excelsis*)
1572: St. Bartholomew's Day Massacre

Appendix 1

1577: Teresa of Avila, *Interior Castle*
1580: Book of Concord defines Lutheran orthodoxy
1588: Spanish Armada sinks
1598: Edict of Nantes guarantees Huguenots certain protections
1601: Matteo Ricci, first European admitted to Forbidden City in Beijing
1618–1619: Synod of Dort further defines Reformed theology
1619: Final edition Francis de Sales, *Introduction to the Devout Life*
1618–1648: Thirty Years War
1630: Sailing to Massachusetts, John Winthrop preaches "Model of Christian Charity"
1642–1649: English Civil Wars; monarchy, bishops, and Book of Common Prayer abolished
1653: Innocent X condemns certain ideas supposedly in Jansen's *Augustinus* (bull *Cum Occassione*)
1654: Influenced by Jansenism, Blaise Pascal writes "memorial"
1660: Restoration of English monarchy, bishops, and Book of Common Prayer
1660: Thieleman van Braght, *Martyr's Mirror*
1675: Philip Jakob Spener, *Pia Desideria*
1681: William Penn forms Pennsylvania as refuge for persecuted Quakers
1687: Innocent XI refutes Quietism of Miguel de Molinos (bull *Coelistis Pastor*)
1688: Act of Toleration allows for "dissenters" in England
1710: Following Chinese Rites Controversy, Emperor Kangxi forbids conversions to Christianity
1722: Nicholas von Zinzendorf welcomes exiled Moravians to Herrnhut
1738: John Wesley has his heart "strangely warmed" at Aldersgate
1741: Jonathan Edwards preaches "Sinners in the hands of an Angry God" in Connecticut
1773: Facing political pressure, Clement XIV suppresses Jesuits (bull *Dominus ac Redemptor Noster*)
1776: American Revolution
1789: French Revolution

Appendix 2

Shortlist of Primary Sources in English Suitable for Teaching

Organized chronologically by subject
See chapter end-notes for more options

Cheslyn, Jones Geoffrey Wainwright, and Edward Yarnold, eds. *The Study of Spirituality*. Oxford: Oxford University Press, 1986.
Bard Thompson, ed. *Liturgies of the Western Church*. Cleveland: Meridian, 1961.
John Shinners, *Medieval Popular Religion, 1000–1500: A Reader*. 2nd ed. Peterborough, Canada: Broadview, 2007.
G. R. Evans, ed. *Bernard of Clairvaux*. Mahwah, NJ: Paulist, 1987.
Dennis Martins, ed. *Carthusian Spirituality* New York: Paulist, 1997.
Simon Tugwell, ed. *Albert and Thomas*. New York: Paulist, 1988.
Bernard McGinn, ed. *The Essential Writing of Christian Mysticism*. New York: Random House, 2006.
Ewert Cousins, ed. *Bonaventure*. New York: Paulist, 1978.
Frank Tobin, ed. *Mechthild of Magdeburg: The Flowing Light of the Godhead*. New York: Paulist, 1998.
Edmund Colledge and Bernard McGinn, trans. *Meister Eckhart*. Mahwah, NJ: Paulist, 1981.
David Blamires, trans. *Theologia Deutsch—Theologia Germanica*. New York: Altamire, 2003.
John Van Engen, ed. *Devotio Moderna: Basic Writings*. New York: Paulist, 1988.
Patrick Hornbeck, Stephen Lahey, and Fiona Somerset, eds. *Wycliffite Spirituality*. New York: Paulist, 2013.
John-Julian, ed. *The Complete Imitation of Christ*. Brewster, MA: Paraclete, 2012.
Philip Krey and Peter Krey, eds. *Luther's Spirituality*. New York: Paulist 2007.
The Annotated Luther 6 Vols. Fortress Press, 2016–2017.
Scott Hendrix, ed. *Early Protestant Spirituality*. Mahwah, NY: Paulist, 2009.
Daniel Liechty, ed. *Early Anabaptist Spirituality*. Mahwah, NJ: Paulist, 1994.
Robert Miola, ed. *Early Modern Catholicism: An Anthology of Primary Sources*. Oxford: Oxford University Press, 2007.
George Ganss, ed. *Ignatius of Loyola: The Spiritual Exercises and Selected Works*. New York: Paulist, 1991.
Elsie McKee, ed. *John Calvin: Writings on Pastoral Piety*. New York: Paulist, 2001.
Keiran Kavanagh, trans. *Teresa of Avila: The Interior Castle*. Mahwah, NJ: Paulist, 1979.
Cummings, Brian, ed. *The Book of Common Prayer: The Texts of 1549, 1559, and 1662*. Oxford: Oxford University Press, 2011.
Mark Noll, ed. *Confessions and Catechisms of the Reformation*. Grand Rapids, MI: Baker, 1991.
John-Julian, ed. *The Complete Introduction to the Devout Life*. Brewster, MA: Paraclete, 2013.
Peter Erb, ed. *Pietists: Selected Writings*. New York: Paulist, 1983.

Paul Stanwood, ed. *William Law*. New York: Paulist, 1978.
Thomas Carroll, ed. *Jeremy Taylor*. New York: Paulist, 1990.
A. J. Krailsheimer, trans. *Blaise Pascal: Pensées*. New York: Penguin, 1966.
Albert Outler, ed. *John Wesley*. New York: Oxford University Press, 1964.
Paul Chilcote, ed. *Early Methodist Spirituality: Selected Women's Writings*. Nashville: Abingdon, 2007.

Bibliography

Ackerman, Jane. "John of the Cross, the Difficult Icon." In *A New Companion to Hispanic Mysticism*, edited by Hilaire Kallendorf, 149–73. Boston: Brill, 2010.
Ahlstrom, Sydney. *Theology in America: The Major Protestant Voices from Puritanism to Neo-Orthodoxy*. Indianapolis: Bobbs-Merill, 1967.
Alighieri, Dante. *The Divine Comedy of Dante Alighieri*. Translated by Courtney Langdon. Cambridge: Harvard University Press, 1921.
Alva, J. Jorge Klor de, "Spiritual Conflict and Accommodation in New Spain: Toward a Typology of Aztec Responses to Christianity." In *The Inca and Aztec States 1400–1800: Anthropology and History*, edited by George Collier, Renato Rosaldo, and John Wirth, 345–56. New York: Academic Press, 1982.
Ames, Christine. *Righteous Persecution: Inquisition, Dominicans, and Christianity in the Middle Ages*. Philadelphia: University of Pennsylvania Press, 2009.
Antry, Theodore and Carol Neel, eds. *Norbert and Early Norbertine Spirituality*. Mahwah, NJ: Paulist, 2007.
Aquinas, Thomas. *Summa Theologica*, Supplement, quest. 40, article 4, response.
Armstrong, Regis, Wayne Hellman, and William Short, eds. *Francis of Assisi: Early Documents*. New York: New City, 1999–2002.
Arnold, John. "Heresy and Gender in the Middle Ages." In *The Oxford Handbook of Gender in Medieval Europe*, edited by Judith Bennett and Ruth Karras, 496–510. Oxford: Oxford University Press, 2013.
Aston, Margaret. *England's Iconoclasts: Laws against Images*. Oxford: Oxford University Press, 1988.
———. *Broken Idols of the English Reformation*. Cambridge: Cambridge University Press, 2016.
Aston, Margaret and Elizabeth Ingram. "The Iconography of the *Acts and Monuments*." In *John Foxe and the English Reformation*, edited by David Loades, 66–141. Aldershot: Ashgate, 1997.
Atwood, Craig. *Community of the Cross: Moravians Piety in Colonial Bethlehem*. University Park: Pennsylvania State University Press, 2004.
———. *The Theology of the Czech Brethren from Hus to Comenius*. University Park, PA: Pennsylvania State University Press, 2009.
Avis, Paul. *Beyond the Reformation? Authority, Primacy and Unity in the Conciliar Tradition*. London: T&T Clark, 2006.
Bach, Jeff. *Voices of the Turtledoves: The Sacred World of Ephrata*. University Park, PA: Pennsylvania State University Press, 2003.
Bagchi, David. "Sic et Non: Luther and Scholasticism." In *Protestant Scholasticism: Essays in Reassessment*, edited by Carl Trueman and Scott Clark, 3–15. Carlisle, UK: Paternoster, 1999.
———. "Catholic Theologians of the Reformation Period before Trent." In *The Cambridge Companion to Reformation Theology*, edited by David Bagchi and David Steinmetz, 220–32. Cambridge: Cambridge University Press, 2004.
Bagnoli, Martina Holger Klein, Griffith Mann, and James Robinson, eds. *Treasures of Heaven: Saints, Relics, and Devotion in Medieval Europe*. New Haven: Yale University Press, 2010.
Bailey, Gauvin. *Art on the Jesuit Missions in Asia and Latin America, 1542–1773*. Toronto: University of Toronto Press, 1999.

Balmer, Randall. *A Perfect Babel of Confusion: Dutch Religion and English Culture in the Middle Colonies*. Oxford: Oxford University Press, 1989.

Barbee, Frederick and Paul Zahl. *Collects of Thomas Cranmer*. Grand Rapids: Eerdmans, 1999.

Barr, Helen, ed. *The Piers Plowman Tradition*. London: Dent, 1993.

Barraclough, Geoffrey. *The Medieval Papacy*. New York: Harcourt, Brace, and World, 1968.

Barstow, Ann. *Married Priests and the Reforming Papacy: The Eleventh Century Debates*. New York: Edwin Mellen, 1982.

Bartlett, Robert. *Why Can the Dead Do Such Great Things? Saints and Worshippers from the Martyrs to the Reformation*. Princeton: Princeton University Press, 2013.

Bellitto, Christopher. "The Reform Context of the Great Western Schism." In *A Companion to the Great Western Schism*. Edited by Joëlle Rollo-Koster and Thomas Izbicki, 303–31. Leiden: Brill, 2009.

Berman, Constance. "Were there Twelfth Century Cistercian Nuns?" *Church History* 68 (1999): 824–64.

———. *The Cistercian Evolution: The Invention of a Religious Order in Twelfth-Century Europe*. Philadelphia: University of Pennsylvania Press, 2000.

Binski, Paul. *Medieval Death: Ritual and Representation*. Ithaca, NY: Cornell University Press, 1996.

Birch, Debra. *Pilgrimage to Rome in the Middle Ages*. Woodbridge, Suffolk: Boydell, 1998.

Bireley, Robert. *The Refashioning of Catholicism, 1450–1700*. Washington: Catholic University of America Press, 1999.

Blamires, David, trans. *Theologia Deutsch—Theologia Germanica: The Book of the Perfect Life*. New York: Altamire, 2003.

Blumenthal, Uta-Renate. *The Investiture Controversy: Church and Monarchy from the Ninth to the Eleventh Century*. Philadelphia: University of Pennsylvania Press, 1988.

Booty, John, ed. *The Book of Common Prayer, 1559*. Charlottesville, VA: University Press of Virginia, 1976.

Borgman, Eric. *Dominican Spirituality*. London: Continuum, 2001.

Bornkamm, Heinrich. *Luther und Eckhart*. Stuttgart: Kohlhammer, 1936.

Bossy, John. "The Mass as a Social Institution, 1200–1700." *Past & Present* 100 (1983): 29–61.

Bougerol, Jacques-Guy. "The Church Fathers and the Sentences of Peter Lombard." In *The Reception of the Church Fathers in the West: From the Carolingians to the Maurists*, edited by Irena Backus, 113–64. Leiden: Brill, 1997.

Bourdieu, Pierre. *Outline of a Theory of Practice*. Cambridge: Cambridge University Press, 1977.

Bouwsma, William. "The Spirituality of Renaisance Humanism." In *Christian Spirituality: High Middle Ages and Reformation*, edited by Jill Raitt, 236–51. New York: Crossroads, 1987.

Bowers, Terence. "Margery Kemp as Traveler." *Studies in Philology* 97 (2000): 1–28.

Bowman, Glenn. "Christian Ideology and the Image of the Holy Land: The Place of Jerusalem Pilgrimage in the Various Christianities." In *Contesting the Sacred: The Anthropology of Christian Pilgrimage*, Edited by John Eade and Michael Sallnow, 98–121. London: Routledge, 1991.

Bozeman, Theodore Dwight. *The Precisianist Strain: Disciplinary Religion and Antinomian Backlash in Puritanism to 1638*. Chapel Hill, NC: University of North Carolina Press, 2004.

Brewer, Brian. *Martin Luther and the Seven Sacraments: A Contemporary Protestant Reappraisal*. Grand Rapids: Baker, 2017.

Brockey, Liam. *Journey to the East: The Jesuit Mission to China, 1579–1724*. Cambridge, MA: Harvard University Press, 2007.

Bromiley, G. W., ed. *Zwingli and Bullinger*. Philadelphia: Westminster, 1953.

Brown, Christopher. *Singing the Gospel: Lutheran Hymns and the Success of the Reformation.* Cambridge, MA: Harvard University Press, 2005.
Brown, Peter. *The Cult of the Saints: Its Rise and Function in Latin Christianity.* Chicago: University of Chicago Press, 1981.
Brundage, James. *Medieval Canon Law.* New York: Longman, 1995.
Buckley, Michael. "Seventeenth-Century French Spirituality: Three Figures." In *Christian Spirituality: Post-Reformation and Modern,* edited by Louis Dupré and Don Saliers, 28–68. New York: Crossroads, 1996.
Bumas, Shaskan. "The Cannibal Butcher Shop: Protestant Uses of Las Casas's "Brevísima relación" in Europe and the American Colonies." *Early American Literature* 25 (2000): 107–36.
Burnett, Amy, *Karlstadt and the Origins of the Eucharistic Controversy: A Study in the History of Ideas.* Oxford: Oxford University Press, 2011.
Burr, David. *The Spiritual Franciscans: From Protestant to Persecution in the Century after Saint Francis.* University Park, PA: Pennsylvania State University Press, 2001.
Burson, Jeffery and Jonathan Wright, eds. *The Jesuit Suppression in Global Context* Cambridge: Cambridge University Press, 2015.
Burton, Janet and Julie Kerr, *The Cistercians in the Middle Ages.* Woodbridge, Suffolk, UK: Boydell, 2011.
Bynum, Caroline Walker. "The Spirituality of the Regular Canons in the Twelfth Century: A New Approach." *Medievalia et Humanistica* 4 (1973): 3–24.
———. *Holy Feast, Holy Fast: The Religious Significance of Food to Medieval Women.* Berkeley, CA: University of California Press, 1987.
———. "Religious Women in the Later Middle Ages." In *Christian Spirituality: High Middle Ages and Reformation,* edited by Jill Raitt, 121–39. New York: Crossroad, 1987.
———. *The Resurrection of the Body in Western Christianity, 200–1336.* New York: Columbia University Press, 1995.
———. "Death and Resurrection in the Middle Ages: Some Modern Implications." *Proceedings of the American Philosophical Society* 142 (1998): 589–96.
———. "Seeing and Seeing Beyond: The Mass of St. Gregory in the Fifteenth Century." In *The Mind's Eye: Art and Theology in the Middle Ages,* edited by Anne-Marie Bouché and Jeffrey Hamburger, 208–40. Princeton, NJ: Department of Art History, Princeton University, 2005.
———. *Wonderful Blood: Theology and Practice in Late Medieval Germany and Beyond.* Philadelphia: University of Pennsylvania Press, 2007.
———. *Christian Materiality: An Essay on Religion in Late Medieval Europe.* Brooklyn: Zone Books, 2011.
Calvin, John. *Institutes of the Christian Religion.* Translated by Henry Beveridge. Grand Rapids, MI: Eerdmans, 1989.
Cameron, Euan. "The Possibilities and Limits of Conciliation: Philip Melanchthon and Inter-Confessional Dialogue in the Sixteenth Century." In *Conciliation and Confession: The Struggle for Unity in the Age of Reform, 1415–1648,* edited by Howard Louthan and Randall Zachman, 73–88. Notre Dame: University of Notre Dame Press, 2004.
Campbell, Ted. *The Religion of the Heart: A Study of European Religious Life in the Seventeenth and Eighteenth Centuries.* Columbia, SC: University of South Carolina Press, 1991.
Carlson, Eric. *Marriage and the English Reformation.* Oxford: Blackwell, 1994.
Carrington, Laurel. "Desiderius Erasmus." In *The Reformation Theologians,* edited by Carter Lindberg, 34–48. Oxford: Blackwell, 2002.
Carroll, Michael. *The Cult of the Virgin Mary: Psychological Origins.* Princeton: Princeton University Press, 1986.
Carroll, Thomas, ed. *Jeremy Taylor: Selected Works.* New York: Paulist, 1990.
Carver, Martin, ed. *The Cross goes North: Processes of Conversion in Northern Europe, AD 300–1300.* Woodbridge, UK: Boydell, 2003.

Castro, Daniel. *Another Face of Empire: Bartolomé de Las Casas, Indigenous Rights, and Ecclesiastical Imperialism*. Durham, NC: Duke University Press, 2007.
Cesareo, Francesco. "The Episcopacy in Sixteenth-Century Italy," In *Early Modern Catholicism*, edited by Kathleen Comerford and Hilmar Pabel, 67–83. Toronto: University of Toronto Press, 2001), 183–210.
Chemnnitz, Martin. *Examination of the Council of Trent*. Translated by Fred Kramer. St. Louis, MO: Concordia, 1971.
Chilcote, Paul, ed. *Early Methodist Spirituality: Selected Women's Writings*. Nashville, Abingdon, 2007.
Chuchiak, John. "Christian Saints and their Intepretations in Mesoamerica." In *Oxford Encyclopedia of Mesoamerican Cultures*, edited by David Carrasco, Vol. 3, 113–16. Oxford: Oxford University Press, 2001.
Chung, Paul. "Mission and Inculturation in the Thought of Matteo Ricci." In *Asian Contextual Theology for the Third Millennium*, edited by Paul Chung, Kim Kyoung-Jae, and Veli-Matti Karkkainen, 303–27. Eugene OR; Pickwick, 2007.
Clayton, Lawrence. *Bartolomé de Las Casas and the Conquest of the Americas*. Oxford: Wiley-Blackwell, 2007.
———. *Bartolomé de Las Casas: A Biography*. Cambridge: Cambridge University Press, 2012.
Clark, Alan. "The Functions of the Offertory Rite in the Mass." *Ephemerides Liturgicae* 64 (1980): 309–44.
Cleugh, Hannah. "'At the hour of our death': Praying for the Dying in Post-Reformation England." In *Dying, Death, Burial, and Commemoration in Reformation Europe*, edited by Elizabeth Tingle and Jonathan Willis, 49–66. London: Routledge, 2015.
Coleman, Simon. "Pilgrimage as Trope for an Anthropology of Christianity." *Current Anthropology* 55 (2014): 281–21.
Cole, Andrew. "William Langland and the Invention of Lollardy." In *Lollards and their Influence in Late Medieval England*, edited by Fiona Somerset, Jill Havens, and Derrick Pittard, 37–58. Woodbridge, Suffolk: Boydell, 2003.
Colledge, Edmund, and Bernard McGinn, trans. *Meister Eckhart* (Mahwah, NJ: Paulist, 1981).
Collier, George, Renato Rosaldo, and John Wirth, eds. *The Inca and Aztec States 1400–1800: Anthropology and History*. New York: Academic Press, 1982.
Collinson, Patrick. *Archbishop Grindal, 1519–1583: The Struggle for a Reformed Church*. Berkeley: University of California Press, 1979.
———. *Richard Bancroft and Elizabethan Anti-Puritanism*. Cambridge: Cambridge University Press, 2013.
Collish, Marcia. *Peter Lombard*. Leiden: Brill, 1994.
Colvin, H. M. *The White Canons in England*. Oxford: Clarendon, 1951.
Como, David. *Blown by the Spirit: Puritanism and the Emergence of an Antinomian Underground in Pre-Civil War England*. Stanford: Stanford University Press, 2004.
Congar, Yves. *The Meaning of Tradition*. New York: Hawthorn, 1964.
Conway, Charles. *The Vita Christi of Ludolph of Saxony*. Salzburg: University of Salzburg, 1976.
Coomans, Thomas. "Cistercian architecture or architecture of the Cistercians?." In *The Cambridge Companion to the Cistercian Order*, edited by M. B. Bruun, 151–69. Cambridge: Cambridge University Press, 2013.
Coster, Will and Andrew Spicer, "Introduction: The Dimensions of Sacred Space in Reformation Europe." In *Sacred Space in Early Modern Europe*, edited by Will Coster and Andrew Spicer, 1–16. Cambridge: Cambridge University Press, 2005.
Cousins, Ewert ed. *Bonaventure: The Soul's Journey into God, the Tree of Life, the Life of St. Francis*. New York: Paulist, 1978.
Cowdrey, H. E. J. *The Cluniacs and the Gregorian Reform*. Oxford: Clarendon, 1970.
———. *Gregory VII, 1073–1085*. Oxford: Oxford University Press, 1998.
———. *Lanfranc: Scholar, Monk, Archbishop*. Oxford: Oxford University Press, 2003.

Cranmer, Thomas. *Writings and Disputations of Thomas Cranmer*, edited by John Cox. Cambridge: Cambridge University Press, 1844.

Cummings, Brian, ed. *The Book of Common Prayer: The Texts of 1549, 1559, and 1662*. Oxford: Oxford University Press, 2011.

Cusato, Michael. "Francis and the Franciscan Movement (1181/2–1226)." In *The Cambridge Companion to Francis of Assisi*, ed. Michael Robson, 17–33. Cambridge: Cambridge University Press, 2012.

Cusato, Michael and Guy Geltner, eds. *Defenders and Critics of Franciscan Life*. Leiden: Brill, 2009.

Cushing, Kathleen. *Papacy and Law in the Gregorian Revolution*. Oxford: Oxford University Press, 1998.

———. *Reform and the Papacy in the Eleventh Century: Spirituality and Social Change*. Manchester: Manchester University Press, 2005.

Cressy, David. *Birth, Marriage, and Death: Ritual, Religion, and the Life Cycle in Tudor-Stuart England*. Oxford: Oxford University Press, 1999.

Crowther, Kathleen. *Adam and Eve in the Protestant Reformation*. Cambridge: Cambridge University Press, 2010.

Dandelion, Pink. *An Introduction to Quakerism*. Cambridge: Cambridge University Press, 2007.

Danker, Ryan. *Wesley and the Anglicans: Political Division in Early Evangelicalism*. Downers Grove, IL: IVP, 2016.

Dauril, Alden. *The Making of an Enterprise: The Society of Jesus in Portugal, Its Empire, and Beyond, 1540–1750*. Stanford: Stanford University Press, 1996.

Davies, Horton. *Worship and Theology in England: From Cranmer to Hooker, 1534–1603*. Princeton: Princeton University Press, 1970.

Davis, Thomas. *The Clearest Promises of God: The Development of Calvin's Eucharistic Teaching*. New York: AMS, 1995.

———. *This is My Body: The Presence of Christ in Reformation Thought*. Grand Rapids, MI: Baker, 2008.

D'Avray, David. *Medieval Marriage: Symbolism and Society*. Oxford: Oxford University Press, 2005.

———. "Authentication of Marital Status: A Thirteenth-Century English Royal Annulment Process and Late Medieval Cases from the Papal Penitentiary." *English Historical Review* 120 (2005): 987–1013.

Deitz, Maribel. *Wandering Monks, Virgins, and Pilgrims: Asectic Travel in the Mediterranean World, A.D. 300–800*. University Park, PA: Penn State University Press, 2005.

DeSilva, Jennifer. "'Piously Made': Sacred Space and the Transformation of Behavior." In *The Sacralization of Space and Behavior in the Early Modern World*, edited by Jennifer DeSilva, 1–32. Aldershot: Ashgate, 2015.

Devlin, Dennis. "Feminine Lay Piety in the High Middle Ages: The Beguines." In *Medieval Religious Women*, edited by John Nichols and Lillian Shank, 183–96. Kalamazoo: Cistercian, 1984.

Dickinson, J. C. *The Origins of the Austin Canons and their Introduction into England*. London: SPCK, 1950.

Diefendorf, Barbara. *Under the Cross: Catholics and Huguenots in Sixteenth-Century Paris*. Oxford: Oxford University Press, 1991.

Dillenberger, John, ed. *Martin Luther: Selections from his Writings*. New York: Anchor, 1962.

Dillon, Anne. *The Construction of Martyrdom in the English Catholic Community, 1535–1603*. Burlington, VT: Ashgate, 2002.

Duffy, Eamon. *The Stripping of the Altars: Traditional Religion in England, 1400–1580*. New Haven: Yale University Press, 1992.

———. *Marking the Hours: English People and their Prayers, 1250–1550*. New Haven: Yale University Press, 1996.

———. *Fires of Faith, Catholic England Under Mary Tudor*. New Haven: Yale University Press, 2009.

———. "Praying the Counter Reformation." In *Early Modern English Catholicism*, edited by James Kelly and Susan Royal, 206–25. Boston: Brill, 2016.

———. *Reformation Divided: Catholics, Protestants and the Conversion of England*. London: Bloomsbury, 2017.

Dupré, Louis. "Jansenism and Quietism." In *Christian Spirituality: Post-Reformation and Modern*, edited by Louis Dupré and Don Saliers, 121–30. New York: Crossroads, 1996.

Durston, Christopher and Judith Maltby, eds. *Religion in Revolutionary England*. Manchester: Manchester University Press, 2006.

Dutton, Marsha, ed. *Aelred of Rievaulx, Spiritual Friendship*. Collegeville, MN: Cistercian Publications, 2010.

Ecker, Ronald and Eugene Crook, eds. *The Canterbury Tales: A Complete Translation into Modern English*. Palatka, FL: Hodge & Braddock, 1993.

Edden, Valerie, "The Mantle of Elijah: Carmelite Spirituality in England in the Fourteenth Century." In *The Medieval Mystical Tradition*, edited by Marion Glasscoe, 67–83. Cambridge: Brewer, 1999.

Edmonson, Robert and Hal Helms, eds. *The Complete Fénelon*. Brewster, MA: Paraclete, 2008.

Egan, Keith. "An Essay toward the Historiography of the Origin of the Carmelite Province in England." *Carmelus* 19 (1972): 67–100.

Eire, Carlos. *War Against the Idols: The Reformation of Worship from Erasmus to Calvin*. Cambridge: Cambridge University Press, 1986.

———. *Reformations: The Early Modern World, 1450–1650*. New Haven: Yale University Press, 2016.

Ellington, Donna. *From Sacred Body to Angelic Soul: Understanding Mary in Late Medieval and Early Modern Europe*. Washington: Catholic University of America Press, 2001.

Emerton, Ephraim. *The Correspondence of Pope Gregory VII*. New York: Norton, 1969.

Erb, Peter, ed. *Pietists: Selected Writings*. New York: Paulist, 1983.

Euler, Carrie. "Heinrich Bullinger, Marriage, and the English Reformation: *The Christen state of Matrimonye* in England, 1540–53." *Sixteenth Century Journal* 34 (2003): 367–92.

———. "Huldrych Zwingli and Heinrich Bullinger." In *A Companion to the Eucharist in the Reformation*, edited by Lee Wandel, 57–74. Leiden, Brill: 2014.

Estes, James, ed. *The Correspondence of Erasmus: Letters 2204–2356*. Toronto: University of Toronto Press, 2015.

Evans, G. R. ed. *Bernard of Clairvaux: Selected Works*. Mahwah, NJ: Paulist, 1987.

———, ed. *Medieval Commentaries on the Sentences of Peter Lombard*. Leiden: Brill, 2002.

Evenden, Elizabeth and Thomas Freeman, *Religion and the Book in Early Modern England: The Making of John Foxe's 'Book of Martyrs'*. Cambridge: Cambridge University Press, 2011.

Fasolt, Constantine. "Hegel's Ghost: Europe, the Reformation, and the Middle Ages." *Viator* 39 (2008): 345–86.

Ferrell, Lori Anne. "The Church of England and the English Bible, c. 1559–1640" in *The Oxford Handbook of the Bible in Early Modern England, c. 1530–1700*, edited Kevin Killeen, Helen Smith, and Rachel Willie, 261–71. Oxford: Oxford University Press, 2015.

Ferrell, Lori Anne and Peter MacCullough, eds. *The English Sermon Revised: Religion, Literature, and History 1600–1750* (Manchester: Manchester University Press, 2000).

Fincham, Kenneth and Nicholas Tyacke, *Altars Restored: The Changing Face of English Religious Worship, 1547- c. 1700*. Oxford: Oxford University Press, 2007.

Fisher, Alexander. *Music and Religious Identity in Counter-Reformation Augsburg 1580–1630*. Aldershot, UK: Ashgate, 2004.

Flaming, Darlene. "The Apostolic and Pastoral Office: Theory and Practice in Calvin's Geneva." In *Calvin and the Company of Pastors*, edited by David Foxgrover, 149–72. Grand Rapids, MI: CRC, 2004.

Fletcher, Anthony. "The Protestant Idea of Marriage in Early Modern England." In *Religion, Culture, and Society in Early Modern Britain*, edited by Anthony Fletcher and Peter Roberts, 161–81. Cambridge: Cambridge University Press, 1994.

Fletcher, Richard. *The Conversion of Europe*. New York: Harper Collins, 1997.

Fogelman, Aaron. *Jesus is Female: Moravians and Radical Religion in Early America*. Philadelphia: University of Pennsylvania Press, 2008.

Foley, Edward. *From Age to Age: How Christians Have Celebrated the Eucharist*. Collegeville, MN: Liturgical Press, 2008.

Foley, S.M. and Clarence Miller, eds. *Thomas More's The Answer to a Poisoned Book*. New Haven: Yale University Press, 1985.

Foster, Paul and Sara Parvis, eds. *Writings of the Apostolic Fathers*. London: Continuum, 2007.

Freeman, Elizabeth. *Narratives of a New Order: Cistercian Historical Writing in England, 1150–1220*. Turnhout, Belgium: Brepols, 2002.

Freeman, Thomas and Sarah Wall. "Racking the Body, Shaping the Text: The Account of Anne Askew in Foxe's 'Book of Martyrs.'" *Renaissance Quarterly* 54 (2001): 1165–96.

Fudge, Thomas. "Hussite Theology and the Law of God." In *The Cambridge Companion to Reformation Theology*, edited by David Bagchi and David Steinmetz, 22–27. Cambridge: Cambridge University Press, 2004.

———. *Jan Hus: Religious Reform and Social Revolution in Bohemia*. New York: Taurus, 2010.

———. *The Trial of Jan Hus*. Oxford: Oxford University Press, 2013.

Galloway, Penelope. "Discreet and Devout Maidens: Women's Involvement in Beguine Communities in Northern France, 1200–1500." In *Medieval Women in their Communities*, edited by Diane Watt, 92–115. Toronto: University of Toronto Press, 1997.

Gambero, Luigi. *Mary and the Fathers of the Church: The Blessed Virgin Mary in Patristic Thought*. San Francisco: Ignatius, 1999.

———. *Mary in the Middle Ages: The Blessed Virgin Mary in the Thought of Medieval Latin Theologians*. San Francisco: Ignatius, 2005.

Ganss, George, ed. *Ignatius of Loyola: The Spiritual Exercises and Selected Works*. New York: Paulist, 1991.

George, Timothy. "Spirituality of the Radical Reformation." In *Christian Spirituality: High Middle Ages and Reformation*, edited by Jill Raitt, 334–66. New York: Crossroads, 1987.

———. "John Calvin and the Agreement of Zurich (1549)." In *John Calvin and the Church: A Prism of Reform* edited by Timothy George, 42–58. Louisville: Westminster John Knox, 1990.

———. *Reading Scripture with the Reformers*. Downers Grove, IL: Intervarsity, 2011.

Gertz, Genelle. *Heresy Trials and English Women Writers, 1400–1670*. Cambridge: Cambridge University Press, 2012.

Gerrish, B.A. "The Lord's Supper in the Reformed Confessions." In *Major Themes in the Reformed Tradition*, edited by Donald McKim, 245–58. Grand Rapids: Eerdmans, 1992.

———. *Grace and Gratitude: The Eucharistic Theology of John Calvin*. Minneapolis: Fortress, 1993.

———. *Thinking with the Church: Essays in Historical Theology*. Grand Rapids: Eerdmans, 2010.

Ghosh, Kantik. "Wycliffism and Lollardy." In *The Cambridge History of Christianity: Volume 4 Christianity in the West, 1100–1500*, edited by Miri Rubin and Walter Simons, 433–45. Cambridge: Cambridge University Press, 2009.

Gibson, Margaret. "The Case of Berengar." In *Council and Assemblies* edited by G.J. Cuming and Derek Baker, 61–68. Cambridge: Cambridge University Press, 1971.

Gordon, Bruce, ed. *Protestant History and Identity in Sixteenth Century Europe*. Aldershot: Ashgate, 1996, 2 Vols.

———. *The Swiss Reformation*. Manchester: Manchester University Press, 2002.
———. *Calvin*. New Haven: Yale University Press, 2009.
Gordon, Bruce and Peter Marshall. "Introduction," in *The Place of the Dead: Death and Remembrance in Late Medieval and Early Modern Europe*, edited by Bruce Gordon and Peter Marshall, 1–16. Cambridge: Cambridge University Press, 2000.
Green, Ian. *The Christian's ABC: Catechisms and Catechizing in England, c. 1530–1740*. Oxford: Clarendon, 1996.
———. "'All people that on Earth do dwell Sing to the Lord with a cheerful voice': Protestantism and Music in Early Modern England." In *Christianity and Community in the West*, edited by Simon Ditchfield, 148–64. Aldershot, UK: Ashgate, 2001.
Gregory, Brad. *Salvation at Stake: Christian Martyrdom in Early Modern Europe*. Cambridge, MA: Harvard University Press, 1999.
———. *The Unintended Reformation: How a Religious Revolution Secularized Society*. Cambridge, MA: Harvard University Press, 2012.
Gregory, Rabia. *Marrying Jesus in Medieval Early Modern Northern Europe: Popular Culture and Religious Reform*. Farnham, Surrey: Ashgate, 2016.
Groeneveld, Leanne. "A Theatrical Miracle: The Boxley Rood of Grace as Puppet." *Early Theatre* 10.2 (2007): 11–50.
Grosse, Christian. "Places of Sanctification: The Liturgical Sacrality of Genevan Reformed Churches, 1535–1566," In *Sacred Space in Early Modern Europe*, edited by Will Coster and Andrew Spicer, 60–80. Cambridge: Cambridge University Press, 2005.
Grundler, Otto. "Devotio Moderna." In *Christian Spirituality: High Middle Ages and Reformation*, edited by Jill Raitt, 176–93. New York: Crossroads, 1987.
Grundmann, Herbert. *Religious Movements in the Middle Ages* trans. Steven Rowan. Notre Dame: Notre Dame University Press, 1995.
Haas, Alois Maria. "Schools of Late Medieval Mysticism." In *Christian Spirituality: High Middle Ages and Reformation*, edited by Jill Raitt, 140–75. New York: Crossroad, 1987.
Hackett, Benedict. "The Spiritual Life of the English Austin Friars of the Fourteenth Century," *Sanctus Augustinus* (Rome, 1956): 421–92.
Hahn, Cynthia. *Strange Beauty: Issues in the Making and Meaning of Reliquaries, 400-c. 1204*. University Park, PA: Pennsylvania State University Press, 2012.
Haliczer, Stephen. *Between Exaltation and Infamy: Female Mystics in the Golden Age of Spain*. Oxford: Oxford University Press, 2002.
Hamilton, Louis. *A Sacred City: Consecrating Churches and Reforming Society in Eleventh Century Italy*. Manchester: Manchester University Press, 2010.
Hamlin, Hannibal. *Psalm Culture and Early Modern English Literature*. Cambridge: Cambridge University Press, 2004.
Hamm, Berndt. *The Early Luther: Stages in a Reformation Reorientation*. Grand Rapids: Eerdmans, 2014.
Hammond, Geordan. *John Wesley in America; Restoring Primitive Christianity*. Oxford: Oxford University Press, 2014.
Harper, John. *The Forms and Orders of Western Liturgy from the Tenth to Eighteenth Century*. Oxford: Oxford University Press, 1991.
Harpham, Geoffrey. *On the Grotesque: Strategies of Contradiction in Art and Literature*. Princeton: Princeton University Press, 2006.
Harrington, Joel. *Reordering Marriage and in Reformation Germany*. Cambridge: Cambridge University Press, 1995.
Harrison, Regina. "Teaching restitution: Las Casas, the *Rules for Confessors*, and the Politics of Repayment." In *Approaches to Teaching the Writings of Bartolomé de Las Casas*, edited by Santa Arias and Eyda Merediz, 132–40. New York: Modern Language Association of America, 2008.
Headley, John and John Tomaro. *San Carlo Borromeo: Catholic Reform and Ecclesiastical Politics in the Second Half of the Sixteenth Century*. Cranberry, NJ: Folger, 1988.

Heal, Bridget. "Sacred Image and Sacred Space in Lutheran Germany." In *Sacred Space in Early Modern Europe*, edited by Wil Coster and Andrew Spicer, 39–59. Cambridge: Cambridge University Press, 2005.

Heales, Alfred. "Easter Sepulchers, Their Object, Nature, and History." *Archaeologia* 42 (1869): 263–308.

Heitzenrater, Richard. *Wesley and the People called Methodists*. Nashville: Abingdon, 1995.

Hellmann, Wayne. "The Spirituality of the Franciscans." In *Christian Spirituality: High Middle Ages and Reformation*, edited by Jill Raitt, 31–50. New York: Crossroads, 1987.

Hempton, David. "John Wesley (1703–1791)." In *The Pietist Theologians: An Introduction to Theology in the Seventeenth and Eighteenth Centuries*, edited by Carter Lindberg, 256–71. Oxford: Blackwell, 2005.

Hendrix, Scott, ed. *Early Protestant Spirituality*. Mahwah, NJ: Paulist, 2009.

Hickerson, Megan *Making Women Martyrs in Tudor England*. New York: Palgrave Macmillan, 2005.

Holifield, Brooks. *The Covenant Sealed: The Development of Puritan Sacramental Theology in Old and New England, 1570–1720*. New Haven: Yale University Press, 1974.

Hollywood, Amy. *The Soul as Virgin Wife: Mechthild of Magdeburg, Marguerite Porete, and Meister Eckhart*. Notre Dame: University of Notre Dame Press, 1995.

Holtz, Mack. "Cults of the Precious Blood in the Medieval Latin West." PhD diss., University of Notre Dame, 1997.

Hornbeck, Patrick. *What is a Lollard? Dissent and Belief in Late Medieval England*. Oxford: Oxford University Press, 2010.

Hornbeck, Patrick, Stephen Lahey, and Fiona Somerset, eds. *Wycliffite Spirituality*. New York: Paulist, 2013.

Howard, Donald. *Writers and Pilgrims: Medieval Pilgrimage Narratives and their Posterity*. Berkeley, CA: University of California Press, 1980.

Howell, Clifford. "From Trent to Vatican II." In *The Study of Spirituality*, edited by Cheslyn Jones, Geoffrey Wainwright, and Edward Yarnold, 285–94. Oxford: Oxford University Press, 1986.

Howells, Edward. *John of the Cross and Teresa of Avila: Mystical Knowing and Selfhood*. New York: Crossroad, 2002.

Hsia, R. Po-chia. *The World of Catholic Renewal 1540–1770*. Cambridge: Cambridge University Press, 2005.

———. *A Jesuit in the Forbidden City: Matteo Ricci, 1552–1610*. Oxford: Oxford University Press, 2010.

———. *Matteo Ricci & the Catholic Mission to China*. Indianapolis: Hackett, 2016.

Hudon, William. *Marcello Cervini and Ecclesiastical Government in Tridentine Italy*. DeKalb, IL: Northern Illinois University Press, 1992.

———, ed. *Theatine Spirituality*. New York: Paulist, 1996.

———. "The Papacy in the Age of Reform." In *Early Modern Catholicism* edited by Kathleen Comerford and Hilmar Pabel, 46–66. Toronto: University of Toronto Press, 2001.

Hudson, Anne. "A New Look at the *Lay folks' catechism*." *Viator* 16 (1985): 243–58.

———. "The *Lay folks' catechism*: a postscript," *Viator* 19 (1988): 307–9.

Hughes, Andrew. *Medieval Manuscripts for Mass and Office: A Guide to their Organization and Terminology*. Toronto: University of Toronto Press, 1982.

Hunt, Arnold. *The Art of Hearing: English Preachers and their Attitudes, 1590–1640*. Cambridge: Cambridge University Press, 2010.

Hunt, Noreen. *Cluniac Monasticism in the Central Middle Ages*. London: Macmillan, 1971.

Ignatius of Loyola, *The Spiritual Exercises of St. Ignatius*. Translated by Anthony Mottola. Garden City, NY: Doubleday, 1964.

Isaiasz, Vera. "Early Modern Lutheran Churches: Redefining the Boundaries of the Holy and the Profane," in *Lutheran Churches in Early Modern Europe*, edited by Andrew Spicer, 17–37. Aldershot, UK: Ashgate, 2012.

Jackson, Robert. *Conflict and Conversion in Sixteenth-Century Central Mexico*. Leiden: Brill, 2013.

Jamroziak, Emilia. *The Cisterican Order in Medieval Europe*. New York: Routledge, 2013.

Jeanes, Gordon. *Signs of God's Promise: Thomas Cranmer's Sacramental Theology and the Book of Common Prayer*. London: T & T Clark, 2008.

Jensen, Gordon, "Luther and the Lord's Supper," in *Oxford Handbook of Martin Luther's Theology*, edited by Robert Kolb, Irene Dingel, and L'ubimir Bàtka, 322–33. Oxford: Oxford University Press, 2014.

Joby, Christopher. *Calvinism and the Arts: A Re-Assessment*. Leuven: Peeters, 2007.

John-Julian, ed. *The Complete Imitation of Christ*. Brewster, MA: Paraclete, 2012.

———, ed. *The Complete Introduction to the Devout Life*. Brewster, MA: Paraclete, 2013.

Johnson, Elizabeth. "Marian Devotion in the Western Church," In *Christian Spirituality: High Middle Ages and Reformation*, edited by Jill Raitt, 392–414. New York: Crossroads, 1987.

Joldersma, Hermina and Louis Grijp, eds and trans., *Elisabeth's Manly Courage: Testimonials and Songs of Martyred Anabaptist Women in the Low Countries*. Milwaukee: Marquette University Press, 2001.

Jones, Claire Taylor *Ruling the Spirit: Women, Liturgy, and Dominican Reform in Late Medieval Germany*. Philadelphia: University of Pennsylvania Press, 2018.

Jotischky, Andrew. *The Carmelites and Antiquity: Mendicants and their Pasts in the Middle Ages*. Oxford: Oxford University Press, 2002.

Jungmann, Joseph. *The Mass of the Roman Rite: Its Origins and Development*. Notre Dame, IN: Ave Maria, 1951, 2 vols.

Jungmayr, Jörg, ed. *Die Legenda Maior des Raimond von Capua*. Berlin: Weidler Buchverlag, 2004.

Kamerick, Kathleen. *Popular Piety and Art in the Late Middle Ages: Image Worship and Idolatry in England, 1350–1500*. New York: Palgrave, 2002.

Karant-Nunn, Susan. *The Reformation of Ritual: An Interpretation of Early Modern Germany* New York: Routledge, 1997.

Kavanaugh, Kieran, ed. *Teresa of Avila, The Interior Castle*. New York: Paulist, 1979.

———. ed. *John of the Cross: Selected Writings*. New York: Paulist, 1987.

Keefe, Susan. *Water and the Word: Baptism and the Instruction of the Clergy in the Carolingian Empire* 2 vols. South Bend: University of Notre Dame Press, 2002.

Kennedy, Kathleen. *The Courtly and Commercial Art of the Wycliffite Bible*. Turnhout: Brepols, 2014.

Kettering-Lane, Denise. "Philip Spener and the Role of Women in the Church: The Spiritual Priesthood of All Believers in German Pietism." *Covenant Quarterly* 75.1 (2017): 50–69.

Kieckhefer, Richard. *Theology in Stone: Church Architecture from Byzantium to Berkeley*. Oxford: Oxford University Press, 2004.

Killeen, Kevin and Helen Smith, "Introduction," in *The Oxford Handbook of the Bible in Early Modern England, c. 1530–1700*, edited Kevin Killeen, Helen Smith, and Rachel Willie, 1–18. Oxford: Oxford University Press, 2015.

Kingdon, Robert. "Social Control and Political Control in Calvin's Geneva." *Archive for Reformation History* (1993): 521–32.

———. *Adultery and Divorce in Calvin's Geneva*. Cambridge, MA: Harvard University Press, 1995.

Kim, Hyun-Ah. *Humanism and the Reform of Sacred Music*. Aldershot, UK: Ashgate, 2008.

Knowles, David. *The Monastic Order in England: A History of its Development from the Times of St. Dunstan to the Fourth Lateran Council, 940–1216*. Cambridge: Cambridge University Press, 2004.

Knox, Lezlie. *Creating Claire of Assisi: Female Franciscan Identities in Later Medieval Italy*. Leiden: Brill, 2008.

Knowlton, Timothy, *Maya Creation Myths: Words and Worlds of the Chilam Balam*. Boulder, CO: University of Colorado Press, 2010.

Kolb, Robert. *For all the Saints: Changing Perceptions of Martyrdom and Sainthood in the Lutheran Reformation*. Macon: Mercer University Press, 1987.
———. *Martin Luther and the Enduring Word of God*. Grand Rapids, MI: Baker, 2016.
Kolb, Robert and James Nestingen, eds. *Sources and Contexts of the Book of Concord*. Minneapolis, MN: Augsburg Fortress, 2001.
Kolb, Robert and Timothy Wingert, eds. *The Augsburg Confession of the Evangelical Lutheran Church*. Minneapolis, MN: Augsburg Fortress, 2000.
Krailsheimer, A. J., trans. *Blaise Pascal's Pensées*. New York: Penguin, 1966.
Kubler, George and Martin Soria, *Art and Architecture in Spain and Portugal and their American Dominions: 1500–1800*. Baltimore: Penguin, 1999.
Kümin, Beat. "Sacred Church and Worldly Tavern: Reassessing an Early Modern Divide." In *Sacred Space in Early Modern Europe*, edited by Will Coster and Andrew Spicer, 17–38. Cambridge: Cambridge University Press, 2005.
Lahey, Stephen. *John Wyclif*. Oxford: Oxford University Press, 2009.
Lake, Peter. "The Laudian Style: Order, Uniformity, and the Pursuit of the Beauty of Holiness in the 1630s." In *The Early Stuart Church, 1603–1642*, edited by Kenneth Fincham, 161–85. Stanford: Stanford University Press, 1993.
Lambert, Malcolm. *Medieval Heresy: Popular Movements from the Gregorian Reform to the Reformation*. Oxford: Blackwells, 1977.
Lane, Calvin. "Before Hooker: The Material Context of Elizabethan Prayer Book Worship." *Anglican and Episcopal History* 74 (2005): 320–56.
———. *The Laudians and the Elizabethan Church: History, Conformity, and Religious Identity in Post-Reformation England*. London: Pickering & Chatto, 2013.
Lane, G.B. "The Development of Medieval Devotional Gestures." PhD diss., University of Pennsylvania, 1970.
Las Casas, Bartolomé de *The Devastation of the Indies: A Brief Account* trans. Herma Briffault Baltimore: Johns Hopkins University Press, 1992.
Laven, Mary. *Mission to China: Matteo Ricci and the Jesuit Encounter with the East*. London: Faber & Faber, 2011.
Laverin, Asunción. *Brides of Christ: Conventual Life in Colonial Mexico*. Stanford: Stanford University Press, 2008.
Lawrence, C. H. *The Friars: The Impact of the Early Mendicant Movement on Western Society*. New York: Longman, 1994.
———. *Medieval Monasticism: Forms of religious life in Western Europe in the Middle Ages* 4th edition. London: Routledge, 2015.
Lazar, Lance. *Working in the Vineyard of the Lord: Jesuit Confraternity in Early Modern Italy*. Toronto: University of Toronto Press, 2005.
Leaver, Robin. *Goostly Psalmes and Spiritual Songs: English and Dutch Metrical Psalms from Coverdale to Utenhove, 1535–1566*. Oxford: Oxford University Press, 1991.
LeBeau, Bryan and Menachem Mor, eds. *Pilgrims and Travelers to the Holy Land*. Omaha: Creighton University Press, 1996.
Leclerq, Jean. *The Love of Learning and the Desire for God*. Translated by Catherine Misrahi. New York: Fordham University Press, 1961.
LeGoff, Jacques. *The Birth of Purgatory*. Translated by Arthur Goldhammer. Chicago: University of Chicago Press, 1984.
Lehmann, Hartmut. "Pietism in the World of Transatlantic Religious Revivals." In *Pietism in Germany and North America, 1680–1820*, edited by Jonathan Strom, Hartmut Lehmann, and James Melton, 13–21. Burlington, VT: Ashgate, 2009.
Lekai, Louis. *The Cistercians: Ideals and Reality*. Kent, OH: Kent State University Press, 1977.
Leppin, Volker. "Luther's Roots in Monastic-Mystical Piety," in *Oxford Handbook of Martin Luther's Theology*, edited by Robert Kolb, Irene Dingel, and L'ubimir Bàtka, 49–61. Oxford: Oxford University Press, 2014.
———. "Martin Luther." In *A Companion to the Eucharist in the Reformation*, edited by Lee Wandel, 39–56. Leiden, Brill: 2014.

Lerner, Robert. *The Heresy of the Free Spirit in the Later Middle Ages.* Notre Dame: University of Notre Dame Press, 1972.
Lesnick, Daniel. *Preaching in Medieval Florence.* Athens, GA: University of Georgia Press, 1989.
Lester, Anne. *Creating Cistercian Nuns: The Women's Religious Movement and Its Reform in Thirteenth-Century Champagne.* Ithaca: Cornell University Press, 2011.
Leupold, Ulrich. *Luther's Works.* Minneapolis, MN: Fortress Press, 1965.
Leyser, Henrietta. *Hermits and the New Monasticism: A Study of Religious Communities in Western Europe, 1000–1150.* New York, 1984.
———. "Clerical Purity and the re-ordered world." In *The Cambridge History of Christianity: Volume 4 Christianity in the West, 1100–1500,* edited by Miri Rubin and Walter Simons, 11–21. Cambridge: Cambridge University Press, 2009.
Liechty, Daniel. *Early Anabaptist Spirituality.* Mahwah, NJ: Paulist, 1994.
Lin, Xiaoping. "Seeing the Place: The Virgin Mary in a Chinese Lady's Inner Chamber." In *Early Modern Catholicism,* edited by Kathleen Comerford and Hilmar Pabel, 183–210. Toronto: University of Toronto Press, 2001.
Lindberg, Carter, ed. *The Reformation Theologians.* Oxford: Blackwell, 2002.
Longenecker, Stephen. *Piety and Tolerance: Pennsylvania German Religion, 1700–1850.* London: Scarecrow, 1994.
Lothar of Segni (Innocent III). "De sacro altaris mysterio," *Patrologia Latina* edited by J-P Migne. (1844–1864), 217: 868.
Luibheid, Colm, ed. *Pseudo-Dionysius: The Complete Works.* New York: Paulist, 1987.
Luria, Keith "The Counter-Reformation and Popular Spirituality." In *Christian Spirituality: Post-Reformation and Modern,* edited by Louis Dupré and Don Saliers, 93–120. New York: Crossroads, 1996.
———. "'Popular Catholicism' and the Catholic Reformation." In *Early Modern Catholicism* edited by Kathleen Comerford and Hilmar Pabel, 114–30. Toronto: University of Toronto Press, 2001.
Lutton, Robert. "Richard Guldeford's Pilgrimage: Piety and Cultural Change in Late Fifteenth- and Early Sixteenth-Century England." *History* 98 (2013): 41–78.
Lutton, Robert. *Lollardy and Orthodox Religion in Pre-Reformation England.* Woodbridge, Suffolk: Boydell and Brewer, 2006.
Luxford, Julian, ed. *Studies in Carthusian Monasticism in the Late Middle Ages.* Tournhout, Belgium: Brepols, 2008.
Lynch, Joseph. *The Medieval Church.* New York: Longman, 1992.
MacCormick, Sabine. *Religion in the Andes: Vision and Imagination in Early Colonial Peru.* Princeton: Princeton University Press, 1991.
———. "Limits of Understanding: Perceptions of Greco-Roman and Amerindian Paganism in Early Modern Europe." In *America in European Consciousness: 1493–1750,* edited by Karen Kupperman 79–129. Chapel Hill: University of North Carolina Press, 1995.
MacCulloch, Dairmaid. *Thomas Cranmer: A Life.* New Haven: Yale University Press, 1996.
———. *The Later Reformation in England.* New York: Palgrave, 2001.
———. *The Reformation: Europe's House Divided.* New York: Viking, 2003.
———. *All Things Made New: The Reformation and its Legacy.* Oxford: Oxford University Press, 2016.
Maddox, Randy. *Responsible Grace: John Wesley's Practical Theology.* Nashville: Abingdon, 1994.
Marsden, George. *Jonathan Edwards: A Life.* New Haven: Yale University Press, 2003.
Marsh, Christopher. "Sacred Space in England, 1560–1640: The View from the Pew." *Journal of Ecclesiastical History* 53 (2002): 286–311.
Marshall, Peter. *Beliefs and the Dead in Reformation England.* Oxford: Oxford University Press, 2002.
———. "Lollards and Protestants Revisited." In *Wycliffite Controversies,* edited by Mishtooni Bose and Patrick Hornbeck, 295–318. Turnout: Brepols, 2012.

———. *1517: Martin Luther and the Invention of the Reformation*. Oxford: Oxford University Press, 2017.
Martin, Dennis, ed. *Carthusian Spirituality: The Writings of Hugh of Balma and Guigo de Ponte*. New York: Paulist, 1997.
Matarasso, Pauline. *The Cistercian World: Monastic Writings of the Twelfth Century*. London: Penguin, 1993.
Mathias, Markus. "Pietism and Protestant Orthodoxy" in *A Companion to German Pietism, 1660–1800*, edited by Douglas Shantz, 17–49. Leiden: Brill, 2015.
McCoog, Thomas. *The Society of Jesus in Ireland, Scotland, and England, 1589–1597*. Burlington, VT: Ashgate, 2012.
McCue, James. "The Doctrine of Transubstantiation from Berengar through Trent: The Point at Issue." Harvard Theological Review 61 (1968): 385–430.
McDowell, Ernest. *The Beguines and Beghards in Medieval Culture*. New Brunswick, NJ: Rutgers University Press, 1954.
McGrath, Alister. *Christian Spirituality: An Introduction*. Oxford: Blackwell, 1999.
———. *The Intellectual Origins of the European Reformations*. Oxford: Blackwell, 2004.
McGinn, Bernard. "The English Mystics." In *Christian Spirituality: High Middle Ages and Reformation*, edited by Jill Raitt, 94–107. New York: Crossroads, 1987.
———. *The Growth of Mysticism*. New York: Crossroad, 1996.
———. *The Flowering of Mysticism: Men and Women in the New Mysticism, 1200–1350*. New York: Crossroads, 1998.
———. *The Mystical Thought of Meister Eckhart: The Man from whom God hid Nothing*. New York: Crossroad, 2001.
———. *The Harvest of Mysticism in Medieval Germany*. New York: Crossroads, 2005.
———. *The Essential Writing of Christian Mysticism*. New York: Random House, 2006.
———. "The Spiritual Teachings of the Early Cistericians." In *The Cambridge Companion to the Cistercian Order* edited by Mette Bruun, 218–32. Cambridge University Press, 2012.
———. *The Varieties of Vernacular Mysticism (1350–1550)*. New York: Crossroad, 2012.
———. "Mysticism and the Reformation." *Acta Theologica* 35 (2015): 50–65.
McKee, Elsie. *John Calvin: Writings on Pastoral Piety*. New York: Paulist, 2001.
McLaughlin, Megan. *Sex, Gender, and Episcopal Authority in an Age of Reform, 1000–1122*. Cambridge: Cambridge University Press, 2010.
Megged, Amos. *Exporting the Catholic Reformation: Local Religion in Early Colonial Mexico*. Leiden: Brill, 1996.
Melvin, Karen. "Priests and Nuns in Colonial Ibero-America." In *Religion and Society in Latin America*, edited by Lee Penyak and Walter Petry, 100–14. Maryknoll, NY: Orbis, 2009.
Mentzer, Raymond. "The Reformed Churches of France and the Visual Arts." In *Seeing beyond the Word: Visual Arts and the Calvinist Tradition*, edited by Paul Finney, 199–230. Grand Rapids: Eerdmans, 1999.
Meuser, Fred. "Luther as preacher of the word of God." In *Cambridge Companion to Martin Luther*, edited by Donald McKim, 136–48. Cambridge: Cambridge University Press, 2003.
Miller, Maureen. *Power and the Holy in the Age of the Investiture Conflict*. New York: Palgrave Macmillan, 2005.
Miller, Tanya. *The Beguines of Medieval Paris*. Philadelphia: University of Pennsylvania Press, 2014.
Mills, Kenneth. *Idolatry and its Enemies: Colonial Andean Extirpation and Extirpation 1640–1750*. Princeton: Princeton University Press, 1997.
Minkema, Kenneth. "Jonathan Edwards: A Theological Life." In *The Princeton Companion to Jonathan Edwards*, edited by Sang Hyun Lee, 1–15. Princeton: Princeton University Press, 2005.
Miola, Robert, ed. *Early Modern Catholicism: An Anthology of Primary Sources*. Oxford: Oxford University Press, 2007.

Mitchell, Daria, ed. *Poverty and Prosperity: Franciscans and the Use of Money, Spirit, and Life*. New York: St. Bonaventure, 2009.
Moore, John, Brenda Bolton, James Powell, and Constance Rousseau, eds. *Pope Innocent III and His World*. Aldershot, UK: Ashgate, 1999.
Morinis, Alan, ed. *Sacred Journeys: The Anthropology of Pilgrimage*. Westport, CT: Greenwood, 1992.
Morris, Bridget. *St Birgitta of Sweden*. Woodbridge, Suffolk: Boydell, 1999.
Morris, Colin. *The Papal Monarchy: The Western Church from 1050–1250*. Oxford: Oxford University Press, 1991.
Muessig, Carolyn, ed. *Preacher, Sermon, and Audience in the Middle Ages*. Leiden: Brill, 2002.
Mulchahey, Michèle. *First the Bow is bent in study: Dominican Education before 1350*. Toronto: Pontifical Institute of Medieval Studies, 1998.
Muller, Richard. "John Calvin and Later Calvinism: The Identity of the Reformed Tradition." In *The Cambridge Companion to Reformation Theology*, edited by David Bagchi and David Steinmetz, 130–49. Cambridge: Cambridge University Press, 2004.
Muller, Richard and John Thompson, eds. *Biblical Interpretation in the Era of the Reformation*. Grand Rapids: Eerdmans, 1996.
Nabhan-Warren, Kristy. "The Place of Las Casas in Religious Studies." In *Approaches to Teaching the Writings of Bartolomé de Las Casas*, edited by Santa Arias and Eyda Merediz, 48–56. New York: Modern Language Association of America, 2008.
Newman, Martha. *The Boundaries of Charity: Cistercian Culture and Ecclesiastical Reform, 1098–1180*. Stanford: Stanford University Press, 1996.
Nilson, B. J. *Cathedral Shrines of Medieval England*. Woodbridge, Suffolk: Boydell, 1998.
Nimmo, Duncan. *Reform and Division in the Franciscan Order (1226–1538)*. Rome: Capuchin Historical Institute, 1987.
Nischan, Bodo. "The Exorcism Controversy and Baptism in the Late Reformation." *Sixteenth Century Journal* 18 (1987): 31–50.
Noble, Bonnie. *Lucas Cranach the Elder: Art and Devotion of the German Reformation*. Lanham, MD: University Press of America, 2009.
Noll, Mark, ed. *Confessions and Catechisms of the Reformation*. Grand Rapids, MI: Baker, 1991.
Oakley, Francis. *The Conciliarist Tradition: Constitutionalism in the Catholic Church, 1300–1870*. Oxford: Oxford University Press, 2003.
Oates, J.C.T. "Richard Pynson and the Holy Blood of Hayles." *The Library* 5.13 (1958): 250–77.
Oberman, Heiko. *The Dawn of the Reformation*. Edinburgh: T&T Clark, 1992.
———. "Martin Luther contra Medieval Monasticism: A Friar in the Lion's Den." In *Ad Fontes Lutheri: Toward Recovery of the Real Luther*, edited by Timothy Maschke, Franz Posset, and Joan Skocir, 183–213. Milwaukee, WI: Marquette University Press, 2001.
O'Callaghan, Joseph. *Reconquest and Crusade in Medieval Spain*. Philadelphia: University of Pennsylvania Press, 2003.
O'Malley, John. *The First Jesuits*. Cambridge, MA: Harvard University Press, 1993.
———. *Religious Culture in the Sixteenth Century: Preaching, Rhetoric, Spirituality, and Reform*. Aldershot, UK: Ashgate, 1993.
———. "Early Jesuit Spirituality: Spain and Italy." In *Christian Spirituality: Post-Reformation and Modern*, edited by Louis Dupré and Don Saliers, 3–27. New York: Crossroads, 1996.
———. *Trent and All That: Renaming Catholicism in the Early Modern Era*. Cambridge: Cambridge University Press, 2000.
———. "The Council of Trent (1545–1563) and Michelangelo's *Last Judgement* (1541)." *Proceedings of the American Philosophical Society* 156 (2012): 388–97.
———. *The Jesuits: A History from Ignatius to the Present*. Lanham, MD: Rowman & Littlefield, 2014.

O'Malley, John, Gauvin Bailey, Steven Harris, and Frank Kennedy, eds. *The Jesuits: Cultures, Sciences, and the Arts 1540–1773*, 3 Vols. Toronto: University of Toronto Press, 1999.
O'Sullivan, Daniel. *Marian Devotion in Thirteenth Century French Lyric*. Toronto: University of Toronto Press, 2005.
Outler, Albert. "Pietism and Enlightenment: Alternatives to Tradition." In *Christian Spirituality: Post-Reformation and Modern*, edited by Louis Dupré and Don Saliers, 240–56. New York: Crossroad, 1991.
Ozment, Steven. *Mysticism and Dissent*. New Haven: Yale University Press, 1973.
———. *The Age of Reform, 1250–1550*. New Haven: Yale University Press, 1980.
———. *When Fathers Ruled: Family Life in Reformation Europe*. Cambridge, MA: Harvard University Press, 1983.
Palmén, Ritva. *Richard of St. Victor's Theory of the Imagination*. Leiden: Brill, 2014.
Palazzo, Eric. *A History of Liturgical books from the Beginning to the Thirteenth Century*. Collegeville, MN: Liturgical Press, 1998.
Panofsky, Erwin. *Gothic Architecture and Scholasticism*. New York: NAL Penguin, 1951.
Pardo, Osvaldo. *The Origins of Mexican Catholicism: Nahua Rituals and Christian Sacraments in Sixteenth-Century Mexico*. Ann Arbor MI: University of Michigan Press, 2004.
Parish, Helen. *Clerical Marriage and the English Reformation*. Burlington, VT: Ashgate, 2000.
Parker, T. H. L. *Calvin's Preaching*. Louisville: John Knox, 1992.
Pauck, Wilhelm, ed. *Luther: Lectures on Romans*. Philadelphia: Westminster, 1961.
Payne, John. *Erasmus: His Theology of the Sacraments*. Richmond, VA: John Knox, 1970.
Payne, Steven, ed. *The Carmelite Tradition*. Collegeville: Liturgical Press, 2011.
Pelikan, Jaroslav. *Mary through the Centuries: Her Place in the History of Culture*. New Haven: Yale University Press, 1996.
Pelikan, Jaroslav, Valerie Hotchkiss, and David Price, *The Reformation of the Bible / The Bible of the Reformation* New Haven and Dallas: Yale University Press and Bridwell Library, 1996.
Pereira, José and Robert Fastiggi. *The Mystical Theology of the Catholic Reformation*. Lanham, MD: University Press of America, 2006.
Pérez, Joseph. *The Spanish Inquisition: A History*. New Haven: Yale University Press, 2005.
Petit, Francious. *Spirituality of the Premonstratensians: The Twelfth and Thirteenth Centuries*. Collegeville, MN: Liturgical Press, 2011.
Pettegree, Andrew. "European Calvinism: History, Providence, and Martydom." In *The Church Retrospective*, edited by Robert Swanson, 227–52. Woodbridge: Boydell, 1997.
Petkov, Kiril. *The Kiss of Peace: Ritual, Self, and Society in the High and Late Medieval West*. Leiden: Brill, 2003.
Pfaff, Richard. *New Liturgical Feasts in Late Medieval England*. Oxford: Oxford University Press, 1970.
———. "Lanfranc's supposed purge of the Anglo-Saxon Calendar." In *Warriors and Churchmen in the High Middle Ages*, edited by Timothy Reuter, 95–108. London: Hambledon, 1992.
———. *The Liturgy in Medieval England: A History*. Cambridge: Cambridge University Press, 2009.
Pitkin, Barbara. "'The Heritage of the Lord': Children in the Theology of John Calvin." In *The Child in Christian Thought*, edited by Marcia Bunge, 181–86. Grand Rapids, MI: Eerdmans, 2000.
Plank, Ezra. "Domesticating God: Reformed Homes and the Relocation of Sacred Space." In *Emancipating Calvin: Studies on Huguenot Community and Culture in Honor of Raymond Mentzer*, edited by Karen Spierling, Ward Holder, and E. A. de Boer. Leiden: Brill, 2017.

Plummer, Marjorie Elizabeth. *From Priest's Whore to Pastor's Wife: Clerical Marriage and the Process of Reform in the Early German Reformation*. Farnham, UK: Ashgate, 2012.
Poole, Stafford. *Our Lady of Guadalupe: The Origins and Sources of a Mexican National Symbol, 1531–1797*. Tucson: University of Arizona Press, 1995.
Poor, Sara. *Mechthild of Magdeburg and her Book: Gender and the Making of Textual Authority*. Philadelphia: University of Pennsylvania Press, 2004.
Poor, Sara and Nigel Smith, "Introduction." In *Mysticism and Reform, 1400–1750*, edited by Sara Poor and Nigel Smith, 1–28. Notre Dame: University of Notre Dame Press, 2015.
Quantz, Amanda. "At Prayer in the Shadow of the Tree of Life." In *Franciscans at Prayer*, edited by Timothy Johnson, 333–55. Leiden: Brill, 2007.
Radding, Charles and William Clark, *Medieval Architecture, Medieval Learning: Builders and Masters in the Age of Romanesque and Gothic*. New Haven: Yale University Press, 1992.
Radding, Charles and Francis Newton, *Theology, Rhetoric, and Politics in the Eucharistic Controversy, 1078–1079*. New York: Columbia University Press, 2003.
Reid, J. K. S., ed. *Calvin: Theological Treatises*. Philadelphia: Westminster, 1954.
Reilly, Diane. "Art." In *The Cambridge Companion to the Cistercian Order*, edited by Mette Bruun, 125–39. Cambridge: Cambridge University Press, 2013.
Rennie, Kriston. *Law and Practice in the Age of Reform*. Turnhout: Brepols, 2010.
Rennis, Austria. *Reforming the Art of Dying: The* Ars Moriendi *in the German Reformation, 1519–1528*. Burlington, VT: Ashgate, 2007.
Rex, Richard. *The Lollards*. New York: Palgrave, 2002.
Ricard, Robert. *The Spiritual Conquest of Mexico* trans. Lesley Byrd-Simpson. Berkeley: University of California Press, 1966.
Rittgers, Ronald. *The Reformation of the Keys: Confession, Conscience, and Authority in Sixteenth-Century Germany*. Cambridge, MA: Harvard University Press, 2004.
Roberts, Penny. "Contesting Sacred Space: Burial Disputes in Sixteenth-Century France," In *The Place of the Dead: Death and Remembrance in Late Medieval and Early Modern Europe*, edited by Bruce Gordon and Peter Marshall, 131–48. Cambridge: Cambridge University Press, 2000.
Robinson, I. S. *The Papacy 1073–1198*. Cambridge: Cambridge University Press, 1990.
———. *The Papal Reforms of the Eleventh Century*. Manchester: Manchester University Press, 2004.
Rogers, Elizabeth. "Peter Lombard and the Sacramental System." PhD diss., Columbia University, 1917.
Rorem, Paul. *Calvin and Bullinger on the Lord's Supper*. Nottingham: Grove, 1989.
Rosemann, Philipp. *Peter Lombard*. Oxford: Oxford University Press, 2004.
Rothenberg, David. *The Flower of Paradise: Marian Devotion and Secular Song in Medieval and Renaissance Music*. Oxford: Oxford University Press, 2011.
Rubin, Miri. *Corpus Christi: The Eucharist in Late Medieval Culture*. Cambridge: Cambridge University Press, 1991.
———. "Choosing Death? Experiences of Martyrdom in Late Medieval Europe." In *Martyrs and Martyrologies. Papers Read at the 1992 Summer Meeting and the 1993 Winter Meeting of the Ecclesiastical History Society*, edited by Diana Wood, 153–83. Oxford: Blackwell, 1993.
———. *Mother of God: A History of The Virgin Mary*. New Haven: Yale University Press, 2009.
———. "The Sacramental Life." In *The Cambridge History of Christianity: Volume 4 Christianity in the West, 1100–1500*, edited by Miri Rubin and Walter Simons, 219–37. Cambridge: Cambridge University Press, 2009.
Rummel, Erika. "Theology of Erasmus." In *The Cambridge Companion to Reformation Theology*, edited by David Bagchi and David Steinmetz, 28–38. Cambridge: Cambridge University Press, 2004.
Rupp, Gordon and Philip Watson, eds. *Luther and Erasmus: Free Will and Salvation*. Philadelphia: Westminster Press, 1969.

Ryrie, Alec. *Being Protestant in Reformation Britain*. Oxford: Oxford University Press, 2013.
Scase, Wendy. "Lollardy." In *The Cambridge Companion to Reformation Theology*, edited by David Bagchi and David Steinmetz, 15–21. Cambridge: Cambridge University Press, 2004.
Scheepsma, Wybren. *Medieval Religious Women in the Low Countries*, trans. David Johnson. Woodbrdridge, UK: Boydell, 2004.
Schilling, Heinz. "Confessionalization: Historical and Scholarly Perspectives of a Comparative and Interdisciplinary Paradigm." In *Confessionalization in Europe, 1555–1700*, edited by John Headley, Hans Hillerbrand, and Anthony Papalas, 21–35. Burlington, VT: Ashgate, 2004.
Schlachta, Astrid von. "Anabaptists and Pietists: Influences, Contacts, and Relations." In *A Companion to German Pietism, 1660–1800*, edited by Douglas Shantz, 116–38. Leiden: Brill, 2015.
Schneider, Hans. *German Radical Pietism*. Lanham, MD: Scarecrow, 2007.
Schwartz, Stuart. *Victors and Vanquished: Spanish and Nahua View of the Conquest of Mexico*. Boston: Bedford/St. Martins, 2000.
Scribner, Bob. "Popular Piety and Modes of Visual Perception in Late Medieval and Reformation Germany." *Journal of Religious History* 15 (1989): 448–69.
Selderhuis, Herman. *Marriage and Divorce in the Thought of Martin Bucer*. Translated by John Vriend and Lyle Bierma. Kirksville, MO: Thomas Jefferson University Press, 1999.
Shagan, Ethan. *Popular Politics and the English Reformation*. Cambridge: Cambridge University Press, 2003.
Shantz, Douglas. *An Introduction to German Pietism: Protestant Renewal at the Dawn of Modern Europe*. Baltimore: Johns Hopkins University Press, 2013.
Shattauer, Thomas. "From Sacrifice to Supper: Eucharistic Practice in the Lutheran Reformation," In *A Companion to the Eucharist in the Reformation*, edited by Lee Wandel, 205–30. Leiden, Brill: 2014.
Sheldrake, Phillip. *Spirituality and History*. London: SPCK, 1991.
Shinners, John, ed. *Medieval Popular Religion, 1000–1500: A Reader*. Toronto: University of Toronto Press, 1997.
———. "The Veneration of the Saints at Norwich Cathedral in the Fourteenth Century." *Norfolk Archaeology* 40 (1988): 133–44.
Short, William. "The Rule and Life of the Friars Minor." In *The Cambridge Companion to Francis of Assisi*, edited by Michael Robson, 55–67. Cambridge: Cambridge University Press, 2012.
Shrady, Maria, ed. *Johannes Tauler: Sermons*. New York: Paulist, 1985.
Simons, Walter. *Cities of Ladies: Beguine Communities in the Medieval Low Countries, 1200–1565*. Philadelphia: University of Pennsylvania Press, 2001.
Smith, James K.A. *Desiring the Kingdom: Worship, Worldview, and Cultural Formation*. Grand Rapids, MI: Baker, 2009.
Snoek, G. J. C. *Medieval Piety from Relics to the Eucharist: A Process of Mutual Interaction*. Leiden: Brill, 1995.
Somerset, Fiona. *Feeling like Saints: Lollard Writings after Wyclif*. Ithaca, NY: Cornell University Press, 2014.
Somerville, Robert. *Pope Urban II's Council of Piacenza*. Oxford: Oxford University Press, 2011.
Spencer, Leith. *English Preaching in the Late Middle Ages*. Oxford: Oxford University Press, 1993.
Spicer, Andrew. "'Rest of their bones': Fear of Death and Reformed Burial Practices." In *Fear in Early Modern Society*, edited by William Naphy and Penny Roberts, 167–83. Manchester: Manchester University Press, 1997.
———. "Iconoclasm and Adaption: The Reformation of the Churches in Scotland and the Netherlands." In *The Archaeology of the Reformation, 1480–1580*, edited by D. Gaimster and R. Gilchrist, 29–43. Leeds: Maney, 2003.

———. "'God will have a house': Defining Sacred Space and Rites of Consecration in Seventeenth-Century England." In *Defining the Holy: Scared Space in Medieval and Early Modern Europe*, edited by Andrew Spicer and Sarah Hamilton, 207–30. Aldershot: Ashgate, 2005.

———. "Sites of the Eucharist." In *A Companion to the Eucharist in the Reformation*, edited by Lee Wandel, 323–64. Leiden: Brill 2014.

Spicer, Andrew and Sarah Hamilton, "Defining the Holy: The Delineation of Sacred Space." In *Sacred Space in Medieval and Early Modern Europe*, edited by Andrew Spicer and Sarah Hamilton, 1–26. Aldershot, U.K.: Ashgate, 2006.

Spierling, Karen. *Infant Baptism in Reformation Geneva: The Shaping of a Community, 1536–1564*. Aldershot, UK: Ashgate, 2005.

———. "Honor and Subjection in the Lord: Paul and the Family in the Reformation." In *A Companion to Paul in the Reformation*, edited by Ward Holder, 465–500. Leiden: Brill, 2009.

Spierling, Karen and Michael Halvorson, eds. *Defining Community in Early Modern Europe*. Burlington, VT: Ashgate, 2008.

Spinks, Bryan. *Reformation and Modern Rituals and Theologies of Baptism: From Luther to Contemporary Practice*. Aldershot, UK: Ashgate, 2006.

———. *Do This in Remembrance of Me: The Eucharist from the Early Church to the Present Day*. Norwich, UK: SCM, 2013.

Spruyt, Bart, ed. *Cornelius Henri Hoen (Honius) and His Epistle on the Eucharist (1525)*. Leiden: Brill, 2006.

Spurr, John. *The Restoration Church of England, 1646–1689*. New Haven: Yale University Press, 1991.

Stanwood, Paul, ed. *William Law, A Serious Call to a Devout and Holy Life and The Spirit of Love*. New York: Paulist, 1978.

Stein, James. "Philip Jakob Spener (1635–1705)." In *The Pietist Theologians: An Introduction to Theology in the Seventeenth and Eighteenth Centuries*, edited by Carter Lindberg, 84–99. Oxford: Blackwell, 2005.

Steinmetz, David. "The Council of Trent." In *The Cambridge Companion to Reformation Theology*, edited by David Bagchi and David Steinmetz, 233–47. Cambridge: Cambridge University Press, 2004.

Stephens, W. P. *Zwingli: An Introduction to his Thought*. Oxford: Oxford University Press, 1992.

Sternberg, Maximilian. *Cistercian Architecture and Medieval Society*. Leiden: Brill, 2013.

Strauss, Gerald. *Luther's House of Learning Indoctrination of the Young in the German Reformation*. Baltimore: Johns Hopkins University Press, 1978.

———. "Ideas of *Reformatio* and *Renovatio* from the Middle Ages to the Reformation." In *Handbook of European History, 1400–1600*, edited by Thomas Brady, Jr., Heiko Oberman, and James Tracy, 1–30. Leiden: Brill, 1995.

Strohl, Jane. "Luther's *Fourteen Consolations*," In *The Pastoral Luther: Essays on Martin Luther's Practical Theology*, edited by Timothy Wengert, 310–24. Grand Rapids, MI: Eerdmans, 2009.

Stroll, Mary. *Popes and Antipopes: The Politics of Eleventh Century Church Reform*. Leiden: Brill, 2009.

Suso, Heinrich. *Wisdom's Watch upon the Hours*. Translated by Edmund Colledge. Washington, DC: Catholic University of America Press, 1994.

Swanson, R. N. *Religion and Devotion in Europe, c. 1215–1515*. Cambridge: Cambridge University Press, 1995.

Tanner, Norman, ed. *The Decrees of the Ecumenical Councils* 2 vols. London: Sheed and Ward, 1990.

Tavárez, David, and John Chuchiak. "Conversion and the Spiritual Conquest." In *Religion and Society in Latin America*, edited by Lee Penyak and Walter Petry, 66–82. Maryknoll, NY: Orbis, 2009.

Taylor, Larissa. *Preachers and People in the Reformations and Early Modern Period*. Leiden: Brill, 2001.

Temperley, Nicholas. *Studies in English Church Music 1550–1900.* Aldershot, UK: Ashgate, 2009.
Thompson, Bard, ed. *Liturgies of the Western Church.* Cleveland: Meridian, 1961.
Thompson, Nicholas. *Eucharistic Sacrifice and Patristic Tradition in the Theology of Martin Bucer, 1534–1546.* Leiden: Brill, 2005.
Tindal, Matthew. *Christianity as Old as the Creation.* London: 1730.
Tobin, Frank, ed. *Mechthild of Magdeburg, The Flowing Light of the Godhead.* New York: Paulist, 1998.
———. ed. *Henry Suso: The Exemplar with two German Sermons.* New York: Paulist, 1989.
Tomkinson, Diane. "Angela of Foligno's Spiral Pattern of Prayer." In *Franciscans at Prayer,* edited by Timothy Johnson, 195–219. Leiden: Brill, 2007.
Torell, Jean-Pierre. *Christ and Spirituality in St. Thomas Aquinas.* Washington, DC: Catholic University of America Press, 2011.
Turner, Denys. *The Darkness of God: Negativity in Christian Mysticism.* Cambridge: Cambridge University Press, 1995.
Turner, Victor and Edith Turner, *Image and Pilgrimage in Christian Culture.* New York: Columbia University Press, 1978.
Turrell, James. "'Until Such Time as He Be Confirmed': The Laudians and Confirmation in the Seventeenth-Century Church of England." *The Seventeenth Century* 20 (2005): 204–22.
Tracy, James. "Ad Fontes: The Humanist Understanding of Scripture as Nourishment for the Soul," in *Christian Spirituality: High Middle Ages and Reformation,* edited by Jill Raitt, 252–67. New York: Crossroad, 1987.
———. *Europe's Reformations, 1450–1650: Doctrines, Politics, and Community.* Lanham, MD: Rowman and Littlefield, 2006.
Trickett, David. "Spiritual Vision and Discipline in the Early Wesleyan Movement." In *Christian Spirituality: Post-Reformation and Modern,* edited by Louis Dupré and Don Saliers, 354–71. New York: Crossroads, 1996.
Trigg, Jonathan. *Baptism in the Theology of Martin Luther.* Leiden: Brill, 2001.
Trueman, Carl. "Lewis Bayly (d. 1631) and Richard Baxter (1615–1691)." In *The Pietist Theologians: An Introduction to Theology in the Seventeenth and Eighteenth Centuries,* edited by Carter Lindberg, 52–67. Oxford: Blackwell, 2005.
Tugwell, Simon, ed. *Early Dominicans: Selected Writings.* Mahwah, NJ: Paulist, 1982.
———. "The Spirituality of the Dominicans" in *Christian Spirituality: High Middle Ages and Reformation,* edited by Jill Raitt, 15–31. New York: Crossroad, 1987.
———, ed. *Albert and Thomas.* New York: Paulist, 1988.
Tylenda, Joseph. "The Ecumenical Intention of Calvin's Early Eucharistic Teaching." In *Reformatio Perennis,* edited by B. A. Gerrish, 27–41. Eugene, OR: Pickwick, 1981.
———, ed. *A Pilgrim's Journey: The Autobiography of Ignatius of Loyola.* San Francisco: Ignatius, 2001.
Usher, Brett. *Lord Burghley and Episcopacy, 1577–1603.* New York: Routledge, 2016.
Vallance, Aymer. *English Church Screens.* London: Batsford, 1947.
Vanderputten, Steven. *Monastic Reform as Process: Realities and Representations in Medieval Flanders, 900–1100.* Ithaca, NY: Cornell University Press, 2013.
Van Engen, John. "The "Crisis of Cenobitism" Reconsidered: Benedictine Monasticism in the Years 1050–1150." *Speculum* 61 (1986): 269–304.
———, ed. *Devotio Moderna: Basic Writings.* New York: Paulist, 1988.
———. *Sisters and Brothers of the Common Life: The Devotio Moderna and the World of the Late Middle Ages.* Philadelphia: University of Pennsylvania Press, 2008.
Van Nieuwenhove, Rik. *Jan van Ruusbroec, Mystical Theologian of the Trinity.* Notre Dame: University of Notre Dame Press, 2003.
Vincent, Nicholas. *The Holy Blood: King Henry III and the Westminster Blood Relic.* Cambridge: Cambridge University Press, 2001.
Voaden, Rosalyn. *God's Words, Women's Voices: The Discernment of Spirits in the Writing of Late-Medieval Women Visionaries.* Woodbridge, Suffolk: Boydell, 1999.

Wabuda, Susan. *Preaching during the English Reformation*. Cambridge: Cambridge University Press, 2002.
Waller, Gary. *The Virgin Mary in Late Medieval and Early Modern English Literature and Popular Culture*. Cambridge: Cambridge University Press, 2011.
Wallman, Johannes. "Johan Arndt (1555–1621)." In *The Pietist Theologians: An Introduction to Theology in the Seventeenth and Eighteenth Centuries*, edited by Carter Lindberg, 21–37. Oxford: Blackwell, 2005.
Wandel, Lee. *Voracious Idols and Violent Hands: Iconoclasm in Reformation Zurich, Strasbourg, and Basel*. Cambridge: Cambridge University Press, 1994.
———. *The Reformation: Towards a New History*. Cambridge: Cambridge University Press, 2011.
Ward, Benedicta. *Miracles and the Medieval Mind: Theory, Record, and Event, 1000–1215*. Philadelphia: University of Pennsylvania Press, 1987.
Watt, Jeffrey. *The Making of Modern Marriage: Matrimonial Control and the Rise of Sentiment in Neuchâtel, 1550–1800*. Ithaca, NY: Cornell University Press, 1992.
———. "Women and the Consistory in Calvin's Geneva." *Sixteenth Century Journal* 24 (1993): 429–39.
———. "Calvinism, Childhood, and Education: The Evidence from the Genevan Consistory." *Sixteenth Century Journal* 33 (2002): 439–56.
Weaver-Zearcher, David. *Martyr's Mirror: A Social History*. Baltimore: Johns Hopkins University Press, 2016.
Wengert, Timothy. "The Small Catechism." In *The Pastoral Luther: Essays on Martin Luther's Practical Theology*, edited by Timothy Wengert, 201–52. Grand Rapids, MI: Eerdmans, 2009.
Webb, Diana. *Pilgrimage in Medieval England*. London: Hambledon, 2000.
———. *Medieval European Pilgrimage, c. 700–c. 1500*. London: Houndsmill, 2002.
Weber, Alison. "Gender." In *The Cambridge Companion to Christian Mysticism*, edited by Amy Hollywood and Patricia Beckman, 315–57. Cambridge: Cambridge University Press, 2012.
Wendebourg, Dorothea. "Luther on Monasticism." In *The Pastoral Luther: Essays on Martin Luther's Practical Theology*, edited by Timothy Wengert, 327–54. Grand Rapids, MI: Eerdmans, 2009.
White, Francis. *A Treatise of the Sabbath Day*. London: 1635.
Whiting, Robert. *The Blind Devotion of the People: Popular Religion and the English Reformation*. Cambridge: Cambridge University Press, 1989.
Williams, Rowan. "Three Styles of Monastic Reform." In *The Influence of St. Bernard*, edited by Benedicta Ward, 24–40. Oxford: Sisters of the Love of God, 1976.
———. *Why Study the Past?: The Quest for The Historical Church*. Grand Rapids: Eerdmans, 2005.
Willis, Jonathan. *Church Music and Protestantism in Post-Reformation England*. Aldershot, UK: Ashgate, 2010.
Wilson, Samuel, ed. *The Indigenous People of the Caribbean*. Gainesville, University Press of Florida, 1997.
Windeatt, Barry, ed. *English Mystics of the Middle Ages*. Cambridge: Cambridge University Press, 1994.
Wiggin, Bethany. "Sister Marcella, Marie Christine Sauer (d. 1752), and the Chronicle of the Sisters of Ephrata." In *Mysticism and Reform, 1400–1750*, edited by Sara Poor and Nigel Smith, 295–320. Notre Dame: University of Notre Dame Press, 2015.
Wright, Jonathan. *God's Soldiers: Adventure, Politics, Intrigue, and Power: A History of the Jesuits*. New York: Doubleday, 2004.
Yoder, Peter. "Rendered 'Odious' as Pietists: Anton Wilhelm Böhme's Conception of Pietism and the Possibilities of Prototype Theory." In *The Pietist Impulse in Christianity*, ed. Christian Winn, Christopher Gehrz, William Carlson, and Eric Holst, 17–26. Eugene, OR: Pickwick, 2011.
Yü, Chün-fang. *Kuan-yin: The Chinese Transformation of Avalokitesvara*. New York: Columbia University Press, 2001.

Zika, Charles. "Hosts, Processions, and Pilgrimage in Fifteenth Century Germany." *Past and Present* 118 (1998): 25–64.

Zinn, Grover, ed. *Richard of St. Victor: The Twelve Patriarchs, The Mystical Ark, Book Three of the Trinity*. New York: Paulist, 1979.

Zumkeller, Adolar. "Spirituality of the Augustinians." In *Christian Spirituality: High Middle Ages and Reformation*, edited by Jill Raitt, 63–72. New York: Crossroads, 1987.

Zupanov, Ines, *The Catholic Frontier in India (16th–17th Centuries)*. Ann Arbor: University of Michigan Press, 2005.

Index of Persons

Aelred of Rievaulx, 59, 66
d'Ailly, Pierre, 101, 103, 113
Angela of Foligno, 68
Albert the Great, 67, 118
Alexander VI, pope, 43, 103, 196
Alexander of Hales, 11
Ames, William, 133
Aquinas, Thomas, 5, 14, 15–16, 26, 35, 44, 67, 83, 118, 119, 140, 200, 204
Arnold, Gottfriend, 231–232
Arndt, Johann, 228–229
Arundel, Thomas, 106
Asbury, Francis, 242
Augustine of Hippo, 40, 43–44, 60, 61, 66, 69, 72, 85, 106, 107, 110, 111, 152, 167, 181, 198, 215, 233

Ball, John, 104, 113
Barton, Elizabeth, 217
Baxter, Richard, 226–227
Beaufort, Lady Margaret, 14
Becket, Thomas, 37–38, 39, 41, 42, 151
Beissel, Conrad, 237
Benedict of Aniane, 55
Berengar of Tours, 10–11, 118
Bernard of Clairvaux, 33–35, 57–59, 61, 62, 77, 80–81, 83, 122, 151, 236
Beza, Theodore, 135
Biel, Gabriel, 87
Blaurock, George, 131
Boehme, Jacob, 228, 231, 237
Bonaventure, 35, 69, 77
Boniface, missionary, 198
Boniface VIII, pope, 40, 42–43, 100
Bonito, Roger da, 40
Borromeo, Carlo, 183
Bucer, Martin, 124, 126, 127, 130, 133, 165–166, 168, 177, 179, 219
Bugenhagen, Johannes, 130
Bunyan, John, 226

Braght, Thieleman van, 221–222
Bridget of Sweden, 25
Brown, Peter, 36
Bruno of Cologne, 62
Bullinger, Heinrich, 121, 124, 126–128, 132–133, 143, 145, 164, 166, 167, 168
Byrd, William, 155

Cajetan, Thomas, 178
Calixtus II, pope, 53
Calvin, John, 126–128, 132–135, 140–141, 143–144, 145, 149, 150–151, 152, 154, 161, 168, 179, 186, 201, 214, 218, 219, 233, 250, 251
Canisius, Peter, 183
Campeggio, Lorenzo, 178
Cartwright, Thomas, 226
Catherine of Siena, 80, 100
Campion, Edmund, 222
Charles I of England, 227
Charles V, emperor, 125, 127, 177, 178, 180–181, 200, 204, 209, 217
Chaucer, Geoffrey, 41, 43, 64, 105
Chemnitz, Martin, 187
Cisneros, Garcias de, 185
Cisneros, Ximenes de, 204
Clare of Assisi, 69
Clement II, pope, 50
Clement V, pope, 26, 100
Clement VII, antipope elected 1378, 101, 104
Clement VII, pope, 178
Cnut of England, 40
Coke, Thomas, 242
Columbus, Christopher, 195–196, 199, 209
Congar, Yves, 171
Cortés, Hernán, 198
Cousin, John, 169–170
Coverdale, Myles, 144

Cranach, Lucas, 149
Cranmer, Thomas, 18, 127, 130, 133, 141–142, 145, 151, 152, 154, 165, 169, 182, 217–219, 223, 227–228
Crespin, Jean, 219
Cuthbert, 39, 42

Damian, Peter, 50
Dante Aligheri, 35
de Sales, Francis, 4, 184, 188–190, 235, 236
Dominic Guzman, 33, 64–65, 66
Dürer, Albrect, 111

Eckhart, Meister, 82–85, 87, 88, 191
Edward VI of England, 145, 151, 164, 165, 226
Edwards, Jonathan, 238–239
Egeria, 39
Elizabeth I of England, 144–145, 151–152, 155, 165, 220
Elizabeth, Anabaptist martyr, 221
Erasmus, Desiderius, 79, 109–113, 121, 122, 141, 148
Eugene III, pope, 57, 58

Fasolt, Constantine, 249
Fénelon, Francois, 235–236
Ferdinand of Aragon, 195–196, 204, 209, 216
Flacius, Matthias, 126
Francis of Assisi, 5, 68–69, 84
Francke, August Hermann, 230
Foley, Edward, 15
Foxe, John, 105, 154, 219–221

Gama, Vasco da, 196, 206, 209
Gerson, Jean, 24, 86, 97, 101–103
Greenham, Richard, 226
Gregory I (the Great), pope, 24, 25, 51, 58, 82, 147, 198, 215
Gregory VII, pope, 10, 40, 50–53
Gregory IX, pope, 69, 71, 215
Gregory XI, pope, 100, 104
Gregory XIII, pope, 191
Gregory, Brad, 216, 248–249
Groote, Geert, 88, 96
Gui, Bernardo, 66
Guigo II, 98

Guyon, Madam, 235–236

Hadewijch of Brabant, 81
Haemstede, Adriaen van, 219
Harding, Stephen, 57
Hart, William, 222
Harpsfield, Nicholas, 221
Helena, 36
Henry II of England, 42
Henry II of France, 180
Henry IV, emperor, 53
Henry VIII of England, 26, 42, 125, 144, 151, 162, 164, 165, 167, 169, 178, 217, 220, 221
Henry of Ghent, 80
Herbert, George, 146, 227
Hilton, Walter, 89–90
Hoen, Cornelius, 121–122
Hooker, Richard, 133, 145, 146
Honorius III, pope, 65, 68
Hubmaier, Balthasar, 131
Hugh of Balma, 63
Hugh of Cluny, 52
Hugh of Lincoln, 31
Hugh of St. Cher, 65
Hugh of St. Victor, 61
Humbert of Romans, 65
Humbert of Silva-Candida, 10, 51
Hus, Jan, 102, 103, 105, 107–108, 216, 232, 247
Hutton, Matthew, 165

Ignatius of Loyola, 63, 109, 148, 180, 184–189, 198, 207, 209
Innocent III, pope, 12, 64, 68, 101, 118
Innocent IV, pope, 71
Innocent X, pope, 234
Innocent XI, pope, 234
Irenaeus of Lyon, 32
Isabella of Castille, 195–196, 205, 216
Isabella Wilson, 242

James of Voragine, 139, 184
Jansen, Cornelius, 233–234
Jerome, 3, 7n3, 11, 32, 36, 45, 109, 110, 111, 215
Jerome of Prague, 105
Joachim of Fiore, 215
John of Gaunt, 104

Index of Persons

John of Leiden, 217
John of the Cross, 71, 191–193, 236
John George of Saxony, 135
Jonas, Justus, 130, 165
Joye, George, 125
Julian of Norwich, 5
Juliana of Cornillon, 25
Julius II, pope, 102
Julius III, pope, 180
Justin Martyr, 197, 206

Karlstadt, Andreas, 123, 131, 148, 164
Kempe, Margery, 27, 214
Kempis, Thomas, 5, 90, 98–99, 185, 240

Lanfranc of Bec, 10, 54
Langland, William, 113
Las Casas, Bartolomé de, 197, 203–205
Latimer, Hugh, 146, 217, 218
Laud, William, 227–228
Law, William, 239–240
Le Bégue, Lambert, 94
Leo IX, pope, 50, 52–53
Leo X, pope, 71, 109
Lombard, Peter, 118, 142
Ludolf of Saxony, 63, 148, 184–185
Luther, Martin, 1, 7, 11, 33, 43, 72, 84, 84–87, 99–100, 105, 106, 107, 109–113, 160, 177–179, 180, 181, 213, 221, 228, 229–230, 231, 240, 247, 250, 251; and art and sacred space, 148–149, 151, 152; and care for the sick, 169; and marriage and family, 161, 163–165; and music, 153; and preaching, 140–144; and sacraments, 117–122, 124, 127, 128–130, 131, 133–134, 135

Mack, Alexander, 231
Manz, Felix, 131, 217
Marguerite de Navarre, 108
Marot, Clement, 154
Mary, Mother of Jesus, 31–35, 42, 71, 147, 148, 149, 184, 188, 189, 201–202, 207, 209
Mary of Oignes, 96
Mary I of England, 144, 151, 152, 180, 217, 219, 220, 226
Mary II of England, 239

McGinn, Bernard, 4, 7n2, 78, 81
Mechthild of Magdeburg, 81–82, 84, 93
Merbecke, John, 154
Michelangelo Buonarotti, 193, 214
Mirk, John, 25, 103, 140, 145
Molinos, Miguel de, 235
More, Thomas, 109, 122, 125, 144, 217, 218, 219, 221
Muhlenberg, Heinrich, 237

Nicholas II, pope, 53
Nicholas of Cusa, 22, 27, 88, 102
Nicholas the Frenchman, 71–72
Nobili, Roberto, 206
Nogaret, Guillaume de, 40, 100

Oberman, Heiko, 86
Oecolampadius, Johann, 110, 121, 127
Osiander, Andreas, 130

Palestrina, Giovanni, 156
Panofsky, Erwin, 15
Parker, Matthew, 155, 165, 167
Pascal, Blaise, 234
Paschasius Radbertus, 11
Paul, apostle, 14, 32, 36, 67, 79, 85, 119, 152, 163, 197
Paul III, pope, 178, 186, 204
Paul IV, pope, 110, 180
Peter, apostle, 37, 40, 42, 50, 178, 214
Peter of Capua, 118
Peter the Chanter, 17
Petersen, Johanna Eleonora, 231
Petrarch, Francesco, 100, 108
Philip of Hesse, 124, 167, 178
Pius II, pope, 103, 177
Pius V, pope, 182
Pole, Reginald, 177, 179, 180, 221
Porete, Marguerite, 80, 95
Pseudo-Dionysius, 67, 79, 84, 85, 89, 185, 189, 191, 192

Radewijns, Florens, 96
Ranke, Leopold von, 249
Ratramnus of Corbie, 11
Ricci, Matteo, 197, 207–209
Richard II of England, 104
Richard of St. Victor, 58
Robert of Molseme, 56

Rolle, Richard, 89, 90
Ruusbroec, Jan van, 84, 88

Scotus, John Duns, 23, 35
Seabury, Samuel, 242
Servetus, Michael, 218
Sherman, William Tecumseh, 205
Spener, Phillip Jakob, 229–230, 231, 232, 237
Sternhold, Thomas, 154
Stock, Simon, 33, 71
Suso, Henry, 83–84

Tallis, Thomas, 155
Tauler, John, 83–87, 88
Taylor, Jeremy, 166, 169, 227, 239, 240
Teresa of Avila, 71, 190–193, 198, 200, 235, 236
Tertullian, 197–198, 215
Thomas of Villanova, 72
Tyndale, William, 144

Urban II, pope, 34, 54, 55, 59, 60
Urban IV, pope, 25–26
Ubertino of Casale, 69–71

Vermigli, Peter Martyr, 168
Vitry, Jaques de, 40, 96

Waldo, Peter, 65
Wesley, John, 154, 232, 239–242
Wesley, Charles, 240, 242
Wied, Hermann von, 130
William of Aquitaine, 50, 51, 54
William of Auxerre, 14
William of Champeaux, 61
William I of England (the Conqueror), 10
William III of England (of Orange), 239
William of Ockham, 11, 86
William of St. Thierry, 58
Williams, Rowan, 56
Wilson, Isabella, 242
Willems, Dirk, 221–222
Whitefield, George, 239, 240, 241–242
Wren, Matthew, 171
Wycliffe, John, 102, 103–108, 113, 247

Xavier, Francis, 186, 187, 206

Zinzendorf, Nicholas Ludwig von, 232
Zwingli, Ulrich, 110, 113, 121–125, 126, 127, 130–133, 134, 140–141, 144, 149–150, 153

Index of Subjects

Albigensians. *See* Cathars
Anabaptists, 110, 113, 122, 125, 129, 131–132, 134–135, 136, 141, 148, 162, 164, 217–218, 219, 221–222, 228, 231, 249
Anglicanism, 90, 155–156, 167, 169–170, 171, 226–228, 242
apophatic/cataphatic spirituality, 59, 79, 143
ars moriendi, 45, 169
art, 59, 146–152; *abussus non tolit usum* argument, 153; adiaphora, 148, 151; *dulia/latria* distinction, 32, 147; iconoclasm, 148, 149–152, 181; *libri laicorum* argument, 147
Articles of Prague, Four, 107
Articles of Religion, Thirty-Nine, 166
Augsburg Confession, 125–126
Augustinian Canons, 60–62, 72, 89–90, 97, 99, 109; Windesheim Congregation of, 97, 98–99
Augustinian Friars, 64, 72–73, 98, 99, 117, 129, 140, 202, 216

Baptism, 11–12, 44–45, 124, 128–136, 161, 162, 164, 179, 188, 203–204, 217, 231–232; emergency baptism, 134, 162, 226; exorcism, 129, 135–136, 199, 200; mass baptisms by missionaries, 197, 199–201, 204, 206
Basel, 109, 121, 127, 150
Basel, Council of, 102, 108, 177
Beguines, 81, 82, 88–89, 93–96, 106, 215
Belgic Confession, 126, 160
Bible. *See* scripture.
Black Legend, 203
Book of Chilam Balam of Chumayel, 202
Book of Common Prayer, 130, 133, 151–152, 154, 162, 166, 182, 206, 226, 240
Book of Concord, 126, 160, 228
Book of Homilies, 145–146, 151, 166
Buddhism, 207–208
burial, 20, 36, 170–171

Calixtines. *See* Hussites
canon law, 10, 50, 52, 103, 166, 167, 168
canons regular, 60–62, 72, 97, 98
Canossa, 53
Canterbury Cathedral, 40, 42
Canterbury Tales, 41, 43, 64, 105
cardinals, 52–53, 100–101, 102, 104, 179
Carmelites, 33, 71–72, 190–193, 198, 200, 235
Cathars, 65, 215–216
Carthusians, 57, 62–63, 89–90, 96, 98, 185, 191
cataphatic spirituality. *See* apophatic/cataphatic spirituality
chantry chapels, 16, 145
Chinese Rites Controversy, 209
churching rite, 159, 162, 227
Cistercians, 55, 56–59, 61, 64–66, 77, 81, 106, 147, 151, 233
Civil Wars, English, 155–156, 226–227
Cloud of Unknowing, 89–90
Cluny/Cluniacs, 50, 51–52, 54–57, 62
colloquies, 124, 145, 177–179, 181
Conciliarism, 100–103, 176–177
confessionalization, 126, 160–162, 176, 225, 231, 249
confirmation, 11, 44, 45, 172n4, 183
Confucianism, 208
Congregationalism, 227, 236, 237–239
consistories, 160–162
Constance, Council of, 97, 101–103, 105, 107, 177, 216
convents, 64, 77, 88, 94, 97, 190, 191, 198–199, 233–234

Corpus Christi, feast of, 19, 23, 25–26
crusades, 26, 34, 39, 40, 54

Decree of Alhambra, 195–196, 216
Devotio Moderna. See Modern Devout
Dominicans, 5, 26, 34, 35, 61, 64–68, 69, 71, 72, 81, 82–84, 88–89, 95, 98, 99, 139–140, 184, 192, 197–200, 203–205, 209, 215
Dort, Synod of, 126

education, 144, 160–162, 177, 183–184, 186, 187, 208, 242
Ephesus, Council of, 32
Ephrata Cloister, 237
Eucharist, 10–27, 44–45, 99, 168, 169–170, 183, 205, 228, 234, 241; liturgy for, 17, 54, 121, 154, 182–183; material context of, 19–23, 118–121, 146–152, 181, 183, 226; and miracles, 25, 27, 42; theology of, 10–12, 118–128; votive masses, 23–25
excommunication, 10, 33, 51, 53, 178

Formula of Concord, 230
Franciscans, 5, 34, 35, 61, 66, 68–71, 98, 105, 192, 198, 199–201, 204, 209, 215, 247; Capuchins, 71, 179, 184; Poor Clares, 69; Spirituals, 71, 201
fraternities, 23, 33, 184, 190
free spirit, heresy of the, 82, 95

Geneva, 6, 63, 127, 135, 143, 149, 154, 160–162, 169, 188–189, 218, 226, 251
Great Awakening, 236, 238–239
guilds. *See* fraternities

heaven, 15, 24, 31
hermits, 50, 56, 57, 62, 71–72, 89, 185, 190, 215
hell, 32, 168, 188, 192, 193, 203, 238
holy orders, 12, 45, 206
Huguenots, 151, 154, 171, 181, 217, 219
Humiliati. *See* hermits
Hussites, 78, 103, 105, 107–108, 118

Imitatio Christi, 98–100, 184–185, 228, 240
inculturation, 197, 206–209

index of banned books, 180, 183
indulgences, 26, 40, 41, 42–43, 57, 109, 117, 170, 251
inquisition, 66, 179, 180, 185, 195–196, 199, 215–216, 221, 234
investiture controversy, 53–54
Islam, 67, 71, 195–196, 200, 216

Jansenism, 233–235, 236
Jesuits, 73, 175, 176, 179, 180, 182, 183, 184–189, 190, 206–209, 217, 222, 231, 234, 249
Judaism, 100, 132, 152, 195–196, 216
justification. *See* soteriology

Lateran Council I, 41
Lateran Council IV, 10, 12, 44, 51, 63–64, 65, 66, 68, 72, 73, 94, 101, 118
Lateran Council V, 102, 176–177
Laudians, 152, 169, 171, 227, 228, 236, 237, 239
law, biblical, 107, 142, 143, 227, 230
legates, 10, 27, 52–54, 187
Lollards, 78, 103–107, 113, 147
Lord's Supper. *See* Eucharist
Lutheranism, 22, 85, 113, 121, 122–124, 125–126, 127–130, 131, 135–136, 140–143, 148–149, 153–154, 160, 165, 168, 177, 180, 218, 219, 228–231, 236–237

Marburg Colloquy, 124, 140
martyrs, 36–37, 39, 40, 42, 170, 184, 185, 213–223; martyrologies, 105, 154, 219–223
marriage, 3, 11, 44, 45, 163–168, 226; of clerics, 50, 52, 60, 125, 163–166; and divorce, 45, 144, 165, 167–168, 178, 220
mass. *See* Eucharist
Methodists, 239–242
Mexico, 198–205
Modern Devout, 5, 83, 96–100, 102–103, 111, 113, 147, 185
Moravians, 108, 232–233, 236–237, 239, 240, 241
music, 17, 81, 121, 124, 135, 152–156, 182–183, 202, 214, 217, 219, 221, 223, 229, 232, 241, 242, 250

Index of Subjects

mysticism, 4, 61, 63, 68, 77–90, 95–96, 97, 98, 148, 185, 186, 190–193, 215, 227, 231, 234–236, 237

Nestorianism, 123
noetic effect of sin, 72, 150
Non-Jurors, 239–240, 241
Norbertines. *See* Premonstratensians
Norman Conquest, 10, 54

papacy, 49–54, 104, 106, 128, 144, 178, 248; Avignon, 78, 80; bulls, 25, 42, 69, 82, 100, 102, 104, 177, 186, 187, 196, 204, 216, 234; and Conciliarism, 100–103; curia, 23, 52, 58, 181, 182, 187, 216
Peace of Augsburg, 135, 160, 180, 228
Peasants' Revolt, 78, 113
Peasants' War, 177
penance, 11–12, 14, 40–41, 44–45, 216, 234
Pietism, 136, 228–232, 236
pilgrimage, 26, 35, 37–46, 54, 67, 107, 185, 186, 226
preaching, 5, 14, 15, 18, 34, 58–59, 65, 68, 119–121, 139–146, 171, 218, 229, 238; and sermon collections, 14, 25, 140, 145–146, 151, 166, 184, 214
Premonstratensians, 25, 61–62
Presbyterians, 226–227, 236, 238
Puritans, 133, 134, 144–146, 156, 162, 167, 226–228, 236, 237–238
purgatory, 24, 36, 37, 40–41, 42, 43, 55, 168, 170–171

Quakers, 129, 133, 228, 231, 236, 238
Quietism, 233, 234–236

Reconquista, 195–196, 209, 216
Regensburg Colloquy, 177, 178, 179
Restoration (England), 156, 169–170
relics, 20, 32, 35–40, 52, 78, 124, 149–152, 222
Rheims, Council of, 61
Rome, city of, 37, 39–43, 42, 51, 52–53, 72, 78, 100–101, 104, 175, 180, 184, 186, 187, 190, 207, 222, 234, 251
Rule of St. Augustine, 61, 72
Rule of St. Benedict, 50, 54–55, 56–57

Saalhof circle, 231
sacred space, 14–16, 53–54, 146–152, 170–171, 226–227
Santiago de Compostela, 40, 42
Schism, Great Western, 80, 93, 101–100, 102, 104
Schism, Great, 10, 51, 101
Schmalkaldic League, 127, 178, 180, 217
Schwarzenau Brethren, 231, 237
scripture, 4, 12, 36, 39, 61, 94, 103, 104, 105–107, 111, 134, 139–145, 147, 149–150, 153, 163, 166, 169, 178, 179–180, 215, 218, 221, 229, 237, 247; exegesis/hermeneutics, 2, 108, 113, 122–123, 124, 140–141, 142, 231; translations of, 5, 94, 96, 106, 107, 144–145, 179–180, 183, 185
soteriology, 2, 24, 36–37, 55, 87, 117, 119, 129, 134, 141, 148, 166, 168–170, 177–178, 179, 228, 230, 233, 251
St. Bartholomew's Day Massacre, 217, 219
Supremacy, (English) Act of, 125, 218
syncretism, 36, 206, 209
Swiss Agreement (*Consensus Tigurinus*), 126, 127–128, 145

Theologia Deutsch, 85, 87, 228
Thirty Years War, 153, 216, 228
Toleration, (English) Act of, 228
Trent, Council of, 20, 22, 54, 103, 110, 118, 156, 176–184, 199

unction, 44–45, 169
Utraquists. *See* Hussites

Vienne, Council of, 88–89, 95, 96, 97

Waldensians, 64–65, 78, 105, 215
Wittenberg, 1, 109, 117, 119–121, 131, 142, 148–149, 163
Worms, Concordat of, 53

Zurich, 1, 121, 124, 126–128, 131, 143, 144, 149–150, 153, 160–161, 165, 168, 226

About the Author

Calvin Lane (PhD University of Iowa) is affiliate professor of church history at Nashotah House Theological Seminary in Wisconsin. He has also served as adjunct professor of history at Wright State University in Dayton, Ohio. Lane has held research fellowships in the U.S. and the U.K., and his first book, *The Laudians and the Elizabethan Church* (London: Routledge, 2013) examined the legitimating power of history and primitivism in post-reformation England. Based on that work, Lane was elected a Fellow of the Royal Historical Society in 2013. He has articles and book reviews in several scholarly journals and is active in the Sixteenth Century Society and the American Society of Church History. Dr. Lane is also a priest of the Episcopal Church and has served parishes in Louisiana and Ohio.